Performance, Fashion and the Modern Interior

urn to ...
ase retu
ıy also
juested b
wwv

Performance, the Modern

From the Victorians to Today

Edited by
Fiona Fisher,
Patricia Lara-Betancourt,
Trevor Keeble and
Brenda Martin

Fashion and Interior

Oxford · New York

English edition

First published in 2011 by

Berg

Editorial offices:

49–51 Bedford Square, London WC1B 3DP, UK

175 Fifth Avenue, New York, NY 10010, USA

© Fiona Fisher, Patricia Lara-Betancourt, Trevor Keeble and Brenda Martin 2011

Berg is the imprint of Bloomsbury Publishing Plc.

Library of Congress Cataloging-in-Publication Data

A catalogue record for this book is available from the Library of Congress.

British Library Cataloguing-in-Publication Data

A catalogue record for this book is available from the British Library.

ISBN 978 1 84788 782 5 (Cloth)

 978 1 84788 781 8 (Paper)

e-ISBN 978 0 85785 059 1 (Individual)

Typeset by Apex CoVantage, LLC, Madison, WI, USA.

Printed in the UK by the MPG Books Group

www.bergpublishers.com

Contents

General Introduction

Brenda Martin

All the world's a stage
And all the men and women merely
players

—*As You Like It,*
William Shakespeare, 1600

This is the second anthology of essays that address the history of the modern interior collected and edited by the Modern Interiors Research Centre (MIRC) at Kingston University, London. The first, *Designing the Modern Interior: From the Victorians to Today* (Berg, 2009), took as its broad remit the spaces of the modern interior as conceived and designed by both amateurs and professionals. It attempted to give a clear definition of 'modern' and the experience of 'modernity' and discuss the cultural ideas that influenced designers and architects in Britain, Europe, the United States, Australia and Japan. Contrary to the narrow twentieth-century definition of European modernism, as articulated by architects such as Walter Gropius at the Bauhaus in Germany and Le Corbusier and others in France in the 1920s, *Designing the Modern Interior* widened the frame of reference to include the experience of modernity as it was perceived by decorators and interior designers from the late nineteenth century to the present day. In the general introduction, Penny Sparke

set out a new framework for the study of the modern interior and a definition of modernity that also informs this collection of essays. The section introductions by Emma Ferry (1870–1900), Penny Sparke (1900–1940 and 1940–1970) and Trevor Keeble (1970–present) outlined the stylistic themes and cultural ideas for each period. These were followed by case studies that considered in depth the topics of taste, style and choice in their complex relationships to the interior and discussed the impact of conspicuous consumption upon it. Moving beyond the usual stylistic boundaries, the essays used sociological, anthropological and cultural approaches to analyse what it meant to inhabit the modern world and introduced the concept of interiority as an extension of the body and as a represented, mediated ideal connoting a modern lifestyle.

In this second volume, this complex study of the interior has been taken further to focus on its relationship with performance and fashion. The essays here are about seeing and being seen in the interior through the lens of fashion, both in terms of what we wear and the interiors we inhabit, public or private. The 'interior' is also considered as a metaphorical stage for the performance of the rituals of modern life, and fashionable dress as an expression of modernity. These themes emerged at two conferences—*Fashioning*

the Modern Interior (2007) and *Staging the Modern Interior* (2008)—at which speakers and delegates from diverse disciplines drawn from around the world explored different aspects of the same question: How are fashion, performance and the interior linked, and how do they influence each other? The question is relevant to fashions and interiors created throughout the modern period and the relationship between them expressed, for example, in Henri van der Velde's art nouveau fashions for his wife, which were made to enhance the settings of his interiors; in Charles Rennie Mackintosh's early-twentieth-century designs for simple dress created to complement his simple white interiors; in Giorgio Armani's couture dresses presented in high-style interiors crafted from the same design principles; and in the UK retail store Next's more downmarket brand of fashion and home wares presented in clearly recognisable branded shops. Have we come full circle? Do fashion and the spaces we inhabit, intimately bound up with our sense of identity, reflect the same design aesthetic?

The context for this book can usefully be taken as the globalization of the study of the history of the modern interior. In the first decade of the twenty-first century it is an indicator of a development and scope of scholarship in this field which in a way has mirrored the worldwide spread of global consumer brands such as Armani Casa, Next Home and Ikea. It seems evident that the homogenization of cultural expectation and lifestyle increasingly needs to be analysed in this wider context. The electronic publication of journals on the Internet, email, and cheaper world travel have made international conferences and collaborations between educational institutions easier and academically profitable, leading to a widely accessible new body of material on the modern interior. This has enabled the publication in hard copy of a number of design readers for students.[1] This global diversity of study is characterized by the close collaboration of MIRC in the UK with scholars from the Bard Graduate Center, Wellesley College and the University of Maryland in America, Queensland University of Technology in Australia, the University of Guelph in Canada, the Politecnico di Milano in Italy, the Katholieke Universiteit Leuven in Belgium and the University of Delft in Holland through a series of international conferences that have taken place from 2000 to 2010.[2] The first issue of the journal *Interiors: Design Architecture Culture,* published globally by Berg in 2010, has provided a new international forum for analysis of the history of the modern interior. The challenge of differing definitions of modernity—which underpin the study of the modern interior, both public and private—affected all periods, changing according to the different social and class structures of each century. In the nineteenth century, what did it mean to belong to the modern world as Charles Baudelaire, Thorstein Veblen and Walter Benjamin defined it? Alongside Baudelaire's figure of the male flâneur inhabiting the public streets and bars, the concept of the private domestic modern interior can be seen to have arisen at that time.[3] Benjamin's perception of nineteenth-century modernity is documented in his *Arcades Project,* upon which many design historians have drawn.[4] As the private domestic interior became distinct from the public spaces of the outside

world in the nineteenth century, it provided a space where women were dominant and where fashion and dress together became an extension of their identity and men's wealth, creating separate spheres of inhabitation for men and women.[5] The split between work and home life enabled personal taste to be displayed at home, in spaces which were staged for activities such as formal dining, reading, listening to and playing music and other family-centred activities. At the end of the nineteenth century, the sociologist Veblen identified the acquisition of the fashionable goods of modernity by the wealthy middle classes for the staging of the interior as 'conspicuous consumption'.[6]

Also important to the discussion in this volume are the signifiers and tropes of Pierre Bourdieu's 'distinctions' of class and taste when applied to the modern interior in the twentieth century.[7] As class distinctions became blurred and were overtaken by now, hybrid social groupings, not always defined by wealth, these were signified by different types of interiors. Gender roles were more openly discussed, and *queer* entered the arena as a term to describe sexual and gendered identities outside heterosexual 'norms'.[8] By the end of the twentieth century, did the traditional family exist to inhabit the domestic interior when statistics regularly quoted in the daily press showed that single occupancy was becoming the norm? Public spaces such as banks and shopping malls are no longer overtly public and corporate. They are becoming 'domesticated' in an effort to put their customers at ease, but who has ownership of these new semi-private/ semi-public spaces? Whose identities do

they express, and what rituals are performed there? This collection of essays explores the idea that the subtle ways in which we express our allegiance to a particular social tribe are inherent in the places we inhabit and in the clothes we choose to wear.

By the early twenty-first century, virtual idealized interiors have come to provide an even wider diversity on the screen, both in reality and fantasy. New to this anthology are essays which take as their subject the 'once removed' interior and the late-twentieth-century's relationship with interiors of the screen through constructed sets for film and television. The transience of modern interiors is also highlighted with regard to contemporary site-specific art installations in two essays in this volume.

The themes which emerged from the papers presented at the two conferences were those of staging and ritual in the modern interior, identity, ceremony and etiquette, and mediated interiors, either through the screen or in other ways. The theme of the interior as a 'stage' for the rituals of modern life is discussed in several essays. Leighton House, a late-nineteenth-century house in London's Kensington, has been written about extensively, but Mark Taylor examines this highly fashionable interior of the Aesthetic Movement less through a stylistic analysis, and more through a poetic reading of the effect on the emotions and its position within design history as a sensual, inspirational interior. In a similar vein, Alice T. Friedman analyses the 1950s country estate of Philip Johnson at New Canaan, Connecticut, in relation to eighteenth-century pastoral traditions and the 'queer pastoral'—secluded spaces on

private estates of romantic and poetic beauty that provided a dramatic backdrop for a 'gay' society away from the 'scrutiny and ridicule' of 'polite society'. Christopher Breward follows this sensual theme as he takes us into the dramatic world of the Edwardian theatre, exposing the synergies between fashionable stage sets and sumptuous costumes and the audiences, who were themselves performing the rituals of modern life in a public space. The inspirational effect of the particular ambience of Viennese coffeehouse interiors at the turn of the century on the intellectual productivity, wit and mental agility of the Jewish intelligentsia who inhabited those interiors is discussed by Tag Gronberg. These interiors are interrogated as sites for self-display and intellectual interplay, staged for public consumption as much as for the players, a theatrical performance which provides an informative metaphor for considering them.

Identity is present as a theme throughout the study, but several authors explore in more depth how it is formed and performed through the agency of the private interior and personal choice. Eric Anderson considers the cultural zeitgeist of Vienna through the writings of Jakob von Falke on dress and the interior in the 1880s. Falke writes of domestic interiors that were an 'ample garment' which expressed identity, both personal and national, as much as clothes did. Mary Anne Beecher explores the creativity and ingenuity of Depression-era women in rural middle- and working-class America for whom shopping for the fashionable home was economically impossible. They learned skills in dressmaking from the extension service programmes of

Cornell University and then employed these techniques to create low-cost versions of fashionable furniture and interiors.

Bridget May takes up the theme of national identity as it related to the historical past of America, forged through the re-enactment of Colonial style in the revivalist interiors and material culture of middle-class America. Meltem Ö Gürel links the trio of home, fashion and feminine identity in the new republican Turkey to a national identity aligned with the capitalist West that signified modernity. Gürel sees modern-style clothing as 'connective tissue' for the new republican state and modern women as manipulated into becoming amateur decorators by versions of Western-style femininity and modernity shown in popular magazines.

Corporate identity, or brand, as seen in fashion houses is the subject of essays by Samantha Erin Safer and John Potvin. In a new approach to the study of Lucile Ltd, the early 1900s fashion house of Lady Duff Gordon, Safer analyses the styling of the models and the creation of separate identities for each room within Lucile Ltd's international premises. Safer describes the deliberate promotion of semi-domestic interiors to create a 'warm seductive' atmosphere as central to Lucile's commercial success and highlights the influence this had on Parisian couturier Paul Poiret and the design of later couture houses. Giorgio Armani's identity as a designer, expressed through the fantastic interiors of his homes and fashion designs in the late twentieth century, is the subject of John Potvin's chapter. Armani's interweaving of home and fashions, his use of the same concepts for a home and the living bodies

within it, produced a 'brand' mutually rec-
ognizable by consumers of a lifestyle which
has become global.

Ceremony and etiquette and the way
interiors interface with them are other themes
explored in this collection. As social practices
changed, people needed appropriate fash-
ions and spaces. For example, the formal
Edwardian dinner party required a separate
dining room, entrances and exits for the
servants, full place settings, the correct serving
dishes and other paraphernalia and formal
evening dress. The same practice, a formal
dinner party, in an expensive loft apartment
in the 1980s was an entirely different version
of the same social ritual, with the hosts per-
haps serving the meal themselves in designer
jeans and casual dress. The theme of cere-
mony and etiquette is explored in an essay
by Grace Lees-Maffei on 1950s domestic
advice literature in Britain and the United
States. Lees-Maffei chronicles the scripting
of a new code and new staged settings
for home entertaining in the postwar home
and concludes that in the modern postwar
servant-less world, the appearances of easy
casual living required just as much behind-
the-scenes effort as the grand productions
of the past. Lees-Maffei analyses the staged
interiors of this domestic discourse in terms of
the practical and material and as an abstract
imaginative concept. Nicky Ryan writes of Ian
Schrager's boutique hotel lobbies that were
designed to be an international signifier of
class and difference. They were spaces to
be seen in, appropriate for the spectacle of
celebrity arrival and departure. These lobbies
functioned as part art gallery and part stage
set, and Ryan asserts that the link with the

artist's studio implicit in their design was a
way of communicating a superior taste and
lifestyle with subtle references to both the
bohemian and the modern.

Also under investigation in this volume
are interiors transposed through the lens
of photography, film and television as the
home or 'stage' for the performance of
screen identities. Recognizing the complexity
of modern society in the twentieth century,
the architectural historian Beatriz Colomina
has argued that the role of the media in the
staging of interiors and architecture was a
key element in forming taste and signifying
modernity.[9] Andrew Stephenson's chapter
looks at the agency of the photography of the
Séeberger brothers, who made postcards
and photographs for the fashion industry in
Paris in the early twentieth century, before
being commissioned by a Hollywood cinema
agency to photograph Parisian life and notable
Parisian sights. These were used in the United
States from the 1920s to reconstruct a vision
of Paris for Hollywood film sets. Stephenson
analyses the fictive Paris—'Paris/Hollywood'
transposed into film interiors—which set up
a unique dialogue of double representations
of perceived space, real space, expectations
of space and the reality of space. Marilyn
Cohen's essay examines the interior through
a reading of private and public spaces and
the part they play in the complex formation
of the identities of the two central characters
in the 1961 film *Breakfast at Tiffany's*. Set
amongst the 'glitter and shimmer' of New
York, Audrey Hepburn's designer clothes,
dark glasses and huge hats support a public
identity which is at odds with her private
identity, and Cohen traces the transgressions

in numerous ways. The ephemeral sets of the smaller screen of television are the subject of Teresa Lawler's chapter. From the domestic interiors of period dramas, to soap operas such as *EastEnders,* and news sets which can be instantly transformed with subtle lighting, Lawler examines how identity is formed and reinforced for the viewer through props and other background material in 'hidden design'.

In reaction to the sterile white cube interiors of art gallery in the 1980s, in the twenty-first-century, empty and disused interiors have become spaces of mobility, change and interventions which disrupt earlier meanings and uses. Both Helen Potkin and Pierluigi Salvadeo discuss contemporary art installations which are site-specific and transform interiors through the use of mirrors, projected images and fashion shows. All give a different use to the interior and a different perception of the spaces of the interior. Visitors to these exhibitions and works are invited to imagine the past and see the present anew. Salvadeo also observes the conflation of architecture and set design, from the Turbine Hall at London's Tate Modern to the Disneyland of Las Vegas, and proposes that expectation and the reality of the interior are confounded in the modern world.

The editors would like to thank all the contributors to this volume; our colleagues at the Modern Interiors Research Centre, Penny Sparke and Anne Massey; the research support team at Kingston University, especially Fran Lloyd; and Tristan Palmer and the editorial team at Berg.

Notes

1. M. Taylor and J. Preston, eds, *INTIMUS: Interior Design Theory Reader* (John Wiley & Sons, 2006); A. Lillethun and L. Welters, eds, *The Fashion Reader* (Berg, 2007); E. Hollis et al., eds, Interiors Forum Scotland, *Thinking Inside the Box: A Reader in Design for the Twenty-First Century* (Middlesex University Press, 2007); G. Adamson, *The Craft Reader* (Berg, 2009); H. Clark and D. Brody, *Design Studies: A Reader* (Berg, 2009); G. Lees-Maffei and R. Houze, *The Design History Reader* (Berg, 2010).

2. *Interior Lives* (2010); *Living in the Past: Histories, Heritage and the Interior* (2009); *Staging the Modern Interior* (2008); *Fashioning the Modern Interior* (2007); *The Professionalisation of Decoration, Design and the Modern Interior, 1870 to the Present* (2006); *Modernity, Modernism and the Interior, 1870–1970* (2005); *Practice and Identity: Women, Sculpture and Place* (2004); *The Modern Period Room—The Construction of the Exhibited Interior, 1870–1950* (2003); *Shopping for Modernities—Selling and Buying Goods for the Home, 1870–1939* (2002); *British Suburbia in the Interwar Years: Its Architecture and Material Culture* (2001); *Women and Building* (2000).

3. P. Sparke, 'The Modern Interior: A Space, a Place or a Matter of Taste?' *Interiors: Design Architecture Culture* 1/1 (July 2010), p. 7.

4. W. Benjamin, *The Arcades Project* (Harvard University Press, 2004).

5. L. Davidoff and C. Hall, *Family Fortunes: Men and Women of the English Middle Class* (Routledge, 1987).

6. T. Veblen, *Theory of the Leisure Class: An Economic Study in the Evolution of Institutions* (Penguin Books, 1994 [1899]).

7. P. Bourdieu, *Distinction: A Social Critique of the Judgement of Taste* (Harvard University Press, 1984).

8. A.T. Friedman, *Women and the Making of the Modern House* (Harry N. Abrams, 1998), chap. 4. T. Rohan, 'The Dangers of Eclecticism: Paul Rudolph's Jewett Arts Centre at Wellesley', in S. Goldhagen and R. Legault, eds, *Anxious Modernisms: Experimentation in Postwar Architectural Culture* (MIT Press, 2000), pp. 190–213. See also C. Reed, 'A *Vogue* that Dare Not Speak Its Name: Sexual Subculture during the Editorship of Dorothy Todd, 1922–26', *Fashion Theory* 10/1–2 (March–June 2006), *Vogue* special issue, pp. 39–72; Katarina Bonnevier, 'A Queer Analysis of Eileen Gray's E1027' in H. Heynen and G. Baydar eds, *Negotiating Domesticity: Spatial Productions of Gender in Modern Architecture* (Routledge, 2005).

9. B. Colomina, *Privacy and Publicity: Modern Architecture as Mass Media* (MIT Press, 1998).

Part One

1850–1900

Introduction

1850–1900

Sabine Wieber

Oskar Mothes's idealized interiors

In 1879, the German architect and cultural historian Oskar Mothes (1828–1903) published an extraordinary interior design manual entitled *Unser Heim im Schmucke der Kunst* (*Our Home Embellished by Art*), which showcased domestic interiors occupied by contemporary inhabitants using each room according to its designated function.[1] The ladies' sitting room, for example, features three generations of women gathered around for tea, the grandmother looking at a picture book with her young granddaughter and the lady of the house rising to greet another female guest who has just entered the room. The painstaking reproduction of the sitting room's historicist and lush décor followed standard visual conventions of late-nineteenth-century German design manuals. These called for an assiduous rendering of individual surfaces and textures and the use of soft light to infuse the room with an overall ambience that unified these individual components into a painterly environment.[2] In this respect, Mothes's publication participated in the gradual standardization of the representation of domestic interiors in a flourishing body of nineteenth-century literature on the subject.[3] Indeed, when looking at photographs in current interior design magazines such as *World of Interiors,* or in the many coffee-table books published in recent years, it could be argued that some of the representational conventions perfected by late-nineteenth-century design publications survived well into the twenty-first century. But in this very context, Mothes's book also marks an important departure from contemporary publications in that the function of each of its interiors is performed by a set of users enacting social codes of behaviour typical of a late-nineteenth-century, upper-middle-class household composed of multiple generations of inhabitants and their servants, as well as a series of visitors from the outside world. Mothes's idealized interiors thus functioned as carefully conceived stages upon which modern life and identity were dramatized. In effect, his vignettes of lavish décor and appropriate behaviour colluded in a celebration of socio-economic status typical of Germany's ambitious upper middle classes of the time.

To envisage Mothes's interiors as stages on which users enacted each room's specific function raises the issue of identity because

these performances were closely implicated in projecting a series of collective and individual modern identities. This raises a number of interesting issues that closely resonate with the essays in this section. Firstly, Mothes's inhabited interiors need to be addressed in terms of recent debates on place and space. For the past decade or so, the notion of 'space' has become a rather fashionable theoretical construct that is employed across the disciplines, but not always with due care and rigour.[4] Despite Lefebvre's early assertion that space is culturally and socially produced and as such an important site of contestation and struggle, place and space continue to be used as an essentialist category.[5] A strict distinction between place as a physical entity 'filled by people, practices, objects and representations' and space as the appropriation, interpretation and narration of these material constellations is absolutely necessary.[6] De Certeau expressed the shift from place to space most poetically when describing the ways in which in their everyday practices, pedestrians navigate the city through a series of 'appropriations of the topographical system' that must be understood as the 'spatial acting-out of the place (just as the speech act is an acoustic acting-out of language)'.[7] Viewed from this perspective, space is dynamic, and identities are formed and contested within it. To engage with place and space from this theoretical vantage point seriously impacts the discussion of the modern interior. It enables us to reformulate the role played by historical interiors in the process of identity formation as an active one. Rather than merely 'reflecting' a particular identity, the

late-nineteenth-century interiors discussed in this section of the anthology participated in the interpellation of the historical subject.[8] Put simply, specific historical interiors might have been created in response to certain ideologies and ideals of the time, but identity was constituted in their user's embodied response to them. The idea of performance called upon in the anthology's title thus flags our attention to the ways in which subjectivity is shaped through the process of enacting the materiality of a given interior.[9] Within this theoretical framework, the modern interior under investigation should be thought of as a mise-en-scène employing actors, costume, décor, lighting and props to actively stage modern identity rather than passively reflecting it. While this performance is scripted by a series of codes and conventions, it is always open to adaptation and even subversion by individual actors and spectators.

Mothes's rooms slightly complicate the discussion of place and space because they are idealized representations of specific types of interiors rather than actual physical environments. And yet, they were implicated in the interpellation of the modern subject by actively participating in late-nineteenth-century discussions about national identity in relation to style and taste. Published in Germany in the late 1870s, Mothes's idealized spaces form the tail end of a fashionable craze for domestic interiors furnished in the style of a revived German Renaissance, taking its cue from sixteenth-century Northern European interiors. Although already exhibiting a certain eclecticism, Mothes's ladies' sitting room, the dining room and the gentlemen's sitting room feature all the conventional

props of a German Neo-Renaissance room as it was envisioned by late-nineteenth-century producers and consumers of culture: elaborately carved chairs and tables, lush carpets, wooden panelling, velvet curtains, stained glass windows, pewter jugs and serving pieces, and even a tiled stove features in a corner of the dining room. These objects and furnishings were historicist reproductions of sixteenth-century pieces and treated the stylistic characteristics of this historical moment quite freely. Historical veracity might not have been the objective of these interiors, but the creation of an atmosphere of cosiness and 'German ness' was high on the agenda. Since Munich had staged the highly successful German Art and Applied Arts Exhibition in 1876, this Neo-Renaissance style was celebrated by critics as epitomizing Germany's new national style. Interiors furbished in the style of a revived Northern Renaissance were not only highly fashionable, but were also seen as a patriotic response to 'foreign' French and British imports.[10] Mothes's idealized interiors manifest this link between stylistically unified Neo-Renaissance interiors and the German nation on two levels: the settings comprised of furniture, objects and artworks as well as the envisioned inhabitants, who not only re-enact the function of each room through their appropriate behaviour but who, on a more abstract level, embody the ideals of German citizenship. Within this collective social performance of German national identity in and through Mothes's interiors, careful attention was paid to issues of class and social hierarchy. Again, this was achieved through the representation of ideal behaviour

as, for example, in one of the female servant's demure behaviour in the anteroom, or the piano teacher's respectful distance from the children's grandfather, who was seated next to the piano.

The confident staging of this historically specific German national identity in Mothes's illustrations also raises the important issue of gender and, indeed, problematizes some of the long-standing discursive divisions between private and public places on the one hand and inside and outside space on the other. Over the past decades, scholars have questioned the seemingly 'natural' division between the private (interior) and public (exterior) spheres firmly articulated by early key texts of the domestic interior such as Peter Thornton's *Authentic Décor*, first published in 1984.[11] By investigating how complex notions of masculinity were articulated in Victorian Britain, the historian John Tosh, for example, challenged supposedly 'stable' configurations of the domestic sphere as an exclusive domain of women and femininity.[12] This is not to suggest a revisionist interpretation of late-nineteenth-century gender relations, but instead to call for a more careful probing of some of the pervasive ideologies of the time that reinforced these divisions in the first place. A careful reading of contemporary sources reveals that critics liked to describe the interior as a refuge from the anxieties and stresses induced by modern life 'on the outside'.[13] Here, the projected comfort of the home organized around the nuclear family under the domestic auspices of the matron of the house engendered the emergence of a discourse on homeliness and privacy. Even Walter Benjamin spoke of the nineteenth-century

interior as a *Gehäuse* (a casing).[14] Despite Mothes's clear codification of certain rooms in terms of décor, function and gender, a second look at his visual representation of the salon or the ladies' sitting room, for example, clearly shows that the public and private very much intersected and thus unveils the tenuous nature of these divisions. In many ways, the salon as a physical place and a conceptual space actually represented a hybrid constellation. Penny Sparke eloquently articulates this idea:

The modern interior was the result of the two-way movement between the private and the public spheres. Within that movement individual and group identities were formed, contested and re-formed. While the ideology of the separate spheres was enormously powerful, so too were the forces that determined to break down the divide between them. The dynamic tension created by that level of determination lay at the very heart of the modern interior and gave it its momentum.[15]

Three themes: place-space, national identity and private-public/interior-exterior

Sparke's astute conceptualization of the modern interior as a 'two-way movement between the private and the public' opens up fascinating new avenues for design historians to engage with historical interiors as key sites for the formation of distinctly modern identities that transgressed restrictive binaries imposed by cultural historians of the past (such as private-public, interior-exterior, feminine-masculine, progressive-regressive etc.).

Each of the four essays in this section uses a specific case study to elucidate how the historical interiors in question staged particular notions of modern life and identity during the time period 1850–1900. As the late nineteenth century was characterized by such great economic, political and social change, the material, spatial and subjective responses by contemporaries to modernity makes this moment such a fascinating and productive topic of study.[16] Each essay deals with the three themes (place-space; national identity; private-public/interior-exterior) invoked by the wonderful interiors in Mothes's *Unser Heim im Schmucke der Kunst* in different ways. Eric Anderson's discussion of Jakob von Falke's groundbreaking nineteenth-century publications on the history of German clothing and domestic interiors chimes nicely with Mothes's book. As a contemporary of Mothes, Falke was equally worried about the state of contemporary *Wohnkultur,* and he made interesting links between fashion, dressing and the interior. Falke's influential theories on interior decoration (*Die Kunst im Hause,* 1871) also featured a series of simulated interiors, albeit without inhabitants. Interestingly, both authors included the word *Kunst* (art) in their title, as though consciously willing the decorative to be elevated above its low nineteenth-century status as mass-produced, aesthetically inferior applied arts. Like Mothes, Falke's design manual for contemporary interiors adapts a historical style (in this case the Italian Renaissance) to articulate an idealized, nineteenth-century interior that was intended to articulate a distinctly modern conceptualization of Germanness. National identity, style and shifting notions of fashionability thus feature prominently in

Anderson's assessment of Falke's work. Mark Taylor's close reading of Mary Eliza Haweis's encounters with Frederic Leighton's Holland Park house, built to the designs of George Aitchison, puts forth an interesting new interpretation of Haweis's well-known *Beautiful Houses,* originally published in 1882. Again, nineteenth-century interiors were presented in the pages of a book. However, contrary to Falke and Mothes, Haweis's publication actually engages with a 'real' (i.e. built) environment in contrast to the formers' idealized spaces. Taylor brings Haweis's emotionally driven and highly subjective experience of Leighton's Narcissus Hall into dialogue with the provocative idea of synaesthesia. This enables Taylor to move the discussion away from looking at Haweis's response to this interior as that of a high-strung amateur and opens up a new theoretical space that takes into account the body and the psyche. Taking his cue from feminist discourse, Taylor proposes that Haweis offered an alternate discourse of the interior by means of a subjective response to her bodily experience of Narcissus Hall. Haweis's subjective performance of place in the pages of her book thus also puts into question some of the aforementioned divisions between interior-exterior/psyche-body. Bridget A. May's essay returns the discussion to issues of national identity, material culture and interiors by investigating how the immensely popular Colonial Revival style activated a particular moment in America's past to forge a modern identity for late-nineteenth- and early-twentieth-century citizens. Moving from an exploration of the mechanisms through which this past was first accessed during the 1870s (through 'words, images, objects, clothing and

environments') into a fascinating discussion of Colonial Revival events such as pageants, parades and tea parties—occasions with entirely different connotations in current politics—May focuses on the engagement between material culture and people. In this context, clothing, objects and interiors are viewed as gateways into the past and, by extension, into contemporary articulations of a national identity. According to May, the past functioned as a 'tool of the present'. The final essay in this section, by Tag Gronberg, proposes an interpretation of the Viennese coffeehouse as a place of spectacle and social performance. In her piece, the Viennese café of the turn of the last century functioned as a physical place and an intellectual space that adhered to very specific conventions developed in the late nineteenth century around the formation of Viennese intellectual and social life. Ephemeral by its very nature, Gronberg pays close attention to the physical setting of the café and the wealth of visual culture circulating in and around this quintessentially Viennese institution in order to reconstitute some of the subjectivities she is interested in.[17] An important aspect of this coffee culture was the formation of particular group identities around particular cafés and, indeed, particular sections in these cafés. According to Gronberg, the 'idea of the Kaffeehaus' was as important in the process of identity formation (self and group) as the physical sites themselves.

This brief synopsis of the essays in this section clearly demonstrates that the impetus behind this anthology to use the theoretical platforms of 'staging' and 'performing' provides an evocative and extremely productive point of entry into thinking about the modern interior

in the late nineteenth century. Although quite diverse in approach and scope, the essays share an interest in shifting the discussion from the producers of the modern interior to their cultural mediators and consumers. Taking their basic cues from performance studies— in itself a highly contested and divergent academic field of study that first emerged in the 1970s—the four authors included in this section pay close attention to how these material environments played a key role in the articulation of diverse modern identities.[18] The conscious reintroduction of practice into the field of studies is an exciting development because it allows us to think about the creative, constructed and collaborative interaction between design and the human body, even when this body is removed from a direct physical experience of the interior as was the case with Mothes, Falke and Haweis. Viewed from this perspective, the modern interior between 1850 and 1900 did not merely serve as a stage for the dramatization of modern life, but actively shaped contemporary actors' experience of modernity.

Notes

1. O. Mothes, *Unser Heim im Schmucke der Kunst* (Leipzig, 1879).

2. The Munich publisher Georg Hirth and the Frankfurt custodian of architecture and applied arts Ferdinand Luthmer were among the earliest proponents of such painterly interiors. G. Hirth, *Das deutsche Zimmer der Renaissance: Anregungen zu häuslicher Kunstpflege* (Georg Hirth Verlag, 1877) and F. Luthmer, *Malerische Innenräume moderner Wohnungen* (Heinrich Keller, 1884). For a superb recent discussion of these interiors see S. Muthesius, *The Poetic Home: Designing the 19th-Century Domestic Interior* (Thames & Hudson, 2009).

3. This was part of a flourishing publishing industry structured around interior design journals, manuals, cultural history books and an emerging exhibition culture that promoted modern interiors across the world. This boom was made possible by the development of new reproduction and exhibition technologies as well as new production methods in furniture-making and the applied arts. For a brief discussion of this 'explosion' see Muthesius, *The Poetic Home,* pp. 58–63.

4. The so-called 'spatial turn' in history and its interdisciplinary repercussions were discussed at a recent conference organized by the Centre for Research in History and Theory at Roehampton University and the German Historical Institute, London, entitled From Space to Place: The Spatial Dimension of History in Western Europe, 16–17 April 2010.

5. H. Lefebvre, *The Production of Space*, tr. D. Nicholson-Smith (Blackwell Publishers, 1991). Lefebvre was, of course, deeply critical of capitalism's abstraction of global space for the purpose of preempting difference and critique.

6. T. F. Gieryn, 'A Place for Space in Sociology', *Annual Review of Sociology* 26/1 (2000), p. 465.

7. M. de Certeau, *The Practice of Everyday Life*, tr. S. Rendall (University of California Press, 1988), pp. 97–8.

8. For an excellent discussion of this process see L. Auslander, *Taste and Power: Furnishing Modern France* (University of California Press, 1996).

9. This consideration of performativity obviously comes out of a reading of Judith Butler's important work on gender. J. Butler, *Gender Trouble: Feminism and the Subversion of Identity* (Routledge, 1999).

10. For a more detailed discussion of the relationship between a revived German Renaissance style and national identity see S. Wieber, 'Eduard Grützner's Munich Villa and the German Renaissance', *Intellectual History Review* 17/2 (2007), pp. 153–74, and S. Muthesius, 'The "altdeutsche" Zimmer, or Cosiness in Plain Pine', *Journal of Design History* 16/4 (2003), pp. 269–90.

11. P. Thornton, *Authentic Décor: The Domestic Interior, 1620–1920* (Weidenfeld & Nicholson, 1984). Penny Sparke was at the forefront of some of the important reconceptualization of interior and exterior, private and public. Her publications are many, but see in particular *The Modern Interior* (Reaktion, 2008).

12. J. Tosh, *Masculinity and the Middle-Class Home in Victorian England* (Yale University Press, 1999).

13. In the German context see for example S. Lichtenstein, 'Die deutsche Kunst- und Kunstindustrie Ausstellung in München', *Zeitschrift für Bildende Kunst* 11/12 (1876), p. 290.

14. 'Die Urform allen Wohnens ist das Dasein nicht im Haus sondern im Gehäuse. Dieses trägt den Abdruck seines

Bewohners. Das neunzehnte Jahrhundert war wie kein anders wohnsüchtig. Es begriff die Wohnung als Futteral des Menschen und bettete ihn mit all seinem Zubehör so tief in sie ein, dass man ans Innere eines Zirkekastens denken könnte, wo das Instrument mit allen Ersatzteilen in tiefe, meistens violette Sammethöhlen gebettet, daliegt.' W. Benjamin, *Das Passagen-Werk: Gesammelte Schriften*, vol. 2 (Surhkamp, 1991), p. 292.

15. Sparke, *The Modern Interior*, p. 16.

16. Here, it is worthwhile to visit the debate generated in the German press by Jürgen Osterhammel's recent book *Die Verwandlung der Welt: Eine Geschichte des 19. Jahrhunderts* (Beck, 2009), which explores the question of what *is* specific to the nineteenth century (in contrast to earlier historical moments).

17. Today, this centrality of the coffeehouse to Vienna's intellectual life at the turn of the last century is greatly exploited by Austria's tourism and the heritage industries.

18. For a contextualization of the emergence of performance studies see S. Jackson, *Professing Performance* (University of California Press, 2004).

Chapter One

From historic dress to modern interiors: the design theory of Jakob von Falke

Eric Anderson

There is perhaps no better way to begin investigating the relationship between fashion and interiors than by turning to the writings of Jakob von Falke, who was among the most widely read nineteenth-century authors on both dress and decoration. Falke remains relatively obscure in the history of design, having spent his career participating in a historicist design culture that has found little critical favour since the advent of modernism.[1] Yet, from the mid-1850s, when he worked as a curator at the Germanisches Nationalmuseum in Nuremberg, until 1895, when he retired as director of the Öster-reichisches Museum für Kunst und Industrie in Vienna, Falke ranked among the most innovative and influential of European writers in the field of applied arts. His books and essays were not only standard literature throughout German-speaking Central Europe but were also widely read in translation from Boston to Budapest.

Among Falke's many publications, two of the most important deal respectively with dress and interior decoration: *Die deutsche Trachten- und Modenwelt* (1858),

a cultural history of clothing, which he wrote while employed in the Germanisches Nationalmuseum; and *Die Kunst im Hause* (1871), a study of domestic interior decoration, which appeared at the height of his career at the Österreichisches Museum. Each of these books was an achievement in its own right. Both count among the first ever studies of their respective topics, both helped establish a significant new area of scholarly and critical interest, and both contributed to the broader discussion around design in the last quarter of the nineteenth century.

Taken together, the two works situate Falke in a rich discourse about the relationship of dress to design that recent scholarship has identified as central to modern architectural theory.[2] In the writings of figures from Gottfried Semper to Le Corbusier, clothing functioned in several different ways: as an analogy to the decorated surface of buildings; as a constituent part of the 'total' interior; and as a realm of material production in which the troubling phenomenon of 'fashion' was most active. Given this context, Falke's dual engagement with dress and decoration

raises some obvious questions: How did his writings on clothing inform his theory of the interior? In what ways does his understanding of the relationship between garments and domestic spaces relate to the notion of total design that was central to the arts and crafts and art nouveau movements? Where does his concept of *Mode* stand in relation to the emerging discourses about fashion and modernity that we know better through turn-of-the-century figures like Hermann Muthesius and Adolf Loos? Finally, what can we learn about the domestic interiors of 1870s Vienna by viewing them against the backdrop of Falke's ideas about clothing and fashion?

Born in 1825, Falke embarked on his career at a time when the modern discipline of art history had just begun to take shape and options for the humanistic study of culture were limited. After completing a diploma in philology at the University of Göttingen in 1849, he took a research position at the recently founded Germanisches Nationalmuseum in 1855. He would remain in Nuremberg for less than four years before departing for Vienna. Yet his brief stay there played an important role in the formation of his intellectual identity. Nuremberg in the 1850s was the epicentre of a vibrant and newly emerging scholarly discipline known as *Kulturgeschichte.* The city was home to both the Germanisches Nationalmuseum (founded in 1852), the first German museum of cultural history, and the *Zeitschrift für deutsche Kulturgeschichte* (published 1856–1859), the first journal dedicated to the field. In addition to working at the museum as *Konservator* of art collections, Falke wrote regularly for the journal, which was edited by his older brother, Johannes, also a member of the museum staff.

At the time these two pioneering institutions were founded, *Kulturgeschichte* was struggling to gain recognition within the historical profession.[3] Its practitioners typically were young, worked outside of the universities, and identified with the liberal politics of the 1848 revolutions. They conceived of cultural history as a challenge to the 'official', politics-centred historiography, which they abhorred as a conservative, top-down approach that privileged the actions of rulers over the everyday life of the *Volk.* Focusing instead on social customs, religion, literature and what today would be called material culture, Falke and his colleagues sought to draw attention to the historical agency of the middle classes and to examine the past in terms of overarching patterns rather than isolated events. Fundamental to *Kulturgeschichte* was the belief that past cultures exhibited an organic unity of expression. It followed that all cultural forms, whether styles of painting, religious beliefs or modes of dress, could be analysed in terms of their relationship to a collective spirit, or *Zeitgeist.* For cultural historians, identifying the *Zeitgeist* and demonstrating its internal consistency was the central task of historical investigation.

Falke's writings on the history of clothing exemplified the method and concerns of *Kulturgeschichte.* He analysed dress as an expression of the *Zeitgeist,* connecting it to a range of cultural forms within a given era. The narrative he constructed emphasized periods of middle-class affluence and political

autonomy. At the apex stood the age of Reformation, defined by a spirit of individual freedom that Falke observed in Luther's theology, Albrecht Dürer's painting, and the clothing worn by the era's prosperous, powerful burghers (see Fig. 1.1). For Falke, the rich velvets, deep colours, and ornamental flourishes of this style of dress conveyed the value placed by Reformation culture on individual wealth and artistic self-expression. In addition, the looseness of the tailoring embodied a characteristic 'urge toward freedom . . . The individual could no longer tolerate any imposition on his body. He demanded to be able to move freely and easily and to be the unopposed master of his limbs'.[4] The polemical undertone of Falke's writing is unmistakable. Here and throughout his analysis, clothing was much more than a practical covering of the body; rather, dress forms became ideological signifiers through which the moral substance of an entire people could be discerned.

The politics of middle-class autonomy are evident in another aspect of Falke's work: his concern with the phenomenon of 'fashion', or Mode, which he understood as a mechanism of rapid, seemingly arbitrary formal change that operates on clothing. In Falke's analysis, fashion reflected instability or weakness in middle-class culture. Fashion arose either during periods of upheaval, when a loss of tradition left the middle classes searching for new forms of self-expression—as at the end of the Middle Ages, following the decline of religious authority and before the humanist flowering of the early sixteenth century—or during periods of political reaction—the Counter-Reformation, for example—when

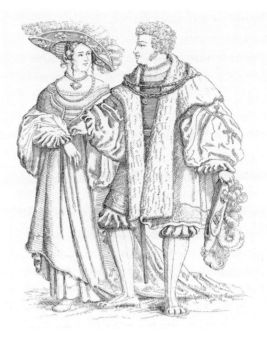

Fig. 1.1. 'Männliche und Weibliche Tracht, 1520–1530', from A. Eye and J. Falke, *Kunst und Leben der Vorzeit*, 2nd ed., Nuremberg: Bauer und Raspe, 1868, plate 47.

the aristocracy imposed its taste from above. In Falke's effort to understand the historical circumstances behind the rise and decline of the German middle class, or *Bürgertum*, fashion became a crucial point of reference.

The centrality of fashion in Falke's clothing research is suggested immediately by the title of his book: *Die deutsche Trachten—und Modenwelt.* Rather than choosing the neutral word *Kleidung* (*clothing*) to identify his subject, Falke instead paired two terms, *Tracht* (*dress* or *costume*) and *Mode* (*fashion*), that carried more qualitative meanings. He drew a basic distinction between these two varieties of clothing. *Tracht,* he explained, refers to 'general and lasting forms' of dress, while *Mode* describes 'that which changes apparently without logic'.[5] Clearly implied is the virtue of

Tracht, which develops naturally out of practical considerations and national characteristics. *Tracht* remains stable over time because of its organic, and hence healthy, relationship to the society in which it exists. *Mode,* in contrast, acts wilfully, without regard for the essential character of culture, and displaces *Tracht* with a rapid succession of new forms derived from its own internal logic of novelty for its own sake. The clothing that results from *Mode* is often ugly, impractical and even immoral. Adjectives like 'mannered', 'baroque', 'lascivious', 'coquettish', 'degenerate', 'arrogant', and 'immoderate' pepper Falke's analysis of fashion.

With his publications of the 1850s, Falke joined a long line of German critics of fashion.[6] Since at least the sixteenth century, writers had lamented the mysterious allure of all things fashionable, often referring to fashion as a tyrant that coerces its subjects by playing on base urges of greed and vanity. Anti-fashion sentiment flourished in the mid-nineteenth century when liberal intellectuals like the composer Richard Wagner linked rapid changes in clothing to industrialization, capitalism, and a perceived disintegration of the organic unity of the traditional culture of the German *Volk.*[7] In an essay of 1849, Wagner proposed his concept of the *Gesamtkunstwerk,* a monumental artistic composition that combined multiple media and united object and audience, as a means of returning coherence to a society fragmented by fashion. Wagner's contemporary, Friedrich Theodor Vischer, the influential professor of aesthetics, echoed this indictment of fashion a decade later in an essay titled 'Vernünftige Gedanken über die jetzige Mode' (Sensible

Thoughts about Contemporary Fashion). Inveighing against the 'witches' cauldron' of the Parisian fashion industry, Vischer conjured long-standing associations between the French, femininity, eroticism and a feared erosion of German reason and masculinity.[8] Most of all, he blamed fashion's rise on the decline of liberalism, arguing that the weakening of middle-class identity and political resolve after 1848 had caused the German *Bürgertum* not only to submit meekly to oppressive state policies but also to be seduced by the allure of aristocratic luxury and French taste.

In drawing this connection between fashion and middle-class autonomy, Vischer credited Falke's 'thoroughly praiseworthy book' for sparking his own observations.[9] The two authors shared a fundamental anxiety about fashion and its power to undermine the *bürgerlich* society to which they as German liberals aspired. The intensification of anti-fashion sentiment in the 1850s represented by their writings thus reflects, not so much the rise of fashion itself—although this was the decade in which the modern French fashion industry was established—as it indicates a response to the reactionary political conditions that followed the failed revolutions. Falke's and Vischer's fascination with the idea of a society without fashion grew out of their broader desire for a Germany without political repression, precisely at a moment when this liberal ideal seemed out of reach.

In August of 1858, Falke left the Germanisches Nationalmuseum and travelled east to Vienna. In Nuremberg, the aura of the *Dürerzeit* had catalyzed his research, but he felt stifled by what he described

as the 'patriotic narrowness and frugal complacency' of a city that derived its identity largely from its past.[10] In Vienna, he found a welcome alternative. In addition to exuding the cosmopolitan air of the capital of a multiethnic empire, Vienna in the 1860s was a burgeoning metropolis in the throes of modernization. Falke arrived almost precisely at the moment when demolition of the city's fortifications began in preparation for the construction of the Ringstrasse. Over the next decade, this physical renovation was accompanied by a series of political, economic, social and cultural transformations: the ascent of the Liberal Party to parliamentary majority in 1860, the economic boom of the *Gründerjahre* of 1866 to 1873, and the rapid emergence of a prosperous and powerful middle class with a distinct set of cultural values and artistic tastes. In Vienna, Falke became intoxicated by what had been conspicuously absent in Nuremberg: the sheer size, wealth and 'bustle of the metropolis', along with the sense of fluidity and possibility that came with dramatic physical and cultural changes.[11]

Shortly after settling in Vienna, Falke met Rudolf Eitelberger, professor of art history at the university and an editor at the *Wiener Zeitung,* who enlisted him in the cause of elevating the quality of the Austrian *Kunstgewerbe,* or applied arts. Hoping to duplicate the success of Henry Cole's reform initiatives in England, in 1864 Eitelberger and Falke founded the Österreichisches Museum für Kunst und Industrie, the first continental institution modelled on the South Kensington Museum.[12] To educate designers, manufacturers and the public in principles of taste and quality, the museum

exhibited exemplary decorative objects, presented lectures on aesthetics and history and, beginning in 1867, offered professional training at an affiliated school of applied arts.

A comparison between the Germanisches Nationalmuseum and the Österreichisches Museum reveals institutions that shared basic characteristics but that were shaped by contrasting intellectual climates and that pursued different goals.[13] Both collected and exhibited historical objects of applied arts. But the Nuremberg museum, with its cultural-historical mission and romantic-nationalist fascination with the *Dürerzeit,* treated its collections exclusively as a source of insight into the attitudes and behaviours of the past. Its preferred mode of display was the period room. According to Falke's brother Johannes, the museum sought 'through the creation of rooms in the taste of the various epochs, to offer complete, well-rounded pictures of domestic life at those times'.[14] By uniting disparate objects into cohesive ensembles, the period room conveyed what the practitioners of *Kulturgeschichte* viewed as the underlying unity of culture itself. In Vienna, the Österreichisches Museum presented *Kunstgewerbe* objects not as artefacts of historical cultures but as models for contemporary artistic production. Its focus was on the improvement of industrial goods for the sake of advancing the national economy. This materialist agenda, an expression of the liberal-positivist spirit of the Ringstrasse era, was reflected in Falke's curatorial approach. Emulating a concept initially proposed by Gottfried Semper in 1852 and put into practice at South Kensington, Falke organized the Österreichisches Museum's collections

according to material and type rather than historical era or national origin. Instead of period rooms, he presented groups of objects inside vitrines, in which they appeared as culturally neutral sources of information about design and manufacturing. The purpose of the *Kulturgeschichte* museum—to examine artefacts as evidence of the *Zeitgeist* of past eras—remained separate from the mission of industrial reform pursued by the *Kunstgewerbe* museum.

Falke acknowledged differences between *Kulturgeschichte* and *Kunstgewerbe* museums.[15] Yet he refused to abandon his earlier concern with culture. In his publications, he continued to apply *Kulturgeschichte* analysis to the study of material objects, while at the Österreichisches Museum, he eventually began to take objects out of the vitrines and display them in ensembles.[16] In 1871, he mounted a small exhibition of complete, full-scale domestic interiors designed by Josef von Storck, the director of the museum's school of applied arts. The implications of this curatorial practice were significant. By presenting furniture, carpets and glassware in simulated interiors rather than as isolated pieces, Falke identified them as objects of use and therefore reflective of social practices. Although these were contemporary interiors rather than period rooms, they nonetheless returned culture to the equation and in this sense brought Falke back to his *Kulturgeschichte* roots.

The importance of culture is especially evident in a series of public lectures that Falke delivered at the museum beginning in 1869, published in 1871 as *Die Kunst im Hause.*[17] Merging *Kulturgeschichte* with *Kunstgewerbe*

reform, the book begins with a history of the dwelling and concludes with a program for decorating the contemporary Viennese home. Falke's historical narrative follows a familiar arc, peaking around 1500. This time, however, it is the Italian Renaissance rather than the German Reformation that marks the high point, indicating a shift in Falke's intellectual outlook from the romantic nationalism of Nuremberg to Viennese cosmopolitanism. Following Jacob Burckhardt's model of Renaissance culture, Falke praised the 'rich, noble, convenient, and truly artistic' homes of 'those cultivated men who lived with Raphael and Titian, appreciating their art and enjoying their society'.[18] For Falke, a powerful affinity existed between the humanist culture of the Renaissance merchant class and the liberal culture of the Viennese bourgeoisie, both of which valued reason, science, private wealth and the cultivation of the arts.[19] According to his historicist logic, it followed that Vienna's middle classes should adopt a 'modern Renaissance' style to decorate their homes.

Among the earliest and most acclaimed realizations of Falke's theory was a study designed in 1871 by the artist Hans Makart for the home of Nikolaus Dumba, a leading manufacturer, banker, liberal politician, patron of the arts and member of the board of the Österreichisches Museum (see Fig. 1.2). Dumba, who would have attended Falke's lectures and heard the curator's glowing descriptions of Renaissance palace interiors, sent Makart to Venice to prepare for the commission, instructing the young painter to 'do nothing there but look. Then make me an entire room'.[20] The resulting interior, located on the *bel étage* of Dumba's

Ringstrasse palace and visible to passers-by from the street, became one of the city's most acclaimed cultural attractions, known simply as the *Makartzimmer*. Its fame rested on the striking combination of neo-Renaissance furniture, exotic objects arranged as if in a *Wunderkammer,* and allegorical mural paintings in the style of Veronese, which depicted Dumba's activities in industry, science and the arts. As a marker of Dumba's identity as a modern-day merchant-humanist, and as an illustration of the liberal culture of Ringstrasse Vienna more generally, Makart's

ensemble perfectly realized Falke's concept of the interior as embodiment of the *Zeitgeist*.

Although the domestic interior became Falke's primary focus during the early 1870s, his interest in clothing and the cultural impact of 'fashion' persisted. In *Die Kunst im Hause,* he occasionally drew an analogy between dress and decoration, commenting for example that the interior should 'fit' the inhabitant 'like a more ample garment'.[21] He retained the term *Mode* as well. As in his history of dress, here *Mode* designated forms that stood outside the boundaries of

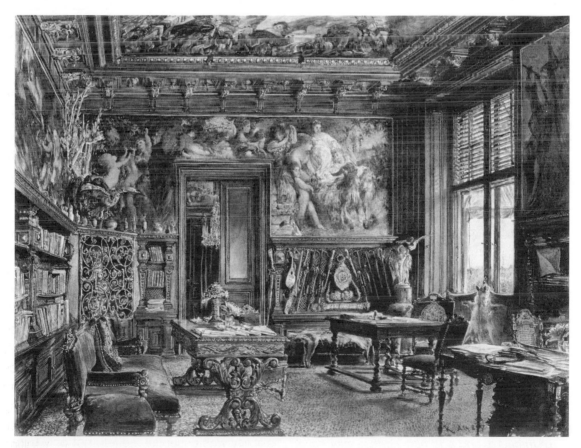

Fig. 1.2. Hans Makart's decoration of the study of Nikolaus Dumba, Parkring 4, Vienna. Watercolour by Rudolf Alt, 1877. Collection of the Historisches Museum der Stadt Wien, inventory number 58.124.

reason, nature and stable culture. Earlier he had defined *Mode* in opposition to *Tracht;* now he set fashion against 'style', a concept that first appeared in his writings after he read Semper's 1860 book *Der Stil.*[22] Like Semper, Falke identified objects as having *Stil* when their forms grew organically from the contingencies of function, materials and culture. *Stil,* like the concept of the *Zeitgeist* or Wagner's *Gesamtkunstwerk,* represented an ideal harmony of form and culture in opposition to the fragmentation wrought by *Mode.*

Cultural unity stood as a central concern in Falke's work. Yet his liberal belief in individual autonomy and self-expression led him to argue against the imposition of aesthetic unity on the interior. In one of the most striking passages in *Die Kunst im Hause,* he criticized the notion that individuals might be compelled to adhere to a single vision of decoration. Just as a later Viennese critic, Adolf Loos, would famously mock the Secessionist interior in which the 'poor, rich man' (*armen, reichen Mann*) found himself psychologically imprisoned, here Falke described the mental anxiety felt by the 'poor mortal' (*armen Sterblichen*) who has subjected himself to the pressure of sustaining his home as an integrated work of total (*Gesamt*) decoration.[23]

> *Constantly tempted by the new objects that prolific artists and happenstance bring daily before his eyes, he must renounce his desire. He can hang no new picture on the wall, set up no statue, exchange no pieces of furniture, and add nothing that may have attracted him with its beautiful workmanship.*

> *Everything has been perfected from the beginning and cannot be improved. By following such a course our homes would finally become a weariness and torment, and, instead of giving us pleasure, would be an obstacle to the gratification of our most legitimate wishes.*[24]

Taking the criticism further, Falke warned that a misguided individual might attempt to extend the notion of decorative unity even to clothing, causing further agony. Again in advance of Loos, he wrote:

> *Finally when every other obstacle had been overcome, we poor moderns would be compelled to put ourselves in harmony with the historic habitation by adopting a fitting costume, unless we were willing to be out of keeping with our surroundings and thus destroy the effect of our own arrangements. No one certainly would carry the thing so far but such a course would be logical.*[25]

For Falke, these difficulties could be avoided only by embracing the aesthetic possibilities of eclecticism and treating the decoration of the interior as an ever-evolving project. The interior, in Falke's theory, should be an organic assemblage of pieces that could be adjusted as the inhabitants' personal circumstances changed. 'Our homes ought to allow us to exchange things of which we have grown tired for such better and more convenient objects as this progressive age may furnish,' he wrote.[26] This kind of flexibility was essential, he felt, not only from the standpoint of practical necessity but also

for the satisfaction of a psychological urge to consume and to continuously find new artistic embellishments for life.

Falke's new interest in the cultural implications of consumption and his fascination with what he termed the 'changefulness and unrest of modern life' signalled a general shift in his thinking about the nature of modernity.[27] This shift would ultimately lead him to revise his views on *Mode.* In an essay of 1878, he began to retract some of the criticisms that he and others had levelled against fashion in the 1850s.[28] Instead of condemning fashion as reflective of a breakdown of reason, morality and social harmony, he took a more favourable view, arguing that shifts in dress forms, however arbitrary they might appear, were in fact nothing more than a by-product of inevitable changes in the *Zeitgeist.* Fashions were not always beautiful, he acknowledged, but the fact of fashion itself must be accepted. Following the appearance in 1879 of a short book by Friedrich Theodor Vischer in which the aesthetician rehearsed his old litany of anti-fashion criticism, Falke published a still more forceful argument in praise of fashion and its dynamic of change.[29] Declaring the very essence of culture to be the constant march of progress, he argued that to reject fashion meant nothing less than 'to renounce education and sink into barbarity'. 'Fashion', he concluded, 'is the clothing of culture'.[30] He went on to dismiss many of the anxieties that had driven the anti-fashion polemics of the past. The transmission of Parisian fashions to Vienna should be understood not as diluting national identity, he argued, but rather as contributing to a healthy cosmopolitanism. He rejected the idea of fashion as a top-down process of elite taste being imposed on the middle classes, arguing that fashion is a 'revolutionary and democratic' force that 'knows no class differences'.[31] And he dismissed the characterization of contemporary women's fashion as erotic and immoral, praising instead its exuberant colours and 'painterly' (*malerisch*) effect.[32] Regarding contemporary dress, Falke disapproved only of that which lacked fashion, namely the anonymous, colourless man's suit, which he felt made no aesthetic contribution to culture. For Falke, fashion's impulse to draw attention to the wearer through bold forms and colours was an essential means by which art and beauty were integrated into everyday existence.

This was a remarkable reassessment. Falke had now taken the bite out of fashion. No longer wilful and arbitrary, fashion appeared instead to be wholly dependent on and aligned with the *Zeitgeist.* Rather than an autonomous force that tyrannically compelled society to follow its mysterious, irrational logic, fashion became an expression of beauty and individual autonomy. Vischer's fear that fashion threatened the authority of masculine reason was turned on its head. For Falke, it was precisely the flamboyance and self-expression that he observed in women's fashions, rather than the reticence of men's dress, that he deemed most beneficial to culture. Fashion infused art into life; its absence meant the death of beauty and of culture itself.

The shift in Falke's judgement of fashion quite clearly reflects the material prosperity and faith in progress that characterized Ringstrasse Vienna. His enthusiasm seems

also to have been inspired by local trends in art and fashion. Around 1880, Hans Makart enjoyed an extraordinary level of popularity and influence in Viennese culture. According to critic Ludwig Hevesi, the theatrical *Makartstil* 'asserted itself in such a multifaceted way . . . that no one could escape it'.[33] In addition to painting, Makart's oeuvre included both clothing design and interior decoration. In the mid-1870s, he began hosting masquerade balls in his studio for which he personally outfitted each one of his guests. In 1879, he staged a spectacular parade on the Ringstrasse to commemorate the Imperial wedding anniversary, for which he designed Renaissance-inspired costumes

for the hundreds of participants (see Fig. 1.3) The parade, which was said to have been seen by over a million people, touched off a fashion among Viennese women for heavy silk fabrics in '*vieux rouge*' and other historicizing elements typical of Makart's costumes (see Fig. 1.4).[34] When Falke in his 1881 essay praised the 'painterly' aspect of contemporary women's clothing, 'the likes of which has not been seen in the world since the Renaissance', he seems to have been referring precisely to these Makart-inspired fashions.[35]

Makart's reputation as a decorator, which began with his work for Nikolaus Dumba, was further enhanced when, sometime after

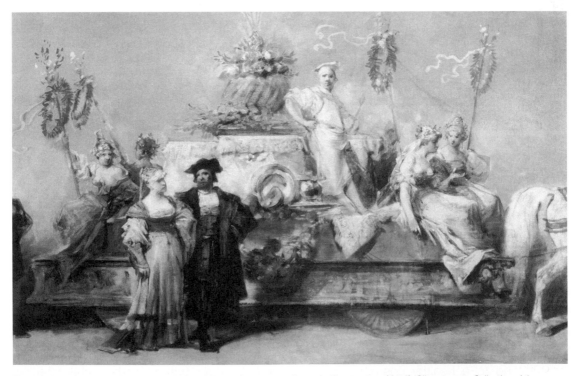

Fig. 1.3. Hans Makart, study for the imperial wedding anniversary parade, confectioners group (detail). Oil on canvas. Collection of the Historisches Museum der Stadt Wien, inventory number 17.738/1.

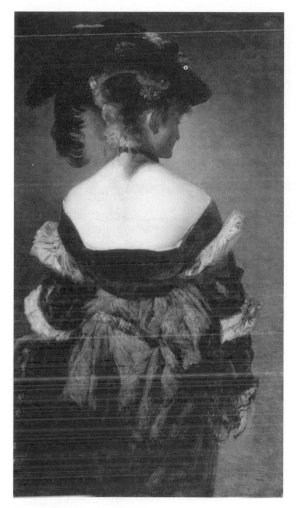

Fig. 1.4. Hans Makart, portrait of a woman with a feathered hat, seen from behind. Oil on canvas. Collection of the Germanisches Nationalmuseum, Nuremberg, inventory number GM 1658.

1873, he opened his own studio to daily public viewing (see Fig. 1.5). In contrast to the Dumba Study, which is distinguished by its stylistic unity, the interior of Makart's studio derived its visual impact from the sheer accretion of eclectic objects. Makart pushed the idea of the antiquary's interior to a fantastic extreme, combining oriental carpets, Baroque architectural fragments, Turkish stools and Renaissance chairs in deliberate juxtapositions of different times and places. Every surface was laden with patterned fabrics, gilded trinkets, animal skins and dried palm fronds. The studio was striking precisely for the artifice and individuality of its decoration. As an aesthetic calling card, it defined Makart as an artist with a highly personal vision.

It was the heterogeneity and artifice of Makart's studio that made it—and continue to make it—so jarring to later generations of observers.[36] But in its own time, Makart's decorative style expressed the essence of Viennese culture. To Falke, this was a city defined by fluidity and the free play of creative energy. Far from the static culture of *Tracht* that Falke had praised in the 1850s and that had appealed to other critics of fashion, the culture of *Mode* in Ringstrasse Vienna existed in a state of constant motion, fuelled by the wealth of the industrial economy and the progressive spirit of the liberal bourgeoisie.

Around 1900, design reformers and cultural critics would again demonize fashion, seeing in its artifice and frenetic pace a reflection of the ills of capitalism.[37] The desire of figures like Hermann Muthesius to bring modernity under control drove attempts to define a new style of architecture and *Kunstgewerbe* that would resist fashion. This project remains in certain ways ideologically captivating, just as the designs that it produced continue to exert a strong aesthetic appeal. Makart's studio, in contrast, may never shake the aura of decadence that hangs over it. Yet, from the perspective of a twenty-first-century culture in which fashion is more often celebrated as self-expression than derided as consumer manipulation, the utopian, anti-fashion position of Muthesius's generation

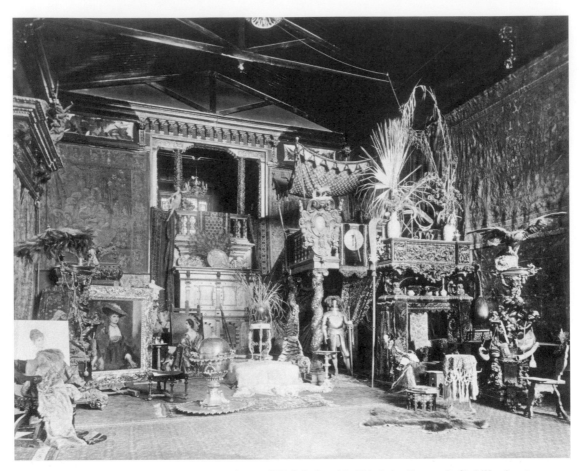

Fig. 1.5. Interior of Hans Makart's studio. Photograph taken ca. 1875. Collection of the Historisches Museum der Stadt Wien, inventory number 97.283.

seems anachronistic at best and hopelessly conservative at worst. In contrast, Falke's later writings on fashion, composed within the optimistic culture of Ringstrasse Vienna, offer a refreshing acknowledgement of the essentially dynamic character of modernity.

Notes

1. On Falke's life and work see E.B. Ottillinger, 'Jakob von Falke (1825–1897) und die Theorie des Kunstgewerbes', *Wiener Jahrbuch für Kunstgeschichte* 42 (1989), pp. 205–23; and E. Anderson, 'Beyond Historicism: Jakob von Falke and the Reform of the Viennese Interior', unpublished PhD dissertation, Columbia University, 2009.

2. Especially M. McLeod, 'Undressing Architecture: Fashion, Gender and Modernity', in D. Fausch et al., eds, *Architecture: In Fashion* (Princeton Architectural Press, 1994); and M. Wigley, *White Walls, Designer Dresses: The Fashioning of Modern Architecture* (MIT Press, 1995). For an overview of the literature see L. Kinney, 'Fashion and Fabrication in Modern Architecture', *Journal of the Society of Architectural Historians* 58 (1999/2000), pp. 472–81.

3. See H. Schleier, *Historisches Denken in der Krise der Kultur: Fachhistorie, Kulturgeschichte und Anfänge der Kulturwissenschaften in Deutschland* (Wallstein, 2000).

4. J. Falke, *Die deutsche Trachten—und Modenwelt: Ein Beitrag zur deutschen Culturgeschichte,* vol. 2 (Gustav Mayer, 1858), p. 12.

5. Author's translation. J. Falke, *Die deutsche Trachten-und Modenwelt,* vol. 1, p. vi.

6. See D.L. Purdy, *The Tyranny of Elegance: Consumer Cosmopolitanism in the Era of Goethe* (Johns Hopkins University Press, 1998), pp. 51–146.

7. R. Wagner, 'The Art-Work of the Future', in *Richard Wagner's Prose Works,* tr. W.A. Ellis (K. Paul, Trench, Trübner, 1895), pp. 69–213.

8. F.T. Vischer, 'Vernünftige Gedanken über die jetzige Mode', in *Kritische Gänge* (Cotta, 1861 [1859]), p. 122.

9. Ibid., p. 99.

10. J. Falke, *Lebenserinnerungen* (Georg Heinrich Meyer, 1897), p. 131.

11. Ibid., p. 171.

12. For background, see P. Noever, ed., *Kunst und Industrie: die Anfänge des Museums für Angewandte Kunst in Wien* (Hatje Cantz, 2000).

13. On the relationship between the Nuremberg and the Vienna museums, see B. Mundt, 'Über einige Gemeinsamkeiten und Unterschiede von kunstgewerblichen und kulturgeschichtlichen Museen', in B. Deneke and R. Kahsnitz, ed., *Das Kunst- und Kulturgeschichtliche Museum im 19. Jahrhundert* (Prestel, 1977). Thanks are due to Peter N. Miller for sharing his forthcoming research on the Germanisches Nationalmuseum.

14. Johannes Falke, 'Das germanische Nationalmuseum', *Weimarisches Jahrbuch für deutsche Sprache, Literatur und Kunst* 5 (1856), p. 95.

15. J. Falke, 'Die moderne Museumsfrage in Bezug auf Geschichte, Kunst und Kunstindustrie', *Österreichische Wochenschrift für Wissenschaft, Kunst und öffentliches Leben* 4 (1864), pp. 161–68, 200–7, 257–63, 298–307.

16. For example J. Falke, *Geschichte des modernen Geschmacks* (T.O. Weigel, 1866).

17. J. Falke, *Die Kunst im Hause: Geschichtliche und kritisch-ästhetische Studien über die Decoration und Ausstattung der Wohnung* (Gerold, 1871). All quotations are taken from the English translation, *Art in the House: Historical and Critical-Aesthetic Studies on the Decoration and Arrangement of the Dwelling,* tr. C.C. Perkins (Prang, 1879)

18. J. Falke, *Art in the House,* p. 119. Compare J. Burckhardt, *Die Cultur der Renaissance in Italien: Ein Versuch* (Schweighauser, 1860).

19. J. Falke's characterization of the Ringstrasse bourgeoisie has been echoed in C. Schorske, *Fin-de-Siècle Vienna: Politics and Culture* (Alfred A. Knopf, 1980), pp. 24–62; and K. Rossbacher, *Literatur und Liberalismus: Zur Kultur der Ringstrassenzeit in Wien* (J&V, 1992), pp. 31–77.

20. L. Hevesi, 'Das Heim eines wiener Kunstfreundes', *Kunst und Kunsthandwerk* 2 (1899), pp. 345–6.

21. J. Falke, *Art in the House,* pp. xxv–xxvi.

22. J. Falke, review of G. Semper, 'Der Stil in den technischen und tektonischen Künste', *Mitteilungen der k. k. Zentralcommission zur Erforschung und Erhaltung der Baudenkmäle* 5 (1860), pp. 358–60.

23. A. Loos, 'Von einem armen, reichen Mann', in F. Glück, ed., *Sämtliche Schriften* (Herold, 1964), pp. 201–7; J. Falke, *Art in the House,* p. 166. Loos's reading of Falke has also been described in E. Ottillinger, *Adolf Loos: Wohnkonzepte und Möbelentwürfe* (Residenz Verlag, 1994).

24. Falke, *Art in the House,* pp. 166–7.

25. Ibid., p. 168.

26. Ibid., p. 167.

27. Ibid.

28. J. Falke, 'Costüm und Mode in ästhetisch-kritischer Schilderung', in *Zur Cultur und Kunst: Studien* (Gerold, 1878), pp. 69–178.

29. F.T. Vischer, *Mode und Cynismus: Beiträge zur Kenntniß unserer Culturformen und Sittenbegriffe* (Konrad Wittwer, 1879). J. Falke, 'Zur Entstehung und Bedeutung der Mode', *Die Gegenwart* 20 (1881), pp. 285–7, 348–51.

30. J. Falke, 'Zur Entstehung', p. 350.

31. Ibid., p. 286.

32. Ibid., p. 351.

33. L. Hevesi, 'Hans Makart [Obituary published October 5, 1884]', in L. Hevesi, *Wiener Totentanz: Gelegentliches über verstorbene Künstler und ihresgleichen* (Adolf Bonz, 1899), p. 174. On Makart's career, see R. Kassal-Mikula, ed., *Hans Makart, Malerfürst (1840–1884)* (Historisches Museum der Stadt Wien, 2000).

34. See G. Buxbaum, *Mode aus Wien, 1815–1938* (Residenz Verlag, 1986), pp. 241–8.

35. J. Falke, 'Zur Entstehung und Bedeutung der Mode', p. 351.

36. For example A. Lichtwark, *Makart Bouquet und Blumenstrauß* (Verlaganstalt für Kunst und Wissenschaft, 1894).

37. See F.J. Schwartz, *The Werkbund: Design Theory and Mass Culture before the First World War* (Yale University Press, 1996), pp. 13–74.

Chapter Two

Frederic Leighton's 'Narcissus' Hall: sensation and interior description in nineteenth-century London

Mark Taylor

In recent years, references to Mary Eliza Haweis's (1848–1898) collection of twelve essays titled *Beautiful Houses* (1882) have appeared in several publications concerned with Victorian art, architecture and interiors. Many of these citations focus on the style of writing, often dismissing her interior descriptions because they use emotive, expressive and sensory language to engage the audience. They also tend to discount her descriptions in favour of more objective and rational period accounts or retrospective critical writing. The method by which this occurs is to foreground or condition any citations with prejudicial comments about her amateur or popular status. Generally couched in the negative, this prejudice is in some sense criticism of her voice as an amateur failing to meet the demands of true scholarship.

Written as a personal response to twelve residences, Haweis's series of short essays describes rooms, spaces, artefacts and surface treatments, as well as conveys the effect an architectural interior has on the body, both physically and psychically; the intention being to step outside rational analytical modes of thinking that privilege the mind and to address space from the body. As the body in question is her own, any descriptions are influenced by such things as location, social situation and psychological state.

This chapter discusses one passage from the description of Frederic Leighton's house as a form of synaesthetic writing intimately bound to the author's personality. To construct an analysis of this passage, and the publication in general, I draw upon book reviews and notices of articles to illustrate period reception. I then review contemporary literature that engages with this publication before discussing synaesthesia as a neuro-scientific disorder and as a form of writing. I trace Haweis's correspondence with Sir Francis Galton, who used her as a subject in his pioneering research on synaesthesia and particularly noted that some people experience sensations in multiple modalities in response to stimulation of one modality. Lastly, I indicate how the writing and book challenge conventional prose and layout in a manner that appeals to sensations—a methodology

taken up by several contemporary feminist authors.

Turning aside from the foot of the stairs, we pass through peacock-greeny arches, with deep gold incision, into the third Hall, called of Narcissus, which strikes a full deep chord of colour, and deepens the impression of antique magnificence. A bronze statuette of the fair son of Cephisus, from that in the Naples Museum, stands in the midst of it. Here the walls are deepest sea-blue tiles, that shades make dark; the floor is pallid (the well-known mosaic of the Caesar's palaces), and casts up shimmering reflected lights upon the greeny-silver ceiling, like water itself. There is something poetic and original in thus echoing here and there the points in the story of Narcissus—not repeating point-blank the hackneyed tale, or showing the fair boy adoring his mirror'd self in the 'lily-paven lake', but just recalling it piecemeal—the lilies in the pavement, the shining lake above, and all the joy and sorrow, the luxury and the pain of his loneliness and aberration, told by the colours, the purple and the gloom, and the boy's own attitude. [1]

This quotation is a partial description of Frederic Leighton's residence on Holland Park Road, London, designed by George Aitchison. It is taken from Mary Haweis's *Beautiful Houses* (1882), a slim volume that contains twelve descriptions of domestic interiors particularly admired by the author for both their artistic merit and individuality. Originally serialized in *The Queen,* all twelve essays were reordered, retitled and reprinted with few amendments in a beautifully bound book in the Queen Anne style. It included the homes of three London artists, Lawrence Alma-Tadema (1836–1912), Frederic Leighton (1830–1896) and George Henry Broughton (1833–1905), two Rome houses belonging to artists William Haseltine (1835–1900) and John Warrington Wood (1839–1886) and three others that were residences of architects William Burges (1821–1887), Alfred Morrison (1836–1879) and J. J. Stevenson (1831–1908). Two houses belonged to Reuben Sassoon (1835–1905), a wealthy East India merchant, card-game addict and favourite crony of the Prince of Wales. The last, titled 'A Bijou House', was an apartment for a single woman (Miss Hozier) and focused on interior decorations by the architect William Wallace.

In the foreword, Haweis described how she selected the various residences because of their distinctive characters, 'houses that reflect no well-defined period in art, but are typical of certain minds, and arranged with exquisite feeling, devotion, and knowledge'. [2] Devoid of any desire to promote a particular style, her intention was to show that 'beauty lies in many eyes; that every style has a beauty and interest of its own'. [3] She argued that the book was a series of exemplars designed to 'give courage to have, and to hold, opinions of one's own . . . [for which] only the individual character which makes itself felt in it, is of value'. [4]

This desire for originality and individuality is consistent with Haweis's generally held opinions. Certainly her eccentricities in dress and decoration were perceived as a sign of original self-fashioning, made possible by extensive subject knowledge (see Fig. 2.1). Moreover, her interest in pre-Raphaelitism, Aesthetic and Artistic dress provided a flexible

mode for self-presentation that extended beyond her dress into her home, particularly when she lived at 16 Cheyne Walk, the former residence of Dante Gabriel Rossetti.

The book's design offered an original and unconventional aesthetic treatment. For example the title page to each essay is headed with an individual decorative border. A large square woodblock initial letter containing imagery associated with the house or occupant is inset into the first paragraph, a technique not dissimilar to that employed at the time by the *Art Journal.* Text is held in a tight justified block with offset margins for

Fig. 2.1. Mary Eliza Haweis (1848–1898). From H. R. Haweis, ed., *Words to Women: Addresses and Essays by the Late Mrs. H. R. Haweis*, London: Burnet and Isbister, 1900.

side notes and terminates by successively reducing each line until a single centralized word is all that remains. Several essays finish with an inverted triangular decorative motive of animo-cherubic-botanic origins. By constructing the book in this manner, each essay is clearly distinguished as a separate manuscript that contributes to the whole (see Fig. 2.2).

Such devices and use of the traditional long *S* convey an atmosphere closer to the early eighteenth century and the Queen Anne style than the late nineteenth century. An observation Ian Fletcher made arguing that, as a product of the Aesthetic Movement, the book amounts to:

> A set of prose poems about the interiors of houses . . . [and] is itself a total work of art, designed for 'time travelling' through museums not altogether imaginary, 'a modern version of the past' and involving the 'beauty of inclusion', a controlled eclecticism that can contain wide margins, rich italics, catchwords, the long 's', sidenotes (anterior to Whistler's *Gentle Art*), wood cut initials, and running heads that rather remarkably extend beyond the sidenotes, unifying the page.[5]

Of the twelve descriptions, the 'Narcissus' passage is often singled out by both period and contemporary critics because it uses 'ecstatic' or 'emotive' language. The difficulty being how to provide commentary on a house that Tim Barringer and Elizabeth Prettejohn acknowledge to be an 'extreme example of Aesthetic Movement principles applied to architecture'.[6] As an example of Aesthetic Movement interior decoration or an aesthetic

Beautiful Houses.

I.

Sir Frederick Leighton's House.

WE find much that revives the *Italian Renascence* palace in the house of the *President of the Royal Academy;* yet the colouring of the entrance halls belongs rather to old *Rome* than to the *Rome* of the sixteenth century. Perhaps it is the want of that echoing space, and magnitude of courtyard and stairway peculiar to the *Renascence* architecture, which suggests the antique time when

B　　　　　　　stairs

Fig. 2.2. Title page with woodblock initial letter. From Mary Haweis, *Beautiful Houses*, London: Low, Marston, Searle and Rivington, 1882.

environment, the interior is both precise and vague in its relationship to the inhabiting subject (see Figs. 2.3 and 2.4).

Effectively, the house, in staging aestheticism, needs a critic such as Haweis who can respond to its effete splendour. Jason Edwards, writing in *Alfred Gilbert's Aestheticism* (2006), observed that it was in the Narcissus Hall that the sculptor Albert Gilbert and his contemporaries 'detected the strongest evidence of Leighton's potential passion for homoerotic as well as Whistlerian Aestheticism'.[7] Edwards further suggested that Haweis's descriptions of this space

> *drew on both W. S. Gilbert's eminently quotable description of the 'greenery-yallery' secondary tones of the effete Grosvenor set, and the Whistlerian vocabulary of the Nocturnes, which combined the Butterfly's interest in music with a painterly technique catching an impression of the metropolis.*[8]

From Haweis's descriptions, Edwards singled out 'peacock-greeny' arches, followed by a 'deep *chord* of colour', a purple *impression*

Fig. 2.3. The Narcissus Hall, Leighton House. © English Heritage, NMR.

and a 'warm grey on the floor'. He revealed other Whistlerian terms including the Narcissus Hall's horizontal space being surrounded by 'deepest sea-blue tiles, that shades make dark', and the vertical dimension shifting from the 'pallid' floor to the 'shimmering reflected lights upon the greeny-silver ceiling, like water'.[9]

Although discussed later in this chapter as synaesthetic writing, it is important to note that such chromatic prose is not the only literary skill on display. Suffice to say that although the overall narrative promenade progresses through rooms and halls, providing spatial and material observations that generally refrain from the noted 'eloquence', descriptions move beyond what is generally regarded as impersonal observation, integrating the thoughts, beliefs and opinions of the author into the narrative.

Of the many period reviews of *Beautiful Houses,* the journal *Academy* is less than favourable, ridiculing descriptive passages that shift beyond fact and attempt to interpret or 'read' the interior in a poetic manner. The *Academy's* review of 1882 begins with, 'This

Fig. 2.4. The Staircase Hall viewed from Narcissus Hall, Leighton House. © English Heritage, NMR.

is an example of real "too too" in literature and we doubt whether some of our modern Della Cruscas of art will be able to refrain from tears as they read some of its most precious passages'.[10] Alighting on a few phrases to affirm a lack of linguistic control, the reviewer confesses that:

> It never occurred to us when we saw the gold and silver ceiling of Sir F. Leighton's passage that it was meant to represent 'the shining lake above' the little bronze figure of Narcissus below. There is indeed something 'poetic and original' about this notion of the water looking down on the youth; and though we don't quite know what she means by the phrase, we are willing to believe that Mrs Haweis is right in thinking that this version of the old myth is 'not repeating point-blank the hackneyed tale'.[11]

Although the reviewer could be mistaken for thinking the phrase 'hackneyed tale' is one of Haweis's more 'fanciful' moments, it is in fact a reference to Horace's *Art of Poetry* (18 BCE). Guarding against being the first in the field with a new theme that is unfamiliar to the audience, Horace suggests, 'A theme that is familiar can be made your own property so long as you do not waste your time on a hackneyed treatment'.[12] Jason Edwards suggests that this passage accounts for Alfred Gilbert's 'predilection for stylistically original re-tellings of ancient myths with new narrative foci'.[13] That is, by focussing not on a literal telling but on what the text suggests, it is possible to locate something profoundly 'poetic and original'.

Further reviews in *Art Amateur* and *Literary World* are much more measured affairs,

although, in speculating on the selection, *Art Amateur* suggests the book is more about 'the varieties of taste they exemplify and the interest attaching to the personality of the owners, rather than because each is to be commended from an artistic standpoint'.[14] This is an interesting observation and perhaps reflects Haweis's lack of a clearly laid exegesis throughout the text. One reason for this is that the book is a collection of essays previously published in *The Queen* and gathered together as a means to generating income.

Mary Haweis's writing on the decorative interior, and *Beautiful Houses* in particular, is cited in several books on Victorian homes and interiors. Some are favourably referenced, others contain more than a hint of cynicism, and on occasion, accuracy is also questioned. When discussing Alma-Tadema's residence in *An Album of Nineteenth-Century Interiors* (1992), Charlotte Gere states: 'Mrs Haweis describes another dado in the house as being of dark brown batiste, a very fine cambric that would have been entirely unsuitable for the purpose, but that may have been due to a mishearing of the word batik'.[15]

On another occasion, Charlotte Gere in *Nineteenth-Century Decoration* (1989) references and quotes from *Beautiful Houses* but not the observations of Alma-Tadema's house or Lord Leighton's residence. Instead she opts for the home of the American painter G. H. Boughton and Tower House—the abode of the architect William Burges.[16] After noting that American period houses offer a certain degree of warmth and comfort, she remarks that Haweis has clearly been 'seduced' by this American talent, implying

that 'sensuous' qualities have interfered with her 'objective' judgement. In observing that the detailed descriptions resemble other 'artistic' Queen Anne houses, Gere suggests 'some particular quality must have prompted the author into her superlatives'.[17]

Jeremy Cooper categorizes *Beautiful Houses* as one of three contemporary design manuals covering attitudes to style and taste.[18] Later, he attempts to dismiss Haweis by quoting her 'sensuous' description of Lord Leighton's Arab Hall and interleaving the quotes with information on the artists involved. This process misunderstands what I later discuss as 'synaesthetic descriptions' and tends to imply that Haweis has not identified artefacts and paintings, an omission that Cooper rectifies. However, evidence demonstrates that Haweis is very capable of meticulous observation of clothing, art and architectural history. In this particular text, she identifies many artists and artworks from Leighton's painting collection as well as notes Walter Crane's frieze. The confusion is in part due to Haweis's writing style, which focussed foremost on the physical and psychological effects of interiors, as well as her antithetical position to rationalized categorization of work in the manner that Cooper implies. She states that 'to catalogue the features singly which make up the august whole would be mistaken, as well as needless. We see no flower's beauty better for dissecting it'.[19] This is her challenge to rational thinking and one that contextualizes her writing as having a clearly defined philosophical basis. Cooper also selects quotes to accompany his coverage of Alfred Morrison's house but balances Haweis's criticism of a cabinet

with a 'simpler verdict from *The Builder*'.[20] The implication being that the point can be argued more succinctly without superfluous adjectives or translation through metaphors.

Joseph Mordaunt Crook, in his biography *William Burges and the High Victorian Dream* (1981), also invokes Haweis as the 'high priestess of "the religion of beauty" [who] thought it [Tower House] a veritable shrine of "brightness, joyousness and strength" '.[21] He concedes that:

> *Mrs Haweis had an equally popular touch. She wrote art criticism in the gushing vocabulary of a ladies' magazine. Still her description of Tower House in its heyday is an intriguing document. Colour and allegory were her obsessions. She found Burges's home 'a treat to the eye and a lesson to the mind'; the product of 'genius', 'poetic feeling' and 'fun'; in truth, an 'Aladdin's palace'.*[22]

Crook's manner of quotation interspersed with his own comments clearly regards her work as 'poetic' and points the reader to more 'prosaic' accounts of these houses published in *Country Life* and *The Survey of London*.

The challenge of *Beautiful Houses* is taken up by Ian Fletcher in his essay 'Some Aspects of Aestheticism', where he comments on how aesthetic manuals offer advice on transforming 'home' into the 'House Beautiful'. Fletcher argues that Haweis's descriptions of Leighton's 'Narcissus' room are 'irresistibly synaesthetic' because they do not crudely retell the story, but rather depict its revelation through colour, light and shade.[23]

Testing for the presence of the condition, according to Harrison and Baron-Cohen,

relies on 'gauging the subject's *consistency* at relating colour descriptions from words across two or more occasions'.[24] Both authors focus on scientific studies that seek independent objective signs rather than subjective symptoms, in order to eliminate the possibility of learned associations of colour to alphabet letter. They also acknowledge that, in contrast, Richard E. Cytowic has 'relied upon a set of diagnostic criteria of "clinical" symptoms' and examines the sublime and complex relation between sensory functions and normal brain functioning.[25] However, Harrison and Baron-Cohen, among others, define synaesthesia as 'occurring when stimulation of one sensory modality automatically triggers a perception in a second modality, in the absence of any direct stimulation to this second modality. So for example a sound might automatically and instantly trigger the perception of vivid colour; or vice versa'.[26]

They also note the difficulty in determining whether the use of metaphor and allegory are 'pseudo-synaesthetic' literary devices, since both are widespread in language. They conclude that 'in metaphoric pseudo-synaesthesia (a) no percept is *necessarily* triggered; (b) the subject will often acknowledge that the description is only an analogy; and (c), it is voluntary'.[27]

The question then is whether Haweis's 'fanciful descriptions' reflect the flair of an artist, using the vocabulary and palette associated with artistic interpretation, or, as noted by Fletcher, proffer descriptions that induce imaginative interpretations.

Ramachandran and Hubbard suggest that it was Sir Francis Galton (1822–1911) who first reported the condition called synaesthesia:

> *He noticed that a certain number of people . . . seemed to . . . experience sensations in multiple modalities in response to stimulation of one modality. For example, musical notes might evoke distinct colours; F# might be red and C# blue. Or the printed number 5 always 'looks' green, whereas 2 looks red.*[28]

Galton's accounts are recorded from his own observations and correspondence with 'sufferers' of this condition; one of which was Mary Eliza Haweis. Throughout her life, Haweis committed a number of visions, dreams and thoughts on the supernatural to her *Thought Book*. On one occasion she recalled seeing scenes and objects with closed eyes and described how, before marriage, visions of the day came to her at night when she said her prayers. Several years later, details of Haweis's visions were recorded in Francis Galton's essay 'The Visions of Sane Persons' (1881). After acknowledging his own ability to see visions, he provides a long quote from Haweis which begins:

> *All my life long I have had one very constantly recurring vision, a sight which came whenever it was dark or darkish, in bed or otherwise. It is a flight of pink roses floating in a mass from left to right, and this cloud or mass of roses is presently effaced by a flight of 'sparks' or gold speckles across them.*[29]

In reviewing this paper, or more precisely the evening lecture of the same title, Karl Pearson in *Life and Letters of Francis Galton* (1924) observed that the talk was aimed at exposing the prevalence of visions, illusions and hallucinations among various people.

While discussing the association of words to image, Pearson noted that:

> The object of this lecture was to show the unexpected prevalency of a visionary tendency among persons who form a part of ordinary society. Visions, illusions, hallucinations are stages of the same mental phenomenon, and may grade in intensity up to the star of Napoleon I or the daemon of Socrates and ultimately link up with a touch of madness.[30]

In a later publication, Galton again used Haweis as a case study and quoted her recollection that:

> Printed words have always had faces to me; they had definite expressions, and certain faces made me think of certain words. The words had no connection with these except sometimes by accident. The instances I give are few and ridiculous. When I think of the word Beast, it has a face something like a gargoyle. The word Green has also a gargoyle face, with the addition of big teeth. The word Blue blinks and looks silly, and turns to the right. The word Attention has the eyes greatly turned to the left.[31]

Although synaesthesia was the topic of intensive scientific investigation by Galton and others throughout the late nineteenth and early twentieth century, it was largely abandoned in the mid-twentieth century with the rise of behaviourism as the dominant psychological paradigm. It has only recently been rediscovered by modern researchers such as Ramachandran and Hubbard, Cytowic, and Harrison and Baron-Cohen. These researchers, along with others from various disciplines, have contributed to 'the condition being widely recognized as having a neurological reality, thereby moving it beyond "romantic neurology" . . . into the realm of the scientific investigation of human experience'.[32]

In literature, synaesthetic writing uses various metaphors to transfer terms from one sense sphere to another. Typically illustrated by phrases such as 'a sharp tone' or 'loud colours', it is, in certain schools of poetry, a 'major element in the technique of sense expression'.[33] For psychologists, the difficulty lies in whether such things as the association of colours to numbers are genuine synaesthesia or learnt associations.

More recently, writing that simultaneously appeals to the eye, ear, the sense of touch and taste has been connected with the idea of 'translating the female body into writing'.[34] Eugenia Sojka has suggested that a number of feminist writers 'employ aural, visual and performance poetics or to use Tostevin's words, texts that incite the reader "to hear to see to smell to taste to touch" '.[35] Claire Oboussier examines the synaesthesia mobilized in the writings of Hélène Cixous and Roland Barthes, particularly how metaphor is bound up with the body and sensory perception.[36] She argues for Cixous's and Barthes's claim that sensorial perception has been repudiated and marginalized, evidenced through Platonic thought. With Cixous, Oboussier identifies an access to knowledge through the senses that 'appeals to a previous edenic state where words existed in direct physical relation to their referents . . . [that is] the word sea should feel wet, salty and smell of seaweed'.[37]

Moreover, Oboussier utilizes Richard Cytowic's *The Man Who Tasted Shapes* (2003) as an intertext for the essay, noting that this neuro-scientific work insists that subjective experiences such as synaesthesia are, in fact, the 'bread and butter' of clinical neurology and, also, the only means to gauge any sensory perception.[38] For example a synaesthete might describe the colour, shape and flavour of someone's voice as a geometric form or movement of shapes and colours. Cytowic proffers several cases of this phenomenon in which two sensations are conjoined, arguing their existence physiologically. Examples include one patient who states: 'What strikes me first is the *colour* of someone's voice . . . He has a crumbly yellow voice, like a flame with protruding fibres. Sometimes I get so interested in the voice, I can't understand what is being said'.[39]

As a literary manifestation of the Aesthetic Movement, this 'book beautiful' may offer synaesthetic descriptions of the House Beautiful in the form of imaginative literature. The book's textual organization to some extent aligns itself with the work of some recent feminist writers who have experimented with synaesthetic writing that appeals to all five senses of the body. These writers use many techniques to break traditional formats, including altering spelling and adding graphic, textual and spatial forms to incite the reader. Mary Haweis's carefully designed volume creates the possibility for 'different sign systems to enter in a process of translation'.[40]

The methodology for *Beautiful Houses* is to 'translate' the interiors through the body and shift—in a somewhat avant-garde manner—the text through time by wrapping it in a simulation of a Queen Anne artefact. In so doing, these practices yield hybridized constructs where techniques from various arts such as woodblock prints, and so forth, are translated into the written text. The blank spaces act as visual silences that draw attention to the act of writing itself.

What is clear from Haweis's writing is that she is intent on conveying a sense of place conditioned by how a place is sensed by the (her) body, and what that sense evokes. For the sensing body, odour and sound offer different spatialities that are dependent on odour/sound strength, wind flow, materiality, obstacles and so on. Therefore, on entering a space any number of triggers promote a reaction, constituting a non-static, more fluid or dynamic reading of space than is possible through traditional 'rational' readings. When the personality is also synaesthetic, colour, form and text will provoke a response as other triggers conjure 'visions'.

Given the aforementioned, it is also possible to say that although the descriptions in *Beautiful Houses* are perhaps fanciful, emotional and delivered with passion, they are written from a woman's point of view, discussing everyday issues relevant to the discourse of women's aesthetic sensibility. They reflect a history of issues pertinent to women, as opposed to the canonical histories provided by funded male academics and writers. This is a position Haweis articulates later in life when referring to books written by women. She argues against those written from a man's point of view, and under the influence of a man (such as George Eliot), and in favour of those

written from the woman's special point of view, from the heart, and from her inner and earnest side—a side not much known to man, and sometimes at issue with man. Such writers are Sarah Grand and George Egerton . . . such women have the strength and courage and polish of men, but keep those qualities for the spiritual and not merely the animal level.[41]

Whatever the literary merits of her volume, Haweis attempts to depict the sensation of the room rather than its actuality. Phrases are intended to capture, affect and inspire rather than offer a description to emulate. Perhaps by rereading the descriptions contained in this volume as synaesthetic descriptions it is possible to understand better such writing as contributing to the discourse of the interior.

Notes

1. M.E. Haweis, *Beautiful Houses* (Low, Marston, Searle and Rivington, 1882), p. 4.

2. Ibid., p. iv.

3. Ibid., p. ii.

4. Ibid., p. iii.

5. I. Fletcher, 'Some Aspects of Aestheticism', in O.M. Brack Jr, ed., *Twilight of Dawn: Studies in English Literature in Translation* (University of Arizona Press, 1987).

6. T. Barringer and E. Prettejohn, eds, *Frederic Leighton: Antiquity, Renaissance, Modernity* (published for the Paul Mellon Centre for Studies in British Art and the Yale Center for British Art by Yale University Press, 1999), p. xxvii.

7. J. Edwards, *Alfred Gilbert's Aestheticism: Gilbert amongst Whistler, Wilde, Leighton* (Ashgate, 2006), p. 71.

8. Ibid.

9. Ibid.

10. Book review, Beautiful Houses, *The Academy* 540 (9 Sept. 1882), pp. 191–2.

11. Ibid., p. 192.

12. Horace, *On the Art of Poetry* (Classical Literary Criticism), tr. T.S. Dorsch (Penguin, 1965), p. 83.

13. Edwards, *Alfred Gilbert's Aestheticism*, p. 71.

14. 'Beautiful Houses', *The Art Amateur: A Monthly Journal Devoted to Art in the Household* 7/5 (October 1882), p. 101.

15. C. Gere and J. Focarino, eds, *An Album of Nineteenth-Century Interiors: Watercolors from Two Private Collections* (Frick Collection, 1992), p. 96.

16. C. Gere, *Nineteenth-Century Decoration: The Art of the Interior* (Harry N. Abrams, 1989), pp. 42, 302.

17. Ibid., p. 42.

18. The other two are H. Shaw, *Specimens of Ancient Furniture* (W. Pickering, 1836); and O. Jones, *Grammar of Ornament* (Day, 1856).

19. Haweis, *Beautiful Houses*, p. 5.

20. J. Cooper, *Victorian and Edwardian Furniture and Interiors: From Gothic Revival to Art Nouveau* (Thames and Hudson, 1987), p. 16.

21. J.M. Crook, *William Burges and the High Victorian Dream* (John Murray, 1981), p. 309. 'Beauty' taste and aesthetic judgement, conditioned by trained appreciation and instinct, were for the Victorians important markers of culture. For further discussion of beauty and aesthetic judgement in the post-Victorian era see D.W. Prall, *Aesthetic Judgement* (Thomas Y. Crowell, 1967 [1929]).

22. Crook, *William Burges*, p. 309.

23. Fletcher, 'Some Aspects of Aestheticism'.

24. J.E. Harrison and S. Baron-Cohen, 'Synaesthesia: An Introduction', in J.E. Harrison and S. Baron-Cohen, eds, *Synaesthesia: Classic and Contemporary Readings* (Blackwell, 1997), p. 5.

25. R. Cytowic, *The Man Who Tasted Shapes* (MIT Press, 2003).

26. Harrison and Baron-Cohen, 'Synaesthesia', p. 3.

27. Ibid., p. 11.

28. V.S. Ramachandran and E.M. Hubbard, 'The Phenomenology of Synaesthesia', *Journal of Consciousness Studies* 10/8 (2003), p. 49.

29. F. Galton, 'The Visions of Sane Persons', *Fortnightly Review* 29 (1881), p. 734. For a more concise account of Haweis's visions see M.E. Haweis, *Thought Book*, 14 October 1871, Stephen Haweis Papers, Columbia University, Box 03.

30. K. Pearson, *Life and Letters of Francis Galton*, vol. 2 (Cambridge, 1924), p. 243.

31. F. Galton, *Inquiries into Human Faculty and its Development* (Macmillan, 1883), pp. 113–4.

32. Harrison and Baron-Cohen, 'Synaesthesia', p. 4.

33. 'Synaesthesia', *Oxford English Dictionary,* http://www.oed.com, accessed 15 May 2007.

34. E. Sojka, 'Canadian Feminist Writing and American Poetry', *CLCWeb Comparative Literature and Culture:*

A WWWeb Journal, http://clcwebjournal.lib.purdue.edu/clcweb01–2/sojka01.html, accessed 16 May 2007.

35. Ibid.

36. C. Oboussier, 'Synaesthesia in Cixous and Barthes', in D. Knight and J. Still, eds, *Women and Representation: Proceedings of the Women Teaching French Conference May 1994* (University of Nottingham Occasional Papers No 3, 1995).

37. Ibid., p. 125.

38. Ibid., p. 118.

39. Ibid., pp. 130–1.

40. Ibid., p. 131.

41. M. E. Haweis, 'Women as Writers', in H. R. Haweis, ed., *Words to Women: Addresses and Essays by the Late Mrs. H. R. Haweis* (Burnet and Isbister, 1900), p. 68.

Chapter Three

Wearing and inhabiting the past: promoting the Colonial Revival in late-nineteenth- and early-twentieth-century America

Bridget A. May

The Colonial Revival is a uniquely American phenomenon that is both a style and a set of professional and amateur practices in architecture, interior design, furnishings, dress and literature. As a style, it adapts and/or reproduces characteristics of American architecture, interiors, furnishings and culture from the seventeenth through the early nineteenth centuries. Emerging in the 1860s and 1870s, the design goal was to capture the spirit of the colonial period, not necessarily to reproduce it. Colonial Revival was, and still is, complex and sometimes contradictory. It affected diverse aspects of American life and material culture because it arose from and reflected both past and present views and experiences of the contemporary world within which Americans lived. From its beginnings, the Colonial Revival was and still remains a significant force in American design and culture.[1]

Wearing colonial clothing and inhabiting colonial interiors, real or recreated, shared many of the Colonial Revival's assumptions, associations and characteristics, which primarily derived their appearance and character from English material culture, mainly in the eastern region of the United States.[2] Widely available authentic images of colonial architecture, furniture and clothing, and manifestations of the Colonial Revival in architecture, interiors, furniture and dress, entered mainstream culture at about the same time—during the 1870s and 1880s. They were and are useful means of commemorating or celebrating the past. At first, examples were a lighthearted means of comparing the past with the present to demonstrate progress and the superiority of modern times and technology. Later examples invoked an imagined past filled with wonderful people of excellent character and tastes which were superior to modern life and material culture. These were nostalgic and anti-modern reactions to the enormous changes in American society and culture resulting from industrialization, immigration and urbanization. In addition to helping Americans cope with change, the

Colonial style represented family, heritage, culture and, of course, America. Throughout their history, Colonial Revival architecture, interiors, furnishings and clothing reinvented themselves in response to societal changes, fashion or scholarly activities. Consequently, they were and are expressions of the society using them, not necessarily the society that created them.[3]

The foundations for Colonial Revival were laid in the first half of the nineteenth century. During the 1820s and 1830s, nationalism, the Picturesque Movement and greater interest in the history of the United States provided the impetus for antiquarians, collectors, tourists, historians and novelists to turn their attention to their own country. Furthermore, colonial houses and artefacts, sources of local pride and patriotism, were beginning to disappear. In this period, images of colonial buildings, interiors and artefacts were not widely available and consisted mostly of engravings, prints or descriptions and word pictures in books, newspapers and magazines.[4]

The first historical accounts of the United States tended to be stories about significant events and people, often describing their appearances, manners of living, accomplishments and character. For example, early historian John Fanning Watson noted that 'it will much help our conceptions of our forefathers and their good dames, to know what were their personal appearances. To this end, some facts illustrating their attire will be given'. He included descriptions of houses and furniture. Some histories included engraved images. Books and articles by Benson J. Lossing included his drawings of houses, portraits, furniture, decorative arts

and an occasional interior associated with individuals important to American history.[5]

Newspapers and periodicals became common in American life in the nineteenth century. These many publications sometimes carried articles about colonial history, towns, houses, clothing and people. For example, beginning in the 1860s, *Harper's New Monthly* ran travelogues about colonial towns along with images.[6] Historical fiction in periodicals and books sometimes featured colonial themes and images. All multiplied as the Centennial of Independence drew near.

Descriptions and engravings of portraits, houses, important buildings, interiors and various objects associated with the Pilgrims, Revolutionary heroes, the founding fathers and mothers and their accomplishments were important because they helped satisfy an American desire for a history, which the youthful nation lacked.[7] Descriptions and images from literature were important to the Colonial Revival because, through them, contemporary audiences learned about the material culture and clothing of the past. Thus, they could recreate what they saw in their own homes and lives, if they wanted. Furthermore, the juxtaposition of texts and pictures emphasized positive qualities thought missing from modern times and people, which helped set the stage for and fuel the Colonial Revival. Additionally, words and images created positive associations and a historical visual language related to people, objects and events. Figure 3.1 and 3.2 shows the Warner House and stair hall from *Harper's New Monthly Magazine* of October 1874. The author characterized the owner, Jonathan Warner, as having 'all the dignity of

the aristocratic crown officers', in his 'broad-backed, long skirted brown coat, those small-clothes and silk stockings, those silver buckles, and that cane'. He noted that the interiors of the 'fine and substantial house' were 'rich in paneling and wood carvings'. The hall was 'wide and deep after a gone-by fashion, with handsome staircases, set at an easy angle, and not standing nearly upright, like those ladders by which one reaches the upper chambers of modern houses'. A parlour held 'a choice store of family relics—china, silver plate, costumes, old clocks, and the like'.[8]

In the second half of the nineteenth century, ways of representing the colonial past expanded to include paintings, stereo-views, lithographs and photographs. Additionally, many books on colonial architecture and furniture were published from the last quarter of the nineteenth century onward. Decorating advice books discussed the colonial style more commonly in the early twentieth century, but a few earlier publications mentioned the colonial or 'old fashioned' style. Trade cards, business cards and advertisements sometimes featured colonial buildings, interiors and/or people in colonial clothing.

Equally important as pictures and textual descriptions to the foundations of the Colonial Revival were the objects—or relics, as they were sometimes called. As visible expressions of the past and its revival, objects defined and created both. From the first decades of the nineteenth century onward, people could see and sometimes interact with colonial artefacts, including clothing, in places such as Pilgrim Hall in Plymouth, Massachusetts, or the homes of collectors.[9] During the Centennial years (1870–1876) and following, relics and

other objects were exhibited at expositions, fund-raising events, teas and balls. By the turn of the century, people could visit museums, period rooms and historic houses. Now they could not only read about the colonial past but also see it, which made it more alive. Words, images, objects, articles of clothing and environments, which 'domesticated history and personalized' America's past, contributed to the dissemination of the Colonial Revival in the 1870s.[10]

Expressions of the Colonial Revival, such as dressing in costumes for tableaus, parlour entertainments and amateur theatricals, became fashionable in American life coevally with the proliferation of visual and textual representations of the colonial past. Some dramas contained scenes from American history, especially the Revolution. Women brought these theatricals outside the home

Fig. 3.1. Warner House. From *Harper's New Monthly Magazine*, October 1874.

HALL OF THE WARNER HOUSE.

Fig. 3.2. Stair hall of Warner House. From *Harper's New Monthly Magazine*, October 1874.

to fund-raising events or as part of their social work. Best known were the New England kitchen exhibits held at Sanitary Fairs to raise funds for the Sanitary Commission during and after the Civil War. Beginning in 1863, the kitchens centred on large fireplaces and were filled with colonial objects and antiques such as spinning wheels. Women wearing 'period costumes' served food, spun flax and participated in various activities and entertainments. People found them interesting because they compared modern technology with that of the past to show progress and, besides, they made money.[11]

As the 1876 Centennial of the birth of the United States approached, events and opportunities for wearing garb of the previous century increased. Teas, balls, receptions, exhibits, re-enactments and celebrations were held across the nation beginning in the early 1870s. Historic costumes, whether worn or exhibited, played large roles in celebrations. Especially popular were 'Martha Washington teas and balls' in which participants wearing colonial clothing or costumes 'recreated colonial life in a unique, participatory ritual, a quasi-dramatic, quasi-social form of living for a few hours in a glamorized past'. Some

continued long after the Centennial even into the twenty-first century.[12]

Pageants, parades and dramas held on national holidays and anniversaries also offered opportunities to wear or exhibit colonial dress. In the 1880s, colonial figures, dress and objects also entered the commercial realm. Advertisements for various products ranging from strawberries to shoes, to flooring or furniture sometimes featured Pilgrims, farmers, affluent colonists or important people like Martha Washington. Continuing the New England kitchen tradition, colonial-themed tearooms had costumed waitresses. In the early twentieth century, interpreters at living history museums, such as Colonial Williamsburg, wore historical costumes, adopted period personas and performed everyday tasks of the colonial era.[13]

Colonial and Colonial Revival dress, interiors and furnishings were linked with and were significant to people because they expressed national, familial and personal identities. This was particularly evident at the inception of the Revival, when activities, interiors and costuming were inspired by and centred on people, especially those important to either the nation's or the individual's heritage. This emphasis on people, represented in period texts and images, created a past that both appealed to and reflected American culture. It also inspired a desire to know about colonial people 'their appearance, manners, and customs; to cross their thresholds and see what they ate and drank and wherewithal they were clothed . . . to estimate their character'.[14] Reading, seeing, collecting and even wearing the past gave it reality and accessibility. As Alice Morse Earle explained, 'Old portraits,

old letters, and old garments! These bring us very close to those who have been gone for centuries'.[15] Figure 3.3 shows the New England farmhouse, a popular Centennial exhibit. The language describing the objects emphasized the people who owned them, their ages or how they arrived in the country, and the pictures showed women interacting with the objects. The accompanying article described the farmhouse as the 'exact imitation of the country dwellings of a hundred years ago' and its rooms as 'furnished with veritable heirlooms . . . articles which really came over in the Mayflower, or were manufactured' long ago. The writer was impressed by the ladies in the farmhouse who 'by right of their surroundings and quaint costumes . . . should be at least a century or more advanced in years' and yet were not.[16]

Because expressions of the Colonial Revival centred on people and their character and possessions, events that celebrated or commemorated America's past were opportunities for activities involving interiors, objects and clothing. Activities included preserving buildings and preserving or collecting interiors, artefacts or clothing; displays and exhibitions of objects or clothing; and impersonating and/or wearing clothing and objects associated with important people from America or one's family. They, along with others, provided ways for modern people to inhabit bygone times, at least temporarily, through clothing and environments. Wearing colonial dress often took place in relation to past or present architecture, interiors and objects, which reinforced relationships between people and environments, people and objects and people and clothing. Interiors formed the backgrounds for re-enactments,

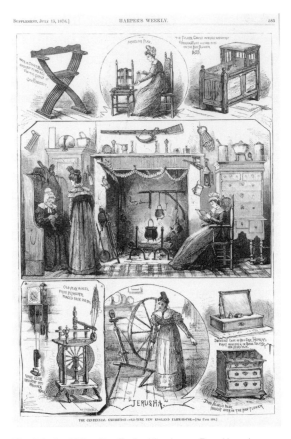

SUPPLEMENT, JULY 15, 1876.] HARPER'S WEEKLY. 585

Fig. 3.3. An old-time New England farmhouse. From *Harper's Weekly*, 15 July 1876.

differently'. Inhabiting the past is making believe, acting and imagining. One could engage the past as much or as little as one wished, and one could, through these acts, become part of the past. One could project one's self into the past for amusement; to educate and inform; to demonstrate status, values, identity or heritage; or to engage with a better time than the present. According to Celia Betsky, practices like these allowed Americans to 'revive, mentally and somehow also physically to go back to and even go beyond, the old-fashioned interior . . . with old folks and the home hearth, maternal affection, family togetherness, and rustic old country furnishings'. Interiors and clothing became a 'means of entering history . . . and grafting an idealized agrarian past, a bucolic colonial way of life, onto an alienating and impersonal urban present'. Trappings of the past gave people an identity, which 'helped dispel the anonymity of metropolitan life'.[18]

In many different settings, such as the ballroom or kitchen, inhabiting the past could depict events important in national or local history; illustrate domestic tasks like cooking or spinning; or imagine formal, social or aristocratic rituals, such as the Martha Washington teas and balls. Thus, environments and the objects that they contained became adornments, props and supports for practices of re-enactment, as in Figure 3.4. The photograph from *Home Life in Colonial Days* shows three generations of women preparing pies in what appears to be a colonial kitchen (probably remodelled later). Here and in her other books, Earle 'created verbal and photographic images of domesticity . . . [Where] work becomes

routines and rituals of the past, which were also chances to wear colonial clothing or costumes. Thus, the interior brought people, dress and objects 'together in one place, and as a single overarching metaphor, identified them with each other'.[17]

Inhabiting the past through dress, image or interior was and still is a means of relating to the past in a direct and personal way. According to Beverly Gordon, 'the very act of putting on clothing and affecting mannerisms of other times and places allows individuals to project themselves elsewhere and imagine themselves

craft, not drudgery [and] . . . busyness is enshrined'.[19]

Settings for these events were not always in real or recreated colonial interiors, of course, but one could dress to match the environment—wearing, for example, a formal eighteenth-century dress at a ball. One could also decorate the environment to match clothing or costumes. For the Centennial Tea held in 1874 to raise funds for the Philadelphia Centennial, the United States Capitol rotunda (1818–1824) was decorated with 'tastefully arranged' flags (see Fig. 3.5). Silk banners on the walls displayed states' names, and above the tables around the rotunda were banners with 'armorial bearings of the thirteen original states'. The tables held 'quaint old silver-ware' along with candlesticks and tea serving implements. The lady attendants 'wore mobcaps and white neckerchiefs, and . . . [their] dainty white aprons showed they were ready for work'. The tea did not make much money, but it did bring together dress, objects and interior decoration to create a 'desired image to the world at large'. The interior decorations, of which the women were part, made a statement of patriotism and celebration. Gordon believes that dress and interiors were reflections and extensions of women and their homes. In this context, women and their clothing become decorations used outside the home, both as

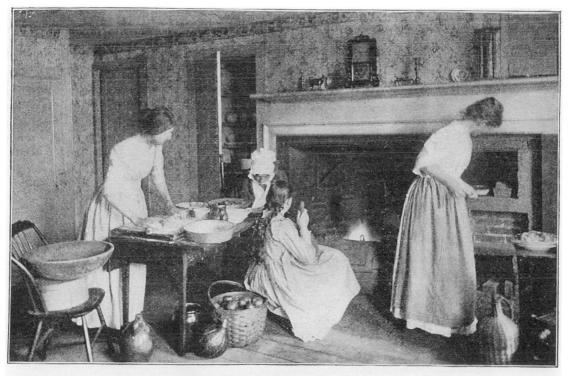

Making Thanksgiving Pies

Fig. 3.4. Making Thanksgiving pies. From A. E. Morse, *Home Life in Colonial Days*, 1898.

reflections of the past and extensions of a collective past projected by and onto them. Women, their clothing, the interior and the decorations represent, contribute to and participate in a common or shared past, allowing all to live in the past momentarily.[20]

For decorating and dressing, whether for an event or one's colonial-style home, replicating the past was not necessary. Capturing the charm, visual appeal and spirit of the past was more important. Definitions and dates for colonial periods were sufficiently elastic to allow many interpretations. Despite assertions of authenticity or accuracy, Colonial Revival expressions were always expressions of contemporary identities reflected in modern

people, houses, interiors, furniture and dress.

Interiors and dress changed to reflect more current modes. As Gordon has shown, colonial costumes usually reflected current fashion more than that of the past. Early colonial-style interiors had an old or old-fashioned object or two in cluttered, eclectic spaces. By the 1890s, colonial-style interiors had more Colonial Revival furniture and finishes. In the 1920s, the Colonial Revival interior became the Modern Colonial room with plainer patterns, fewer objects and simple colonial-style furniture.[21]

Certain elements of costume and architectural forms, furniture and objects

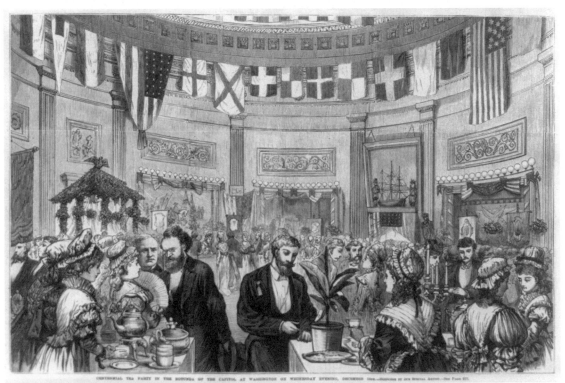

Fig. 3.5. Washington: The Centennial Tea Party in the Rotunda. From the *New York Times*, 17 December 1874.

became signals of the past. This created an historical visual language that was common and easily recognized, understood and usable. Figure 3.6 shows some objects and symbols of the early Colonial Revival. They include the spinning wheel, a large fireplace, wood panelling and antique or old-fashioned furniture representing old-fashioned domesticity, home and handicraft, all bolstered by the woman in Puritan clothing. In contrast, the musket over the mantel stood for masculine presence, bravery and courage at a time when men were absent because many worked outside of the home. Other common elements included a tall case clock,

a reference to Henry Wadsworth's poem 'The Old Clock on the Stair', and pewter tea pots and cups. In the twentieth century, signals of the colonial-style interior were white paint, wood floors and mahogany furniture.[22]

Colonial-style costumes evolved, too. For women, signifiers included kerchiefs around shoulders, mobcaps, aprons and powdered hair. 'Of course, black patches must appear upon the faces'. Although costuming was usually a feminine occupation, men could be persuaded to don colonial garb particularly when they could impersonate an important person or re-enact primarily male events like battles. Masculine dress included knee

Fig. 3.6. Henry Loveloy, 'A Puritan Hearthstone', c. 1906. Library of Congress, LC-USZ62-90823.

britches, buckles, powdered wigs and braided queues and ruffles and frills of lace at wrists and necks.[23]

One of the most important aspects of colonial images and dress is that they played a significant role in the development and recognition of a common experience—a national historical narrative, vital to any nation. They helped create an American past—a shared history and democratic values— which was crucial in the late-nineteenth-century's increasingly diverse culture. Images and dress contributed to the development of the colonial as an American style 'distinct from European modes'. This, too, was critical to the young nation because, as one writer expressed it, 'we feel the want of nationality and delight in whatever asserts our national "American" existence . . . We have no record of Americanism and we feel its want'.[24]

Nationalism and patriotism were re-sponses to the changes and problems facing America in the second half of the nineteenth century, when industrialization, urbanization and immigration seemed to threaten a unified American society and culture. Colonial images and dress visibly showed the patriotic and nationalistic spirit inherent in the Colonial Revival. From the early nineteenth century onward, patriotism became a dominant motivation for what was worn, built, decorated, used and preserved from the past. This nationalist and patriotic spirit helped reunite a country torn apart by civil war and, later, would help defend against newcomers. Despite differences, all could share in the colonial past. Much of 'colonial architecture's popular appeal was based on patriotic sentiment'.[25] The same

can be said of dress, interior decoration and furnishings.

In the last quarter of the nineteenth century, a huge influx of immigrants, especially those from Eastern Europe, added to fears that American ways and heritage would be lost. Consequently, the Colonial Revival became a tool for two seemingly contradictory functions. It became an emblem of separation from and a means to Americanize immigrants. Examples communicated heritage and ancestry, whether real or supposed, and also demonstrated and defended status and ethnic origins. The act of living in or building a colonial-style house declared heritage, which was very important to affluent Anglo-Americans in New England, the Mid-Atlantic, the South and some parts of the Mid-west. Many held their ancestry dear and demonstrated it in their homes and furnishings and what they wore to events. Families were proud of clothing, houses and furnishings that had been passed down. The middle class adopted the Colonial Revival for similar reasons, and those who lacked heirlooms collected them. In these ways, possessions helped separate residents from immigrants and newcomers.

Colonial Revival buildings, interiors, furniture and dress were used by various groups to help Americanize immigrants. The architecture and interiors of many settlement houses, schools, playhouses, churches and other structures across the country were colonial in style or origin. Not only did they represent American history and culture, but they also were regarded as 'the means by which [people] from all parts of the world . . . will have instilled in them the spirit of patriotism and loyalty to America'.

Immigrants learned English, American history, and various skills within these structures.[26]

Similarly, patriotic pageants and parades were thought to encourage knowledge and respect for the past and democratic values in immigrants. Parade floats included colonial scenes or recreations of colonial buildings. Pageants usually focused on local, regional or national history with local participants contributing to the shared historical narrative. Even immigrants with limited language skills could take part because many of the scenes had minimal dialogue. Members of lineage societies, such as the Daughters of the American Revolution, the National Society of Colonial Dames of America or the National Society of the Sons of the Revolution, wore colonial costumes for various events, parades and re-enactments. They too believed this would help 'inspire reverence for the past and "Americanize" immigrants'. Parades and pageants also were ways to raise funds for preserving historic buildings, which became house museums or headquarters for local chapters. The special contribution of costuming for these events is that, as a group activity, it enhanced homogeneity and shared group experience and unity.[27]

A final link between clothing and interiors is that people used the historical and visual language created by and for pictures, interiors and clothing to view the present and help determine the future. Language and pictures along with interiors and clothing created positive associations that conjured up powerful images in people's minds and hearts, enhancing the desire to own, live or dress colonial. Associations carried significant meanings and were a driving force in the selection of clothing, houses, furnishings and decorative arts. For the future of the American past, associations affected museum collections and displays, period rooms and historic preservation. These associations live on today in colonial-style buildings, interiors, decorative arts and costuming, sometimes chosen for similar reasons.

Writers, design reformers and tastemakers insisted that objects and environments revealed the owners' culture, taste and heritage.[28] Environments and objects were thought to influence inhabitants and users so that people became like the objects with which they lived, positively or negatively.[29] Similarly, in dress one could become or, at least be influenced by the character of who was impersonated or whose clothing one wore.

Colonial Revival clothing and interiors developed from and contributed to perceptions of the colonial period as a mythical golden past. The past, particularly the eighteenth century, was considered a dignified age with noble and 'unostentatious people of gentle manners and culture' who lived 'a gracious mode of existence', both of which were lacking in modern individuals. Colonial times and people became models for modern people to emulate, as it was believed that environments influenced behaviour; in that way, living in colonial interiors and wearing colonial clothing were seen as socially beneficial. Thus, modern people could embody the character of colonial ones — 'their patient endurance, their zealous patriotism, their unconquerable devotion, their thrift, frugality, simplicity, rectitude, and fortitude', which 'contributed to enduring

national character'. Not only were colonial people finer in character, but 'they were respectably clad . . . Many of the fabrics used were elegant, and the fashion of their dress was frequently very stately', the implication being that modern dress was not.[30]

Colonial people were thought to have lived simpler, less hurried lives and to have engaged in more profitable past times than did modern ones. They had enjoyed life in 'quiet blissfulness, un-known in these bustling times . . . Knitting and spinning held the places of whist and flirting fans . . . Those were days of simplicity, comparative inno-cence'. Even more important, colonial people had better taste, and their houses and furnishings were simple, functional, and well designed. 'Colonial is synonymous of the best, and objects created during its influence are always of a higher degree of perfection than the best of other periods,' declared Mary Northend.[31]

Inspired by and commemorating the past and its people, wearing colonial costumes and inhabiting colonial interiors emphasized, represented and linked people, interiors, objects and clothing, both past and present, and also expressed relationships between and among them. Colonial practices allowed individuals to interact with or inhabit the past in a variety of ways and were also opportunities for people to express themselves, their family heritage or that of their nation. Colonial dress and interiors were part of a shared, imagined golden past. Yet they were tools of the present, helping people cope with change and cultural diversity and providing models for character and design. Always an expression of the culture that produced them, dressing and inhabiting the past helped the Colonial Revival provide a history and a style for America and, more important, contributed to a national historical narrative.

Notes

I am indebted to Beverly Gordon's scholarship on colonial dressing for many ideas in this chapter.

1. K. L. Ames, 'Introduction', in A. Axelrod, ed., *The Colonial Revival in America* (Henry Francis du Pont Winterthur Museum, 1985), pp. 3–10.
2. Exceptions to English dominance include Dutch Colonial houses and Southern Colonial houses often modelled after Mount Vernon. Additionally, California and the south-western United States created their own Spanish Colonial Revival. Examples of all are found across the United States.
3. B. Gordon, 'Dressing the Colonial Past: Nineteenth Century New Englanders Look Back', in P. A. Cunningham and S. V. Lab, eds, *Dress in American Culture* (Bowling Green University Popular Press, 1993), pp. 109–39; Gordon, 'Costumed Representations of Early America: A Gendered Portrayal, 1850–1940', *Dress* 30 (2003), pp.16–17; and W. B. Rhoads, *The Colonial Revival* (Garland Press, 1977). Gordon and others have proposed phases of the Colonial Revival. All agree that the first were based on associations and aesthetics.
4. The destruction of the John Hancock House in Boston in 1863 raised an outcry but did not save it. Rhoads, 'The Colonial Revival and American Nationalism', *Journal of the Society of Architectural Historians* 35/4 (1976), pp. 239–54; W. B. Maynard, ' "Best, Lowliest Style!" The Early-Nineteenth-Century Rediscovery of American Colonial Architecture', *Journal of the Society of Architectural Historians* 59/3 (2000), pp. 338–57; and H. Green, 'Popular Science and Political Thought Converge: Colonial Survival Becomes Colonial Revival, 1830–1910', *Journal of American Culture* 6/4 (1983), pp. 3–24.
5. E. Stillinger, *The Antiquers* (Alfred A. Knopf, 1980), p. 4; and J. F. Watson, *Annals of Philadelphia* (E. L. Carey & A. Hart, 1830), p. 171. Two examples of Benson J. Lossings's work are *The Pictorial Field Book of the Revolution* (Harper & Brothers, 1850) and 'The Boston Tea Party', *Harpers New Monthly Magazine* 4/19 (December, 1851), pp. 1–11.

6. Vincent Scully thought these articles were important to the inception of the Colonial Revival in architecture. By extension, they were important to the dissemination of Colonial-style interiors and furniture. V. J. Scully Jr, *The Shingle Style and The Stick Style* (Yale University Press, 1955), pp. 24–31; and T. J. Schlereth, *Victorian America: Transformations in Everyday Life, 1876–1915* (Harper Perennial, 1991), pp. 177–200.

7. Stillinger, *The Antiquers,* p. 4.

8. T. B. Aldrich, 'An Old Town by the Sea', *Harper's New Monthly Magazine* 49/203 (October, 1874) pp. 643–4. In using the term *relic,* the author recalls a venerated object associated with a saint or martyr. Many people regarded old objects as such.

9. Ames, 'Introduction', p. 9. Stillinger noted that an early collector of American furniture, Cummings Davis, 'received visitors [to his collection] in eighteenth-century costume, complete with knee breeches and long white stockings', *The Antiquers,* p. 25.

10. Museums did not begin to collect and display American artefacts until the end of the nineteenth century, when they began to be appreciated as art or expressions of American culture. Period rooms existed in collectors' homes, but the museum period room is a twentieth-century creation. Stillinger, *The Antiquers,* pp. 120–32. C. Betsky, 'Inside the Past: The Interior and the Colonial Revival in American Art and Literature, 1860–1914', in Axelrod, *The Colonial Revival in America,* p. 252; and Maynard, '"Best, Lowliest Style!"' p. 353.

11. H. Green, 'Looking Back to the Future', in G. L. Rossano, ed., *Creating a Dignified Past: Museums and the Colonial Revival* (Rowman & Littlefield Publishers, 1991), p. 3; Gordon, 'Dressing the Colonial Past', pp. 110, 134; Gordon, 'Costumed Representations of Early America', pp. 4–20; Gordon, *The Saturated World: Aesthetic Meaning, Intimate Objects, Women's Lives, 1890–1940* (University of Tennessee Press, 2006), pp. 107–38; and R. Roth, 'The New England, or "Olde Tyme", Kitchen Exhibit at Nineteenth-century Fairs', in Axelrod, *The Colonial Revival in America,* pp. 159–83.

12. K. A. Marling, *George Washington Slept Here: Colonial Revivals and American Culture, 1877–1986* (Harvard University Press, 1988), p. 44. Since 1898, Laredo, Texas, has held a Martha Washington Ball and Pageant to present debutantes. M. Swartz, 'Once Upon a Time in Laredo', *National Geographic* 210/5 (November 2006), pp. 92–109.

13. Gordon, *The Saturated World,* pp. 126–7; Green, 'Popular Science and Political Thought', p. 102; T. H. Witkowski, 'The Early American Style: A History of Marketing and Consumer Values', *Psychology & Marketing*

15/2 (1998), pp. 129–33; Marling, *George Washington Slept Here,* pp. 191–5, 237.

14. 'A Glimpse of "Seventy-Six"', *Harper's New Monthly Magazine* 49/294 (July 1874), p. 230.

15. A. M. Earle, *Two Centuries of Costume in America, 1620–1820* (Macmillan Company, 1903), p. 797.

16. 'An Old-Time New England Farm-house', *Harper's Weekly* 20/1020 (15 July 1876), p. 588.

17. Gordon, 'Costumed Representations of Early America', p. 3; and Betsky, 'Inside the Past', p. 241.

18. Gordon, 'Dressing the Colonial Past', p. 109; and Betsky, 'Inside the Past', p. 243.

19. J. A. Conforti, *Imagining New England* (University of North Carolina Press, 2001), p. 231.

20. 'Washington: The Centennial Tea Party in the Rotunda', *New York Times* (17 December 1874), p. 5; and Gordon, 'Woman's Domestic Body: The Conceptual Conflation of Women and Interiors in the Industrial Age', *Winterthur Portfolio* 31/4, (1996), pp. 201–3.

21. Gordon, 'Costumed Representations of Early America', pp. 16–17; Gordon, *The Saturated World,* p. 110; and B. May, 'Progressivism and the Colonial Revival', *Winterthur Portfolio* 26/2–3, pp. 107–22.

22. C. Monkhouse, 'The Spinning Wheel as Artifact, Symbol, and Source of Design', in Ames, ed., *Victorian Furniture* (Victorian Society of America, 1982), pp. 153–72; and Betsky, 'Inside the Past', pp. 248–56.

23. May, 'Progressivism and the Colonial Revival', p. 117; Gordon, 'Dressing the Colonial Past', pp. 122–32; and Gordon, *Masquerades, Tableaux, and Drills* (Butterick Publishing Company, 1906), p. 12.

24. Throughout the nineteenth century, Americans struggled with historic and cultural inferiority to Europe because they were a young nation. Most Colonial Revivalists seemed to overlook the fact that the colonists were European immigrants who tended to replicate houses, interiors and furniture from their homelands. Rhoads, 'The Colonial Revival and American Nationalism', p. 242; and Stillinger, *The Antiquers,* p. 3.

25. Rhoads, 'The Colonial Revival and American Nationalism', p. 239.

26. Marling, *George Washington Slept Here,* pp. 253–6; quoted in Rhoads, 'The Colonial Revival and the Americanization of Immigrants', in Axelrod, *The Colonial Revival in America,* p. 354.

27. Gordon, *The Saturated World,* pp. 110 and 126.

28. For examples on design reform see C. E. Eastlake, *Hints on Household Taste in Furniture, Upholstery, and Other Details* (Longmans, Green, 1868) or C. Cook, *The House Beautiful* (Scribner, Armstrong & Co., 1877).

29. Domestic environmentalism, the idea that environments affected people's characters, developed during the 1820s and 1830s in the United States. It remained a common notion throughout the nineteenth century and the first decades of the twentieth. Some examples include C.B. Stowe and H.B. Stowe, *The American Woman's Home or Principles of Domestic Science* (J.B. Brown & Co., 1969); A.J. Downing, *The Architecture of Country Houses* (D. Appleton & Co., 1850); and 'The Domestic Use of Design', *The Furniture Gazette* 1/1 (12 April 1873), p. 4.

30. 'A Glimpse of "Seventy-Six"', pp. 249, 241–2.

31. 'The Dutch on Manhattan', *Harper's New Monthly* 9/26 (September 1854), pp. 250–1; and M. Northend, *Furnishing the Colonial House* (Little, Brown & Co., 1912), p. 236.

Chapter Four

The Viennese coffeehouse: a legend in performance

Tag Gronberg

For ten years now, the Viennese Kaffeehaus has been the subject of regular performances in the form of the 'Tinte & Kaffee' (Ink & Coffee) series.[1] Initiated as one of several cultural events to mark the millennium in 2000, 'Tinte & Kaffee' are informal entertainments which take place in Vienna's most prominent cafés. These shows have included readings and re-enactments, paying tribute to famous Viennese writers: those of the golden age of the city's intellectual life, around 1900, as well as more recent authors. Conceived in order to reinforce claims for Vienna's historical status as an internationally important intellectual centre, 'Tinte & Kaffee' (as I hope to demonstrate with this essay) also involves significant issues about artistic production more generally. The highly suggestive pairing of ink and coffee prompts a reconsideration of the connections between consumption (physical as well as economic) and writing, particularly in the sense of professional authorship. The fact that these are performances is telling, too, not merely as a means of evoking the literary glories of the past, but also in highlighting what I shall argue is the productive performativity of

the Kaffeehaus.[2] The legendary Viennese coffeehouse was an urban social space construed as spectacle in which performers and audience formed fluctuating, often interchangeable, roles.[3]

The audience for 'Tinte & Kaffee' is urged to 'just show up', to relax at a café table with suitable refreshments and enjoy the show as it unfolds. Here in the absence of a stage, audience and actors to a large extent mirror each other's activities. We are reminded that the characteristic Viennese coffeehouse ambiance—talking, smoking, reading the newspapers, drinking coffee—is not only the subject but also the very means of artistic and literary endeavour (see Fig. 4.1). The Kaffeehaus is hereby presented not so much as a relaxing or *gemütlich* (cosy) retreat from the pressures of everyday life, but rather as the fertile terrain of Viennese intellectual creativity. Hence the apt conjunction of ink and coffee; the first 'Tinte & Kaffee' brochure quoted writer Hans Weigel: 'in the café, coffee is not so much the ends as the means.'[4] The glittering conversation and literary readings staged at a 'Tinte & Kaffee' performance demonstrate the extent to which the Viennese

café offered opportunities to formulate and contest ideas through social interaction. To claim that intellectual life is often—indeed perhaps best—carried out through public discussion is of course not a new idea. This was the activity of the classical agora, a space for both discussion and commerce. Raphael's Vatican fresco (1510–1511) known as *The School of Athens* shows famous philosophers of antiquity harmoniously grouped in order to depict the act of philosophical discourse. During the latter part of the nineteenth century, a modern analogy was drawn in naming a Parisian artistic café (at that time a favourite haunt of impressionist painters) the Nouvelles Athènes. In the years around 1900,

a period regularly described as the heyday of Viennese Kaffeehäuser, Vienna too was often proudly referred to by its inhabitants as a new Athens, astride the Danube.

The 'Tinte & Kaffee' performances are thought-provoking at a number of different levels. They juxtapose not only past and present, but also the evocation of historic, literary cafés with a 'real' setting, a twenty-first century Kaffeehaus which is the modern survival of the nineteenth-century environment being re-enacted. This acts as a reminder that a sense of simulacrum pervades the city more widely. For example, in the case of certain newly restored establishments, such as the Café Museum, it can often seem that

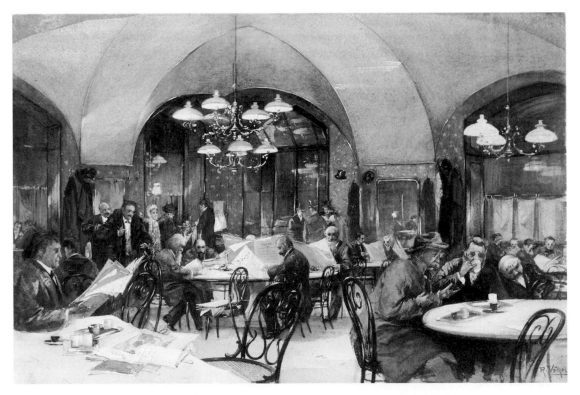

Fig. 4.1. Reinhold Voelkel, *Café Griensteidl,* 1896. Wien Museum.

the 'legend' of the Kaffeehaus predominates in order to market what has by now become a clichéd stereotype, not only of cafés but of Vienna itself. In his posthumously published *The European Imagination 1860–1920,* the writer Hermann Broch (1886–1951) dated the transformation of Vienna into 'a museum to itself' to the later stages of the Habsburg regime, in the years prior to the end of World War I.[5] I would argue, however, that whether due to an Imperial agenda (as implied by Broch) or to the dynamics of the post–World War II heritage industry, the significance of the Viennese café as simulacrum, or as an idea which can mutate through time and space, should not be underestimated. The life of the mind, as portrayed by 'Tinte & Kaffee', is carried out in a series of spaces which are both material and social in distinctive ways. In this essay, I explore the complex dynamics associated with the 'traditional' Kaffeehaus in order to speculate on the survival of the Viennese café beyond the glory years of 1900. As I hope to show, even when it appears at its most 'fake', as kitsch simulacrum or commodified nostalgia, the Viennese café can prompt us to rethink the dynamics of intellectual production as they take place at different points (and places) throughout history.

An example of the cultural resonance of the Kaffeehaus, beyond the immediate Viennese context, can be found in a newspaper obituary to the eminent art historian Professor Michael Podro:

Continuing the . . . tradition of coffee-house discourse, Podro displayed his impressive learning often through brilliant conversation, maybe somewhat to the detriment of the written word. The death of Michael Podro ends in my opinion the fascinating strand of a mélange of the Central European mode of thinking with the English intellectual tradition, a strand which shaped much of the English humanities in the years after 1933.[6]

Here, the reference to the 'tradition of coffee-house discourse' invokes the performativity of intellectual engagement—the 'brilliant conversation'.[7] Such thinking out loud requires an audience; it is (to use current terminology) an interactive process, constantly shifting and evolving. Witty repartee alternates with challenge and critique. The aim is less the kind of unanswerable put-down of an Oscar Wilde (although that too can play its part in the humour identified with the Kaffeehaus) but rather an ongoing debate of a type not dissimilar to that of the university seminar. It is important to realize that cafés were often identified with particular professional groupings, and that each establishment had its *Stammtische,* tables frequented by regular guests. Such cafés, during the years around 1900 mainly located in or near the inner city of Vienna and largely frequented by a middle-class clientele, thus afforded opportunities for well-informed discussion and, given the relatively small size of the city, interdisciplinary cross-fertilization of ideas.

This is not to say, of course, that such conversation needed necessarily (or literally) take place in a café, but rather that the Kaffeehaus came to epitomize a certain kind of intellectual ambiance and stimulus. What

the obituary to Podro also highlights is the elusiveness of 'coffee-house discourse'. How can we know exactly what was said, how ideas evolved in discussion, the ins and outs, the twists and turns of conversational gambits? The obituary, like the curriculum vitae, depends so much on the track record of the printed word, of publications and officially documented deeds. Rather than dwelling on the impossibility of being able to totally recapture intellectual interactions as they evolved in a coffeehouse milieu, however, this is an impetus for us to acknowledge that the coffeehouse environment—like various literary and theatrical forms—involved its own discursive and performative genres. If not exactly scripted or choreographed, then the parameters of what was said and enacted in the Kaffeehaus were nevertheless subject to certain historical conventions.

These conventions are, in different ways, the subject of recent publications such as Friedrich Torberg's *Tante Jolesch or the Decline of the West in Anecdotes,* a bitter-sweet anecdotal account of the rich culture engendered by the Viennese Kaffeehaus, until its ultimate demise in 1938.[8] Harold B. Segel's 1993 compendium *The Viennese Coffeehouse Wits, 1890–1938* includes examples of feuilleton essays, prose poems and other writing associated with the literary *Kleinkunst* (small arts) emanating from the city's diverse cafés.[9] Some of the material in these two books relates to pieces subsequently performed in the context of 'Tinte & Kaffee'. Rather than focussing on the idea of 'great literature', both volumes are richly evocative of Kaffeehaus wit and mental agility (most often variants of what has been

identified as 'Jewish humour'). These books give a good account of the legendary (or stereotypical) aspect of the Viennese café, but even more usefully they alert readers to the ways in which coffeehouses functioned as a kind of switch point between high and low culture, between facetious banter and serious intellectual engagement. Certainly many of Vienna's most famous figures from around 1900 are identified with the city's café life. Sigmund Freud regularly frequented the Café Landtmann, Trotsky the Café Central and Arthur Schnitzler (until it closed in 1897) the Café Griensteidl. As I have argued elsewhere, such excursions to the café functioned not so much as an interlude but rather as an extension of professional life.[10]

I will return to what I have referred to as the genres and characteristic parameters of the Viennese Kaffeehaus. First, though, I would like to dwell briefly on the assertion made in the Podro obituary concerning 'a mélange of the Central European mode of thinking with the English intellectual tradition' in the years after 1933. This would be an interesting line of enquiry to pursue in more detail, and there has indeed been considerable research into the ways in which the European émigré culture of the 1930s and 1940s enriched and shaped British artistic and intellectual life.[11] My point here, though, is more historiographical than historical and has to do with how we conceive and write history when we attempt to take into account the more ephemeral, performative aspects of artistic milieux. In the spring of 2009, the *Guardian* newspaper published an article entitled 'Enthusiasts Mark Centenary of Modern Poetry'.[12] This was largely about British modernist poetry

in the years between 1900 and World War I. Here we discover that there was a 'Vienna Café' at New Oxford Street (number 24–28), close to the British Museum, a 'hangout' for the Vorticist Group of artists and poets. The Imagists, by contrast, frequented the nearby 'Tour d'Eiffel'. This conveys not only the rather basic point that British permutations of the Viennese café pre-existed the 1930s, but also that London's bohemian intelligentsia found local 'Viennese' and 'Parisian' cafés an appropriate setting in which to meet and forge artistic identities for public consumption.

A further telling instance, in the British context, of the invocation of Viennese cultural life through references to 'ink and coffee' can be found between the covers of Percy A. Scholes's *Oxford Companion to Music,* first published in 1938. Second and third editions of the *Companion* were published in 1939 and 1941. The preface to the third edition makes explicit the wartime context of this project: 'The fact that in the period between the appearance of the Second and Third Editions certain countries have disappeared from the map of Europe is, for the present, hopefully ignored.'[13] This inevitably imbues the *Oxford Companion to Music* with a sense of musical heritage as being somehow jeopardized, not only through actual loss (in the case of performers and composers), but also perhaps through uncertainty about the role of German (and Austrian) culture in Britain during a period of war. In addition to the information presented in dictionary format, the publication also prided itself on its illustrations and its photographs as well as the 'imaginative' or 'synthetic' portraits by Oswald Barrett (identified as 'Batt' of the

Radio Times). These, it is claimed, were the product of extensive research and aimed to produce portraits that

> *penetrate to the mind of the character represented and express his personality, and that also, by its circumstantial details . . . the operative influences of his surroundings and the manner in which those surroundings represented his own nature.*[14]

Barrett's pictures offer a vivid instance of how 'old Vienna' was represented to the English-reading world during World War II. Especially telling, for the purposes of this essay, are the illustrations of Viennese-based composers Beethoven, Brahms and Schubert—evocative scenarios in which coffee is accorded a vital role in the creative process of musical composition.

Batt's depictions of renowned composers at work in Vienna are intriguing from several points of view. These are obviously retrospective, based on a synthetic compilation of visual and written records and drawing on well-known (and in some cases contemporary) portraits. The illustrations fit into a tradition of representing famous figures from the past, writers and artists, where one portrait (or portrait type) is so often reproduced and so widely recognized as to constitute a virtual 'branding' of the figure in question. (Think for example of the familiar recurring images of Shakespeare.) The *Companion*'s emphasis on 'circumstantial details' in Batt's 'imaginative portraits' alerts readers to the fact that this is not solely a matter of objects symbolizing something about the subject (as in the

iconographical system of saints' attributes) but rather an indication of how surroundings had functioned as 'operative influences'. It is in this sense that we discover, in the pages of the *Companion,* another permutation on the theme of 'ink and coffee', not merely in literal terms but also as an acknowledgement of the formative role of particular environments on artistic production.

Beethoven and Schubert are represented in the context of interiors which are emphatically undomestic. (Indeed, the entries for all three composers stress that they were unmarried: 'The comforts of a home were ever denied Beethoven, for, more than once disappointed in love, he never married.')[15] Beethoven's portrait, in familiar glowering mode, shows the composer as he 'nears the end'. The 'squalid disorder' of his workroom, we are told, signifies the fact that 'he had finished with the world'. His Graf piano, out of which burst broken strings, has been 'wrecked by his frantic efforts to hear his own playing'. Tellingly, 'a broken coffee cup' sits

on the piano's keyboard, like the collapsed instrument itself, testimony to the necessary stimulus for the destructive fervour of the composer's imagination (see Fig. 4.2). Batt shows Brahms as far less dishevelled, albeit 'very simple in his habits and frugal in his tastes', throughout his life (even when more financially successful) a lodger in furnished rooms. By contrast with Beethoven's tragic aura, Batt's Brahms is a creature of routine and habit. His 'daily rite' apparently involved making his coffee with his own coffee machine and cup 'as nobody else could make it strong enough' (see Fig. 4.3).

'Schubert Leaving the Coffee House', with the composer pictured outdoors on the streets of Vienna, in effect establishes the wider urban context for the visual staging of Beethoven and Brahms in the interiors which they inhabited (see Fig. 4.4). Beethoven's peripatetic existence in Vienna, from one rented apartment to the other, epitomized a certain kind of artistic existence, in which

Fig. 4.2. Batt (Oswald Barrett), 'Beethoven Nears the End', Percy A. Scholes, *The Oxford Companion to Music*, Oxford University Press, 3rd ed., 1941, plate 18. Courtesy of Michael Abbott.

Fig. 4.3. Batt (Oswald Barrett), 'Brahms Begins the Day', Percy A. Scholes, *The Oxford Companion to Music*, Oxford University Press, 3rd ed., 1941, plate 23. Courtesy of Michael Abbott.

the Kaffeehaus (rather than 'the home') functioned as the acknowledged site of social continuity and intellectual encounter. As has already been mentioned, high-profile figures of the Viennese intelligentsia were known to frequent particular cafés. In the case of Schubert, the *Oxford Companion* cites Bogner's Coffee House in the Singerstrasse as a favourite haunt of Schubert's circle. The caption to Batt's Schubert, like several other such texts in this volume, takes the form of a charming anecdote:

> *The solitary figure of Beethoven could be seen, quite unaware of the identity of the timid little Schubert, who, too scared to approach the formidable presence, would sit silently amongst his companions with reverent gaze fixed upon the lonely figure in the corner.* [16]

The implications of this 'strangely interesting spectacle' extend beyond the anecdotal, let alone the mythologizing 'histories' that accrue around famous personalities. The very presence of such artistic or professional circles constituted part of the spectacle of the Kaffeehaus. Well-known figures were on public show to be admired and venerated, as well as engaged in discussion by their peers. Nor did this coffeehouse performance depend solely on individual 'stars'; it involved too the groups themselves as a kind of ensemble cast in which characters negotiated professional position and public profile.

To consider the café as a performative space in this way further problematizes notions of exactly what kinds of consumption were

Fig. 4.4. Batt (Oswald Barrett), 'Schubert Leaving the Coffee House', Percy A. Scholes, *The Oxford Companion to Music*, Oxford University Press, 3rd ed., 1941, plate 149. Courtesy of Michael Abbott

involved in the Viennese Kaffeehaus. Clearly visiting a coffeehouse involved much more than drinking beverages. Tourists, as well as the inhabitants of the city, might well visit particular cafés – partly, at least, to observe the interactions between well-known *Stammgäste*. At the same time, the inevitable focus on coffee—given its associations with mental stimulation—emphasized the intellectual status of certain of these coffeehouses. A proper literary café did not, it was widely acknowledged, aim to provide an extensive menu of food. Nourishment in such establishments was, by implication, more a matter of the mind than the body. A key factor in this connection was the vast array of printed literature, and, in particular, newspapers and journals, made available to a café's clientele. Such publications, often in a variety of languages, were imported from various constituent parts of the Austro-Hungarian Empire, as well as from overseas. Indeed, advertisements published by coffeehouses regularly cited the range of papers on offer.

This raises the question of whether we might consider the act of reading, one of the key forms of consumption undertaken in the Kaffeehaus, as being somehow performative. Certainly in the case of the Viennese café an element of ritual was widely acknowledged. The writer Anton Kuh (1890–1941) for example wrote as follows in 1918, when this activity seemed under threat due to wartime conditions:

The newspaper is Vienna, Vienna a newspaper. The city lives only when it reads itself in print . . . Without newspapers, Vienna is timeless . . . it is well known that Vienna's clocks are set according to the appearance of morning, midday, evening and late evening papers. When the midday paper appears, the warder in St. Stephen's Cathedral pulls the bell rope.[17]

Analogous to Broch's later claim for Vienna constituting a museum to itself, Kuh depicts newspaper reading as a form of narcissistic compulsion, not only at the individual level, but also on the part of the city as a whole. I shall return to issues of narcissistic self-preoccupation. Here, however, it is Kuh's wry description of newspapers punctuating the day that I wish to pursue. This echoes an earlier formulation by the philosopher Georg Wilhelm Hegel (1770–1831), who invoked newspapers to describe a 'realist morning prayer':

Reading the newspaper in early morning is a kind of realist[ic] morning prayer. One orients one's attitude against the world and toward God [in one case], or toward that which the world is [in the other]. The former gives the same security as the latter, in that one knows where one stands.[18]

Of course this new, secular kind of morning prayer could well be performed alone, in solitude and at home. However, in Vienna, where (in no small part due to the city's proliferation of coffeehouses) newspaper reading was so much a communal activity and such a well-known feature of public life, the interactive and hence performative potential of this ritualized aspect of modern life was by no means inconsiderable.

Benedict Anderson specifically cites Hegel's morning prayer in formulating his own arguments regarding 'imagined communities':

The significance of this mass ceremony—Hegel observed that newspapers serve modern man as a substitute for morning prayers—is paradoxical. It is performed in silent privacy, in the lair of the skull. Yet each communicant is well aware that the ceremony he performs is being replicated simultaneously by thousands (or millions) of others in whose existence he is confident, yet of whose identity he has not the slightest notion. Furthermore, this ceremony is incessantly repeated at daily or half-daily intervals throughout the calendar. What more vivid figure for the secular, historically clocked, imagined community can be envisaged?[19]

Anderson's concept of 'imagined communities' forms an interesting gloss on Edward Timms's

influential account of Viennese intellectual life around 1900 as taking the form of interlocking artistic circles, or groups.[20] The *Stammtische* in various Viennese cafés formed a kind of tangible realization of these circles while at the same time being, like the cafés themselves, one of the important mechanisms whereby such groupings were formed, sustained and contested. At and around the tables of the Kaffeehaus, thinkers, writers and artists gathered not only as groups, but also (we might argue) as 'imagined communities'. Such communities were by no means confined to the space of the café, but the Kaffeehaus was undoubtedly a key site for such professional and intellectual identifications to take place, an important showcase to display oneself professionally in public.

I have cited British examples of how the idea of the 1900 Viennese Kaffeehaus persisted into the twentieth century even beyond Austria—but what about in Vienna itself? After World War II, it seemed all too evident that the old-style Viennese coffeehouses were no longer financially viable. Numerous factors were involved here, not least Nazi expropriation of such establishments during the war, but the issue of time also played a role. As Torberg points out, without ample amounts of time 'to waste', an intellectual Kaffeehaus milieu is impossible.[21] A clientele based largely on customers sitting around for hours over one coffee (and innumerable glasses of free tap water) in order to talk, read and write is clearly not sustainable. In the last two or three decades, however, a number of cafés have re-established themselves, either as 'heritage' recreations of historically important institutions (the Griensteidl, Central, Museum, for example) or as a local amenity, also serving snacks and meals to local residents and workers. My concern in this essay, though, is not so much with the existence of actual cafés, but rather the extent to which the 'idea of the Kaffeehaus' might continue to function as a means of articulating selfhood and professional identity.

The oblique allusions to a kind of self-regarding narcissism (in the quotations from Broch and Kuh) are, I believe, significant here, both at an individual and at a group level. A telling example is found in Thomas Bernhard's (1931–1989) short work (part memoir, part novella) *Wittgenstein's Nephew: A Friendship,* first published in 1982. Bernhard, a renowned Austrian novelist and playwright, enjoyed a love-hate relationship with his homeland. He was a vociferous critic of Austrian politics and culture, both during and after the war. His last play, *Heldenplatz,* was performed at Vienna's prestigious Burgtheater in 1988, on the occasion of the fiftieth anniversary of the Nazi annexation of Austria. It is a blistering attack on Austrian anti-Semitism and a powerful accusation of Austria's unwillingness to confront its own part in the atrocities of World War II, in particular the Holocaust. Bernhard's work relied heavily on a confrontational stance, which he attempted to sustain beyond his own lifetime. His will specified that after his death, his work should not be performed or published in Austria. *Wittgenstein's Nephew* includes extensive musings on Bernhard's relationship to the Viennese Kaffeehaus.

Bernhard writes with an irony that recalls Karl Kraus, another self-consciously adversarial Austrian writer, and in a style of incremental repetition reminiscent of Gertrude Stein. Linguistically and even visually (he writes without paragraph breaks) he demonstrates how he relies on the café for intellectual stimulus while at the same time, despite himself, succumbs to a compulsion which he endows with the power of, and self-hatred engendered by, a chemical dependency.

At one level, Bernhard's perverse ode to the Viennese Kaffeehaus is all too familiar. It is in large part the foreign newspapers and publications that draw him to the coffeehouse. He refers to himself as a person

> who attaches greater importance to the reading of dailies and periodicals every morning than to anything else and who in the course of his intellectual life has primarily specialized in English and French books and periodicals.[22]

At the same time, there is the reiterated claim that 'I have always hated the typical Viennese café' and that 'in a literary café I should never have been able to devote myself to my papers entirely undisturbed for a whole morning'.[23] His disgust is regularly expressed in evocatively physical terms: 'The literary cafés have a stench-laden, nerve-irritating and soul-killing atmosphere and I have never been told anything new there.'[24] Indeed, Austrian newspapers are dismissed as being 'not really newspapers at all, only useless lavatory paper'.[25] This stress on the physical environment of the café—rather than on its

virtues as an intellectual milieu—is striking. Here, the associations with coffee—its fragrance and its power as a mental stimulant—are displaced by 'stench'. The Bräunerhof, which came to be known as Bernhard's local, comes in for particularly vicious criticism: its spine-destroying seating, its murky parsimonious lighting levels and (again) its dreadful smells, the 'penetrating kitchen odours . . . which, even if one stops there for quite a short period, cling to one's clothes'.[26]

Given Bernhard's views on Austrian society, his hostile evocation of the postwar Kaffeehaus is unsurprising. Coffeehouses may still exist, in some cases well supplied with foreign newspapers, but in this post-Holocaust society, it is (for someone like him, at least) impossible to remain unaware that the chief constituency of the 1900 literary café—its Jewish clientele—has been brutally eradicated. What is perhaps so powerfully unsettling is not only that this Viennese intellectual milieu no longer exists, but that the coffeehouse remains as a constant reminder of that loss. This lends a particular resonance to Bernhard's rejection of the literary society of his own day, which might otherwise be read merely as a condemnation of pretentiousness:

> I have always hated the Viennese cafés because in them I have always been confronted with my own kind, that is the truth, and why should I wish to be continually confronted with myself, least of all in a café where, after all, I go in order to escape from myself and in there, of all places, I then find myself confronted with myself and my kind. I cannot bear myself, let

alone a whole horde of philosophising and writing types like myself.[27]

Ultimately, the power of Bernhard's writing lies in its awareness and demonstration of his own compromised position within the society in which he lives and works.

However much he may hate what he is describing, he feels himself somehow part of, or at least drawn to, exactly that which he so disparages:

> *I have always hated the Viennese café and I have time and again entered that Viennese café, visited it day after day, because, though I always hated the Viennese café and especially because I always hated it, I have always in Vienna suffered from that going-to-cafés disease, indeed I suffered from that going-to-cafés disease more than anyone else.*[28]

This is, of course, about much more than café life in 1980s Vienna. Bernhard's writing, simultaneously amusing and scathing, removes us from the more *gemütlich*, heritage and touristic view of the former Habsburg capital. This is neither the city fascinated by its own appearance in the daily newspapers (Kuh) nor the Vienna compelled to erect endless museums to itself to the point where it becomes one vast museological environment (Broch). Bernhard's panegyric on the Kaffeehaus transcends the merely personal or autobiographical. (Indeed, there are contemporary accounts of the writer happily ensconced in the Bräunerhof, holding forth to its clientele.) Mediated through

Bernhard's enraged, relentless writing style, the coffeehouse comes to stand for Austria itself—part of the modern world, yet irrevocably formed by the culpability of the recent past. Unlike Bernhard's *Heldenplatz, Wittgenstein's Nephew* does not take the form of a dramatic performance. However, it does reveal that certain of what I have referred to as the performative aspects of the 1900 Viennese Kaffeehaus have been (at best) severely compromised. At the Bräunerhof, Bernhard claims, he is disinclined to identify (or even engage with) his professional and literary colleagues. He cannot bear them, perhaps precisely because he cannot, in the end, disassociate himself from them: as we are told, 'I cannot bear myself'.

In conclusion, I take the liberty of turning to a more recent representation of the café quite outside any Viennese context. In the spring of 2009, the artist Jiro Osuga mounted an ambitious site-specific installation at the Flowers gallery in London's Cork Street.[29] Osuga's large-scale project *Café Jiro*—a mural over three meters high and thirty meters long—was in effect a panorama which transformed the interior of the gallery into a highly personalized vision of the café as a social and artistic environment. This included an idiosyncratic mix of characters as clientele (Osama Bin Laden as well as Shakespeare) along with a witty acknowledgement of the complexity of the café as an urban space. Jiro's *Café* puts into play the interactions between street and interior, as well as the necessary dynamics between kitchen, waiting staff and customers. What I find especially poignant in the context of this essay, however,

is the representation of the café's shopfront. Here we are confronted by multiple images of the artist himself, seated both inside the café and outside at its pavement tables. Osuga is shown smoking, drinking coffee, reading the newspaper (or a book) and writing—indeed, all the traditional activities of the Viennese Kaffeehaus (see Fig. 4.5). Osuga's *Café Jiro* was conceived in explicitly performative terms: 'For Shakespeare, all the world was a stage, and Liza Minnelli sang about life being a Cabaret, but couldn't life, in fact, be a café?'[30] Here, again, we see the café as a performative site for its inhabitants. In this case, however (as signalled too by the eponymous title of Osuga's installation), the exuberant proliferation of self in and through the café stands in striking contrast to the sense of revulsion in Bernhard's literary rejection of the Kaffeehaus as a place of encounter and identification. Unlike postwar Vienna, in which the horizons of the Kaffeehaus had been so painfully diminished, Osuga's work holds out the hope that in present-day London the café retains some of its potential to stage 'all the world'.

Fig. 4.5. Jiro Osuga, *Café Jiro,* 2009. Installation at the Flowers gallery. By permission of the artist.

Notes

In memory of Paul Overy and Arthur Overy, whose intellectual curiosity—and love of coffee—has been instrumental in furthering my own pursuits.

1. For further information on 'Tinte & Kaffee' see www.wieninternational.at. The series has also included a performance entitled 'Melange Fatale' about the role of women in connection with the intellectual and artistic life of Viennese coffeehouses.

2. Numerous commentators have written about the importance of nineteenth-century Vienna as a 'stage' for the realization of identity. Carl Schorske for example refers to the 'cultural self-projection' that dominated the Ringstrasse. See C.E. Schorske, 'The Ringstrasse, Its Critics, and the Birth of Urban Modernism', *Fin-de-siècle Vienna: Politics and Culture* (Vintage Books, 1981), pp. 24–115. See also D.J. Olsen, 'Vienna: Display and Self-Representation', *The City as a Work of Art: London, Paris, Vienna* (Yale University Press, 1986), pp. 235–48.

3. On various aspects of the 'legend' of the Viennese Kaffeehaus, particularly in the form of literary coffeehouses which proliferated in the city around 1900, see C. Ashby, T. Gronberg, S. Shaw-Miller, eds, *The Viennese Café and Fin-de-siècle Culture* (Berghahn, 2011). I am grateful to all my colleagues on the AHRC-funded 'Vienna Café' project (2006–2009), out of which this publication arose.

4. Hans Weigl as quoted in 'Tinte & Kaffee' brochure.

5. H. Broch, *Hugo von Hofmannsthal and His Time: The European Imagination 1860–1920* (University of Chicago Press, 1984), p. 61.

6. *The Independent* (Sunday, 2 April 2008).

7. On the different ways in which 'performativity' has been construed as a constitutive process, I have found helpful J. Loxley, *Performativity* (Routledge, 2007).

8. F. Torberg, *Tante Jolesch or the Decline of the West in Anecdotes* (Ariadne Press, 2008). The English translation is based on a compilation of two works in German: *Die Tante Jolesch oder Der Unterganag des Abendlandes* (1975 and 1988) and *Die Erben der Tante Jolesch* (1978 and 1986).

9. H.B. Segel, *The Vienna Coffeehouse Wits, 1890–1938* (Purdue University Press, 1993).

10. See 'Coffeehouse Encounters: Adolf Loos's Café Museum', in T. Gronberg, *Vienna: City of Modernity, 1890–1914* (Peter Lang, 2007), pp. 69–96.

11. In connection with the arts and design, see for example R. Kinross, 'Emigré Graphic Designers in Britain: Around the Second World War and Afterwards', *Journal of Design*

History 3/1 (1990), pp. 35–57; C. Benton, *A Different World: Emigré Architects in Britain, 1928–1958* (RIBA Heinz Gallery, 1995). For an account of the impact on the world of music in Britain see A. Garnham, *Hans Keller: The Development of an Emigré Musician* (Plumbago Books, 2010).

12. M. Brown, 'Enthusiasts Mark the Centenary of Modern Poetry', *Guardian* (25 March 2009).

13. P.A. Scholes, 'Preface to the Third British Edition', in P.A. Scholes, *The Oxford Companion to Music* (Oxford University Press, 1941), p. vii.

14. Ibid., p. xiii.

15. Entry for Ludwig van Beethoven (1770–1827), ibid., p. 83. On the representation of masculinity in the interior Vienna during the nineteenth century see 'The Inner Man: Interiors and Masculinity', in Gronberg, *Vienna: City of Modernity,* pp. 37–67.

16. Scholes, *The Oxford Companion to Music,* p. 848.

17. A. Kuh, 'Vienna without Newspapers' [1918], in Segel, *The Vienna Coffeehouse Wits,* p. 306.

18. As discussed in S. Buck-Morss, 'Hegel and Haiti', *Critical Inquiry* 26/4 (Summer 2000), pp. 821–65. For the original German (from the period 1803–1805) see K. Rosenkranz, *Georg Wilhelm Friedrich Hegels Leben* (Darmstadt, 1977), p. 53.

19. B. Anderson, *Imagined Communities: Reflections on the Origin and Spread of Nationalism* (Verso, 1991), p. 35.

20. Edward Timms's influential chart, 'The Vienna Circles: A Diagram of Creative Interaction in Vienna around 1910', appeared in *Karl Kraus—Apocalyptic Satirist: Culture and Catastrophe in Habsburg Vienna* (Yale University Press, 1986), p. 9.

21. 'Time is the most important, an indispensable requirement for any kind of coffeehouse culture (probably of any culture).' F. Torberg, 'Treatise on the Viennese Coffeehouse' [1959], in *Tante Jolesch or the Decline of the West,* p. 210

22. T. Bernhard, *Wittgenstein's Nephew: A Friendship* (Quartet Books, 1986), p. 100.

23. Ibid., p. 99.

24. Ibid., p. 99.

25. Ibid., p. 101.

26. Ibid., p. 100.

27. Ibid., p. 102

28. Ibid., p. 101.

29. Jiro Osuga, *Café Jiro,* Flowers, 21 Cork Street, London W1S 3LZ, 29 April to 23 May 2009.

30. Publicity material, Flowers, London, for Jiro Osuga's *Cafe Jiro* installation, 29 April to 23 May 2009.

Part Two

——

1900–1940

Introduction

1900–1940
Trevor Keeble

The interiors of the first decades of the twentieth century have been accounted for largely through the lens of a progressive modernist architectural ideology. Prioritizing discourses of efficiency, innovation, technology and purpose, this account has arguably diminished the 'place' of the interior as a distinct concept in its own right in favour of an architecturally determined reconfiguration of 'space'.

The essays presented in this section of *Performance, Fashion and the Modern Interior* offer a view into some very different interiors of this period and, in so doing, open up new places to the design historical gaze; the Edwardian theatre production, the couture house, the film stage and the middle-American home. Seen through the critical lens of fashion and performance, these interiors reveal a nascent engagement with the world resolutely beyond their walls. The 'developed' world of the early to mid-twentieth century was one of increasing commerce, leisure and consumption, much of which was achieved through a burgeoning media and entertainment culture of print, photography, film and radio. The representational contexts of these interiors is fundamental not only to a better understanding of their material, spatial and visual construction but also to an understanding of how these places were shaped by the activities, societies and performances within them. Understood in these terms, the interiors of the first half of the twentieth century provide a critical means by which to witness and understand the social and cultural modernity of this period.

The modernity of change which characterized the first half of the twentieth century focused primarily upon the spectacular form of the city, and though change happened and was experienced far beyond the urban context, it was the city with its increasingly mass cultures of consumption, leisure and entertainment that became the source and referent for fashionability and change. It was in this period that the certainties of the Victorian era came gradually into question, and the political mobilization of the working classes and women suffragists literally changed the ways and spaces in which modern society lived. This introduction, therefore, offers some interiors of London as a means through which to consider the themes and ideas that underpin the performances, fashions and interiors discussed by the essays in this section.

Designed for business

As a number of historians have demonstrated, the department store was a key site of women's urban activity during the early to mid-twentieth century and perhaps typifies most clearly the centrality of gender to the discourse of modernity.[1] With some exceptions, the spatial development of department stores during the nineteenth century was often piecemeal, as stores gradually acquired adjoining premises in which to open up new departments. Although some department store retailers had by the end of the century sought to create purpose-built stores, unlike the galleried grands magasins of Paris these often recreated the more intimate spaces of discrete departments. Erika Diane Rappaport has argued that the opening of Selfridges, the American department store, in 1909 marked a significant development in the history of women's movement in and through London.[2]

The advertisements for the opening of the store made explicit the ambition that visiting the store might provide more than just shopping. Inviting visitors to spend an 'hour or day' beneath its roof, the store sought to characterize shopping at Selfridges as 'a pleasure, a pastime, a recreation'.[3] The configuration of the store into high-ceilinged galleried space made the interior open and flexible. Whilst it provided its inhabitants with the opportunity to move fluidly from one area to the next, perhaps more importantly, it offered its visitors interior vistas across and throughout the store. This fluid visual experience of the store was extended beyond the boundaries of the building by large plate glass windows designed to entice the passing pedestrian in. In its attempts to provide the 'modern' experience of shopping, Selfridges offered a visual and spatial model of the department store clearly recognizable to shoppers of the present day, but at its heart it was not simply an attempt to improve the experience of its shoppers but rather to optimize its purpose as a consumer-oriented business, concerned to increase its profits. In this sense, Selfridges offers a rich example of how in the early years of the twentieth century, companies and organizations came to understand the important role that the considered design of corporate image and 'place' might play in their success, demonstrating the importance of design in the formalization and shaping of the modern experience.

Often noted as a significant example of early corporate design, London Underground provides another early example of the use of interiors alongside graphic designs, uniforms, advertising and signage to express the corporate identity of an organization.[4] Many of the most iconic and heavily used of these interiors were those created by Charles Holden. As David Lawrence has demonstrated in his study of Holden's station designs, his was a progressive approach concerned with 'good design'.[5] Designed to express the modernity of urban rail travel, the buildings and interiors did so with style, modesty and great efficiency. Although overwhelmingly coherent in their design and styling, each station interior offered a subtle variation according to which railway line it was on and, indeed, to its specific location. Perhaps the most notable of these is the station at

Piccadilly Circus. Located at the epicentre of London's West End, the elliptical plan of the station placed the escalators, automatic ticket machines and retail stalls in the centre of the room. Around these was a colonnade of cast bronze columns, each lit by a pair of yellow glass lamps, and on the outer walls of the interior beside the information boards, cloakroom and telephones, three showcases displayed the merchandise of local retailers such as Swan and Edgar, which was above ground in Piccadilly Circus itself.[6]

Located on a triangular site on the north side of the Circus, the Regent Palace Hotel was opened in May 1915 by Lyons and Co Ltd.[7] At the time the largest hotel in Europe, the Regent Palace offered a number of decorative interiors which ran sequentially from the street. Beyond the entrance vestibule, the interior led into a reception hall furnished with marble and a highly decorated and embellished dome ceiling, and beyond that opened up a large rotunda court—furnished with a stained glass dome, cane furniture, rugs and plants—in which guests took afternoon tea. Whilst all of these rooms presented an air of traditional, decorative informality, the Louis XVI Restaurant offered a more studied interior of the past and perhaps marks most explicitly the intention of the hotel's design to echo the interiors of earlier years. Set alongside other rooms such as a ladies' writing room, a hairdressing salon, a billiards room and a grill room, the largest hotel in Europe presented for its guests numerous public places in which they might perform the fashionable modernity of their stay in the capital. It was not, however, until the 1930s that the hotel owners chose to express this modernity explicitly within the design of the interior by refurbishing the hotel's cocktail bar with a black and white ensemble of chequers and stripes, upholstery and accent lighting which looked straight out of a Hollywood movie.

Lyons and Co were better known for Lyons Corner Houses. These large high street tea rooms, first established in 1909, offered far more to the pedestrians of London's West End than simply tea.[8] Often occupying between four and five floors, the Corner House interiors were decorated in varying ways, but many, such as the Mountview Café in the Oxford Street Corner House, had heavily sculpted, fluid ceilings, accented by up-lighting, beneath which the walls were clad with highly stylized painted murals and the floor covered with large-scale, modern, repeat-pattern carpets. Within these large interiors, orchestras played for customers who took tea or made use of the hairdressing salon, the theatre ticket agency or the food delivery service. Waited upon by the ubiquitous 'Nippy' waitresses, dressed in their black and white uniforms, the diverse groups of customers of the Lyons Corner Houses could rest their feet whilst taking in and contributing to interiors devoted to consumption both of the food and drink and the ambient spectacle of modern leisure.

The fashionable style of modern living

That it was at Piccadilly Circus that the Undergound station, the Regent Palace Hotel and the Lyons Corner House should be so lavishly created is no surprise given the

significance of the area to modern London of the interwar years. Located between Leicester Square, Regent Street, Soho and Trafalgar Square, the area had long been a focus for popular entertainment and leisure activities. Chief amongst these in interwar London was the growth of cinema going. Although the design and form of cinemas had precedent, and often an actual heritage in theatres and music halls, the period witnessed the blossoming of a distinct design and style for newly built cinemas. Given the evolving modernity and spectacle of film during the first decades of the twentieth century, these buildings and interiors expressed the modernity and fashionability of contemporary London, not just as the increasingly urbanized capital of the United Kingdom and its Empire, but as a city increasingly linked to other modern metropolitan centres such as Paris, New York and Berlin by aspects of design, style and popular entertainment.

London cinemas, like many of those in Europe and North America, often took theatrical and striking form. As though their dedication to the romance and fantasy of the 'silver screen' freed them from any serious responsibility to the civic environments in which they were built, cinemas became almost stage-set like in their heavily stylized and controlled presentation. Whilst the design of cinemas in this period could often take on quite eccentric form, the style most commonly used was what came to be known as art deco. As Ghislaine Wood has demonstrated, Hollywood films such as *Our Modern Maidens* (1929), *Grand Hotel* (1932) and *42nd Street* (1933) played a fundamental part in the construction and dissemination of an American art deco style.[9] Through the very modern medium of the day, these images and styles offered an all-encompassing vision of modern life which placed fashionable femininity, romance and glamour at its heart and located them within interiors which had the impeccable styling of hard shining surfaces, chic but comfortable furniture and the monochrome hues demanded by black and white film.

As the accompanying catalogue to the 2003 V&A exhibition *Art Deco 1910–1939* demonstrates, art deco was a style which ranged internationally across all building types, objects and fashions.[10] Although its stylistic range was often far more diverse than we have come to think, its unifying factor lay in its intention to express the modernity of its age. This modernity—commonly found in the interconnected relationships between fine and decorative art, film, architecture and design—might be within the interior spaces of the factory, the open-air Lido and the hotel alike, and in this sense art deco offered a mass stylistic response to modernity for all classes of people: to be within an art deco interior was to be modern.

Given the range of its application, few art deco interiors in London survived the inevitable waning of its fashion. One notable interior that has is the foyer of the Daily Express building, designed by Robert Atkinson in 1932. One of the most exotic unfurlings of art deco in London, the foyer of this vitrolite-clad building was accessed directly from the street and presented a heavily silvered and gilded interior which had at its centre a striking star-shaped ceiling within which hung an equally striking silvered pendant

lamp. The walls of the foyer were adorned with gilded plaster reliefs by Eric Aumonier, and opposite the street entrance, the lobby offered a stunning oval staircase which ran the height of the building.

Another significant foyer of the period was designed by Oliver Bernard at the Strand Palace Hotel in 1930. Originally a stage designer, Bernard came to specialize in high-style interiors and designed a number of cafés, restaurants and hotels during his career, including interiors for the Lyons Corner Houses. At the Strand Palace Hotel, Bernard created something of an archetypal art deco interior as might be seen in a Hollywood film. The interior was created of light pink marble walls and a limestone floor. With a faceted and geometric form, the foyer led to a grand but utterly modern staircase made of translucent moulded glass, chromed steel and mirrored glass, from which emanated the soft glow of backlighting. Offering as it did a stylistic rather than an ideological position, art deco has come to be understood as the counter to the apparently austere innovations of continental modernism and, as such, has become fundamentally understood as an expression of decorative glamour, entertainment and leisure. In this sense, it was formed inextricably within the context of an ephemeral, feminine fashionability.

Of course, not all innovative buildings concerned with performance and fashionability were offered quite so explicitly for the consumption of women. Another building that found itself perhaps unusually within the fashionable deco style during the 1930s was the Arsenal Football Club's stadium at Highbury, North London. The early decades of the twentieth century represent an important moment in the history and development of football stadiums in Great Britain. Football-going was at its height during this period, with a club like Chelsea FC building up its capacity at Stamford Bridge during the first two decades of the century to over 85,000 spectators. These stadiums were, however, hardly buildings as such during this time, with most spectators being accommodated on increasingly high-banked terraces and only a lucky few within open-sided seating stands. The vast popularity of football established these spaces throughout Britain as the focus for a masculine, largely working-class, mass culture, on a scale without comparison.

Though largely functional in their design and construction, stadiums became the subject of much scrutiny when, in 1902 at the Glasgow Rangers' stadium, designed only three years earlier by the renowned stadium designer Archie Leitch, a terraced stand collapsed, killing 25 people.[11] Thought to have been caused, in part, by people attempting to shelter from the rain and a subsequent failure of crush bars, the Ibrox disaster, followed shortly by another at Owlerton, instigated the regulation of football stadium design. It was not until the later 1920s and 1930s that football clubs began to consider more fully the ways in which their stadiums represented them, and the redevelopment of Highbury during the early 1930s marks a moment when design became more than an issue of function and construction.[12]

Commissioned to design a West Stand in 1932, followed by the East Stand in 1936, architects Claude Ferrier and William Binnie, neither of whom had previous experience

of designing sports venues, brought the football stadium within the style of the day. With a façade that echoed the decorated classicism of London's West End department stores, the East Stand provided a 'formal' entrance to the stadium and housed the club's administrative offices and the players' locker rooms. Facing one another, both stands stood as buildings in their own right and were painted in the club's red and white colours and adorned with its field gun emblem and flagpoles. It was inside the East Stand, however, that Ferrier and Binnie overspent the club's budget by furnishing a grand art deco hall which extended the height of the building. Although when compared with its Daily Express counterpart the Marble Hall, as it came to be known, was modest, the use of marble and ziggurat designs, accent colours of red and black, and high styling within a football club stadium was at the time highly unusual and, much like the consumer-oriented developments of West End department stores, marks a moment when the club seized upon design as a means of enhancing the performance and spectacle of its football.

Performing the modern life

At the outset of this introduction it was suggested that the dominant history of the early-twentieth-century interior was one accounted for within the unfolding narrative of a progressive modernism concerned primarily with notions of functional performance and innovation. This is not to suggest, however, that aspects of performance and fashionability were not fundamental to these modernist interiors and their developing language.

As Elizabeth Darling has argued, the spread of modernism in interwar London was a complex and piecemeal phenomenon which developed from numerous perspectives.[13] As her work demonstrates, a reformist agenda concerned with social housing and public health was central to this, and buildings such as the Pioneer Health Centre (1935), Kensal House (1936) and Finsbury Health Centre (1938) brought modern interiors to London as the means for public and social reform. The users and inhabitants of these interiors were brought together in ways which challenged former understandings of public and private, interior and exterior. These buildings offered a degree of permeability which explicitly connected the interior with the urban, and in so doing made the scrutinizing gaze and expectation of the public realm a condition of these spaces, one concerned explicitly with behavioural performance and opportunities to influence and change it.

Of course, the developing modern oeuvre was certainly not confined simply to public works. One of the key ways in which modern architects and designers established themselves both within interwar London, and in the pages of the architectural press, was by designing and building new and challenging single-family homes. To commission an up-and-coming architect to build you a home in the latest continental style was perhaps the epitome of fashionable patronage in the interwar years and made explicit the performance of personal identity. Miramonte was built by Maxwell Fry in New Malden, a suburb of south-west London,

during 1936–1937. Created for property developer Gerry Green and his wife, the home demonstrates the influence of what might best be understood to be the 'classic' European domestic modernism of architects such as Le Corbusier and Walter Gropius, with whom Fry was working at that time. Using ribbon windows, terraces and canopied walkways, the interiors of the home offered themselves up to the secluded space of the garden and typified the continental fluidity of interior and exterior space. The house made only a passing nod to open-plan living and never lost the formal distinction between rooms. Nor did it present the modern vision of servant-less living, including as it did several maids' bedrooms and a small functional kitchen, attached by a servery to the dining room. Nevertheless, for Mr and Mrs Green, Miramonte could not have represented anything less than the latest fashion in modern living and the stage from which to perform their very affluent modern lives.

Four new essays

The fashionable representation and performance of home is central to Christopher Breward's essay '"At Home" at the St James's: Dress, Décor and the Problem of Fashion in Edwardian Theatre'. Breward draws upon the domestic settings presented at the St James's Theatre to explore how the dressing of stage and body spoke directly to the more conservative taste of the late Victorian and Edwardian political and economic elite. Demonstrating how these productions were intimately connected to the fashion and furnishing trades of Mayfair and the West End, the essay proposes that the 'understated luxury' of these productions tells us as much about the material and psychological parameters of the fin-de-siècle moment as any more self-consciously innovative and 'modernist' endeavour.

Samantha Safer takes up discussion of the shifting 'place' of home within the public realm in her essay 'Designing Lucile Ltd: Couture and the Modern Interior, 1900–1920'. The essay explains how Lucile used interior decoration to assist in her commercial endeavours, thus intersecting her fashion designs with her decorative environments, and shows how Lucile believed, as did other retailers at the time, that certain interiors or environments affected clients psychologically; 'hence a beautiful interior would make her customers want to consume more of her designs'. Furthermore, in exploiting interior decoration, she made women feel as if they were in their own homes rather than a place of business. By finding correspondences between fashion and interior decoration, Lucile gained a unique advantage over her competition whilst enhancing her career, reputation and clientele.

Andrew Stephenson is concerned with a different kind of modern, fashionable production. '"Paris, Hollywood": Viewing Parisian Modernity through the Lens of the Séeberger Brothers 1909–1939', describes how, in 1923, Parisian photographers the Séeberger brothers received a request from International Kinema Research in Hollywood asking if they would supply detailed photographs of Paris 'interiors and

exteriors of hotels, railway stations, cafés and theatres, shops, street scenes etc'. The objective being that American set designers would be able to use these photographs to reconstruct accurate and identifiable interiors for films using Paris as a location. Stephenson shows how the image of Paris that derived from the Séeberger brothers' photographs became the archival source for a whole fictive Paris—'Paris, Hollywood'— that persisted in American cinema through to the 1970s and argues that this fictional 'Paris, Hollywood', derived from actual locations and landmarks, offered English audiences new and meaningful ways of 'seeing' Paris and interpreting its modern fashion culture.

Mary Anne Beecher's essay, 'Fashioning Thrift: Finding the Modern in Everyday Environments', considers life as it was lived in the non-metropolitan margins of modernity. Asking what must it have meant to 'belong to the modern world' at a time when economic depression limited many American's full participation in the system of commercial consumption upon which the world of 'fashion' depends, the essay considers the connections between the home production of dress and domestic interior environments in rural America in the 1930s. Beecher suggest that women's knowledge of fashionable modern clothing design and construction empowered them to take control over the design of their interior environments and to apply the principles of modern design to their homes in innovative and cost-saving ways. And, in doing so, Beecher demonstrates that the unlikely partnership of fashion and thrift

helped elevate the desire for modern design in commonplace environments.

Each of these essays demonstrates the way in which interiors and the representation of interiors in the first half of the twentieth century offered their inhabitants and viewers the opportunity of fashionable modernity. Central to this was a developing understanding of modern personal identity as being relative to the surroundings within which it was performed.

Notes

1. M. Nava, 'Modernity's Disavowal', in M. Nava and A. O'Shea, eds, *Modern Times: Reflections on a Century of English Modernity* (Routledge, 1996).

2. E. D. Rappaport, *Shopping for Pleasure: Women in the Making of London's West End* (Princeton University Press, 2000).

3. Nava, 'Modernity's Disavowal,' p. 54.

4. A. Forty, *Objects of Desire: Design and Society since 1750* (Thames and Hudson, 1986), pp. 222–38.

5. D. Lawrence, *Bright Underground Spaces: The Railway Stations of Charles Holden* (Capital Transport Publishing, 2008), pp. 9–10.

6. Lawrence, *Bright Underground Spaces,* pp. 86–9.

7. I am indebted to the work of my colleague Lyanne Holcombe, who is currently researching the design history of the Regent Palace Hotel.

8. L. Holcombe, *Lyons Brand: The Design and Consumption of the Corner House Experience,* unpublished MA thesis, Royal College of Art/V&A Museum Libraries, 2005.

9. G. Wood, 'Art Deco and Hollywood Film', in C. Benton, T. Benton and G. Wood, eds, *Art Deco, 1910–1939* (V&A Publications, 2003), pp. 325–33.

10. Benton et al., *Art Deco.*

11. S. Inglis, *Archibald Leitch: Football Ground Designer* (English Heritage, 2005), pp. 16–25.

12. B. Smith, *Highbury: The Story of Arsenal Stadium* (Mainstream Publishing, 2005).

13. E. Darling, *Re-Forming Britain: Narratives of Modernity before Reconstruction* (Routledge, 2007).

Chapter Five

'At home' at the St James's: dress, décor and the problem of fashion in Edwardian theatre

Christopher Breward

Nice plays, with nice dresses, nice drawing rooms and nice people are indispensable; to be un-genteel is worse than to fail.

– George Bernard Shaw

In his Preface to *Three Plays for Puritans* (1901), George Bernard Shaw deftly offered both a swift dismissal and a sharp acknowledgement of the rising status of what would become known as the 'drawing room drama' in Edwardian thought and experience. His crisp appraisal of this largely forgotten theatrical subgenre opens up a space for considering the simultaneous articulation of dress and the interior as a key relationship in the formation of a characteristically popular and middlebrow fashion culture in Britain, as well as their loaded representation on the early-twentieth-century London stage as a lens through which the fashionable sensibilities of Edwardian audiences might be further analysed (see Fig. 5.1). For Shaw, the lens was not a flattering one: in his work as a theatre critic during the 1890s, he recorded a

London stage 'awash with sensuousness in the form of ritualised Shakespeare, sham Ibsen and voyeuristic musical farce'.[1] This produced a flow of mediocre productions sustained by consumers who craved little more than vulgar spectacle and a hypocritical flattering of their own pretensions to good manners, as well as 'substitute sex.'[2] Like much commentary of the time, Shaw's characterization of the market may well have carried misogynistic and anti-Semitic overtones, but it hit the target with typical acuity:

In the long lines of waiting playgoers lining the pavements outside our fashionable theatres every evening, the men are only the currants in the dumpling. Women are in the majority; and women and men alike belong to that least robust of all our social classes, the class which earns from eighteen to thirty shillings a week in sedentary employment, and lives in lonely lodgings or in drab homes with nagging relatives. These people preserve the innocence of the theatre: they have neither the philosopher's impatience to get to realities (reality being the one thing

"MOLLENTRAVE ON WOMEN," AT THE ST. JAMES'S.

MISS MARION TERRY AS LADY CLAUDE DERENHAM.
Photograph by Ellis and Walery.

Fig. 5.1. Miss Marion Terry as Lady Claude Derenham in Mollentrave on Women, from *Sketch* supplement, 15 March 1905, p. 8. Courtesy of the Yale University Library.

are paid for) by people who have their own dresses and drawing rooms, and know them to be a mere masquerade behind which there is nothing romantic, and little that is interesting to most of the masqueraders except the clandestine play of natural licentiousness. The stalls cannot be fully understood without taking into account the absence of the rich evangelical English merchant and his family, and the presence of the rich Jewish merchant and his family . . . All that can be fairly said of the Jewish influence on the theatre is that it is exotic, and is not only a customer's influence but a financier's influence: so much so, that the way is smoothest for those plays and those performers that appeal specially to the Jewish taste. English influence on the theatre, as far as the stalls are concerned, does not exist, because the rich purchasing-powerful Englishman prefers politics and church-going: his soul is too stubborn to be purged by an avowed make-believe. When he wants sensuality he practices it: he does not play with voluptuous or romantic ideas . . . He demands edification and will not pay for anything else in that arena. Consequently the box office will never become an English influence until the theatre turns from the drama of romance and sensuality to the drama of edification.[3]

they want to escape from), nor the longing of the sportsman for violent action, nor the full-fed, experienced, disillusioned sensuality of the rich man, whether he be gentleman or sporting publican. They read a good deal, and are at home in the fool's paradise of popular romance. They love the pretty man and the pretty woman, and will have both of them fashionably dressed and exquisitely idle, posing against backgrounds of drawing room and dainty garden; in love, but sentimentally, romantically; always ladylike and gentlemanlike. Jejunely insipid all this, to the stalls, which are paid for (when they

The romance and sensuality of late Victorian and Edwardian popular theatre have, of course, attracted significant attention from cultural historians in recent years; both the theatre's role in promoting powerful versions of fashionable femininity, through the figure of the celebrity actress, and its links to the commodity culture of the department store and to the luxury trades of the West End have

provided fertile ground for the arguments of Joel Kaplan and Sheila Stowell, Peter Bailey and Erika Rappaport in particular.[4] But the focus here has tended to fall on the spectacular form of musical comedy, exemplified most vividly by the productions held at the Gaiety Theatre, off the Strand, under George Edwardes's management during the 1890s. These borrowed from the older theatrical traditions of pantomime, music hall and burlesque, drawing on the fantastical, satirical and sexualized appeal of each to create a new kind of performance premised on the idea that the glamour of contemporary metropolitan life constituted a fitting platform for escapism directed largely at a huge and largely untapped lower-middle-class female audience. The incorporation of fashionable dressing into the dramatic scenario was an important element in the success of such plays, and when the Gaiety premiered its first example, *The Shop Girl,* in 1894, the press reaction certainly focused on its well-regulated but inconsequential modishness. Commenting on the character of the leading actress, the critic for the *Theatre* stated that 'one is tempted to forget that she is anything more than a lay figure, intended for the exhibition of magnificent costumes. In this respect, however, she merely fulfils the law of her being.'[5] An earlier Edwardes production, *In Town,* staged at the Prince of Wales Theatre in 1892, had set the precedent for a form of theatre whose primary function was the promotion of contemporary trends through locating the action in the effervescent milieu of London's theatre land. Its reviewer in the *Players* devoted a great deal of print to a description of the wardrobe:

Some very, very smart frocks are worn by the 'chorus ladies of the Ambiguity Theatre' in the first act, Miss Maud Hobson being well to the fore in the way of style and presence. Her dress . . . is quite of the smartest I have seen for some time. The skirt, which is made in a demi-train, lined underneath (and seen only when the wearer moved) with pale pink silk, was composed of a beautiful shade of dove coloured silk—over this was worn a bodice of the richest purple velvet, designed in a new and very quaint manner . . . The eyes of many of the female portion of the audience grew large with envy as they watched this creation . . . move about the stage.[6]

Significantly, the writer did not stop at a description of stage dress, but went on to note the mantle of a member of the audience 'made of turquoise poult de soie, and lined all through with the same material in a most delicate peach colour'. Such synergy was clearly novel, adding weight to the claims of another reviewer that the play 'embodies the very essence of the times in which we live'.[7]

And yet, this very celebration of contemporaneity—achieved largely through costume design and clever commercial tie-ins—also limited the comedies, leaving them open to charges of superficiality and manipulation that for social historian Peter Bailey brackets them to those broader regimes of fin-de-siècle modernity that included the routines of the office and the factory production line, as well as the parade-ground drills and stock-market speculations of military and economic imperialism. The fashionable stage confection was then another regulatory device, controlling unruly desires

and encouraging unthinking consumption among the widest possible audience, but also, as Bailey suggested, offering important psychological compensations:

> Within a generation . . . London women came to use the greater range of cheap consumer goods available in ways that not only followed the promptings of popular fashion and femininity but realised a more independent sense of self. Although a blithely manipulative mode, musical comedy may have stimulated such new imaginative gains for women in a more overtly sexualised identity that was no longer merely hostage to the designs of men.[8]

Bailey thus credited the musical comedy of the 1890s as an important conduit for the emergence of new, more assertive feminine subject-positions, linked to the performative potential of consumer culture, whose implications would become much more evident in the 1920s through the figure of the flapper. But in essence, although its appeal was undoubtedly formidable, we should not lose sight of the fact that the nature of the genre itself was fairly haphazard and unsophisticated— less a self-conscious attempt at theatrical innovation or social progressivism than a blatant case of managerial opportunism and creative prostitution. Aside from the gorgeous contemporary costumes, musical comedy was characterized by predictably romantic and coy plotlines, stereotypical characterization, lushly sentimental but derivative scoring and plenty of colourful crowd-pleasing ensemble scenes; settings tended to a broad-brush and overblown approximation

of the familiar haunts of the fashionable— ballrooms, park promenades, restaurants and department stores—that would have served equally well as backdrops for the more louche vaudeville offerings of the Empire Theatre in Leicester Square (see Fig. 5.2). Henrik Ibsen it was not—and, as Shaw pointedly noted:

> If I despised the musical farces, it was because they never had the courage of their vices. With all their laboured efforts to keep up an understanding of furtive naughtiness between the low comedian on stage and the drunken undergraduate in the stalls, they insisted all the time on their virtue and patriotism and loyalty as pitifully as a poor girl of the pavement will pretend to be a clergyman's daughter.[9]

Across town, on the edges of Green Park, the actor-manager George Alexander and his wife, Florence, were pioneering a parallel form of presentation whose carefully considered constitutive parts represent perhaps a more profound, or at least self-reflexive, commentary on the formations of fashionable taste in early-twentieth-century London. In their minutely observed studies of the genteel sensibility under stress, we may perhaps find fertile ground for tracing the manner in which stage representations of dress and the interior produced a powerful conception of metropolitan modernity that deserves closer scrutiny than the extant literature has so far provided.[10]

The St James's Theatre, which became the epicentre of drawing room drama following Alexander's appointment in 1891, had flourished as the West End's westernmost playhouse since its erection in

THE LOUIS XIV. RESTAURANT,
PICCADILLY HOTEL, REGENT STREET, LONDON.

Fig. 5.2. The Louis XIV Restaurant, Piccadilly Hotel, Regent Street, London, plate 1 from souvenir programme, *Special Morning Performance in Aid of the Re-building Fund of the Royal National Orthopaedic Hospital* (3 December 1908). V&A Theatre Collections.

1835. Sandwiched between Pall Mall and St James's Street on the south side of Piccadilly, its proximity to the royal household, to club land and to the residences of the upper ten in Belgravia and Mayfair earned it an aristocratic reputation by association (see Fig. 5.3). Such associations were not lost on the new management, and although the theatre had fallen out of fashionability for some years, Alexander pursued a policy of understated gentility that stood in vivid contrast to the overtly entrepreneurial approach of Edwardes and his peers in the commercial theatres of the Strand. His three key management principles stressed the promotion of British and colonial over foreign productions, well-balanced dramatic characterizations in preference to the reification of the celebrity actor and the maintenance of 'perfectly cogged and oiled wheels back and front of the curtain' to ensure maximum audience comfort. An overriding sense of 'decorum' linked all three desiderata, and as the historian of the theatre Barry Duncan has suggested, the organization behind the scenes stripped back the usual association of thespian affairs

with bohemian chaos, opting instead for the polished efficiency of the modern hotel or luxury liner: 'Back stage, carpets, mostly overlaid with white drugget, lined all corridors and departments. Stage-hands were attired in white overalls with cuffs coloured to denote their duties, cotton gloves and white soft shoes . . . Visitors were banned from dressing rooms which were at one time reached by a staircase for ladies and another for gentlemen.'[11]

Alexander's first new play at the St James's was a piece by the young Sydney-born playwright C. Haddon Chambers that had premiered recently in New York. *The Idler* opened on 26 February 1891 and set the template for the drawing room plays that would follow. The action proceeded over four days through three acts: the first in Sir John Harding's quarters in Kensington Palace Gardens, the second in Mrs Cross's apartment, and the third in Mark Cross's

rooms in Piccadilly. The theatrical raconteur Walter Macqueen-Pope recounted the narrative in his history of the theatre of 1958:

It was drawing room drama alright. Mark Cross, a rich young man, makes an unhappy marriage and leaves his unfaithful wife. Although still married he falls in love with a young girl. He has the decency to go to America and there leads a wild life among the miners, making a great friend of one of them, 'Gentleman Jack.' News of his wife's death brings him home. He goes to the girl he loved, only to find she has married John Harding MP . . . No other than his old acquaintance 'Gentleman Jack!' Sir John has not told his wife about his past, which includes killing a man in a drunken bout and fleeing the consequences. The dead man's brother is in England seeking revenge on the killer, and Cross warns Harding about this. In due course the brother, Simeon Strong, calls on both men and lays his plans. Seeing a chance to win the girl he loved, Cross plans to get her to his chambers and possess her, in return for saving her husband. Lady Harding, who loves her husband, sees no way out. Cross obtains a written promise from Strong that he will let Sir John alone. When Lady Harding visits him and he attempts to seduce her, her appeal to his better nature brings out the latent good in him, and he is allowing her to depart when her husband arrives and puts the worst construction on the situation. He demands a duel between Cross and himself . . . Strong turns up and stops this. Lady Harding convinces her husband of this and they go away together. Cross decides to commit suicide—a worthless idler only causes trouble in the world. But his mother, whom he dearly loves, comes to see him. He puts away

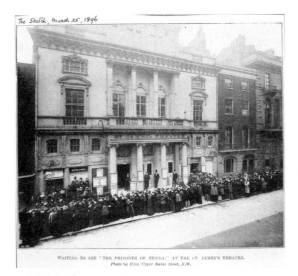

Fig. 5.3. The St James's Theatre, London, from *Sketch*, 25 March 1896. V&A Theatre Collections.

his revolver and orders his servant to pack for a long journey. Whither will he travel? 'God knows!' he says as the curtain falls.[12]

There was, of course, much here reminiscent of mid-Victorian melodrama, but it is also possible to discern the emergence of some of the distinctive characteristics associated with Edwardian theatre, as outlined by theatre historian Joseph Donohue. These included, he wrote, the promotion of a new ethical realism that went hand in hand with the apotheosis of late-nineteenth-century verisimilitude in settings, costume and décor: 'A realism that views society in its social and moral aspects as a matrix of moving and shifting values, rather than as an essentially monolithic conglomeration of persons and classes all with fixed attributes . . . An insistent, restless desire to see things for what they really are and name them accordingly' — setting them in meaningful context. This was accompanied by 'a continuing love of fantasy . . . a heightened appreciation of and appetite for pleasure—hedonistic, intellectual, innocent or guilty' bracketed with 'an enthusiastic idealism that vents itself . . . in visions of a new theatre and even a new audience . . . a strong re-orientation towards [the present and] the future [and] a quasi-teleological sense of progress towards a goal'.[13] That such a goal could be manifested in the dressing of sets and actors was a new proposition, and one that the critics of *The Idler* were quick to identify. Macqueen-Pope cites the 'well-known journalist' A. W. Bean:

The action on the part of our managers in placing the furnishing of their stage interiors in the hands of competent men, proves that they are making an effort, and with success, to enable us to escape from the opprobrium of being a people without taste. Some of us, especially the ladies, dress better than we used to do—often the result of seeing a model costume on the stage. The next step in the same direction is to furnish better—to better dress our dwellings. Hence the appreciation of art furniture and its accompanying decorations. For instance, who can visit the Idler at the St James's Theatre and come away without their artistic perceptions receiving improvement? The charming set in the second scene, arranged in the Louis Seize style shows a strong contrast to the sumptuous chambers of Mark Cross in the last act, so artistically arranged by the firm of Messrs F. Giles and Co., whose setting of this scene in antique oak furniture will be much appreciated by those who see the play, and especially those whose financial positions will enable them to carry out in their own houses such elegant designs.[14]

All this polish was made possible by the rise of the actor-manager, whose promotional skills were made manifest in the suave figure of Alexander. He had risen from a fairly humble middle-class background as the son of a Reading commercial traveller to work as a leading man under Sir Henry Irving at the Lyceum in the 1880s before finding wider success and a degree of infamy as the producer of Oscar Wilde and Arthur Pinero in the 1890s. 'Hierarchically and organizationally', the theatre historian Ian Clarke suggested, 'the commercial Edwardian Theatre was dominated by the actor-managers. They leased and managed

the building, chose the plays and controlled their production, and usually acted a leading role. A consequence of the extent of this organisational control was an ability throughout the period to embody and create the tone of the theatre as a social institution.'[15] For the St James's Theatre, this tone was only firmly established after 1900, following a complete refurbishment in February of the same year. The correspondent of the *Sketch* noted that:

> *The brand new St James's Theatre, a blaze of crimson and gold as regards colour . . . looked very handsome indeed when filled with a brilliant first night audience on February 1st . . . We all rose to accord fullest sympathy to the National Anthem, in the chorus of which joined with special heartiness the best gowned lady in the house—a graceful and captivating Irish girl sitting just in front of me in the dress circle. The suave lines of that . . . white silk dress fitted the figure most exquisitely, and I am sure that the maker must be a woman of genius.[16]*

His observations could not have accorded more perfectly with those of Henry James, who simultaneously recorded the impression that 'the theatre in England is a social luxury and not an artistic necessity . . . The audience is well dressed, tranquil, motionless, it suggests domestic virtue and comfortable homes; it looks as if it had come to the play in its own carriage, after a dinner of beef and pudding.'[17]

Thus in the images created by managers such as Alexander, in both the front and the back of the proscenium, a simulacrum of the Edwardian social experience based on the concept of politeness was maintained, which was both 'suitably flattering and acceptable to the bulk of the theatre-going public'.[18] And as Clarke argued, 'despite the image-making, the social image was partly founded on fact. For most of the nineteenth-century, the acting profession had not genuinely been received into polite society, but, by the Edwardian age, it had been so successfully assimilated that this . . . relatively new-found social position and respectability affected a whole range of assumptions about the nature and function of theatre as an institution and about the drama it presented.'[19] At the core of these assumptions lay the thorny issue of what constituted a respectable lifestyle and how this might be conveyed through the problematic but highly modern concept of fashionability. Although the evidence for the way that these concerns were represented on stage is by nature ephemeral and patchy, the material is rich enough to yield new insights. Having sketched in the broader developmental and institutional contexts that gave rise to such concerns, here I consider in a little more detail how they were practically resolved at the St James's during the first two decades of the twentieth century.

Kaplan and Stowell, in their groundbreaking analysis of the relationship between fashion and theatre during the 1880s and 1890s, bluntly characterized the provision of stage costumes, both by couture companies such as Redfern, Worth and Paquin and more obscure Mayfair dressmakers, as part of

> *a cynical collusion of stage, shop and society press . . . facilitated by a new wave of independent designers determined to break*

the monopoly of established houses . . . In London, where Worth's influence had been felt at one remove, the stage became the principal marketplace in which his authority was tested by rivals who had neither the prestige nor resources of their Parisian counterparts.[20]

At the St James's Theatre, this process was clearly seen at play in the contributions made by West End dressmakers Mesdames Savage and Purdue, who between 1892 and 1897 costumed thirteen productions including Wilde's *Lady Windermere's Fan* (1892), Pinero's *The Second Mrs Tanqueray* (1893) and H. A. Jones's *The Masqueraders* (1894). Once their names, prominently displayed in programmes and discussed in the reviews, were in broader circulation among society, it is notable that Savage and Purdue curtailed their stage work and concentrated on the lucrative drawing-room commissions that allowed them in due course to call themselves 'Court Dressmakers.' The playhouses had simply functioned as secondary showrooms, 'with London's leading ladies serving as living mannequins'.[21]

After 1900, the situation seems to have shifted, with a more concerted effort by the theatre's management to harness all aspects of production toward producing a coherent account of the play's setting. This left fewer opportunities for ambitious dressmakers to use the St James's as a personal career platform and no doubt owed much to the contribution of Florence Alexander (see Fig. 5.4), who was described in the *Sketch* of 1901 as 'one of the best dressed women in London . . . Not a play, especially a modern play, goes on to the St James's stage the

costumes of which have not been suggested or decided upon by this able actor-manager's very able wife'.[22] Her crucial creative role and its place in a more cohesive design process, which incorporated consideration of dress and setting in tandem, are also alluded to by the set and costume designer W. Graham Robertson, who recalled in his memoirs that]

work was very pleasant at the St James's. Alexander and I, as old friends, were able to discuss matters comfortably. Florence Alexander, his wife, was always of immense help, and she and I used to make secret and illicit raids upon

Mrs. GEORGE ALEXANDER with "Pan," a Favourite.

Photo Foulsham & Banfield

Fig. 5.4. 'Mrs. George Alexander with "Pan," a Favourite', from *Play Pictorial* 17, no. 101 (1911), p. 48. Courtesy of the Yale University Library.

the sacred "wardrobe" where we often found just what we wanted ready to our hand.[23]

Their concern for producing a convincing mise-en-scène was first tested through Robertson's contribution to Alexander's 1897 production of *As You Like It,* for which, he remembered, 'I was most conscientious over the dresses, and the forest scenes looked really rustic; nothing but russets, browns and greens—what a tailor would call "gent's heather mixture." '[24] The final "masque of Hymen" offered the opportunity for an expensive, high-aesthetic sensory overload:

Flower-decked children danced, demure white maidens swung their garlands, it was a picture of Spring in the faint pure tints of primrose and anemone. Then came a burst of colour. A coven of little crimson-robed cupids fluttered in on peacock wings shooting golden arrows, tipped with red roses, and finally the beautiful golden figure of Hymen emerged from the misty blue deeps of the wood. I had certainly attained my riot of colour, the gentle hues of the opening wiped out by the rush of crimson, the crimson effaced in its turn by the only colour that will efface crimson—orange—and orange against its complementary blue, which doubled its effect.[25]

But a striving after elegant effect and nuanced mood was not restricted to Shakespeare. The modern drawing-room plays that earned the St James's Theatre its reputation were the focus of similarly intense labour, whose function was usefully described by the French critic Georges Bourdon, writing on the English theatrical trades in 1903:

What they try to achieve in the mis-en-scène is not so much the representation, in a form as precise as possible, of material objects that will confer value as a sign of art. They are pre-occupied less with establishing a décor that will constitute a faithful image of nature than with giving adequate symbolic expression to the nature of the characters who inhabit it. The job of painters and carpenters is not to restore nature itself: they evoke environments, they create 'atmosphere,' they confer thought and a voice on décor, they make of it a living, speaking character, they impose it on the spectator's mind, they send across the auditorium the soul of the work itself, elusive but still present.[26]

Bourdon's generalized account of the communicative role played by the set in conveying narrative, character and mood is supported four years later by the research of Italian critic Mario Borsa, who in interviewing Pinero noted:

I had under my eyes 'the author's copy' of several of his plays and the stage directions in these were quite as long as the texts. Pinero not only gives a most minute description of each scene, going so far as to describe the colours of the stuffs used to cover the chairs and sofa, not only does he indicate every step and every movement of the actors and the actresses, but he even suggests their very gestures . . . If you were to first read the author's copy of one of his plays, and then go to see it produced upon the stage, your first feeling would be one of displeasure; for you would imagine yourself to be seeing wooden puppets, moved about by means of invisible threads of wire by the guiding hand of Pinero![27]

Pinero was not alone in setting exacting and lavish standards of representation; for example, the stage directions set by Somerset Maugham for the decoration of Lady Grayston's country house drawing room in the play *Our Betters* (1915) are similarly prescriptive:

It is a sumptuous double-room, of the period of George II, decorated in green and gold, with a coromandel screen and lacquer cabinets; but the coverings of the chairs, the sofas and the cushions show the influence of Bakst and the Russian Ballet; they offer an agreeable mixture of rich plum, emerald green, canary and ultra-marine. On the floor is a Chinese carpet, and here and there are pieces of Ming pottery. [28]

Scraps of evidence from the programme notes, production photographs and reviews of the series of productions held at the St James's between the turn of the century and World War I are testament to the genre-defining dictums of Maugham and Pinero that (to use Pinero's words) 'wealth and leisure are more productive of dramatic complications than poverty and hard work . . . [and] if you want to get a certain order of ideas expressed or questions discussed, you must go pretty well up in the social scale'[29] and, in addition, that in order to set a convincing context for such ideas it would be necessary for actor-manager, playwright, costume mistress, property buyer and scene painter to work together to an unprecedented degree.[30] Thus, the programme note for the play *Saturday to Monday*, staged during April 1904, states that 'the dining room scene was painted by Mr Walter Hann and the Garden Scene by Mr Hawes Craven, the furniture was by Wiseman and Butcher of 7 High Street Kensington and the dresses by Madame Frederick, 14 Grosvenor Place and Marshall & Snelgrove, Ladies Hats by Mme Elise, 33 New Bond Street.'[31] That autumn a revival of *Lady Windermere's Fan* necessitated a wider trawl for costumes, with the following result:

The gowns and cloaks worn by Mesdames Braithwaite, French, Lewis and Hamilton designed and made by Madame Frederick . . . Miss Terry's gowns by Madame Hayward, New Bond Street, Miss Coleman's gowns by Marshall and Snelgrove, Oxford Street, the other gowns by Mme Brown, 169 Knightsbridge and Mrs Evans. Hats by Mme Elise . . . The furniture by Wiseman and Butcher and Ernest Renton, King Street St James. [32]

Such retailers reoccur with regularity, furnishing the décor of *Mollentrave on Women* by Alfred Sutro, *John Chilcote MP* by Katherine Cecil Thurston and *The Man of the Moment* by Alfred Capus (all 1905), although for the latter 'Mme le Bargy's dresses were provided by the Maison Doucet, Rue de la Paix, Paris' (see Fig. 5.5).[33]

Pinero's *His House in Order* (February 1906), with its dresses by Mme Hayward and Mme Purdue, scenery by Mr Joseph Harker from decorations designed by Percy MacQuoid and furniture by Waring's, Bailey's, Lyon's and Ernest Renton, elicited a telling review by Edith Waldemar Leverton in a commemorative edition of the *Play Pictorial*, which cleverly segued observations of fashionable life before, during and after the play to suggest the unbroken continuum of

4 [SUPPLEMENT.] THE SKETCH. JULY 12, 1905

A FRENCH ACTRESS WHO HAS MADE A ''HIT'' IN AN ENGLISH PART.

MME. SIMONE LE BARGY, WHO IS PLAYING MARIANNE DARLAY IN "THE MAN OF THE MOMENT," AT THE ST. JAMES'S.

Fig. 5.5. Mme Simone le Bargy in *The Man of the Moment*, from *Sketch* supplement, 12 July 1905, p. 4. Courtesy of the Yale University Library.

taste between audience and production that Alexander so desired:

> *'Say!' exclaimed my American friend, 'guess I'm about tired of Musical Comedy, can't you give me something with pure drama in it, and no Bernard Shaw.' 'Certainly' I responded with alacrity 'there's the Immortal Pinero, George Alexander, Irene Vanbrugh and "His House in Order"' . . . We first of all repaired to that delightful restaurant the Dieudonne, with its . . . delicate mural decorations, and its incomparable little dinners . . . Between*

the courses I had leisure to observe the pretty gowns worn by the many pretty women. Lady J who always displays such exquisite taste in frocks had selected one in hydrangea mauve silk, the skirt bearing a wide-border of silk embroidery in a design of forget-me-nots in their natural colouring. Close by was one of our best beloved actresses in a gown of Irish lace slashed over an underskirt of white chiffon and laced across by silver cords . . . In due course we settled ourselves comfortably in our stalls. Before the curtain rose I had leisure to admire a very fascinating lady in front with the prettiest coiffure imaginable, one mass of tiny curls and a white aigrette waving above a small diamond tiara.

Finally, describing the costumes of the play itself, Leverton is drawn to

> *the rebellious wife in a wonderful creation of pink silk mousseline, the skirt clinging and trailing in graceful folds, the bodice displaying an under-blouse of pure white with cape-like sleeves of Irish lace . . . A veritable dream gown this, and one to make every true woman sigh with envy . . . 'I'm real glad that idiot of a husband gave the Ridgeley family the "skipoo" ' remarked my companion, as he lighted a homeward cigar. 'Say, but Pinero is a dandy writer.' I sighed! I was thinking of that pink frock![34]*

A final example of theatrical fashion journalism from a *Play Pictorial* (November 1910), commemorating the play *The Eccentric Lord Comberdene* by R.C. Carton, takes the elision between experience and its representation to its extreme:

The lounge of the Imperial Hotel, Shingelford Bay . . . shows us some elegantly dressed lady visitors, who wander in and out of the hall in a most natural manner, entertaining visitors at afternoon tea . . . It is a rather restless mis-en-scène and seems without any apparent object, for few of the ladies . . . play any part in the story. But the dresses are pretty and form a varying background to the male and female characters in the rather melodramatic plot. There was a lady visitor to the hotel who wore a very attractive gown of white cloth, with a shawl-like mantlet, and the movement of this mannequin was quite refreshing as she came and went . . . The deck of the Morning Star looked rather inviting at first, but when the yacht started and got away the movement was so realistic that more than one bad sailor amongst the audience looked ready for the stewardess . . . Such is life, or rather such is stage life![35]

On a superficial reading, this, then, was the sum contribution of a dramatic form that George Bernard Shaw famously dismissed as 'a tailor's advertisement making sentimental remarks to a milliner's advertisement in the middle of an upholsterer's and decorator's advertisement', a jolly and well-engineered conduit for the commodification of life, which sat securely within the dominant, highly materialistic mind-set of the Edwardian middle classes.[36] Yet within this skilful placement of contemporary dress and furniture, this concerted play with their performative possibilities—intended to produce that crowning accolade of 'niceness'—so bitterly dismissed by Shaw, I would suggest there

are valuable lessons to be learnt, both about the role played by theatrical methods in the construction of fashionability and about the embedding of the idea of fashion in certain conservative theatrical forms. As Ian Clarke has observed:

The desire for 'nice' plays, over and above its creation of a social tone, entailed a more fundamental ideological affiliation. 'Nice' plays could only be those which demonstrated and endorsed a non-objectionable subject-matter and morality. The successful plays of the serious commercial theatre were almost inevitably conservative in matters of social conduct and sexual morality. The success of the drama depended not only on a congruity of taste between providers and consumers, but on a congruity between the ideological foundations of the Edwardian theatre, ramified by notions of a stable social structure and concepts of correct behaviour, and the ideological construction of the drama itself.[37]

There's a reactionary reciprocity here that deserves further analysis, not just in the realm of theatre, but as a marker of middlebrow aspirations in the history of modern English visual and material culture more generally: in the home, the shop, the novel and latterly through film. For we can certainly be sure that whether these signs occurred through the prism of fashion or the interior, they will always have been fetchingly, expensively and appropriately dressed—and nowhere more so than on the Edwardian stage.

Notes

The epigraph is from George Bernard Shaw, 'Preface', in *Three Plays for Puritans* (Penguin Classics, 2000), p. 15. Also cited in I. Clarke, *Edwardian Drama: A Critical Study* (Faber & Faber, 1989), p. 5.

1. M. Billington, 'Introduction', in Shaw, *Three Plays for Puritans*, p. vii.

2. Ibid.

3. Shaw, 'Preface', pp. 8–10.

4. J.H. Kaplan and S. Stowell, *Theatre & Fashion: Oscar Wilde to the Suffragettes* (Cambridge University Press, 1994). See also P. Bailey, *Popular Culture and Performance in the Victorian City* (Cambridge University Press, 1998); and E.D. Rappaport, *Shopping for Pleasure: Women in the Making of London's West End* (Princeton University Press, 2000).

5. R. Mander and J. Mitchenson, *Musical Comedy: A Story in Pictures* (Peter Davies, 1969), pp. 18–19.

6. Ibid., p. 13

7. Ibid.

8. P. Bailey, 'Naughty but Nice: Musical Comedy and the Rhetoric of the Girl 1892–1914', in M.R. Booth and J.H. Kaplan, eds, *The Edwardian Theatre: Essays on Performance and the Stage* (Cambridge University Press, 1996), p. 55.

9. Shaw, 'Preface', p. 14.

10. Two recent exceptions from the field of art history are L. Tickner, *Modern Life & Modern Subjects: British Art in the Early Twentieth Century* (Yale University Press, 2000); and P.M. Fletcher, *Narrating Modernity: The British Problem Picture, 1895–1914* (Ashgate, 2003). For earlier explorations of the fashion-related arguments developed in this essay see also C. Breward, *Fashioning London: Clothing and the Modern Metropolis* (Berg, 2004); and C. Breward, 'Ambiguous Role Models: Fashion, Modernity and the Victorian Actress', in C. Breward and C. Evans, eds, *Fashion and Modernity* (Berg, 2005), pp. 101–21.

11. B. Duncan, *The St James's Theatre: Its Strange and Complete History, 1835–1957* (Barrie & Rockliff, 1964), pp. 218–19.

12. W. Macqueen-Pope, *St James's: Theatre of Distinction* (W.H. Allen, 1958), pp. 112–13.

13. J. Donohue, 'What Is Edwardian Theatre?' in Booth and Kaplan, *The Edwardian Theatre*, pp. 14–6.

14. Macqueen-Pope, *St James's*, p. 114.

15. Clarke, *Edwardian Drama*, p. 1.

16. *Sketch,* 7 February 1900, p. 103.

17. H. James, quoted in A. Wade, ed., *The Scenic Art* (London, 1949), pp. 100–1.

18. Clarke, *Edwardian Drama*, p. 1.

19. Ibid.

20. Kaplan and Stowell, *Theatre & Fashion*, pp. 8–10.

21. Ibid.

22. H.C. Newton, 'Mr and Mrs George Alexander at Home and Out', *Sketch*, 23 January 1901, p. 23.

23. W.G. Robertson, *Time Was: The Reminiscences of W. Graham Robertson* (Quartet, 1981), p. 267.

24. Ibid., p. 261.

25. Ibid.

26. G. Bourdon, 'The English Theatre 1903', cited in Booth and Kaplan, *The Edwardian Theatre*, p. 29.

27. M. Borsa, *The English Stage of Today* (John Lane, 1907), p. 82.

28. M. Booth, 'Comedy and Farce', in K. Powell, ed., *The Cambridge Companion to Victorian and Edwardian Theatre* (Cambridge University Press, 2004), p. 136.

29. A. Pinero, quoted in Booth, 'Comedy and Farce', p. 135.

30. Further work needs to be completed on the luxury trades of London (many of whom contributed to the designs for St James's Theatre productions) during this period. Some important work has been achieved tracking the network of court and society dressmakers in the 1890s and 1910s. See for example A. de la Haye, L. Taylor and E. Thompson, *A Family of Fashion: The Messels: Six Generations of Dress* (Philip Wilson Publishers, 2005).

31. All programmes are held in the Theatre Collections at the National Archive of Art and Design, Victoria & Albert Museum, London.

32. Theatre Collections, National Archive of Art and Design, V&A Museum.

33. Theatre Collections, National Archive of Art and Design, V&A Museum.

34. E.W. Leverton, *The Play Pictorial* 8/48 (1906), p. 78.

35. E.W. Leverton, *The Play Pictorial* 17/101 (1910), p. 46.

36. Shaw, 'Preface', p. 15.

37. Clarke, *Edwardian Drama,* p. 8–9.

Chapter Six

Designing Lucile Ltd: couture and the modern interior 1900–1920s

Samantha Erin Safer

The English couturier Lucile, Lady Duff Gordon (1863–1935), who ran the fashion house Lucile Ltd, was a pioneering fashion designer, entrepreneur, style guru and keen self-promoter. In a short period of time she transformed herself from a small private dressmaker to a designer of international repute. By 1915, she was the first and only couturier to have branches in London (Lucille Ltd incorporated 1904), New York (1910), Paris (1911) and Chicago (1915), turning the Maison Lucile into a multimillion-dollar company. Her rise to fame in the early twentieth century was almost unprecedented for a businesswoman, let alone a fashion designer, both in Europe and America. Lucile, Lady Duff Gordon had a particular skill in the marketing and branding of her label using various techniques: she designed for the theatre, wrote for the women's press, created lavish mannequin parades and carefully styled photographic images to gain widespread publicity. Most importantly, she utilized interior decoration to assist in her endeavours, thus intersecting her dress designs with her decorative environments, an area which has been overlooked within the study of Lucile Ltd. In 1986, Meredith Etherington-Smith

and Jeremy Pilcher published The 'It' Girls, a work that looked at the complicated and entangled personal lives of Lady Duff Gordon and her sister, romantic novelist Elinor Glyn, using letters and other ephemera to bring their lives and relationships to light. Recent studies have focused on Lucile's theatrical designs and the cross fertilization of ideas from fashion and the theatre. Joel H. Kaplan and Sheila Stowell's publication Theatre and Fashion: Oscar Wilde to the Suffragettes (1994) investigates this particular aspect of Lucile's oeuvre alongside that of many of her contemporaries. Nancy Troy, in her seminal work Couture Culture: A Study in Modern Art and Fashion (2003), compares the sales, marketing and promotional aspects of Lucile Ltd with those of Paul Poiret and with his passion for Orientalism, which Lucile emulated in fashionable evening- and daywear. Alistair O'Neill's London—After a Fashion (2007) explores Lucile Ltd's dependence on theatrical conventions within the couture house—the pungent combination of diaphanous gowns, beautiful models and stage setting. The most complete academic work on Lucile Ltd to date, Lucile Ltd: London, Paris, New York and Chicago 1890s–1930s, by Valerie D. Mendes

and Amy de la Haye (2009), concentrates on Lucile as a designer and maker of fashionable clothes, particularly highlighting objects from the Victoria and Albert Museum's collection of her work.

My concern in this chapter is with the ways in which identity was constructed within the walls of Lucile Ltd. The highly designed interiors, which perfectly showed off the label's fashionable day- and eveningwear, were integral to the formulation of Lucile Ltd as an identifiable brand. Amongst the rolls of fabrics, trims, clothes and accessories, Lucile wove a fantastical web that would mesmerize her clients and make her very rich. In her work on Lucile's lifelong friend and interior design collaborator, Elsie de Wolfe, Penny Sparke wrote:

> It was primarily her [Elsie de Wolfe's] own identity she was intent on representing, it was a process which involved a close knowledge of self as well as an acute understanding of the cultural forces which had defined her and which continued to reinforce her own self-image.[1]

Lucile believed that clothing should express the wearer's personality, increasing her allurement. Lucile Ltd's brand identity was tied up with the beautiful, colourful designs tailored to suit each customer's personality, which Lucile termed 'Gowns of Emotion' or 'Personality Gowns'. The brand was also concerned with theatricality, femininity, sensuality, sexuality and luxury for aristocrats and women with a penchant for a distinctive look. These attributes were steeped in psychology, history, poetry, literature and the arts and were mirrored in the names given to each ensemble, such as 'Red Mouth of a Venomous Flower', taken from Algernon Swinburne's Sadian poem 'Dolores' (*Poems and Ballads,* 1866), 'A Silent Appeal', 'A Frenzied Song of Amorous Things' and 'Enrapture'. Lucile sought out young, beautiful women as her mannequins, trained them in deportment, and styled them until they blossomed into exotic women. She provided them with 'stage' names, christening girls from Bermondsey 'Dolores', 'Hebe', 'Gamela', 'Florence' and 'Phyllis' to harmonize with their personalities. Lucile's belief in designing to express personality ultimately influenced the interiors of her couture house—each room was given its own design scheme. 'Our home . . . is the extension . . . of our personality. Our furniture, our bibelots, chosen by us, reveal our secret tastes, our ideas, our conceptions of happiness and beauty,' wrote the editor of *Fémina,* Marcelle Tinayre.[2] Elsie de Wolfe echoed this sentiment, stating: 'It is the personality of the mistress that the home expresses.'[3] Decoration, like couture, was equated with femininity, celebrating a woman's ability to adorn both her body and the spaces in which she belonged and inhabited.[4] Thus, if the home can be understood as an extension of one's personality, then the couture house might be understood as the extension of the label's personality or identity, within which various ambiences were constructed.

No single room in the couture house was ever designed in the same way, although there was some cohesion; each of Lucile Ltd's premises, for example, had a Rose Room set aside for the sale of filmy lingerie. This practice of differentiation through

contemporary decoration was reinforced by the editor of *L'Interieur*: 'One may formulate this rule: there is no, and there must not be any, general, uniform, or absolute style: each interior and each room must have its own style.'[5] In creating visual pleasure through dress and interior design, Lucile asserted her artistic authority and created an identity that her wealthy clientele related to.

With the expansion of Lucile Ltd, interior design became indispensable to the image of the label and its marketing. Like other retailers of the time, Lucile believed that interiors and environments could affect clients psychologically; hence, a beautiful interior would make a client want to consume more of her designs. She wrote: '[One cannot] over estimate the effect of environment on a woman, for women are infinitely more adaptable than men, they become part of their surroundings.'[6] Attention to detail was important in the seduction of the client into the luxurious Lucile Ltd lifestyle. Lucile aimed to make clients feel as if they were in their own homes rather than a place of business (see Fig. 6.1). She used interiors like a set or a shop window, arranging scenes and moods in different rooms to recreate the aesthetic of her diaphanous dresses. She draped each room with textiles and chose the furniture for a certain feel, just as she draped each mannequin with clothes and accessories. During the early twentieth century, there were over two thousand private dressmakers in central London; of those, some four hundred were listed as court dressmakers, as was Lucile Ltd.[7] By intermingling fashion and interior decoration, Lucile Ltd gained a unique advantage over London's other couture

houses as well as the stiff competition that came from other fashion cities; the conflation of fashion and interior design enhanced the reputation of the label, of Lucile as a fashion designer and, by association, of the clientele who chose to frequent the house and wear her designs.

Private dressmakers' shops in London during the early twentieth century typically consisted of hard chairs, a few dull mirrors, a door that led the way into a little fitting room and a space that was aesthetically unpleasing leaning towards austere. Even the great couture houses of the fin de siècle, in or near the rue de la Paix in Paris, were not designed to resemble ladies' private spaces: they were utilitarian rather than luxurious salons. Trying

Fig. 6.1. Lady Duff Gordon styling a mannequin, undated, Lucile Archive © V&A Images/Victoria and Albert Museum, London.

on and choosing clothes had been, Lucile said, a thing 'of as much secrecy as fitting a wooden leg might be expected to be'.[8] In the 1880s, Charles Frederick Worth set a precedent for interior design to be considered when selling couture. He was the first grand couturier to become involved in interior design, dressing his couture house walls in satin, as well as having a Salon de Lumière, a darkened room lit by gas so his clients could see their gowns in the same light environment that they would find at balls and other social occasions. From 1910 onward, however, the interior design of couture houses changed drastically, with Jacques Doucet, Jeanne Paquin and Paul Poiret taking their inspiration from the success of the Lucile Ltd houses. In 1912, *Vogue* commented that while it was common practice to combine the sale of millinery, bags, belts, caps and other apparel accessories,

certainly couturiers have never before insisted that chairs, curtains, rugs and wall-coverings should be considered in the choosing of a dress, or rather that the style of a dress should influence the interior decorations of a home.[9]

Lucile Ltd's careful and considered design of spaces was used to make women feel as if they were in a drawing room or bedroom, masking the reason for the couture house's existence—to sell fashion. Lucile was well known for her passion for interior decoration and her impeccable taste. The *New York American Examiner* wrote: 'The London house of the Duff-Gordon's is in Lennox Gardens and is noted in fashionable society for the beauty of its furniture and decoration,

which were of course designed by Lady Duff-Gordon.'[10] In her early career, Lucile had designed costumes for both amateur and professional theatre productions, most famously for Lily Elsie in the *Merry Widow* (1907). This experience helped formulate her thoughts on environmental factors, theatricality and their transformative powers. Her work in the theatre also led her to be the first designer to create a small stage within her couture house on which to show live, musically accompanied mannequin parades to the label's clientele.

Contemporary art movements and ideas surrounding the psychology of advertising also shaped Lucile's thoughts on interior environments and the meanings that they conveyed. Publications on the psychology of advertising were beginning to appear during the early twentieth century. These new writings argued that owners of establishments should do their utmost to administer pleasure to their clients, provide a welcoming and agreeable interior and courteous treatment for each customer: in doing so, large orders would be placed.[11] In the same period, innovative ideas, such as those of the Wiener Werkstätte in Vienna, began to be disseminated. The Wiener Werkstätte was dedicated to the concept of *Gesamtkunstwerk*—the creation of a 'total work of art', tying together all aspects of the designed environment where fashion and accessories were considered as important as the building and its decoration in creating a harmonized space. Lucile took heed. Her couture houses provided rooms for serving tea, playing cards and relaxation. Customers were made to feel as if they were in their own homes sipping tea with

their friends, imitating the domestic rituals of polite society (see Fig. 6.2). Lucile tapped into her clients' interests in history, culture, theatre and art, connecting the purchasing of fashion to a context that was already valued. By appealing to her clients' worldly interests and motives, Lucile was accessing the ruling principles in their thinking, branding the Lucile Ltd label and creating a distinct identity from other couturiers of the day: an emerging trend. Lucile's interior decoration scheme, along with her fetching designs, created desire—her clients aspired to the Lucile Ltd lifestyle. They read the spaces, and, in turn, the design of the spaces spoke to them, creating a very personal association between brand and client.

Lucile followed a strict formula for each house opening: choosing an address that signified taste with an upwardly mobile society around it; creating beautiful decorated interiors, tantalizing Rose Rooms, mannequin parades and stunning dresses completed the Lucile Ltd branded picture. Lucile's London showroom, an eighteenth-century house at 17 Hanover Square, was decorated as if it

Fig. 6.2. Private mannequin parade with tea at Lucile Ltd, Paris, c. 1911–1913. Lucile Archive © V&A Images/Victoria and Albert Museum, London.

was still a private home. Within each house, Lucile put the seamstresses in the maids' bedrooms, transformed the drawing room into the main salon, and drew her designs in what had formerly been the morning room.[12] The smaller rooms off the drawing room, now the main salon, were beautifully light fitting rooms with large gilt mirrors. It was believed that a special relationship between women and the domestic interior resulted not only in their strong presence in the physical space but, more fundamentally, in their creative efforts to elaborate it and imbue it with meanings.[13] By re-conceptualizing the space of the private home to work within the business of selling and housing couture, Lucile Ltd played with the definition of home, placing new meanings and values into each room. Presenting the couture house as a home allowed Lucile Ltd to stretch the boundaries of what was expected of such an establishment, breaking with the traditional roles of the couture house. In addition, there was a new importance placed on the domestic interior to indicate the visitor's social status. The Hanover Square location, situated in the golden rectangle between Regent Street, Piccadilly, Oxford Street and Park Lane, where the elite dressmakers and couture houses were concentrated, signified a superior status appealing to Lucile Ltd's aristocratic clientele.

In 1900, the firm leased 23 Hanover Square, a large Georgian mansion a few doors down from number 17. 'It was ideally suited to us because there were more rooms and the big ballroom was ideal for the main showroom,' wrote Lucile.[14] With her eighteenth-century preoccupations, instilled in her at a young age by her grandmother, she set out to

decorate her new couture house with pale grey walls and carpets. This neutral palette harmonized with the colours of the label— lilacs, soft pinks, baby blues, bright greens over nudes and greys—working twofold, the gowns accessorizing the space as well as the space accessorizing the gowns. The dadoes and skirting boards were painted white, crystal chandeliers hung from the ceiling and the tall windows were bedecked with silk taffeta curtains, fastened back and trimmed by hundreds of tiny silk roses. Silk flowers of all varieties were one of the defining embellishments on many of the gowns and a motif that would be repeated in the Rose Room.[15] Louis XV chairs and sofas, some bought in Paris, were upholstered in grey silk to match those in the other rooms.

Doucet and Paquin both used Louis XVI– style reproduction furnishings upholstered in pastel colours, which, combined with large carpets, heavy wall coverings, screens and paintings, created a heady mix of historicism. Their interiors were heavily embedded in nineteenth-century design ideas based on the French style of curves, gilding, heavy embroidery and copious amounts of furniture, whereas Lucile Ltd's interiors appear cleaner and fresh, with more space, light, air and simplicity. Miss Elsie, one of Lucile's first house models and sales assistants, described the couture house before the redecoration for the purposes of selling clothes:

Far more spacious [with] heavy mahogany doors designed and carved by Adam, with enormous rooms whose walls were lined with fine heavy brocades, the yellows, reds, blues and heliotropes softened by age, was unlike

any place in London then given over to trade. Each appointment—the fretted wainscoting above the tall windows, the woodwork of the baseboards, the great golden framed mirrors, the high decorated ceilings—wore dignity and magnificence. To complement the interior, a perfect gem of a garden, high-walled, with trees centuries old, graced the back of the house.[16]

In London and at 11 rue de Penthièvre in Paris, the gardens were used for spring and summer mannequin parades. The gardens, containing lush greenery and a fountain, were spaces in which mannequins posed in Lucile Ltd's latest ensembles for photography and paraded to the house's clients.

The main Paris salon also featured mannequin parades, as well as being an area where clients were served tea during more private presentations (see Fig. 6.2). In London, a sumptuous carpet was laid on the floor, and grey silk taffeta curtains covered the windows. At the far end of the room, a small stage was erected, with a neo-classical arched frame that mirrored the stage.[17] Misty olive chiffon curtains were used as the background, which gave the stage a mysteriously tempting feel. A large chandelier hung in the middle room, and seating was placed along the windows on each side of it. As Lucile Ltd was an international label, each house had a specific design focus, created in response to the local needs of clients in the cities that the company served. As Paul Poiret followed Lucile's lead with mannequin parades, the naming of dresses and the way in which he went about conceiving his couture house, so Lucile looked to Poiret for ideas that were working in the French

marketplace when she opened her Paris house. Poiret's interiors were decorated with Directoire or Directoire-inspired furniture and soft furnishings, using strident colours of green and raspberry stripes in one case, as well as Orientalist references, with multicoloured pillows piled high and strewn across the floor.[18] Lucile wrote, 'Knowing the Parisian temperament I decided to have more colourful decorations in the house in the rue de Penthièvre than in Hanover Square' and chose a purple carpet for the broad staircase that led up to the main salon.[19] The purple carpet was also used in the Chicago location but with an emerald green border in order to create some consistency across the houses, but with an American touch.

Despite sharing a similar decorative language with London, such as the grey curtains in silk taffeta and the striped grey upholstery for the seating, the main salon in Paris had its own character. The room had a natural recess at one end, where the stage, with four steps down onto wooden floors, fitted perfectly. The room was narrow and long—perfect for the catwalk—before it opened out into a larger area where there was more seating. Columns, flanked by large green potted plants, were repeated throughout the room.

The Paris interior elicited comment from magazines and newspapers, which included photographs of the interiors alongside the copy signalling a strong interest in the design. 'The new Paris house of Lady Duff Gordon is entirely in the period of Louis Philippe, and the new empire fashions are delightfully displayed in such an environment,' wrote one reporter.[20] In 1911, at the opening, the

Daily Graphic noted that Lucile's great talent lay in the display, or 'stage-setting' of her dresses, setting off her fashions with 'music, appropriate backgrounds, effective lighting, [and] gestures to suit the purpose. [It] put her clients in the atmosphere for properly appreciating her creations'.[21] Conversely, a reviewer from the *Theatre Magazine* commented:

> *My impressions of her salons is they are much too small as is the entire house. 'Lucile' should have selected a larger frame, which is really indispensable for the proper exploitation of the aesthetic idea on which the house was founded. Another criticism I may permit myself upon the error in taste, shown in the selection of a sofa and two armchairs covered with cretonne in glaring colours, which swear outrageously at the exquisite mauve tones of the carpet. This mistake is probably due to the hurried instalment of the establishment.[22]*

The glaring colours would have been inspired by Lucile Ltd's gowns, which frequently featured brilliant coloured layers, sashes and flowers with more neutral tones such as mauve and nude underneath, as well as Poiret's colourful home accessories. The mutual reinforcement of fashion and interior decoration created a heady mix that would tantalize her house's clients.

Taking inspiration from the large department stores, Lucile also encouraged her clients to stay and relax by developing new social practices within the couture house: a small room was created for playing cards and taking beverages whilst waiting to be fitted or assisted. The small room, with large windows, was furnished with sinuous ladylike chairs upholstered with a light floral print, a card table as well as flowers, plants and a large mirror. The bright atmosphere conjured a sense of gaiety and polite entertainment, encouraging the client to spend a few hours enjoying herself in the belief that an increase in the time spent at Lucile Ltd meant more money would change hands.

Lucile Ltd's saucy underwear was contained in its own special room, the Rose Room, at each of the couture houses in London, New York, Paris and Chicago. Lucile and her sister Elinor Glyn were passionate about delicate roses, a key motif within Lucile's oeuvre. Silk rosebuds were consistently applied in soft bunches or sprays on the bodice and sleeves of her gowns, hats and other ensembles and inspired the name of the most important room in her couture houses. Miss Elsie commented that: 'No Duff-Gordon establishment could have been complete without a Rose Room.'[23] The Rose Room was a luxurious pink boudoir, always fitted with a daybed in the middle of the room; the New York establishment boasted a Louis XV daybed said to be an exact copy of a bed Madame de Pompadour had owned. The woodwork of the furniture was painted white, a sign of Elsie de Wolfe's influence. Howard Greer, who was employed at Lucile Ltd from around 1916, originally as a sketch artist, noted:

> *It was called the Rose Room and rightly, for its walls were hung with pink taffeta, over-draped with the frailest lace, and the pink taffeta curtains at the windows and around the day bed were caught up with garlands of satin, taffeta and jewelled flowers.[24]*

Lucile sketched a copy of the bedspread that adorned the Rose Room daybed complete with trimmings of lace and handmade flowers for a client, pointing to how the interior design scheme and room sparked interest from the public.

Elsie de Wolfe, a close friend and Lucile's design collaborator in New York and Chicago, was dependent on French eighteenth-century style. Like Lucile, she used antique and reproduction furniture in her design schemes for her couture houses as well as her own home. In the Washington Irving house that de Wolfe shared with Elizabeth Marbury, both of the women's bedrooms featured a daybed—an item she considered as an 'essential component to any woman's bedroom'.[25] Each Lucile Rose Room featured an elaborate daybed with a silk canopy trimmed in silk flowers, taking direct advice and influence from de Wolfe (Fig. 6.3). By placing the daybed into the Rose Room, where filmy lingerie, nightwear and other exotic underpinnings were sold, the boudoir mood and scene were set. The surveying and purchasing of underclothes, normally a private matter, was thus acted out in the faux-private space of the bedroom

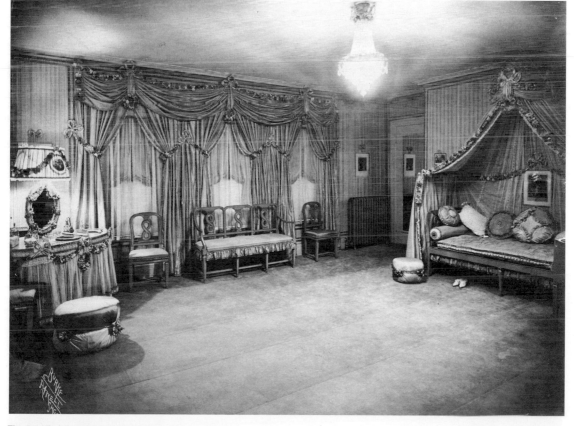

Fig. 6.3. The Rose Room at Lucile Ltd, 1400 Lake Shore Drive, Chicago. Lucile Archives 1915–1925. Courtesy of Special Collections, Gladys Marcus Library, Fashion Institute of Technology, New York.

and enabled an element of fantasy within the sales perimeter, where illicit liaisons could take place, all leaning to a risqué image of the environment.

The Rose Room at Lucile Ltd in New York, at 37–39 West 57th Street, was located on the second floor of the establishment. It was designed by Elsie de Wolfe in 1912 and was noted in the mannequin parade programme from the fall season of 1913 with a simple line stating: 'The Rose Room designed and furnished by Elsie de Wolfe, 4 West 40th Street.' Lucile had had to leave for business matters in London, and much of

the New York house, as Lucile wrote in her autobiography *Discretions and Indiscretions* (1932), was left to de Wolfe to design, albeit with instructions as to Lucile's requirements and colour schemes. A rare photograph of a parlour room attributed to the New York house bears de Wolfe's trademark aesthetic, such as the use of antique and reproduction furniture, grey-panelled walls, contemporary objects, a marble fireplace, sconces and large mirrors (see Fig 6.4).[26]

A dressing table at the far end of the Rose Room, where bottles of perfume and makeup items were kept, was accentuated with floral

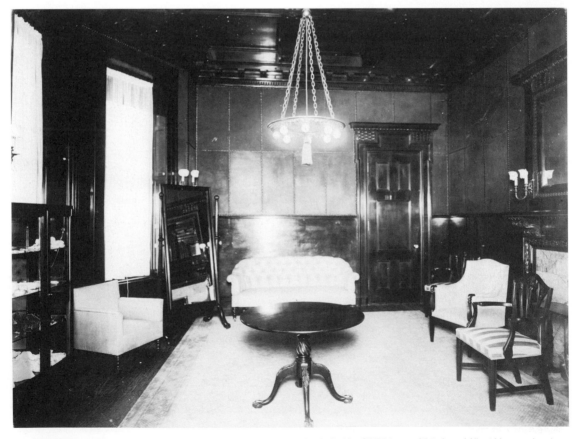

Fig. 6.4. The Parlour Room, Lucile Ltd, 37-39 West 57th Street, New York. Lucile Archive © V&A Images/Victoria and Albert Museum, London.

trim, and a gilt mirror with lamps flanked each side (see Fig. 6.5). Swags of sumptuous fabric influenced by stage curtains dressed the window treatments and lent drama to the space. Both Lucile's and de Wolfe's design philosophies and taste for eighteenth-century furniture and furnishings seem to meld together to create the warm yet seductive space, echoed in the Chicago Rose Room. Here, sweeping fabric was hung for curtains, and a dressing table placed in the corner was adorned with taffeta and Lucile's trademark floral trim. On the table rested a rounded mirror and personal effects, and pictures hung on the panelled walls. Along with the daybed, chairs and a matching bench, low silk-covered stools were employed for seating. The major difference between Lucile Ltd's Chicago Rose Room and the New York and Paris Rose Rooms was that the main feature was a stage, where mannequin parades created magical spectacles in the artificial boudoir.

Lucile sought to captivate the client in her brand and her feminine and sensual lifestyle. Great importance was given to innovative use of colour and light in the creation of a sensuous commercial atmosphere. Behind all

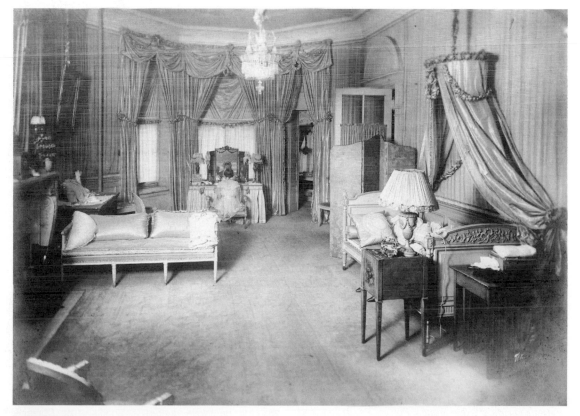

Fig. 6.5. The Rose Room at Lucile Ltd, 37-39 West 57th Street, New York. Lucile Archives 1915–1925. Courtesy of Special Collections, Gladys Marcus Library, Fashion Institute of Technology, New York.

the stylistic metamorphoses within the house and the Rose Room lay the bottom line: sales. Though the rooms were specifically designed to make one feel as if one were in a bedroom, this was a sales and marketing technique. Miss Elsie noted the Rose Room had 'all sorts of unique and expensive feminine luxuries. The sales made in these rooms were always surprisingly large'.[27] The faux-bedroom space along with the sexy underpinnings became a signature of the Lucile Ltd brand, as well as increasing the profits of the business.

Lucile deliberately constructed a complete picture of style and good taste for the company. Her calculated choices included the addresses of her couture houses, the women who were her mannequins, instituting mannequin parades with musical accompaniment, her clothing designs from dresses and suits to lingerie and accessories and, significantly, the ambience of the specifically decorated rooms. All this brought to life the constructed image of Lucile Ltd—one that thousands of women embraced and were eager to consume for more than thirty years.

Notes

1. P. Sparke, 'The Domestic Interior and the Construction of Self: The New York Homes of Elsie de Wolfe', in S. McKellar and P. Sparke, eds, *Interior Design and Identity* (Manchester University Press, 2004), p. 74.
2. M. Tinayre, 'L'Art de Parer son Foyer', *Femina* (1 April 1910), p. 189.
3. Elsie de Wolfe quoted in P. Sparke, *Elsie de Wolfe: The Birth of Modern Interior Decoration* (Acanthus Press, 2005), p. 13.
4. On the relationship between the interior and the fashioned body in this period see for example D. L. Silverman, *Art Nouveau in Fin-de-Siècle France: Politics, Psychology and Style* (University of California Press, 1989); N. Troy, *Couture*

Culture: A Study in Modern Art and Fashion (MIT Press, 2003).
5. *L'Interieur* (November 1911), p. 3.
6. Lady Duff Gordon, *Discretions and Indiscretions* (Jarrods Ltd, 1932), p. 74.
7. V. Mendes and A. de la Haye, *Lucile Ltd London, Paris, New York and Chicago: 1890s-1930s* (V&A Publishing, 2009), p. 20.
8. Lady Duff Gordon quoted in M. Etherington-Smith and J. Pilcher, *The 'It' Girls: Lucy, Lady Duff Gordon, the Couturiere, 'Lucile' and Elinor Glyn, Romantic Novelist* (Hamish Hamilton Ltd, 1986), p. 75.
9. 'Poiret's New Kingdom', *Vogue* (1 July 1912), p. 16.
10. 'The Distinguished Madame Lucile', *New York American Examiner* (23 January 1910).
11. W. Dill Scott, *The Psychology of Advertising* (Small, Maynard & Company, 1908), p. 24.
12. Etherington-Smith and Pilcher, *The 'It' Girls,* p. 58.
13. Sparke, 'The Domestic Interior', p. 72.
14. Gordon, *Discretions and Indiscretions,* p. 54.
15. Etherington-Smith and Pilcher, *The 'It' Girls,* p. 72.
16. A. Strakosch, 'Fashions for the Famous: Dressmaking Days with Lady Duff Gordon, as Told by Her First Model, Miss Elsie', *Saturday Evening Post* (19 February 1927), p. 36.
17. The only photograph I have seen of the main showroom and mannequin stage at 23 Hanover Square, London, was featured in *Harper's Bazaar,* August 1914, p. 38. The Lucile archive at the Victoria & Albert Museum, London; the Fashion Institute of Technology, New York; and the Chicago History Museum, Chicago, do not contain an image of the showroom.
18. Troy, *Couture Culture: A Story of Modern Art and Fashion,* p. 133 and 137.
19. Gordon, *Discretions and Indiscretions,* p. 187.
20. 'Lady Duff Gordon Talks of Fashions'. Unattributed article dated 1911. Box 15, Lucile Archive, Special Collections, Gladys Marcus Library, Fashion Institute of Technology, New York. Many thanks to Caroline Evans.
21. 'Blue Blood and Business—Lady Duff Gordon's Fashion Salon in Paris', *Daily Graphic* (6 April 1911), p. 113.
22. 'European Supplement', *Theatre Magazine* (June 1911), p. 218.
23. A. Strakosch, 'Fashions for the Famous: Dressmaking Days with Lady Duff Gordon, as Told by Her First Model, Miss Elsie', *Saturday Evening Post* (26 February 1927), p. 22.
24. G. Howard, *Designing Male* (G. P. Putnam's Sons, 1952), p. 43.
25. Elsie de Wolfe quoted in Sparke, 'The Domestic Interior', p. 83.

26. The Elsie de Wolfe and Lucile connection is quite interesting; de Wolfe, for her part, does not write about or mention Lucile in her autobiography *After All* (1935), and there is no mention of her in the existing working papers and documents that consist of de Wolfe's archive. Conversely, de Wolfe features quite prominently within Lucile's autobiography as a close confidant, business advisor and her couture house decorator within the documents housed in the Victoria & Albert Museum's Lucile archive at the Archive of Art and Design.

27. Strakosch, 'Fashions for the Famous' (26 February 1927), p. 22.

Chapter Seven

'Paris, Hollywood': viewing Parisian modernity through the lens of the Séeberger brothers, 1909–1939

Andrew Stephenson

Popular mythologies about Paris have often seemed more alluring and compelling than historically factual, and between 1909 and 1939, 'Paris' became one of the most powerful metaphors for a modernizing and sophisticated European urban experience centred around consumption, commerce and culture. As the popular American refrain put it, 'How ya' gonna keep 'em down on the farm after they've seen Paris?'[1] Within its haute couture fashion houses, its decorative arts studios and its burgeoning entertainment industries, 'Paris' held a unique position as a sign for a distinctively cosmopolitan site of pleasure, leisure and amusement. It also registered in the mass media as the pre-eminent site of the Western urban experience of women's (and, less often, men's) consumerist modernity par excellence, contributing to what Walter Benjamin saw as a large-scale historical shift in the organization of human perception.[2] The city's extensive exposure in the developing forms of photojournalism and film reinforced its allure, confirming Paris, as Tag Gronberg has demonstrated, as a 'ville lumière, world

centre of luxury shopping'; a superiority that 'was heavily predicated on advertising notions of femininity . . . a feminised city . . . a woman's city'.[3]

This chapter extends this discussion into the area of male modernity and considers the significance of technologically mediated cultural forms in shaping men's urban experience and attitudes towards Parisian interiors. It examines the work of the Séeberger brothers, Jules (1872–1956), Louis (1874–1946) and Henri (1876–1956), who in 1906 established a family-operated photography studio in Paris, initially as co-producers of postcards of Parisian sights and French landmarks. In 1909, following an invitation by Madame de Broutelles, editor of La Mode Pratique, the brothers began to undertake fashion photography. Their headed notepaper announced their business as 'High Fashion Snapshots. Photographic Accounts of Parisian Style'. Their photographs of leading celebrities or paid models wearing the latest season's outfits were reproduced by French women's magazines such as Les Élégances Parisiennes (1916–1929), Vogue

(1916–1939), *Femina* (1916–1935), *La Femme Chic* (1916–1939), *Les Modes* (1917–1925), *Le Jardin des Modes* (1929–1939) and *Vu* (1928–1939) or syndicated abroad to foreign press agencies (notably Fairchild Publications (1930–1939) and the Associated Press (1937–1939)) as well as to foreign journals, including the English-language publications *Harper's Bazaar* (1918–1939) and *Good Housekeeping* (1929–1935).[4]

From 1923 to 1931, the Séeberger brothers added another sideline to their business, acting as purveyors of photographs of Paris and Parisian life to a Hollywood cinema agency, International Kinema Research Corporation. First contacted by Mr. L. A. Howland in October 1923, the Séeberger brothers were commissioned to produce photographs and photographic picture postcards upon request, supplying specified views of Paris 'interiors and exteriors of hotels, railway stations, cafés and theatres, shops, street scenes etc'.[5] These images would be consulted by artistic and technical directors of films on Parisian, or broadly French, subjects who wished to have 'authentic' film sets produced for the American movie industry. Over eight years, until 2 May 1931, the Séeberger brothers furnished the agency with a comprehensive photographic archive of interwar Paris. Although rarely copied wholesale into American film sets, nevertheless, these locations evoked a Paris and 'Parisianism' that exerted a captivating hold on the American imagination. It was one that became the source for a fictive and distinctively cinematic Paris — 'Paris, Hollywood' — that persisted in American cinema through the 1970s.[6]

On many levels, the Séeberger brothers' photographic practice commercially exploited the entrepreneurial opportunities provided by the complex and dynamic circuits of international visual culture as it emerged and was developing within the early twentieth century. As Walter Benjamin recorded, 'every day the urge grows stronger to get hold of an object at very close range by way of its image or, rather, its copy, its reproduction. Unmistakably, reproduction as offered by illustrated magazines and newsreels differs from the image.'[7] Moreover, the Séeberger brothers' freelance business kept pace with the increasingly sophisticated visual technologies evidenced by the picture postcard, the fashion still and the snapshot in the illustrated press, providing the means for approaching contemporary Paris as one of many metaphors for an updated and pervasive visual modernity that used the streets and social life as the sources for its new visual language.[8]

In trying to unravel these intricate photographic re-inscriptions of Parisian interiors and modernity, it becomes evident that for the Séeberger brothers, knowing the tropes of earlier popular repertoires within visual and literary culture and mapping them onto changing metropolitan perceptions was a precondition of commercial success. In their early career, knowledge of the 'Paris' of nineteenth- and early-twentieth-century guidebooks, travel literature and travelogue films was essential when inscribing these pre-existing narrative codings into that 'immense enterprise' which was the comprehensive 'post carding of Paris'.[9] Postcard photography strategically transformed urban spectatorship

and gendered viewing practices from its rapid expansion in 1900 when there were approximately 100,000 postcard views of Paris available. Its market, more often than not, was the tourist, notably women visitors, in the new age of urban mobility and leisure. This striking engagement of visual culture with the market opportunities provided by female spectators as consumers expanded before and after the Great War, when, following the gender upheavals of 1914–1918, women's increased social and economic significance registered not only in their enhanced degree of public visibility, but also in the way that the mass media, especially photojournalism and film, orientated itself towards female spectatorship.

In this respect, the Séeberger brothers' increasing specialization in fashion journalism is revealing. Between 1919 and 1939, they photographed for all the leading Paris fashion houses and after 1918 quickly established a reputation as photojournalists of international stars, leading celebrities and the wealthy, capturing the mainstays of the high society season, including events at racetracks, seaside resorts and winter sports centres.[10] Available in the new and cheaper forms of the illustrated press and the photo-book (containing compilations of film stills, on set shots or fan-club photographs) and syndicated extensively abroad by international press agencies, the market for freelance photographers such as the Séeberger brothers was primarily, though not exclusively, magazines aimed at fashion-conscious younger female consumers. Moreover, these illustrated magazines—such as *Vu,* which published the Séeberger brothers'

photographs from 1928 to 1939—pioneered a new type of collaged and 'filmic' layout in which it employed snapshots and human interest photographs in photo-essays that covered the overlapping worlds of theatre, music hall, cinema, sport, art and fashion.[11] Photographs of international celebrities such as Mistinguett, Josephine Baker, the Dolly Sisters, Harry Pilcer, Gaby Deslys (captured at Deauville with Pilcer in a dress by couturier Jenny in 1919, see Fig. 7.1), Lily Damita (photographed in Biarritz in 1933, see Fig. 7.2), Errol Flynn, Marlene Dietrich, Buster Keaton, Michael Farmer and many more were regularly featured in these magazines to promote and reinforce the notion of a sophisticated, cosmopolitan modernity.

This international interest in and fascination with Paris, its *beau monde* and its cosmopolitan neighbourhoods did not go unnoticed by commercial entrepreneurs or by the new style capitalists such as the press distributors and film agencies who were eager to employ freelance photographers to cover not only news items, but also topical interest stories. The recruitment of the Séeberger brothers by the International Kinema Research Corporation in 1923 was both timely and opportunistic. The choice of Parisian locations, viewpoints and details that they were required to photograph was dictated in French by the American agency in telegrams from California (often incorporating misspellings of names and abbreviated telegram-speak). To cite an example from Howland: 'La Cigale, interior only; Nouveau Cirque; Foilies Bergères; L'Abbaye de Thélème; Perroquet, Chez Pigall . . . Bal Tabarin, Embassy Club, Rector, The Seymour,

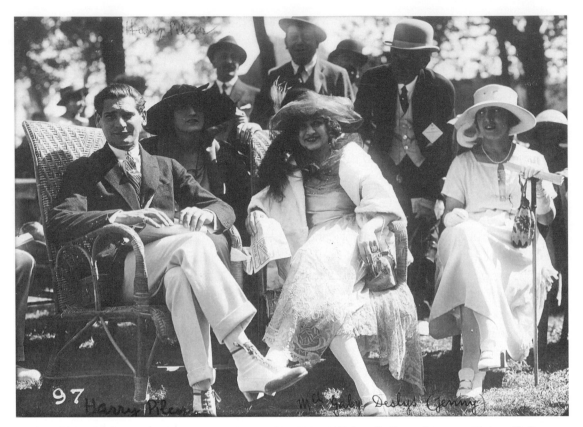

Fig. 7.1. The Séeberger brothers. Photograph of Harry Pilcer and Gaby Deslys, 1919, Deauville, France. Estampes et Photographie © Bibliothèque nationale de France.

Casino de Paris; Concert Mayol; Restaurant de Voisin; . . . A country inn—picturesque; A Peasant's house; A Fine garden of the sort a rich family would have; Garage and petrol station where you buy petrol; A French Boudoir elegantly furnished.'[12] Requests ranged from general views of cafés, hotels, shops and restaurants to specific photographs of interior fittings and details (such as taxi phones and telephone booths in well-known bars). Accuracy of visual information was essential. As the agency had clearly stated in an earlier telegraph, what they required were 'interior and exterior views of each subject . . . Our speciality is to provide authentic details of

the interiors and exteriors of buildings for the film studios of Hollywood in order that the film sets may be constructed in a convincing and accurate way. It is always preferable that your photographs show no people'.[13]

Attention to detail and the supply of sufficient corroborating evidence was crucial to attaining authenticity in the Americans' eyes, and they stipulated that 'if you take [a photograph] of a café, we strongly advise [one of] the menu and the receipt of the bill given to you by the waiter as well. In the case of a theatre, we want an entrance ticket marked and stamped. If you take a shop, we would like a photo of the receipt with the

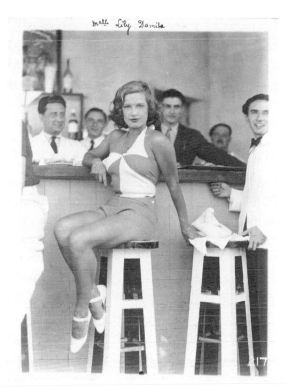

Fig.7.2. The Séeberger brothers. Photograph of Mlle Lily Damita, Biarritz, France, September 1933. Estampes et Photographie © Bibliothèque nationale de France.

name of the shop on it. All these documents are useful in order to give an air of reality to the film, and please understand that we are ready to buy all such photos at a reasonable price.'[14] The largest number of requests was for photographs of famous Paris hotels such as the Ritz, the Crillon and the Prince of Wales. Also in demand were images of fashionable restaurants such as Le Dôme (photographed in 1931), Le Café de la Paix, Maxim's and Les Capucines, photographed from the outside as well as inside. Shots of recently refurbished American-style cocktail bars (such as Harry's New York Bar), night clubs (such as Le Perroquet) and spectacular revue halls such as the Moulin Rouge

and Folies-Bergère (whose toilets were eventually photographed three years after the initial request) were also commissioned. In addition, views of popular landmarks like the Place du Tertre in Montmartre were ordered as well as interior photographs of local cafés and bars. These sights and stops on tourist itineraries mapped closely onto those popular with American expatriates and tourists in Paris and were increasingly familiar to younger U.S. audiences. The Séeberger brothers followed these instructions to the letter, especially when they came attached to diagrams showing where and in what ways to photograph subjects in order to aid the smooth production flow of the film cameras and make the work of the Hollywood film crews easier.[15]

In the interwar years, rapid technological improvements in cinematography meant that sophisticated visual illusions and new mobile languages of visual editing and, later, sound-tracking re-orchestrated 'Parisianism' to fit the requirements of sequencing and editing procedures *à la mode américaine*. These refurbishing processes were symbolically at their most acute, as Jonathan Crary has argued, with the arrival and expansion of the synchronized sound film in Europe from the late 1920s.[16] Not only did the 'talkie' demand a new kind of attention from its audiences, but as Crary asserts, 'the full coincidence of sound with image, of voice with figure, not only was a crucial new way of organising space, time and narrative, but it instituted a more commanding authority over the observer enforcing a new kind of attention.'[17] Film refigured Paris and its mythologies within 'spectacularizing' models

of mass consumption aimed at international audiences and dubbed into English from 1932.[18] Moreover, as film companies targeted the expanding markets of female consumers, thereby opening up differences in approach between traditional masculine and feminine experiences of the city, so film reconfigured and updated older, more established readings of Paris for the younger, more economically independent female audiences. As the German film director G. W. Pabst warned in an article in *Close Up* in December 1927, what was not needed were outmoded and jejune literary precedents, nor any replication of the paste-board parodies circulating within 'the Paris of the [silent] films, a place of Moulin-Rouges, cheap cabarets, carnival streamers, apache dancers and views of the Rue de Rivoli'.[19]

Although dominant accounts stress Paris as embodying women's modernity in the interwar years, younger men were also implicated in these exchanges. Throughout the 1920s, the signification of Paris as fashionable and sophisticated for British audiences was informed by articles syndicated in influential fashion and lifestyle magazines such as *Vogue, Harper's Bazaar* and *Good Housekeeping* for whom the Séeberger brothers regularly worked. Many British men were affected by greater exposure in film and the mass media to alternative French and other European, especially Latin, and non-Western models of masculinity and manliness. Illustrated magazines like *Vogue* published regular bimonthly gossipy columns from Paris that mixed fashion, dance, cinema, literature, theatre, interior design and art alongside the comings and goings of high society, thereby publicizing more relaxed, contemporary masculine role models. Exposed to sexual ambiguity, androgyny and altered gender definitions, their approach to social freedom and sexual emancipation was framed by and according to these up-dated cosmopolitan re-inscriptions of Paris and 'Parisianism'.[20]

To take one example, the British artist Edward Burra was intermittently resident in Paris from 1925 until 1933. Burra thrived in the city, and his letters home glory in the endless cycle of bars, cafés, cinemas, music halls, revues and parties in which gender roles were fluid and sexual protocols relaxed. Writing in October 1928 from the Hotel du Calvados, rue du Départ, Montparnasse, Burra noted how the vibrant world of Parisian urban culture and street life could only be understood as a dazzling kaleidoscopic array where 'real' life intersected with media references, celebrity identifications and memory-spectacle. His accounts structure it as a montage of interrelated popular cultural sources including references to the recently released German film by G. W. Pabst, *Die Liebe der Jeanne Ney* (1928), film stills, fashion magazines, *Vogue* illustrations and shopping. He wrote in October 1929 that 'the hotel . . . is exactly like the hotel in the Loves of Jeanne Ney . . . We went to *La Grande Adventurière* . . . Lilli D[amita] looks just like a continuous succession of *Vogue* drawings, covers of *Harper's Bazaar, Vanity Fare* [sic] and drawings by André Lepape . . . *Crise* the new Pabst film is starting here on Friday for a Grand run . . . I must go. the photos look glorious.'[21] Later, having been to the restaurant Le Dôme, which Burra referred to as 'the most interesting place in all Paris' and

'the café des ruins americain',[22] he wrote, 'Have you ever seen anything so lovely as the Bazaar Hotel de Ville. Its my ideal shop.'[23] It was in these Parisian inner city commercial geographies and within these overlapping French and expatriate communities that an emancipated cosmopolitanism thrived; any account of which was framed by and according to these new media and filmic approaches to urban modernity.[24]

One feature of interwar Paris as a terrain of masculine social and sexual freedoms was the way the city sanctioned modern configurations of homosociality and generated updated human-interest stories, especially involving the underworld and prostitution. The Hollywood agency was clearly already aware of the appeal this side of Paris had to younger American filmgoers when in 1930 they commissioned the Séeberger brothers to photograph the cafés, bars, *bals musettes* [popular dance halls] and shops on the working class rue de Lappe near Les Halles, stipulating: 'The Rue de Lappe, taken from every angle—views—ext[erior] and int[erior]; details of some shops situated on the street—photos of the inhabitants of the quarter—details of entrances and alleys round about the rue de Lappe'.[25] In response, the brothers photographed the street itself, its intersection with the Passage Thiéré, the courtyard of number 26 and what they called 'a maison apache': a gangster den. They also snapped the exteriors and interiors of the Bal Monteil at 21 rue de Lappe, the Bal Bousca at number 11 and the dance hall of Au Petit Balcon (see Fig. 7.3).

Although once celebrated as clandestine spaces for encountering criminal types, gangsters, prostitutes and drug dealers and cruising for rough trade, the *bals musettes* and *bals mixtes* of the rue de Lappe were already well documented within contemporary tourist literature, the illustrated press and popular literature, music and film by the late 1920s.[26] French city guides such as *Paris en flânent* (1927) and *Comment et où s'amuser à Paris* (1932) and English-language ones such as *Pleasure Guide to Paris* (1927) encouraged adventurous tourists to venture out at night (with the security of a plain-clothed police escort if necessary).[27] The itinerary took in the 'dingy and very dangerous edens' and *boîtes de nuits* of the city's northern red-light areas, then the rough and roady *caboulots* of Montmartre and concluded with the underworld dance halls of Belleville, Menilmontant and Les Halles, notably the rue de Lappe and Passage Thiéré, particularly recommending the Bal Bousca.[28] Such itineraries structured Paris as and through a series of unlikely encounters in underworld interiors inhabited by shady individuals, prostitutes and criminal gangs—narrative trajectories and characterization common in the popular detective and underworld novels that had themselves been transformed by Hollywood screenwriters into successful contemporary films.

These late-night neighbourhoods with their disreputable establishments were a regular feature in popular French illustrated journals, notably *Détective, Voilà* and *Variétés,* where photographs by Germaine Krull, Eli Lotar, André Kertész and Brassaï, amongst others, were employed as part of an innovative montage layout on 'Montmartre nights' or 'Venal Paris', or within racy photo-stories

Fig. 7.3. The Séeberger brothers. Photograph of dance hall 'Au petit balcon', rue de Lappe, Paris, 1930. Médiathèque de l'Architecture et du Patrimoine, Paris © Ministère de la Culture—Médiathèque du Patrimoine, Dist. RMN / Frères Séeberger (FSK35-03).

that went 'behind the scenes' of the Paris underworld. In April 1931, *Détective* featured just such a story with a cover photograph, probably by Krull or Lotar[29] (see Fig. 7.4) as part of an exposé of '*La rafle au musette*' ('the police raid on the popular dance hall') in which the Parisian police force had attempted to clean up the most notorious dance halls of northern and eastern Paris. Showing the packed dance hall inhabited by apache gangsters wearing their distinctive caps, heavily made-up prostitutes and on-leave French sailors in uniform, the caption identified the precise location—the rue de Lappe: 'Rue de Lappe . . . the accordion sobs . . . the gangsters are diverted by the rhythms of the java or planning the next night's attack . . . Outside the vans of the Paris police headquarters discharge an army of detectives, it's a police raid'.

Whilst the *bals* held the vicarious excitements of going slumming and the possibility of illicit contacts with a criminal underclass, these marginal spaces also fostered diverse forms of heterosexual and homosexual cultures. As Daniel Guérin recalled: 'These night clubs [in the Rue de Lappe] were sexual, not homosexual, but in them there was enormous permissiveness—people didn't kiss though, as the "lads" stuck to their

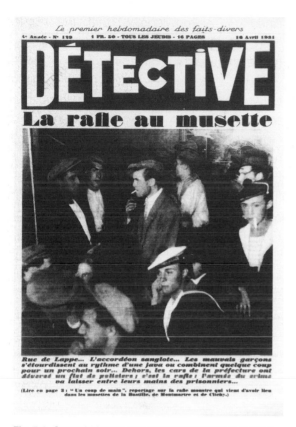

Fig. 7.4. Cover of *Détective*, April 1931 © Bibliothèque nationale de France.

out'.[34] It was on this same visit that Burra's friend William Chappell reported that he had 'danced with one of the Spaniards who made Freddie [Ashton] buy drinks. He had awful breath but was quite a twee of course. The one I should have liked would not dance. The great thrill of the evening was to see Ed and me doing a voluptuous tango . . . The loveliest thing about the dancings in the Rue de Lappe is that one sees the toughest creatures in check caps and mufflers with heavy painted faces dancing together'.[35]

From the evidence of these letters, indecency and crime, hot-blooded Latin types, duplicitous working-class men, cross-dressing, passionate dancing, pronounced makeup and open displays of bisexuality and homosexuality mark out the seductive culture of the dance hall in terms of the visibility of its social diversity and sexual alterity. As an escape from the restraints of bourgeois English respectability, these inner city spaces generated a frisson of danger and erotic possibility that Guérin also recalled: 'For men like me who loved soldiers or simple types [from the working class], the whole décor of the Rue de Lappe, its sound of accordions and the traditional sirop drinks, made up an ensemble of passion.'[36] It was this interior space, its layout, décor and lighting, the sounds of the accordions, the unrestrained java and tango dances and the bustling excitement that stirred the imaginative potential for sexual adventure and evoked connotations of illicit desire that the Hollywood film industry was eager to capture and market. And it was the visual details of these locations that the Séeberger brothers were careful to supply to the Hollywood agencies so that Californian

virile image.'[30] Central to their attraction was dancing, especially the tango and the java.[31] Burra first visited the rue de Lappe in March 1927 when 'there was quite a little fricassee at the Bal. arrested for indecency indeed. did you ever?'[32] In October 1928, Burra reported again that 'we penetrated about 40 miles into old Montmartre (the heart of the Apache quarter, you know)'.[33] Ten days later, Burra was back at the dance halls on the rue de Lappe reporting that everyone in the dance hall thought his friend Sophie Fedorovitch was a man and addressed her as 'monsieur' and 'as for the matelots such buttocks ma chere and the lesbiennes so long drawn

carpenters and set designers would be able to reconstruct an 'authentic' Parisian dance hall interior in which its star actors could perform its density of meanings.[37]

To conclude, my study of the rue de Lappe in Paris has opened up the complex and highly sophisticated ways within which interwar consumers approached and understood the potential significations of the *bals musettes* as they were depicted by freelance photographers such as the Séeberger brothers, relocated within the dynamic layouts of photo-journals, appropriated and recast by Hollywood film directors and disseminated by international film agencies and distributors of American films. These wider shifts in the conditions of visual consumption and gendered spectatorship within photojournalism and film carried profound implications for the Séeberger brothers' updating of Paris and its popular tropes for international consumption. At a time of the most extensive, heterogeneous interface of American advanced mass technology, tourism and consumerism with the city and 'Parisianism', the view of Paris that derived from their photographs became the archival source for a whole fictive 'Paris' that persisted in American cinema well after World War II. More specifically, the Séeberger brothers' collections currently housed in the Bibliothèque nationale de France, the Archives of the Caisse Nationale des Monuments Historiques et des sites and the Bibliothèque historique de la Ville de Paris proffer a memorable lexicon of fashionable identification that had been extensively disseminated and syndicated in the illustrated press, in film stills, in photo-books and by

cinema.[38] Acknowledging that this filmic 'Paris' and its interiors exerted a captivating, transformative hold on their imagination, many younger interwar audiences were caught between the pull of localized French culture and the force of American consumerism. Given the connotative wealth of these dance halls and the exotic and erotic appeal that they held whatever your sexual preferences, these sites, experienced at a safe distance, nevertheless presented a powerful challenge to normative masculine behaviour and to the polite standards of middle-class masculinity in Britain or the United States. Many younger male consumers (and many women, too) would, no doubt, have agreed with the German film director, Ernst Lubitsch, who moved to Hollywood in 1922, when he remarked, 'I've been to Paris Hollywood and Paris France, and Paris Hollywood is better.'[39]

Notes

I am indebted to Beverly Gordon's scholarship on colonial dressing for many ideas in this chapter.

1. This popular song sung by Nora Bayes, a successful American singer and comedienne, was written by Walter Donaldson, Sam Lewis and Joe Young and released in 1919. It primarily addressed, in a humorous way, the issue of how American GIs returning from World War I and having spent time in Europe would re-adapt to provincial and rural American lifestyles.

2. W. Benjamin, 'The Artwork in the Age of Its Technical Reproducibility' [1935], as translated by M. Hansen in 'Benjamin, Cinema and Experience: "The Blue Flower in the Land of Technology"', *New German Critique* 40 (Winter 1987), special issue on Weimar Film Theory, p. 184.

3. T. Gronberg, *Designs on Modernity: Exhibiting the City in 1920s Paris* (Manchester University Press, 1998), p. 23.

4. For a full list of journals in which the Séeberger brothers' photographs were published see S. Aubenas, X. Demange

with V. Chardin, *Elegance: The Séeberger Brothers and the Birth of Fashion Photography 1909–1939* (Chronicle Books, 2007), p. 223. This is a translation of their earlier French publication, *Les Séeberger Photographes de l'Élégance 1909–1939* (Seuil/Bibliothèque nationale de France, 2006).

5. My translation from the telegram from L. A. Howland to the Séeberger brothers on behalf of the International Kinema Research Corporation dated 26 October 1923 quoted in G. Salachas, *Le Paris d'Hollywood* (Caisse nationale des monuments historiques et des sites, 1994), p. 11. All subsequent translations are my own.

6. See M. Blume, 'The Heyday of the Seine in Hollywood', *International Herald Tribune* (19 August 1995), p. 10. Alice Yaeger Kaplan addresses this idea of a 'France made in the United States' in a broader analysis of American attitudes towards France and French culture in A. Y. Kaplan, 'Taste Wars: American Professions of French Culture', *Yale French Studies* 73 (1987), special issue on Everyday Life, pp. 156–72.

7. Benjamin, 'The Artwork in the Age', p. 183.

8. For a discussion of Parisian modernity and photography see K. Sichel, *Germaine Krull: Photographer of Modernity* (MIT Press, 1999), pp. 83–112.

9. See N. Schor, 'Collecting Paris', in J. Elsner and R. Cardinal, eds, *The Cultures of Collecting* (Reaktion Books, 1994), pp. 252–74, quotation p. 265.

10. See X. Demange, 'Trend Setters at the Race Track', in Aubenas, Demange with Chardin, *Elegance: The Séeberger Brothers*, pp. 28–36.

11. For *Vu*'s innovative layout and photographic editing see M. Frizot and C. de Veigy, *Vu: The Story of a Magazine that Made an Era* (Thames & Hudson, 2009), pp. 18–22. This is an English translation of their original *Vu: Le magazine photographique, 1928–40* (Éditions de la Martinière, 2009).

12. Telegram from Howland to the Séeberger brothers dated 2 January 1925.

13. Telegram from Howland to the Séeberger brothers dated 10 November 1924.

14. Telegram from Howland to the Séeberger brothers dated 30 September 1926.

15. A sketch included in a telegraph from Howland dated 30 September 1926 showed which three viewpoints should be adopted by the Séeberger brothers in their photographs in order to allow easy access for the cameras when a Hollywood set of Harry's New York Bar was reconstructed. Many examples of these photographs of Parisian bars, nightclubs and restaurants are reproduced by G. Salachas in *Le Paris d'Hollywood*, pp. 102–15, with the diagram illustrated on p. 14.

16. J. Crary, 'Spectacle, Attention, Counter-Memory', *October* 50 (Fall 1989), pp. 97–107.

17. Ibid., p. 102.

18. See A. Stephenson, 'Pariscope: Mapping Metropolitan Mythologies and Mass Media Circuitry', *Oxford Art Journal* 18/1 (1995), pp. 160–5.

19. G. W. Pabst, *Close Up* (December 1927).

20. In relation to *Vogue*'s liberal approach to sexuality, especially addressing homosexual audiences, see C. Reed, 'A *Vogue* that Dare Not Speak Its Name: Sexual Subculture during the Editorship of Dorothy Todd, 1922–26', *Fashion Theory* 10/1–2 (March–June 2006), *Vogue* special issue, pp. 39–72. On the recommendation of Madge Garland, Todd's partner, Edward Burra was approached to work for *Vogue*. See J. Stevenson, *Edward Burra: Twentieth-century Eye* (Jonathan Cape, 2007), p. 132. For *Vanity Fair*, see M. Murphy, 'One Hundred Percent Bohemia: Pop Decadence and the Aestheticization of the Commodity in the Rise of the Slicks', in K.J.H. Ditmar and S. Watt, *Marketing Modernisms: Self-Promotion, Canonization, Rereading* (University of Michigan Press, 1996), pp.64–6.

21. Letter to Barbara Ker-Seymor from Edward Burra dated 9 October 1928, published in W. Chappell, *Well Dearie! The Letters of Edward Burra* (Gordon Fraser, 1985), pp. 45–6.

22. Quoted in Stevenson, *Edward Burra*, p. 111.

23. Burra was a regular reader of *Vogue* and *Harper's Bazaar*, and he frequently mentioned it in letters. See Letter to Barbara Ker-Seymor from Edward Burra dated 9 December 1927, published in Chappell, *Well Dearie!* p. 40, where he asks 'I lave you seen the December vogue?'

24. For Burra's circles in Paris see Stevenson, *Edward Burra*, pp. 118, 169–74. Guides such as Thérèse and Louise Bonney's *A Shopping Guide to Paris* (Robert M. McBride & Company, 1929) and *A Guide to the Restaurants of Paris* (Robert M. McBride & Company, 1929) were crucial in advising American visitors, especially young women, where to go and what to see. Thérèse Bonney was a journalist and photographer who published her work extensively in the *New York Times, New York Herald Tribune, Vogue* and *Harper's Bazaar*. See L. Schlansker Kolosek, *The Invention of Chic: Thérèse Bonney and Paris Moderne* (Thames & Hudson, 2002).

25. Telegram from L. A. Howland to the Séeberger brothers quoted by Salachas, *Le Paris d'Hollywood*, p. 77. The photographs of the rue de Lappe and Passage Thiéré are reproduced in Salachas, *Le Paris d'Hollywood*, pp. 76–83.

26. See L. Chevalier, *Montmartre de Plaisir et du Crimes* (Editions Robert Lafont, 1980), pp. 321–31. For a full account of how Paris is configured within the Parisian entertainment industries and in music see A. Rifkin, *Street*

Noises: Parisian Pleasure 1900–40 (Manchester University Press, 1993).

27. *Paris en flânent* (Editions d'Art Yvon, 1927) and *Comment et où s'amuser à Paris* (Editions du Couvre Feu, 1932) and *Pleasure Guide to Paris* (Editions Fontenay aux Roses, 1927).

28. This advice and details are given in *Pleasure Guide to Paris*, pp. 125–6.

29. It is often difficult to identify exactly which photographer took which view as the same image is in different magazines accredited to Germaine Krull and Eli Lotar. Probably the most well-known and reproduced images of these *bals* and underworld communities are Brassaï's published as *Paris de Nuit* in 1933.

30. Interview with Daniel Guérin in G. Barbedette and M. Carassou, *Paris Gay 1925* (Presses de la Renaissance, 1981), pp. 48–9.

31. For the growth of 'tangomania' in Paris in the 1910s and 1920s and the avant-garde interest in the tango, see M. E. Davis, *Classic Chic: Music, Fashion and Modernism* (University of California Press, 2006), pp. 84–6.

32. Letter to Barbara Ker-Seymer from Edward Burra dated 1927.

33. Letter to Barbara Ker-Seymer from Edward Burra dated 9 October 1928, published in Chappell, *Well Dearie!* p. 44.

34. Letter to Barbara Ker-Seymer from Edward Burra dated 19 October 1928, published in Chappell, *Well Dearie!* p. 46.

35. Quoted by Stevenson, *Edward Burra,* p. 173.

36. Interview with Daniel Guérin in Barbedette and Carassou, *Paris Gay 1925,* p. 48.

37. On questions of performativity see the introduction to A. Jones and A. Stephenson, *Performing the Body/ Performing the Text* (Routledge, 1999).

38. The extent of these archival holdings is summarized in 'Le Fonds Séeberger, Kinema', in Salachas, *Le Paris d'Hollywood,* pp. 130–3.

39. Quoted by Blume, 'The Heyday of the Seine', p. 10.

Chapter Eight

Fashioning thrift: finding the modern in everyday environments

Mary Anne Beecher

As recent shifts in the international economy cause designers to consider their ability to encourage responsible and economical approaches to the creation of our built environment, much can be learned from the past about how design thinking has empowered the public to employ notions of thrift to improve their domestic circumstances. The period of the 1930s provides a particularly relevant backdrop for the study of how consumers promoted the creation of modern environments for themselves and their families in a time of economic depression, when dire financial constraints limited access to resources and building materials. Focusing on the contributions of women to the establishment of design processes that enhanced middle- and working-class Americans' access to modern design, this chapter investigates how taking a broader view of the definition of modern design can reveal new ways of conceptualizing it. While most of the examples discussed in this article pertain to the circumstances of rural Americans, there is ample evidence in the popular women's journals of the period to

suggest that American women in cities and towns were grappling with the same issues and drawing the same kinds of conclusions.

When examining women's contributions to the design of their daily lives in the early twentieth century, the topic often shifts to the study of making and, more specifically, to women's skills in front of a stove and behind a sewing machine. Most middle-class American women in the first half of the twentieth century learned how to sew by the time they reached adulthood, and many served their families as relatively skilled seamstresses.[1] Mothers passed the art of sewing on to their daughters, beginning with simple mending techniques and advancing to clothing construction and the creation of goods for their household.

In public secondary education, courses in 'home economics' typically included sewing lessons so that teenaged girls who hadn't learned to sew at home had the opportunity to acquire those skills. Even girls who learned from their mothers benefited from home economics instruction because the techniques presented were the 'best

practices' of sewing, and more advanced techniques could be explained and practiced until acquired. Within the context of their high school education, future homemakers discussed the design principles of fashions and gained experience selecting fabrics and designs for themselves. With home economists trained in the fundamentals of textile science and garment manufacturing to guide them, young American women often constructed garments that were expected to match the features and quality of their ready-to-wear competitors, and the evaluation of their work used this premise as a yardstick to determine the level of their success.

Young women with access to college-level study often sought more advanced education in the science of textiles and the production of clothing. In colleges and universities across the United States, professors encouraged experimentation with the science of dyeing, a more advanced analysis of styles based on design principles and the execution of modern assembly techniques. Students designed their own patterns in these courses, constructed their own garments and often modelled the results. At many agriculture and technology-oriented universities in the United States, such as those first established as part of federal land-grant legislation known as the Morrill Act in the mid-nineteenth century, students worked on projects in 'clothing laboratories' that supported the collaborative development and critical analysis of design ideas.[2]

Women who didn't attend college could also access additional education in home economics through the federally sponsored Cooperative Extension Service, which was officially established by the Smith-Lever Act in 1914. Operated through land-grant universities across the United States, the Cooperative Extension Service provided information on a range of domestic topics that included nutrition, child-rearing techniques, housekeeping processes and domestic design. Most schools supported professional extension-oriented staff members who travelled into communities and rural areas to facilitate presentations and discussion groups to enhance the accessibility and usefulness of the knowledge made available by the programme.

Much of the information provided by the Cooperative Extension Service came in the form of publications that could be mailed out to constituents in rural areas of the country. Faculty members at the colleges developed the content of the small illustrated pamphlets through their research and experimentation. Typical extension publications such as Cornell University's 1926 bulletin no. 126 by Annette J. Warner, entitled *Artistry in Dress,* included a general lesson followed by detailed descriptions of the processes necessary to conduct the activities recommended in the bulletin.[3] In the case of *Artistry in Dress,* Warner began by providing an explanation of the principles of design and aspects of colour theory along with a brief history of costume. Lessons about the use of the elements and principles of design such as line and texture in the creation of garments formed the most critical content. The intent of this bulletin was to help readers become more skilled designers (or selectors) of their own wardrobes. By studying such publications and discussing them with other women, readers learned

about proportion and scale and about the effect of pattern and form on the composition of the figure. These practically oriented lessons became particularly valuable when the economic crisis of the 1930s minimized a family's opportunities to purchase new goods and improve their living circumstances.

Despite the fact that middle-class women had little means and few opportunities to shop for the latest modern fashions seen in the fine stores of New York City, they could access the newest design trends in the pages of their magazines. Unlike more exclusive magazines such as *Harper's Bazaar,* popular American magazines such as the *Delineator* (begun by the Butterick Company—the first in the United States to manufacture patterns for clothing in graded sizes) showed illustrations of each season's latest styles for women and children routinely and published them with corresponding Butterick pattern numbers and advice for readers about how to choose appropriate colours and fabrics. With pattern prices ranging from 30 to 50 cents each, the prospect of manufacturing one's own modern dress instead of purchasing clothing from a store better suited the budgets of most Depression-era women in the early 1930s.

Although the *Delineator* did not stress the effects of the economic depression in its pages, it did include subtle suggestions for strategies for improving one's wardrobe without purchasing ready-to-wear garments. By emphasizing the details that defined a season's style, authors of the *Delineator*'s articles recommended tactics for 'modernizing' older garments, and they subtly encouraged readers to save money by acting as their own seamstresses. They also described wardrobe accessories such as collars and cuffs that, if constructed, would allow a single garment to serve double duty.

It is particularly interesting that authors of all kinds of sewing literature in the 1930s borrowed terminology from the building trades and drew a clear distinction between expressions such as renovating and remodelling. To these garment technologists, 'renovating' garments involved making simple improvements by laundering, dry cleaning or otherwise freshening garments or by changing their colour through dyeing. Changing buttons, adding decorative stitching or pockets or other slight alterations also fell into this category. Even women without advanced sewing skills or access to a sewing machine could accomplish these upgrades.

'Remodelling' garments involved making more radical alterations such as dismantling an article of clothing and recutting it to change its size and/or style. By taking the typically more voluminously styled garments of the early twentieth century apart, sleeves could be shortened or reshaped, and the fit of a shirt, skirt or a gentleman's trousers could be tailored into flatter, tapered or more closely fitting up-to-date forms. Sometimes garments for one family member were transformed into clothing for others. This ability to expand one's wardrobe through remodelling appealed to the progressive attitudes of many Depression-era Americans, as expressed by the flowery prose of one extension publication that noted, 'If making two blades of grass grow where one grew before is a feat to be proud of, then surely the making of a comfortable, becoming, and

attractive dress from a garment discarded and seemingly useless is cause for rejoicing.'[4]

Through instruction by demonstration and publication, home economists and extension educators strongly encouraged their students to 'remodel' garments as a valid approach to attaining a modern wardrobe. Across the United States, extension curricula included presentations on 'style trends' that articulated the most desirable shapes and silhouettes, materials, colours and popular types of accessories.[5] A middle-class family's lack of material resources for clothing projects required the innovative use of older, worn-out garments as raw materials for new projects. Women used worn or damaged adult clothing to fashion modern garments for their children. They changed the sleeve design, colour or waist positions of their own dresses to update them. They were not, however, made to feel inferior about the invocation of a remodelling process. The opposite is, in fact, the case. The intellectual and material wastefulness of using new fabrics is implied by one publication's claim that 'there is no doubt about the fact that it takes more brain power and work to produce a successful make-over than it does to make a lovely gown from sumptuous new material, for the pieces of material to be made over have certain set limits beyond which (seamstresses) may not go, while new material stretches out yard upon yard to lure the scissors'.[6] As a rhetorical strategy, the intellectual superiority of working within such boundaries helped extension educators appeal successfully not only to women's desire to be economical, but also to their desire to demonstrate their creativity by enhancing the beauty of their belongings.[7]

As evidence of their success, extension specialists reported in 1930 that teaching remodelling principles to homemakers saved an estimated $3,022.20 in one county in New York State alone.[8]

Once extension educators established a philosophy that privileged remodelling or remaking articles of clothing over the purchase of more expensive ready-to-wear garments with their constituents, the desirability of improving one's living environment through the use of similar strategies developed naturally. With limited economic resources to use to acquire up-to-date furnishings, 'reconditioning furniture' became a popular activity for women interested in making use of worn or outdated seating pieces, tables, beds and chests of drawers. The same women who were competent at generating fitted patterns and disassembling garments to recut and reconstruct them into a new outfit learned to evaluate furniture forms and structures to determine the alternative designs their raw materials afforded. Updating the appearance of chairs, couches and stools with new upholstery and reshaping objects such as beds and chests of drawers, therefore, increased women's ability to generate modern furniture designs of their own.[9]

Unlike garments that could take on strikingly new appearances, remodelling strategies for furniture did not involve radical transformation because home economists nearly always stressed the notion that modern design was characterized more by the favouring of function based on principles over the inclusion of particular stylistic features. In the case of chairs, women were encouraged to alter the more ornate Victorian designs

and more heavily proportioned Mission-style pieces they might have on hand to evoke other traditional styles of upholstered chairs, such as wing-backed forms, using more comfortable padding and up-to-date fabrics. Integral but historical structural features such as turned or carved legs were often retained while women eliminated extraneous ornament such as attached carvings and old-fashioned hardware in order to evoke a modern expression. Women learned to create modern characteristics by lightening and simplifying surfaces and silhouettes and increasing the usefulness of outdated furnishings by enhancing their comfort with new springs and better padding without feeling compelled to create radically streamlined forms.

As with clothing remodelling, the extension service at various American universities produced bulletins such as Extension Bulletin 256: *Reconditioning Furniture,* by Florence E. Wright (part of the Cornell Bulletin for Homemakers series).[10] These publications introduced 'students' to the tools needed to do the work of reshaping and recovering chairs along with placing new springs and webbing into their inner spaces. They provided detailed criteria for selecting appropriate candidates for reconditioning and illustrated the bulletins with before-and-after pictures that challenged readers to see the connections between the outdated chairs and their new modern identities (see Figs. 8.1 and 8.2).[11] Using diagrams to illustrate the processes of producing specific types of knots or stitching strategies for tying new springs into place, the bulletins' authors relied on women's familiarity with reading sewing patterns to read the sectional line drawings of chair components (see Fig. 8.3). Because the primarily rural recipients of this information were no strangers to manual labour and the use of some tools, the idea of cutting off a chair's back or restructuring its arms using a wood frame did not dissuade them from tackling the contents of their attics or parlours.

Once the remaking of their modern wardrobes and furnishings had been conquered, middle-class women of the 1930s also used their newly acquired design knowledge to modernize the condition of whole rooms with little to no expenditure required—particularly focusing on the rooms that served as family gathering spaces and those in which they worked. Some of this improvement could be achieved simply through the rearrangement of furniture. By participating in extension projects about room arrangement, women learned that their old-fashioned living rooms could be less cluttered if objects were culled carefully and included only if they served a current functional need. They also determined that objects within a space should be composed into groups that had functional and aesthetic relationships, thereby creating the perception of larger spaces that better supported the ways their families intended to use them. Groupings of furniture in conjunction with items displayed on the walls above them were to be studied as compositions, and readers were instructed about the design principles of balance and dominance in order to make better decisions with a critical eye.

Kitchens became prime targets for improvement and modernization by these

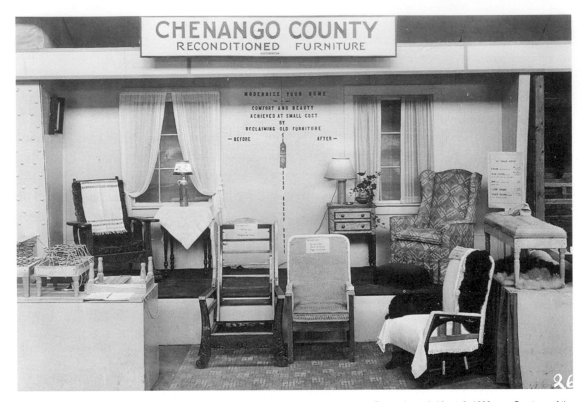

Fig. 8.1. Unpublished appendix to *Annual Report New York State Extension Service in Home Economics,* vol. 16, pt. 2, 1933, n.p. Courtesy of the Division of Rare and Manuscript Collections, Cornell University Libraries.

newly empowered women with few monetary resources. Through the demonstrations and publications of the extension service, they learned that the storage capacity of existing cabinets could often be enhanced at little or no cost through the addition of shelves made of scrap lumber, salvaged cheese boxes or dismantled packing crates (see Fig. 8.4). Older two-part portable kitchen cabinets were often reconditioned and reused, either by separating their upper sections from their bases for use in varying areas or by building additional storage units around them. Sometimes families created hybrid cabinetry using furniture more common to other rooms of the house like chests of

drawers or desks. They also upgraded their old kitchen cabinets by integrating parts from abandoned furnishings, such as by creating vertical divisions in existing cabinets by using partitions from file drawers found in unused desks or by building the tiny drawers from sewing machine cabinets into existing cabinets to provide micro-compartmentalization for small kitchen tools or silverware.

In New York State, the extension service of Cornell University emphasized kitchen modernization by recommending a 'conference' process that brought neighbours together in each others' kitchens to evaluate the existing space and listen to what the woman of the house had to say about her

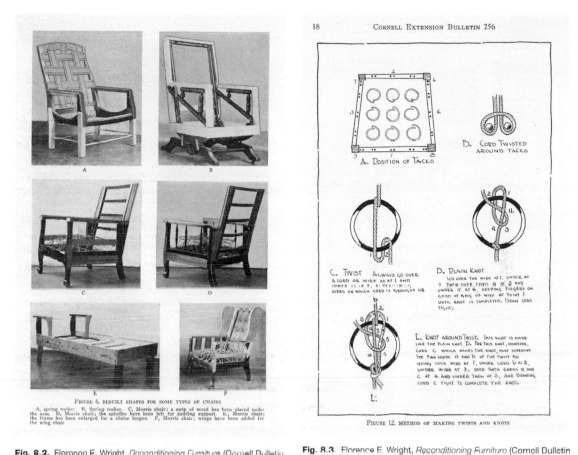

Fig. 8.2. Florence E. Wright, *Reconditioning Furniture* (Cornell Bulletin for Homemakers No. 256), Ithaca, New York: New York State College of Home Economics, April 1933, p. 12. Courtesy of the Division of Rare and Manuscript Collections, Cornell University Libraries.

Fig. 8.3. Florence E. Wright, *Reconditioning Furniture* (Cornell Bulletin for Homemakers No. 256), Ithaca, New York: New York State College of Home Economics, April 1933, p. 18. Courtesy of the Division of Rare and Manuscript Collections, Cornell University Libraries.

needs and desires for a more workable arrangement. They often toured the other rooms of the house and the outbuildings to determine whether raw materials for kitchen modernization existed. With the help of an extension specialist, women who participated in the conference process developed a plan for making improvements to their kitchens, and, when finished, they hosted a public tour of the completed space in order to demonstrate the possibilities of affordable modern design to other families in their area.

The demonstration agents who circulated through the rural counties in upstate New York frequently took photographs of the ingenious and thrifty solutions they encountered in the kitchens of their constituents. Unlike the sleek modern images of the works of celebrated European modern masters, these images of modernized kitchens celebrated the use of scrap wood, salvaged metal parts and ingenuity. As a collection, they provided illustrations for subsequent extension bulletins and textbooks and for

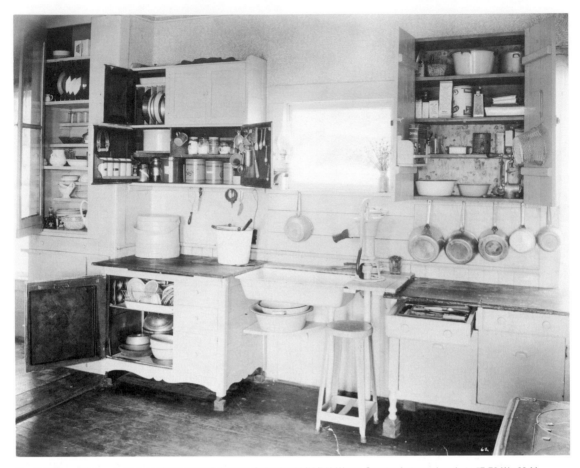

Fig. 8.4. Cornell University Rare and Manuscript Collection, Collection 23/18/919 Wayne County photographs: photo #7-76-Wa-62-M (no date), Ithaca, New York. Courtesy of the Division of Rare and Manuscript Collections, Cornell University Libraries.

use as visual aids for later demonstrations to other groups.

Along with the sense of purpose and accomplishment achieved by women who modernized their families' wardrobes, studying extension bulletins and attending short courses and demonstrations changed the ways women interacted with their environments and the ways they understood their ability to affect objects and architectural spaces. Processes that cultivated design knowledge, analytical skills and critical perspectives transformed women from consumers to designers. Women received encouragement from peers to pursue a broad range of possible improvements to their goods and spaces by pushing for change through a consideration of 'better ways to do things' and by 'changing situations to make improvements possible'.[12] They based their ideas for change on analyses of each other's needs and intervened by proposing modifications. Considering the value of extension publications and programming, one homemaker who participated in such a process reported back to the sponsoring

university that 'even if we hadn't made any changes in our kitchens we would have gotten a lot out of the project because we see things in a different way'.[13] It is by understanding and invoking the elements and principles of design as reinforced in extension bulletins such as *Artistry in Dress* and *Reconditioning Furniture* that participants adopted and applied this new way of viewing the world and their circumstances in it.

Preconceived notions of modern design often suggest that it is a universal and pure expression of function and simplicity. The order and regularity evoked by buildings and objects that are considered part of the modern design canon evoke the sense of being generated by processes defined by both control and predetermination. As designers with a new vision of the modern world, women who remodelled their families' former garments, chairs and kitchens instead faced the challenge of 'finding' modern design solutions within existing materials. They did this, in part, by developing the skill to analyse their resources at hand by studying the shapes of the parts of shirtwaists and rocking chairs and by understanding the relationship of these parts to the components of the latest style trends. The creation of a woman's sense of herself as a designer often first came through the acquisition of sewing skills. Possessing the ability to sew reinforced visual thinking, since sewing usually involved transforming a series of flat components into a three-dimensional object (clothing). Seamstresses also have advanced understanding of ordering and of the impact of various methods of assembly since seams that are buttoned and seams that close with zippers require very different hardware and yield very different results.

The ability to act as a modern designer also came, in part, through the understanding of structure and the properties of the materials they chose to use. Women's knowledge of fashionable modern clothing design and construction empowered and encouraged them to take control—first, of the design of their own image, and then over that of their interior environment, by applying the principles of modern design to their homes in innovative and cost-saving ways.

In what ways does this shift in role from consumer to designer express acts that can be considered specifically modern? It is the unlikely partnership of fashion and thrift that helped elevate the desire for modern design in commonplace environments. Because Depression-era working Americans could not afford to participate fully in the emerging system of mass consumption, they had to translate modern design principles into terms that could be achieved with the frugal use of materials and effort.

Women employed at least three design tactics in order to meet these constraints. The first is simplification. The remodelled garments, furnishings and rooms women produced reflected their understanding of basic surfaces, forms and spaces as products of creativity and intellect. As noted in one publication of the time, 'extravagance in dress conveys to thinking persons a feeling of doubt as to a woman's intelligence. Thrift, intelligent application of knowledge, and skill with the hands are really worth-while factors in life and are recognized as such by persons qualified to judge.'[14] Extension specialists at

Cornell University and others echoed this message when they encouraged the removal of ornament from furnishings and the placement of kitchen tools in open, precisely fitting containers.

A second related strategy for generating modern design within the framework of thrift is the use of the process of subtraction. Women often achieved simplicity by removing extraneous ornament from their belongings and environments rather than by adding parts or materials. The removal of fussy collars, buttons or voluminous sleeves, or the elimination of clutter in the living room or cupboard doors in the kitchen, all signalled the newness of their efforts just as industrial designers' use of 'a process of elimination' achieved the minimal streamlined forms of modern objects—particularly those associated with hygiene—in the 1930s.[15] Middle-class American women achieved their own versions of 'clean designs' by eliminating extraneous parts.

While cleanliness was at the heart of much of the extension message, one cannot ignore the fact that the improved spaces depicted in their documenting photographs can hardly be considered minimal. The kitchens, for instance, shown with their drawers and doors standing open, are always filled with a vast assortment of pots, pans, platters, plates and culinary tools (see Fig. 8.5). I would argue that women reading extension literature and attending short courses and demonstrations interpreted the functional advantage of simplicity and subtraction by establishing an 'aesthetic of order' to manage their goods and that seeing this order visibly expressed became part of

the key to achieving a successful modern solution. For instance, within the context of the kitchen, women expressed the control of goods by privileging contents and interiors over exteriors and forms, by emphasizing the grouping of like objects, by exposing objects for convenience and by matching the sizes of goods to their place within the workspace. Through the maintenance of an aesthetic of order women negotiated the limited but continuing role of consumption in the lives of their Depression-era families.

Finally, in each of these instances— remodelled garments, chairs or rooms—the modernity of the end result is keyed to the cultivation of tailored solutions: designs that

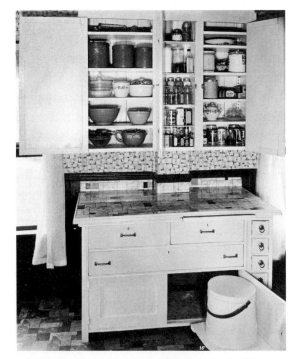

Fig. 8.5. Cornell University Rare and Manuscript Collection, Collection 23/18/919 Rochester County photographs: photo #7-50-12 (no date), Ithaca, New York. Courtesy of the Division of Rare and Manuscript Collections, Cornell University Libraries.

were literally developed to meet a person's specific individualized needs. Including the careful review of the contents of existing kitchens and the potential of used or alternative furnishings to contribute to an improved kitchen environment, thrift-based processes challenged and enabled homemakers to make customized improvements without expenditure. In a period characterized by a growing national obsession with the acquisition of mass-produced goods, these women distanced themselves from preconceived notions that the used resources they already possessed lacked value. University specialists encouraged women to embrace thrift and reuse by portraying the planning of no- or low-cost improvements as a way to demonstrate intelligence and creative thinking; qualities they did not see, by inference, in acts of pure consumption such as shopping for and purchasing manufactured cabinetry or new dresses.[16] As a rejection of the one-size-fits-all solution, the customized results of women's design efforts cultivated functional and fashionable solutions that proved to be well-suited to modern middle-class life.

Notes

1. Data from extension studies by researchers in home economics colleges around the United States conducted in the 1940s and 1950s demonstrates that nearly all women in rural households owned sewing machines and knew how to use them. The documentation and analysis of the contents of rural households and commonly used domestic practices became the basis for much of the social science research performed as part of this emerging discipline.

2. The Morrill Act of 1862 established the donation of federal land in each state for the purpose of founding engineering and agricultural schools. The first land-grant school is what is now Iowa State University. Today, major land grant universities can be found throughout the United States. They include Cornell University and the Rutgers University in the East, the universities of Wisconsin, Minnesota and Missouri in the Mid-west, Auburn University and Clemson University in the South, and Oregon State University and the University of California system in the West.

3. A. J. Warner, *Artistry in Dress* (New York State College of Agriculture, 1926).

4. *Dyeing, Remodeling, Budgets* (The Woman's Institute of Domestic Arts and Sciences, 1934), p. 1.

5. *Extension Service Annual Report for New York State,* 1933–34, appendix part II, vol. 17, pp. 22–3.

6. *Dyeing, Remodeling, Budgets*, p. 1.

7. Ibid., p. 2.

8. *Annual Report to New York State,* vol. 13, p. 45.

9. 'Housing Report', *Annual Report to New York State,* 1934, p. 78.

10. F. E. Wright, *Reconditioning Furniture* (New York State College of Home Economics, April 1933).

11. The removal of stylistic contours and ornate trim enabled the transformation of furniture from previous eras to become simplified and modern in appearance. Displays like that shown in Figure 8.1, at the 1933 New York State Fair, celebrated the modern identities for chairs remodelled by local women who used processes taught by the extension service. The deconstruction of out-of-date furniture styles by removing their upholstery and eliminating old stuffing and springs formed the first step of the remodelling process. Once exposed, the wood frames of older furnishings could then be altered to generate simpler and often more compact forms (see Fig 8.2). Authors of extension bulletins used detailed step-by-step drawings of processes and techniques to instruct their readers about the methods they could use to perform the transformations recommended.

12. Wright, *Reconditioning Furniture*.

13. *New York State Extension Service Annual Report*, 1930, p. 122.

14. *Dyeing, Remodeling, Budgets*, p. 2.

15. This concept formed the basis for the exhibition documented in E. Lupton and J. Abbott Miller, *The Bathroom, the Kitchen and the Aesthetics of Waste: A Process of Elimination* (MIT List Visual Arts Center, 1992).

16. *New York State Extension Service Annual Report*, 1932, pp. 220 and 222.

Part Three

1940–1970

Introduction

1940–1970
Fiona Fisher

Between 1940 and 1970, the development of the modern interior was informed by the rise of mass culture and a reshaping of architectural and design modernism in response to new social, economic and political circumstances arising from World War II.[1] Rapid media expansion, including the widespread adoption of television and the rise of mass circulation magazines, extended the contexts within which both elite and mainstream interiors were represented. From the 1940s, America took an international lead in redefining the modern interior and popularizing modernism as a mainstream style. A strong social and political emphasis on family life and the reestablishment of social stability, coupled with an intense need for new housing, placed the single-family dwelling in a pivotal cultural position during and immediately after the war. The idealized and widely disseminated image of the American home, with its spacious open-plan interiors, technological advancements and associated style of easy and informal family living, emerged in this period as a powerful symbol of Western modernity, democracy and industrial strength.[2]

In certain public contexts, notably that of the American corporate interior, designers, including Charles and Ray Eames and Hans and Florence Knoll, evolved a humanized modernism that mediated the public and private spheres, allowing individuals some continuity of social experience as they moved between their homes and places of work.[3] In contrast, many of the new tourist and leisure environments that developed in the 1950s—shopping centres, cafés, resort hotels, bars and restaurants—appealed to the psychological desires of newly affluent consumers for novelty, luxury, colour and diversion. Inspired by popular cultural sources, including commercial art, film and magazines, their architects and designers created what were often highly theatrical interiors that expressed and allowed users to participate in a fashionable and glamorous public modernity.[4] From the mid-1950s, as increased spending power among young people led to the development of youth-oriented retail and leisure environments, including coffee bars and fashion boutiques, and to the emergence of a vibrant media culture within which young lifestyles were represented, the close relationship between fashion and the interior was reconceived within the context of a nascent youth culture.

The chapters in this section of *Performance, Fashion and the Modern Interior* draw on the themes of fashion and performance to explore the modern interior from the vantage points of consumer magazines, Hollywood film and domestic advice literature, with reference to professional design practice and discourse. The postwar domestic interior forms a focus for all four authors, whose chapters variously consider it as a site of sociability, private experience and self-expression and examine its place within a wider public framework of consumption, entertainment, leisure and modern lifestyles. An important concern for the authors, shared with other contributors to this collection, is the relationship between the modern interior and modern identities.

Staging private life: domestic modernity in the 1940s and 1950s

Beatriz Colomina has suggested that in the twentieth century, the 'discourse around the modern house is fundamentally linked to a commercialization of domestic life'.[5] That process of commercialization accelerated after the war as modern housing, homes and interiors proliferated across a rapidly expanding media landscape, within which domesticity and homemaking figured in explicitly consumerist terms. During that period, the promotion of 'good design', a central strand of government strategy to stimulate economic recovery in Europe and America, was closely aligned with the concept of 'good living', which emphasized

the potential of modern design to transform social experience. While the notion of 'good design' implies aesthetic considerations and prioritizes the world of production, that of 'good living' was more closely concerned with consumption and the role of design in the performance of everyday life.

As David Smiley has indicated, these aesthetic and social accents, evident in professional design discourse and popular cultural sources, situate and define the domestic interior in a particular relation to modern architecture. Smiley has positioned the single-family dwelling as a significant site within which modernism was reshaped through the activities of a 'domestic culture industry' comprising architects and designers, house buyers and cultural mediators.[6] His analysis of American mass-circulation magazines of the 1940s, including *Ladies Home Journal* and *House Beautiful,* alongside contemporary debates on prefabrication, suggests the emergence of two intersecting modernisms: a modernism of 'production aesthetics' and 'a socially-derived modernism of inhabitation'.[7] Although these shared certain features—including flexibility within the plan, the flow of interior and exterior space and a commitment to accommodate diverse lifestyles—the former derived from the conviction that modern living could only take place in a building of modern design, while the latter acknowledged that it might occur equally well in a home of hybrid or traditional style.[8] As a result, Smiley has suggested that this 'separation of exterior appearances from interior performance' produced 'a vision of the modern as a sense of personal, frictionless interior convenience'.[9]

With its reduction of conventional functional divisions, and its promise of flexibility, the open-plan, or partially open-plan, domestic interior determined new forms of social activity that required mediation. An important context within which 'interior convenience' was represented to consumers was that of the design exhibition. Staged interiors and exhibition houses were a popular component of such events and have a history dating back to the nineteenth century. What distinguished a number of these mid-century interiors from earlier examples, however, was the employment of actors, models or consumers to experience them, or to simulate domestic life within them. In the case of Idea House II, a 1947 exhibition house shown at the Walker Art Centre in Minneapolis, competition winners were invited to occupy the house and report on its liveability.[10] At the We're Building a Better Life (*Wir bauen ein besseres Leben*) exhibition of 1952, which opened in West Berlin and then toured, professional actors representing an average working family demonstrated a model home to visitors.[11]

Enacted domestic environments could also be found within the postwar department store; one state-run Czech department store of the 1950s, for example, gave over its front windows to a set of staged domestic interiors, populated by actors representing a family undertaking everyday domestic tasks.[12] Similarly, the model homes that were furnished and decorated by the Dutch Association for Correct Living (Stichting Goed Wonen) in the 1950s and 1960s were represented in its magazine, *Correct Living* (*Goed Wonen*), complete with model families performing appropriate domestic lifestyles.[13]

The public performance of domesticity played a significant role in mediating the new spaces and technologies of the home: elaborating modern lifestyles, inculcating desirable and socially constitutive forms of domestic behaviour and encouraging participation in economically and politically desirable forms of consumption. As Greg Castillo has shown, in certain contexts performances of this type were part of wider state-sponsored propaganda initiatives.[14] In others, they are perhaps best understood as enacted forms of domestic advice.

Grace Lees-Maffei's chapter, 'Dressing the Part(y): 1950s Domestic Advice Books and the Studied Performance of Informal Domesticity in the UK and the US', examines the ways in which domestic advice books attempted to script and codify new forms of fashionable social performance within the British and American home of the 1950s. Drawing on Erving Goffman's dramaturgical metaphor, it examines a transitional moment in the history of the domestic interior; one, that is, when the relationship between kitchen and dining spaces, and the types of public and private activities that took place within them, began to be reconfigured, giving rise to social behaviours that 'produced new advice about domestic interactions, or performances within the home'.

Alice T. Friedman's chapter on Philip Johnson's New Canaan estate is also concerned with the public and private dimensions of domestic experience and the choreography of everyday life within the home and moves the discussion of the modern

interior into the territory of professional design practice and discourse. Drawing on the work of art historian Jill Casid, and her proposition that 'queer versions of Georgic' are evident in the design of eighteenth-century country estates, Friedman reconsiders the relationship between two canonical modernist homes, Mies van der Rohe's Farnsworth House and Philip Johnson's New Canaan estate. Friedman argues that while Farnsworth aims at 'formal, timeless, design values' that resisted the inscription of the occupant's identity, Johnson's New Canaan incorporated picturesque, theatrical and processional elements, rooted in history and open to narrative intervention, through which the architect was able to perform and express his identity as a gay man.

Mediating modernity: fashionable identities in public and private

According to Michael Hatt, 'Interior spaces are not simply stage sets into which characters walk and act. The relationship between self and space is more complex, and the interior needs to be understood as a mix of the real and the imagined; the projection of the imagination onto or into space and space itself enabling that imagining.'[15] Television, which advanced rapidly after 1946 in most countries of the Western industrialized world, altered and complexified the imaginative landscape of the interior, bringing the spectacle of public life into the living room and exposing occupants to a multiplicity of real and fictive spaces and identities with which to engage.

As a marker of social status, television ownership played a symbolic role in the representation of suburban middle-class lifestyles. It also generated new forms of sociability within the home, domesticating what had previously been public leisure activities, such as film attendance, and generating a range of advertising and domestic advice on how to create the optimum viewing environment, or home theatre.[16] Lynn Spigel has argued that 'these new home theaters provided postwar Americans with a way to mediate relations between public and private spheres' and, through their incorporation into the domestic setting, made 'outside spaces part of a safe and predictable experience'.[17] Television was also an important context within which modern suburban lifestyles were represented. Mary Beth Haralovich has, for example, suggested that through the narration of family life within the spaces of the home, American suburban sitcoms of the 1950s naturalized a white, middle-class, suburban lifestyle within which gendered roles and sexual identities were clearly articulated.[18]

Equally significant for the dissemination of the modern interior and its incorporation within the notion of the fashionable lifestyle was the expansion of consumer magazine markets. As many women returned to domestic life as wives, mothers and homemakers, women's magazines helped shape the concept of professionalism in the home and played a central role in the realignment of gendered roles and identities in the immediate postwar period.[19] Magazine market growth was not, however, limited to titles aimed at women, and neither were domestic concerns the

exclusive domain of the women's magazine. The segmentation of the mass market and the rise of general interest titles such as *Ebony,* aimed at African American readers, catered to and represented the domestic lifestyles of a wider range of consumers than had been the case in the interwar period.[20] The mid-twentieth century has also been acknowledged as a critical moment in the development of heterosexual masculine ideals, rooted in consumption and articulated within a domestic setting.[21] *Playboy,* launched in 1953, featured luxuriously decorated and furnished bachelor apartments throughout the 1950s and 1960s. Bill Osgerby has described these interiors as 'idealized habitats for a new breed of male consumer . . . a man who was affluent and independent, with a sense of individuality crafted around fashionable display and the pleasures of commodity consumption'.[22]

Meltem Ö Gürel's chapter, which explores the role women played in 'performing modernity' in mid-century Turkey, considers the political and sociocultural implications of the conspicuously Western terms in which modernity was conceptualized within the Turkish media of the 1950s and the cultural resonance of the American domestic interior within that context. Her case study demonstrates the significance of the mass-circulation general interest magazine as a productive context, which through its depictions of fashionably dressed women in glamorous public locations, and of homemakers within a domestic setting, interpellated a modern feminine identity that symbolized the modern Turkish state.

The significance of mass mediation for mid-century architectural and interior design practice is the subject of Alice T. Friedman's recent study, *American Glamour and the Evolution of Modern Architecture.* Friedman has suggested that what many American mid-century buildings share is 'an approach to representation, image-making, and audience that is rooted in the notion of a distinctive American glamour and in its visual culture', drawn not only from advertising and consumer magazines, but also from the worlds of fashion and film.[23] This referencing of the visual codes of contemporary mass culture lent a cinematographic quality to mid-century interiors designed by architects such as Morris Lapidus, whose extravagant Miami Beach hotels fulfilled a sense of expectation in visitors, described by the architect as follows: 'When they walk in they *do* feel, "This is what we've dreamed of, this is what we saw in the movies, this is what we imagined it might be." '[24] In calling upon the rich symbolism of contemporary film, luxurious public interiors of this type offered individuals a material setting and an imaginative context within which to express and test the limits of their modern selves.

Youthful lifestyles in the 1960s

Marilyn Cohen's chapter on *Breakfast at Tiffany's* (1961), Blake Edwards's Hollywood recreation of Truman Capote's novella, examines the performance of identity within the film and—with reference to the relationship between Audrey Hepburn and George Peppard, and the dramatis personae of Holly Golightly and Paul Varjek—its framing within a wider celebrity culture.

Breakfast at Tiffany's is a film that in many respects subverts the gendered image of domestic modernity and homemaking promulgated by mainstream media in the 1950s. Cohen's analysis of the domestic mise-en-scène and her proposition that Holly is 'more defined by what she does outside than inside' point toward playful and fluid engagements with interior design and identity that from the mid-1950s were a feature of an emergent youth culture. As Cohen observes, Holly's bathtub couch, which subverts the conventional functionality of the object, calls to mind pop art and design. Characterized by informality and experimentalism, reflected in cheap, disposable, mass-produced items aimed at young consumers, pop design emerged out of the popular culture of mass-circulation magazines, film and television in the second half of the 1950s.[25] Stylistic expendability, a hallmark of what Nigel Whiteley has defined as the High Pop period, beginning in 1963, produced a heightened fashionability in which each new *look* was rapidly superseded by the next.[26]

As the global fashion capital of the 1960s, London offers a useful context within which to explore the close relationship between fashion, performance and the interior as it was reconceived within pop culture. Boutiques—small, informal, independent fashion retailers—represent an important category of interior environment within which youthful identities were constructed and performed. Alexander Plunket Greene and Mary Quant opened their boutique Bazaar in London's King's Road in 1955. Many of the boutiques that followed, estimated at around two thousand in Greater London by the mid-

1960s, incorporated music and art along with clothes and accessories, creating a relaxed ambience that blurred the boundaries between public and private.[27] Some cultivated a deliberately domestic atmosphere; Barbara Hulanicki, for example, claimed that she wanted the interiors of Biba 'to replicate the feeling of being in a private space, like walking into my sitting-room'.[28] Designed for hanging out as much as shopping, London's boutiques accommodated and reformulated domestically encoded modes of social performance, allowing individuals to style themselves within quasi-domestic, intimate settings unlike those associated with the polite formality of the department store. The relationship between interior design and fashion was further reinforced through the representation of the domestic interiors of leading figures in the design world, such as those created by Jon Bannenberg for Mary Quant, described in the *Telegraph Magazine* as 'an exercise in pure fashion'.[29]

The energetic and mobile aesthetic favoured by a new generation of photographers produced fashionable new postures, as well as reflecting those determined by the youthful clothing styles, notably the mini skirt.[30] 'Fashion as a sign of self', as Marnie Fogg has suggested, 'became no longer just about individual garments, but about body shape, posture, and a different kind of physicality that conveyed a "total look."'[31] The cross-fertilization of ideas originating in diverse spheres of creative practice, which Dominic Sandbrook has suggested as 'one of the most obvious characteristics of British culture in the sixties', is reflected in contemporary

attitudes to the place of fashion in everyday life, aptly encapsulated in fashion consultant Clare Rendlesham's assertion in a national newspaper article of 1967 that 'fashion and living and the things you surround yourself with should all be considered and practised together'.[32]

The chapters in this section of the volume suggest a number of productive ways in which the concepts of fashion and performance were used to elaborate the social, cultural and political significance of the postwar domestic interior, as a mass-mediated site, implicated in the formation and performance of national, sexual, gender and class identities. Through their diverse approaches, the authors offer new perspectives on the public/private relationship as articulated through the spatial and material organization of the home and the choreography and dramatization of social life within it.

Notes

1. The context for interior design practice between 1940 and 1970 is explored in greater detail in the companion to this volume. See P. Sparke, 'Introduction to the Mid-Twentieth-Century Interior', in P. Sparke, A. Massey, T. Keeble and B. Martin, eds., *Designing the Modern Interior: From the Victorians to Today* (Berg, 2009), pp. 147–58.

2. The home was increasingly politicized in this period, and during the Cold War an idealized image of American domestic modernity was deployed for propaganda purposes. On Cold War politics and the domestic interior see G. Castillo, *Cold War on the Home Front: The Soft Power of Midcentury Design* (University of Minnesota Press, 2010).

3. See P. Kirkham, 'Humanizing Modernism: The Crafts, "Functioning Decoration" and the Eameses', *Journal of Design History* 11/1 (1998), pp. 15–29; and B. Tigerman, '"I Am Not a Decorator": Florence Knoll, the Knoll Planning Unit and the Making of the Modern Office', *Journal of Design History* 20/1 (2007), pp. 61–74. On the changing relationship between public and private interiors in this period see P. Sparke, *The Modern Interior* (Reaktion Books, 2008), pp. 185–203.

4. See A.T. Friedman, *American Glamour and the Evolution of Modern Architecture* (Yale University Press, 2010), pp. 1–37.

5. B. Colomina, 'The Media House', *Assemblage* 27 (1995), p. 61.

6. D. Smiley, 'Making the Modified Modern', *Perspecta* 32, Resurfacing Modernism (2001), pp. 39–54, quotation p. 39.

7. Ibid., p. 42.

8. Ibid., p. 42.

9. Ibid., p. 42 and 46.

10. A.G. Winton, '"A Man's House Is His Art": The Walker Art Center's *Idea House* Project and the Marketing of Domestic Design 1941–1947', in P. Sparke, B. Martin and T. Keeble, eds., *The Modern Period Room: The Construction of the Exhibited Interior, 1870–1950* (Routledge, 2006), pp. 87–111.

11. G. Castillo, 'Domesticating the Cold War: Household Consumption as Propaganda in Marshall Plan Germany', *Journal of Contemporary History* 40/2 (2005), pp. 261–88.

12. G. Castillo, 'Domesticating the Cold War', pp. 284–6.

13. I. Cieraad, 'Milk Bottles and Model Homes: Strategies of the Dutch Association for Correct Living (1946–1968)', *Journal of Architecture* 9 (Winter 2004), p. 441.

14. Castillo, 'Domesticating the Cold War', pp. 261–88.

15. M. Hatt, 'Space, Surface, Self: Homosexuality and the Aesthetic Interior', *Visual Culture in Britain* 8/1 (2007), pp. 105–28, quotation p. 106.

16. See L. Spigel, 'Installing the Television Set: Popular Discourses on Television and Domestic Space, 1948–1955', in L. Spigel and D. Mann, eds, *Private Screenings: Television and the Female Consumer* (University of Minnesota Press, 2003).

17. L. Spigel, *Welcome to the Dreamhouse: Popular Media and Postwar Suburbs* (Duke University Press, 2001), p. 40.

18. M.B. Haralovich, 'Sit-coms and Suburbs: Positioning the 1950s Homemaker', in Spigel and Mann, *Private Screenings*, pp. 111–41.

19. P. Sparke, *As Long as It's Pink: The Sexual Politics of Taste* (Pandora, 1995), p. 166–86.

20. J. Chambers, 'Presenting the Black Middle Class: John H. Johnson and *Ebony* Magazine, 1945–1974', in D. Bell and J. Hollows, eds, *Historicizing Lifestyle: Mediating Taste, Consumption and Identity from the 1900s to 1970s* (Ashgate, 2006), quotation p. 61.

21. B. Osgerby, 'The Bachelor Pad as Cultural Icon: Masculinity, Consumption and Interior Design in American Men's Magazines, 1930–1965', *Journal of Design History* 18/1 (2005) pp. 99–113, quotation p. 101.

22. Ibid., p. 99.

23. Friedman, *American Glamour and the Evolution*. See Introduction; quotation p. 5.

24. Morris Lapidus quoted in T. Hine, *Populuxe* (Bloomsbury, 1990), p. 149.

25. See N. Whiteley, *Pop Design: Modernism to Mod* (Design Council, 1987). Pop culture also influenced the elite world of interior design, informing the work of London-based designers such as David Hicks, Jon Bannenberg and Max Clendinning.

26. Ibid., p. 84.

27. See S. Ashmore, '"I Think They're All Mad": Shopping in Swinging London', in C. Breward, D. Gilbert and J. Lister, *Swinging Sixties: Fashion in London and Beyond 1955–1970* (V&A Publications, 2006), pp. 58–77.

28. Barbara Hulanicki quoted in M. Fogg, *Boutique: A 60s Cultural Phenomenon* (Mitchell Beazley, 2003), p. 81.

29. Drusilla Beyfus quoted in Whiteley, *Pop Design,* p. 112.

30. See Whiteley, *Pop Design,* pp. 104–7.

31. Fogg, *Boutique,* p. 85.

32. D. Sandbrook, *White Heat: The History of Britain in the Swinging Sixties* (Abacus, 2007), pp. 77–8; Clare Rendlesham, fashion consultant and former *Vogue* fashion editor, quoted in P. Glynn, 'Last of the Great Style Setters?' *Times* (12 September 1967), p. 7.

Chapter Nine

The modern home, Western fashion and feminine identities in mid-twentieth-century Turkey

Meltem Ö. Gürel

The trio of modern home, Western fashion and feminine identities offers productive opportunities to explore the politically charged sociocultural changes, as well as the continuity, that marked Turkish modernity. An abundance of idealized images and texts that exemplifies the trio and the way they were portrayed in popular media codify the convoluted concepts of 'modern' and 'Western' and frame an ideal contemporary citizen, defined with the founding of the Turkish Republic in 1923. At a discursive level, such images and written and oral expressions—as 'statements', to use Michel Foucault's term—contribute to the formation of common values and shared beliefs (in this case, around the meanings of terms such as *modern, Western, progressive* and *civilized*) and influence the way a person comes to know her- or himself as a member of a particular social group.[1] Hence, they can be considered a technique of power that constructs and conveys certain ideas and ideals to a wide spectrum of society—and from the bottom up—and results in the significant internalization of these values. In part by constructing and in

part by causing an idealized woman to be internalized, such 'statements' contribute to the establishment of strong bonds between the style of women's clothing and the materiality of domestic space, assumed to be an extension of a woman's gendered identity. An analysis of visual and textual statements in popular media, hand in hand with an account of women's lived experiences, exposes how women assumed a leading role in performing modernity in mid-twentieth-century Turkey.[2] Furthering this conceptualization, this chapter focuses on the 1950s, when images of postwar women had a global impact on capitalist societies defined by the outcome of World War II, and asks the following: How did the discourse around women engage with political ideology? How did fashion, as a cultural code, signify the contemporary woman? What was a woman's position in framing a concept of the modern domicile? How did this trio of woman, fashion, and home embody modernity?

In Turkey, a woman's appearance has been an important aspect of national identity since the founding of the Turkish Republic in

1923. How a woman dresses has signified a change and a civic stance. Thus, a woman's outfit has been an important ingredient in selling or representing political ideology. One can argue that whether identified by a headscarf tied in a certain style, which has increasingly occupied the political scene since the 1990s, or a secular appearance, the style of women's clothing has been centre stage in Turkish politics. For M. K. Atatürk, the founder of the Republic, a certain clothing style for women and men symbolized progress and modernization. In 1925, he stated, 'We should be civilized people in all aspects. Our ideas, our mentality will be civilized from the top to the bottom. Civilized and international clothes are [secular] suitable clothes for our nation. We shall wear them.'[3] His words signalled the changes to be initiated in clothing, moving away from the veiled woman and outlawing the fez and turban; men were to wear Western hats. These changes were among the republican reforms that included adopting the Latin alphabet and replacing Islamic law (sharia) with the Swiss civil code (1926), which radically changed society both in the private and public spheres while structuring the country as a secular and Western state.

The republican project of modernization revolutionized the family structure and altered women's status in society, significantly by banning polygamy and extending suffrage to women. In return, this status shift assisted the building of the new nation as a Western state.[4] Women were important actors in representing the modern nation, which was dichotomous to the past Orientalist representational tropes of the Ottoman Empire. Images of educated contemporary women in the public domain as doctors, lawyers, teachers and even aviators were instrumental in establishing the new nation as secular and progressive.[5] This was propagated through official publications as well as popular media, even though sociocultural prejudices against women working in public were still powerful.[6] In contrast to the traditional Islamic image, these educated women were Western-looking. Men, with Western-style hats, suits and neckties, as well as children, were also idealized as Western citizens. But women's firm contrast in appearance more powerfully symbolized the new nation, as a visual confirmation of women's abrupt emancipation. The imported fashions that regularly appeared in the Turkish media not only helped redefine women's identities but also were politically significant because of the way in which they were construed by society.[7] Ranging from evening gowns for elite women to school uniforms for girls, clothing style played a significant role in idealizing women as Western and modern, reflecting the ideals of the new republic. Significantly, fashion had a great impact in forming a collective cultural expression and bonding women around ideas of modernity.

The modern style of clothing as connective tissue subversively portrayed the Islamic veil as a threat to secularity and traditional attire as rural.[8] Both suggested the exclusion of women from modernity. A pair of dichotomous visuals that appeared in the popular magazine *Resimli Hayat* in 1954, for example, encapsulates the symbolic role of fashion in depicting the modern and its *other* in the streets of Istanbul (see Fig. 9.1). Contrasting

women in contemporary dresses to a woman in a veil, this visual pairing solidifies the binary oppositions of republican/Ottoman, new/old, modern/traditional, Western/Eastern, secular/Islamic, urban/rural, educated/uneducated, civilized/uncivilized, progressive/backward and emancipation/captivity. At a discursive level, such statements serve as instruments that form and communicate norms around women.[9]

Using images as instruments to construct and influence certain ideals is pertinent to the post–World War II era. During this time, the idea of fashion as a visual declaration of women's liberation and the desire to redefine female identity were inevitably impinged on by international relations in Turkey. The country reinforced ties with the capitalist West led by the United States. Located strategically at the periphery of the Union of Soviet Socialist Republics, Turkey was included among the countries receiving aid under the Marshall Plan—structured by the US government to fight the spread of communism in Europe—although it did not participate in the war.[10] The aid extended to the country largely supported agricultural productivity and road development. As was the case in many European locations, the influx of foreign aid, and postwar cultural

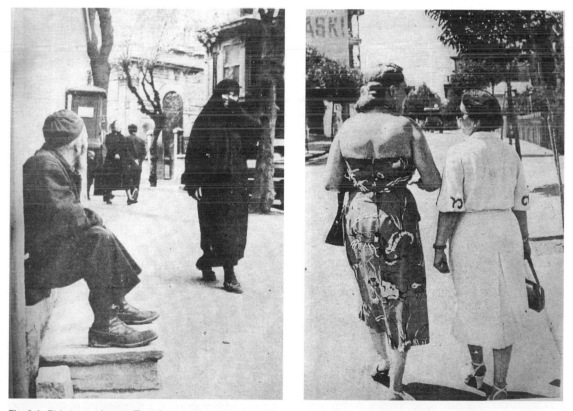

Fig. 9.1. Dichotomous images: The pair, comparing a veiled woman to women in summer dresses, encapsulates the symbolic role of fashion in depicting the modern and its other in the streets of Istanbul. *Resimli Hayat*, January 1954.

politics in general, cultivated approbation for the United States as the embodiment of modernity and democracy, influencing values, norms and beliefs about what cultural forms were considered contemporary, ranging from music to movies, fashion and architecture. Arguably, visuals of women as impeccably groomed feminine figures dressed in fashionable clothes, mediated through magazines, newspapers, posters, advertisements and the film and entertainment industries, were powerful tools in constructing and spreading American ideas and ideals.[11] According to Françoise Giroud of *Elle* magazine, 'In those days, an American woman was someone whose hair was always freshly washed and combed'; she manifested hygienic confidence and an enthusiasm for frivolity and change in clothing.[12] In Turkey, the conception of women wrought by World War II cultural politics can be vividly traced in the popular *Hayat* (1956–1978, translated as *Life*) and its forerunner *Resimli Hayat* (1952–1955, *Life with Pictures*), weekly magazines of current events, fashion, theatre, cinema, sports and art.[13] These were Turkish versions of the American magazine *Life* and depicted contemporary lifestyles, informed by Europe and the United States, before the advent of television in Turkey. With a circulation of more than that of the newspapers, they catered to a large female readership.[14] Similar magazines had existed previously; *Yedigün,* for example, was published from 1933 until 1951. However, with the *Hayat* magazines the printing techniques and paper quality were much improved, and the readership increased.[15] *Hayat* was mainly promoted as a magazine of quality photography, and

its staff included famous photographers.[16] Arguably, this visual quality operated much like a television set in domestic space.

Hayat and *Resimli Hayat* were leading examples of media that served to frame and disseminate notions of how contemporary citizens should look. Their pages were packed with the latest vogue in clothing and advertisements for items such as nylon stockings and cosmetic products that promised beautiful skin and shining hair; advertised products included soap, lotion, shampoo and cologne—novelties in Turkey at that time (see Fig. 9.2). Articles, headlines and advertisements publicized an imported postwar expression of femininity, characterized by hygiene and fashion, symbolizing modernity. Such women as alluring citizens were conceptualized as national assets representing the country. For example, appearing on countless front covers and within the issues, Günseli Başar—the Miss Turkey who won the European Beauty Pageant in 1952—was celebrated as a modern and Western face of Turkey. Her appearances matched the celebrity quality of royalty and Hollywood stars, further examples of glamorous Western imagery who were also widely portrayed in these magazines.[17]

Undoubtedly, Hollywood was (and still is) a powerful medium through which modes of fashion were propagated globally. In the 1950s, for upper- and middle-class Turkish women living in urban contexts, Hollywood movies and their Turkish adaptations were the dominant means of entertainment and a source of inspiration in terms of contemporary looks. Many admired the fashions promoted in these movies and often saw them as a

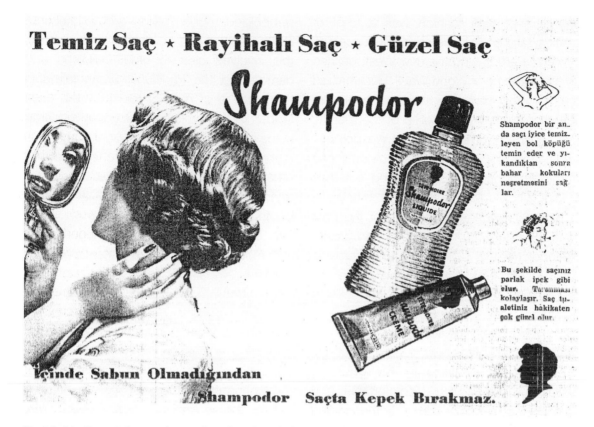

Fig. 9.2. Advertisements for women's cosmetic products depict the imported postwar expression of femininity, characterized by an enthusiasm for frivolity and hygienic confidence and symbolizing modernity. *Hayat*, 15 June 1956.

source for dress patterns. Reflecting the views of her generation of city-dwelling middle-class women, one interviewee commented that, 'Hollywood movies were a great source for dressing fashionably. If I liked a dress in a movie, I used to go and watch that movie again in order to precisely extract the pattern of that dress. I would take a piece of paper and pencil with me so that I could sketch the model and take notes as I watched the scenes with that dress in it. I made many dresses from movies.'[18] As another woman explained: 'My generation of women cared deeply about how they looked.

We weren't like today's youth, wearing jeans or wrinkled and saggy clothing in the name of fashion. We wore two-piece suits, sleek shirts, silk dresses . . . we were chic.'[19]

Fashion was an important preoccupation for the 1950s modern urban woman partly because it depicted the cultural and subjective experience of postwar capitalist society with which Turkey firmly identified in the Cold War years. Style of clothing was not only a visual representation of women's emancipation and a symbol of the republican reforms, but it also indicated a yearning for the new, as modernity does. Women's

engagement with fashion was a form of political take on liberation and announced an interest in embracing the new West, defined by the outcome of World War II. But what did the new West really offer in terms of women's liberation? What were some of the themes that engaged women with Cold War politics? What were the functions of individual and domestic appearances in playing out their (sociopolitical) role?

Eradicating certain elements of the past was an underlying theme of modernization. Abandoning the old suggested improving the present and bettering the future. Its replacement with new spatial and design elements in the city and at home, such as asphalt surfaces replacing dirt roads and modern bathroom and kitchen fixtures, plumbing, central heating and hot water and elevators, implied more comfortable and hygienic surroundings. In a homogenizing postwar world, modern would mean the same thing to people everywhere.[20] This was the case behind the modernization efforts initiated by the Democrat Party and by Prime Minister Adnan Menderes, who came to power with the 1950 elections. Envisioning the country as 'little America', Menderes's urban renewal projects included building modern housing complexes and constructing new highway networks, which meant importing cars as well as technical and financial aid for building roads from the United States. New 'apartments instead of [old] houses [with inadequate equipment], asphalt instead of cobble stone, moreover a wide enough, beautiful road', as an article comparing the old and the new domestic architecture of Istanbul in *Resimli Hayat* proclaimed,

symbolized modern living and a desire to modernize major cities.[21] Unfortunately, this involved clearing older buildings and demolishing the traditional urban fabric in the process of making room for the new. Modernization projects were widely rendered in the media. For example, *Hayat* magazines reported developments in architecture and urban planning in major Turkish cities and often showed large terrestrial and aerial photographs of urban development sites. The construction of new neighbourhoods, with modern homes and high-rise apartment buildings, wider boulevards and asphalted roads, public plazas and better-equipped or larger harbours, were celebrated as the building blocks of modern culture.[22] Through portraying women in public life and public spaces, as well as in the home, popular magazines and major newspapers maintained the republican message that contemporary women, as liberated citizens, took pleasure in modern cities. A mass of photographs exhibiting stylish ladies in à la mode clothing at nightclubs, parties, balls, fashion shows, movie galas, beaches and, significantly, with cars (marking her mobility) was in line with the portrait of the ideal postwar woman painted in the United States. Also compatible with this ideal was the woman's assumed social role inside the house. Through images, texts and advertisements, the modern Turkish woman in the urban context was conceptualized as a (Western) homemaker and mother—in fact, no different from women in traditional and/ or rural settings, responsible for the order, hygiene and visual quality of the domestic domain. What was different from these settings, however, was that the modern

Western woman was accompanied by men in both the public and private domains. They socialized and entertained together. Famous men attending to household chores, such as preparing meals and serving drinks for guests, or pictures in the media of American husbands helping their wives in the kitchen, could be followed through the press. But any household task carried out by a husband for his wife beyond light assistance was not the norm. These examples, therefore, reinforced the conception of women as the primary custodians of the home (and men as their partial/insignificant/irregular helpers at best), rather than challenging their implicit social roles.[23]

Construction of gendered identities, as such, is rooted in assuming women as indiscrete from the house.[24] Because domestic space is often conceived as an inherent part of a woman's identity, the appearance of the home, its cleanliness and its physical qualities act as a reflection of her personality and expertise.[25] Likewise, domestic space is often conceived of as a paradigm expressing a woman's 'cultural capital' or (acquired) taste, which, according to Pierre Bourdieu, embodies the 'habitus' of the inhabitant.[26] For Bourdieu, the 'determinant type of conditions of existence . . . (sexual division of labor, domestic morality, cares, strife, tastes, etc.), produce the structures of the "habitus", which become the basis of perception and appreciation of all subsequent experience'.[27] Hence, an individual's preferences depend on her or his habitus. As Bourdieu suggests: 'Every interior expresses, in its own language, the present and even the past state of its occupants, bespeaking the

elegant self-assurance of inherited wealth, the flashy arrogance of the nouveaux riches, the discreet shabbiness of the poor and the gilded shabbiness of "poor relations" striving to live beyond their means.'[28] The physical conditions of the home embody layers of meaning through which class identity or group belonging is obtained. Accordingly, taste, as a socially and culturally formed and valued phenomenon manifested through spatial designs and objects, serves to indicate the 'distinction' of the residents.

The notion of distinction, suggesting being a member of a community in terms of social status, economic power, culture, civilization, civic identity, urbanity and modernity, constituted an important motivation for women in creating and maintaining the material quality of domestic space. This quality—embodied in the physical character of interior furnishings, fixtures, accessories and equipment—was a great cause of pride for women, and worked, as much as the style of clothing, to represent the gendered and modern identity of the individual as well as the sociocultural status and/or up-to-dateness of the family.[29] One woman's memories shed light on the power of distinction as a concept that suggests belonging by status: 'I gave away the old stuff that was left to me from my mother. Large copper pots and pans, rugs, chairs . . . Perhaps they would have been considered antiques today. But I did not want them at the time because they were not considered modern.'[30] The material culture of the domestic environment worked as a mechanism to define and establish a civic position—that is, being part of the Western/non-Western, urban/rural,

modern/traditional, new/old—as related to the ideals of the nation. Middle- and upper-middle-class Turkish women of the 1950s considered being a homemaker prestigious. This is not to say that these women did not pursue employment in the workplace, but the conception of modern women as Western-style housewives arguably mired their advancement in public life. On the other hand, it granted them a dynamic position in fashioning their environment and manipulated them into becoming amateur decorators, clients, users and consumers of and for the modern domicile.[31]

Advertisements for building materials, paint, window treatments, plastics and new synthetic flooring such as fiberboard and vinyl depicted homemakers as consumers in charge of domestic interiors during the mid-twentieth century. These advertisements—featuring drawings of stylish women holding paint rollers or glamorous ladies in nightgowns superimposed against American-system window blinds and American wallpapers with the motto, 'Fabric adorns women, paper adorns wall[s]'—exemplify how women's gendered identities intertwined with notions of fashion, the modern home and consumerism (see Fig. 9.3).[32] This social construction can also be traced in *Hayat,* which published decorating guides to creating contemporary and fashionable home interiors. The content in this and other media was often translated or adapted from Western sources since modern interiors were indexed to Western cultural capital. The substance reflects emerging trends in domestic design at the time; it also reveals how decoration is conceptualized as an important concern for

women. For example, in an article entitled 'Simple Beauties inside the Home'—borrowed from Western sources—a 1952 issue of *Resimli Hayat* explains:

No matter how much we work outside the house, a big portion of our daily life is spent at home. Women especially attend to matters inside the home. That's why the better we arrange our houses, the more we decorate certain corners to please the eye, the more delightful it becomes to us.[33]

Fig. 9.3. Advertisements for building materials and finishes exemplify how women's gendered identities intertwined with notions of fashion, femininity, the modern home and consumerism. *Arkitekt*, 193–4 (1948).

In the same spirit, a decorating column that appeared regularly in 1958, entitled 'Practical Recommendations for Your Home', comprised drawings accompanied by instructions on how to modernize and improve the look of domestic spaces. The authoritative tone used in texts and captions such as 'You will change the upholstery of your furniture' and 'If you want to modernize your kitchen' recalls the manner of late-nineteenth- and early-twentieth-century tastemakers and decorators in the United States and Europe.[34] Suggesting how space should be manipulated and decorated through furniture arrangement, colour selection, window treatments, use of accessories and the like, they assumed the role of teaching desired notions of taste for modern lifestyles. Following the decorating column, a small section of the 1959 *Hayat* magazines entitled 'Beautiful Homes' displayed a shift in taste towards modern aesthetics expressed by unadorned designs. Towards the end of 1950s, mid-century modern emerged as a popular style in international architecture and interior design. Modernist planning precepts—most often characterized by open plans, flow of space, large glazed surfaces and interior-exterior continuity, as well as designs of sleek and undecorated furniture with slanted and/or thin metal or wooden legs, partitions, built-in closets, integrated storage units and indirect and cove lighting—made their mark in residential interiors. At this time, materials and finishes such as veneer, lacquer and plastic laminates such as Formica were used in furniture manufacturing. Although architectural journals of the time promoted modern designs as a way of mass-producing

inexpensive and functional furniture for everybody, in reality these designs were usually only available in upscale furniture stores. Thus, the demand for undecorated style was not because it was affordable, but because it was considered fashionable—a sign of being modern.[35]

Imported visuals promoted combined living and dining areas (referred to as *salon salomanje,* adapted from the French words of *salon* and *salle à manger* to Turkish), flowing spaces (for example study areas instead of study rooms, and airy or open kitchens), fireplaces and built-in furniture.[36] One commentary in *Hayat* stating that 'display sideboards are démodé' also advised women to store their 'dishware and tea sets in closets' and was placed under a photograph of a chic woman in high heels pointing to dishware neatly organized inside a built-in closet.[37] Such visuals and commentary exemplify how notions of fashion, femininity and domesticity were intertwined with concepts of contemporary interior design as signs of belonging to the capitalist West. This implicit assumption was embodied in the composition of that section of the magazine, which combined domestic interior design ideas with photographs of smiling women offering practical advice on household tasks, such as how to clean lamps and polish household metals (see Fig. 9.5). Codifying the contemporary woman in her relationship to domesticity, the photo composition in fact negotiates the gap between what it meant to be a modern or Western woman and a traditional or local woman, both of whom are tasked with managing the home. As these home sections and other combinations of

visuals suggest, towards the end of the 1950s many threads came together to represent the modern state in Turkey; these included the material culture of fashionable home interiors, architectural and urban renewal projects and a feminine culture depicting an image of the fashionable Western housewife.

Conceptualized as national assets representing the country, women played a critical role in spreading and normalizing state-led modernization and Westernization. Fashion as a cultural code helped transform women's

appearances and ideas around domestic interiors. While feeding political ideology, the trio of modern home, Western fashion and feminine identities reflected the collective cultural expression and women's acquired formation, embodying Turkish modernity. Identified with the contemporary home, women negotiated the difference between modern and traditional by simultaneously undoing the notion of captivity and enclosure associated with the Ottoman past and sustaining assumed gendered roles in the home and society at large.

This dual role is consolidated in the page layouts appearing first in *Yedigün* and later in *Hayat* magazines. *Yedigün* paired new house designs with Western fashions for the idealized woman (see Fig. 9.4). The style of clothing, purses, shoes and accessories implies how a modern Turkish woman dresses. To an extent, they depict women's preferences at a certain cultural formation and income level in urban areas but exclude most women living in traditional and/or rural settings. House plans, which had been included in the magazine since the 1930s, underscore the changes the Republic had already induced, namely eliminating gender segregation and emphasizing the nuclear family, conceptualized as the smallest unit of the state. House plans incorporate compact bathrooms with Western-style fixtures, new kitchen designs, and the equipment and furniture deemed necessary to acquire the idealized contemporary way of living. Houses are designed as extraverted structures, different from a typical Ottoman house with screens and high courtyard walls to keep the

Fig. 9.4. A typical page layout of *Yedigün* pairing 'Our Home' and 'Fashion' sections. The former features new home plans that frame contemporary living, and the latter features Western fashions that frame modern women. *Yedigün*, 25 September 1948.

Fig. 9.5. A typical page layout of *Hayat* pairing women's fashion with the 'Beautiful Home' section. The composition reinforces and codifies the strong connection between women's clothing and domestic designs while framing contemporary looks. *Hayat*, 13 March 1959.

is still essential in framing and conveying sociocultural codes (see Fig. 9.5). Different from the 1930s and 1940s plans, designs reflect combined living and dining activities, which became a typical feature of architect-designed residential schemes by the 1960s. There is more content on interior styles, furniture design, materials, finishes and accessories, and the general emphasis is on the cultural cliché of women as fashionable, skilful and proud homemakers. This cliché embodies various meanings. For one, it serves as a mechanism in solidifying a firm connection with the Western sphere. Second, it indicates a fallacy of women's liberation that the new West was offering through postwar politics in the early Cold War era. Further, the cliché structures a *liminal* position for women negotiating between traditional and modern identities in the local milieu. The simultaneous depiction of idealized women as liberal and domestic figures in popular media combined with lived experiences reveals how women were instrumental in playing out themes of being modern in 1950s Turkey.

gaze of outsiders away from the household. The modern living rooms are given large windows, providing more sunlight and views than traditional ones. And unlike traditional layouts, rooms are assigned specific functions such as dining, sleeping, sitting and studying.[38] Despite these changes, interior space is usually compartmentalized partly to reflect sensitivity towards the still-prevalent sociocultural importance of privacy. *Hayat*'s page composition echoes the changes in fashions, but the strong connection between women's clothing and home design

Notes

1. M. Foucault, *The Archaeology of Knowledge* (Pantheon Books, 1972). See, in particular, 'The Discourse on Language', pp. 215–37.
2. From 2005 to 2007, I held in-depth interviews in an informal life-history format with seventeen middle- and upper-middle-class women between 60 and 85 years old in Izmir, Istanbul and Ankara. The individuals lived in one of these major cities in the 1950s and 1960s and were consistent in terms of cultural background. For the most part, these interviews and the research were a part of a larger study. See M. Ö. Gürel, 'Domestic Space, Modernity,

and Identity: The Apartment in Mid-20th Century Turkey', PhD dissertation, University of Illinois at Urbana-Champaign, 2007, p. 255.

3. H. Eroğlu, *Türk İnkılap Tarihi* [Turkish Revolution History] (Milli Eğitim Basımevi, 1982), p. 324. Unless otherwise noted, all translations are my own.

4. Y. Arat, 'The Project of Modernity and Women in Turkey', in S. Bozdoğan and R. Kasaba, eds, *Rethinking Modernity and the National Identity in Turkey* (University of Washington Press, 1997), pp. 95–112.

5. Sabiha Gökçen (1913–2001) was the first Turkish female aviator and military pilot. She was also one of Atatürk's adopted daughters.

6. For more on this point and liberal representations of women see S. Bozdoğan, *Modernism and Nation Building: Turkish Architectural Culture in the Early Republic* (University of Washington Press, 2001), pp. 80–7. Arguably, this attitude was prevalent not only in Turkey, but also in the majority of the West. However, Turkey had that much more of a hurdle to overcome because its change was so drastic.

7. For a similar argument see M. L. Roberts, 'Samson and Delilah Revisited: The Politics of Women's Fashion in 1920s France', *American Historical Review* 98/3 (1993), p. 684.

8. I am inspired by the role of fashion as discussed in E. Wilson, *Adorned in Dreams: Fashion and Modernity* (Rutgers University Press, 2003), p. 12.

9. M. Foucault, *The Archaeology of Knowledge*. See in particular pp. 215–37.

10. As said by John Kenneth Galbraith, President J. F. Kennedy's aide on economics, 'It was accepted in the 1950s that if the poor countries were not rescued from their poverty, the Communists would take over.' J. K. Galbraith, *The Nature of Mass Poverty* (Harvard University Press, 1979), pp. 31–2, quoted in M. H. Haefele, 'Walt Rostow's Stages of Economic Growth: Ideas and Action', in D. C. Engerman, N. Gilman, M. H. Haefele and M. E. Latham, eds, *Staging Growth: Modernization, Development and the Global Cold War* (University of Massachusetts Press, 2003), p. 84.

11. For this argument see M. Ö. Gürel, 'Defining and Living Out the Interior: The "Modern" Apartment and the "Urban" Housewife in Turkey during the 1950s and 1960s', *Gender, Place & Culture* 16/6 (2009), pp. 703–22.

12. F. Giroud quoted in K. Ross, *Fast Cars, Clean Bodies: Decolonization and the Reordering of French Culture* (MIT Press, 1995), p. 79.

13. *Hayat* was published by Şevket Rado.

14. Ö. Bağcı, 'Ozan Sağdıç ile Birlikte' [With Ozan Sağdıç], *Fotografya* 10 (August 2001), http://64.233.161.104/search?q=cache:dmIvLXgo8koJ:www.fotografya.gen.

tr/issue-10/cadi_kazani.html+hayat+mecmuasi&hl=tr, accessed 18 January 2006. All of the interviewees read *Hayat* with great enthusiasm at the time and identified it as a very popular magazine.

15. *Yedigün* was published by Sedat Simavi.

16. Photographers included Ara Güler and Ozan Sağdıç.

17. Among the most covered royal figures were Grace Kelly, Princess of Monaco; Queen Elizabeth and Princess Margaret of England; Princess Soraya (Süreyya), former wife of the late Reza Pahlavi; and the former empress Farah Pahlavi of Iran.

18. Interview with a middle-class housewife born in 1930, conducted by the author in Izmir on 21 July 2007.

19. Interview with an upper-middle-class housewife born in 1927, conducted by the author in Izmir on 21 July 2007.

20. For debates on modernization see N. Gilman, *Mandarins of the Future: Modernization Theory in Cold War America* (Johns Hopkins University Press, 2007).

21. 'Tezatlar memleketi Istanbul' [Country of Contrasts Istanbul], *Resimli Hayat* (January 1954), p. 31.

22. For some examples of urban development projects published in *Hayat* see 'Mustakbel Çehresi ile Izmir' [Izmir with Its Future Appearance], *Hayat* (12 April 1957), pp. 10–11; 'Mersin Limanı' [Mersin Harbor], *Hayat* (14 June 1957), pp. 16–17; 'Atatürk Bulvarı' [Atatürk Boulevard], *Hayat* (21 November 1958), p. 1; 'Yeni Çehresi ile Ankara' [Ankara with Its New Appearance], *Hayat* (5 December 1958), p. 12–13; 'Alsancak Limanı' [Alsancak Harbour], *Hayat* (10 October 1958) p. 12–13; 'Izmir Limanı tamamlanıyor' [Izmir Harbour Is Being Completed], *Hayat* (6 June 1958).

23. As argued by Foucault, disagreements, abnormalities and conflicts, more than unified ideas or opinions, contribute to the discursive formation of an object. M. Foucault, *The Archaeology of Knowledge,* see in particular pp. 215–37.

24. My references related to this argument include, A. Oakley, *Housewife* (Penguin Books, 1976); Ç. Kağıtçıbaşı, ed., *Sex Roles, Family and Community in Turkey* (Indiana University Turkish Studies, 1982); M. Wigley, 'Untitled: The Housing of Gender', in B. Colomina, ed., *Sexuality and Space* (Princeton Architectural Press, 1991), pp. 326–90; L. Davidoff, J. L'Esperance and H. Newby, 'Landscape with Figures: Home and Community in English Society', in L. Davidoff, *Worlds Between: Historical Perspectives on Gender and Class* (Polity Press, 1995), pp. 41–72; F. Özbay, 'Houses, Wives and Housewives', in E. M. Komut, ed., *Housing Question of the Others* (Chamber of Architects, 1996), pp. 49–59.

25. For elaboration on this point with regard to the production of social identities through women's performativity in the context of apartment living in Turkey see Gürel, 'Defining and Living Out the Interior', pp. 703–22.

26. This abstract concept refers to the conceptual world of a person and includes experiences, upbringing, beliefs and education. P. Bourdieu, *Distinction: A Social Critique of the Judgement of Taste* (Harvard University Press, 1984).

27. P. Bourdieu, *Outline of a Theory of Practice,* tr. R. Nice (Cambridge University Press, 1977), p. 78.

28. Bourdieu, *Distinction,* p. 77.

29. See note 2.

30. Interview with an upper-middle-class housewife, conducted by the author in Izmir on 17 October 2005. Similar comments were made by a number of interviewees, all of whom were over the age of 70.

31. Gürel, 'Defining and Living Out the Interior', p. 717.

32. *Arkitekt* (1946–1965). This was the first professional architectural journal in Turkey, which started publication under the name *Mimar* in 1931. The journal was renamed *Arkitekt* in 1933.

33. 'Evin içinde basit güzellikler' [Simple Beauties inside the Home], *Resimli Hayat* (August 1952), p. 37.

34. Seminal sources for such an authoritative tone include E. de Wolfe, *The House in Good Taste* (Century Company, 1913); E. Wharton and O. Codman, *The Decoration of Houses* (B. J. Batsford, 1898); C. Wheeler, *Principles of Home Decoration: With Practical Examples* (Doubleday, Page & Company, 1903); H. J. Jennings, *Our Homes, and How to Beautify Them* (Harrison & Sons, 1902); L. A. Throop, *Furnishing the Home of Good Taste* (New York, McBride, Nast & Company, 1912); L. H. French, *Homes and Their Decoration* (Dodd, Mead and Company, 1903).

35. M. Ö. Gürel, 'Consumption of Modern Furniture as a Strategy of Distinction in Turkey', *Journal of Design History* 22/1 (2009), pp. 47–67.

36. See 'Güzel Yuva' [Beautiful Home], *Hayat* (13 March 1959), p. 21; 'Güzel Yuva', *Hayat* (17 April 1959), p. 23; 'Güzel Yuva', *Hayat* (13 March 1959), p. 21; 'Güzel Yuva', *Hayat* (6 March 1959), p. 21; 'Güzel Yuva', *Hayat* (24 April 1959), p. 25; 'Güzel Yuva', *Hayat* (20 March 1959), p. 23; 'Güzel Yuva', *Hayat* (15 May 1959), p. 21.

37. 'Güzel Yuva', *Hayat* (3 April 1959), p. 26.

38. A. Batur, '1925–1950 Döneminde Türkiye Mimarlığı' [Turkish Architecture in the Period of 1925–1950], in Yıldız Soy, ed., *75 Yılda Değişen Kent ve Mimarlık* (Tarih Vakfı, 1998), p. 219.

Chapter Ten

Breakfast at Tiffany's: performing identity in public and private

Marilyn Cohen

In 1958, Truman Capote published the novella *Breakfast at Tiffany's,* and in 1959, the sociologist Erving Goffman published *The Presentation of Self in Everyday Life.* Goffman used the metaphor of theatrical performance as a framework for understanding how the individual creates him- or herself in everyday social situations.[1] Using an actor's vocabulary, it is not a stretch to consider the 1961 movie version of *Breakfast at Tiffany's,* directed by Blake Edwards, as one in which the idea of identity is central. This essay is a reading of public and private spaces within the movie as sites or stages for the performance of identity. It uses the changes made from the book to the movie to ascertain cultural meanings specific to the filmed representation of Capote's narrative.

Breakfast at Tiffany's the movie, like Capote's novella, tells the story of Holly Golightly, played by Audrey Hepburn. According to the narrative, Holly is really Lulamae Barnes, a poor and orphaned young country girl from a small town in Texas where, at fourteen, she married Doc, a much older horse doctor. Lulamae flees Texas and winds up in Hollywood, where the agent O. J. Berman plans to launch her career as

an actress—all of which speaks immediately to performance. Holly, however, runs away to New York City, where she makes her way as a dinner companion to men on business trips with big expense accounts. According to Capote, Holly was a type of 'playgirl' with whom he was quite familiar, numbering many among his friends. She was one of a group of newly independent and sexually available young women who came to the city looking to marry successful men and then move to the suburbs.[2]

Purchased by Paramount Studios, the story of *Breakfast at Tiffany's* as written by Capote was changed by screenwriter George Axelrod in at least two important ways. Capote had written the story as a memory piece in which the narrator remembers Holly Golightly when he is summoned back to a bar they frequented together during World War II. Although the narrator loves Holly in the story, it is not clear whether it is a heterosexual love. In the movie, the narrator no longer tells the story but instead becomes the character Paul Varjak. In both the novella and the movie, this character is Holly's upstairs neighbour in a New York brownstone on

East 71st Street. Many of Holly and Paul's encounters in both the novella and movie are facilitated by the fire escape which connects their two apartments on the outside, and on the inside by the stairs between their floors (see Fig. 10.1). This fluid movement between their private spaces sets up their relationship as close and secret or outside normative space, shielding it and them from Paul's older girlfriend and benefactor, Mrs. Faylenson, played by Patricia Neal, a character created for the movie. The shared brownstone establishes space as integral to relationships both physically and metaphorically.[3]

The other major change from the novella to the movie is the time period. While the novella was set in 1943, Axelrod set the movie in contemporary, or 1960, New York. This no doubt gave the audience a closer connection to the narrative and, in the case of Hepburn, an already established star, allowed the actress to be dressed in the kind of high-fashion clothing, designed by Hubert de Givenchy,

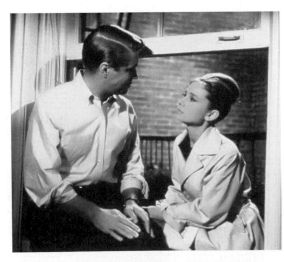

Fig. 10.1. Fire escape at East 71st Street. *Breakfast at Tiffany's* (1961).

for which she was known.[4] George Peppard, an up-and-coming leading man, plays Paul. The movie was touted as the first time that Hepburn would play opposite a man her own age, promising a more believable sexual relationship for her. Hepburn's earlier male co-stars, such as Fred Astaire and Gregory Peck, were appreciably older. The trailer for *Breakfast at Tiffany's* overtly signals this to the audience, as an unseen male voice extends an invitation to see Audrey as they have never seen her before. The trailer titillates filmgoers, as it were, with the production and consumption of a new Audrey, a new identity, a new performance, to be garnered from both the actress and, importantly, her installation in the 'glitter and shimmer' of contemporary New York. Stills for the movie similarly posit Audrey/Holly as an object of spectatorship such that the movie reads as much as a text on performance for Hepburn as for Holly.

By this time, Hepburn's movies were known for their themes of transformation.[5] And transformation figures throughout the movie. Despite the fact that the Holly seen has already left Lulamae behind, the dialogue is often literally about identity. Says Holly to Doc, when he comes to New York trying to reclaim her: 'I love you but I'm just not Lulamae anymore.' As soon as Doc has left, however, Holly turns to Paul and says, 'The terrible thing is I am still Lulamae stealing turkey eggs and running through the briar patch.' Often quoted from the film is the dialogue between Paul Varjak and the agent O. J. Berman at Holly's party: 'Is she or isn't she?' says Berman to Paul, referring to Holly. 'Is she or isn't she what?' Paul replies. 'A phony.' Berman answers his own question,

saying she isn't a phony 'because she's a real phony'.[6] This exchange establishes the idea that identity is indeed a performance. It is the degree of self-consciousness or self-awareness of the artifice of that performance that registers it as truthful or not.

In addition, throughout the movie, Hepburn/Holly uses makeup and clothing to create the Holly that sallies forth into the world. In Givenchy dresses and fabulous jewels, Hepburn/Holly creates herself right before Paul and the cinema audience, inviting us into her performance space much as in the movie trailer when she asks Paul, and by extension the audience, 'How do I look?' In large, dark sunglasses worn even in the dark and picture hats, she literally hides behind, frames herself, or is framed by her accoutrements or material objects. That spectatorial quality runs through the film as a whole. Edwards, the director, frequently uses mirrors and windows as reflective sites for Holly and viewpoints or cinematic shots that show her enclosed and observed in narrow spaces such as corridors or stairwells.[7] These elements are all part of a formal and aesthetic narrative that centres on a classically white, middle-class, female-gendered identity.[8] These elements are then imbricated in a text of decoration and design that utilize location or the mise-en-scène, as Pat Kirkham has written, as a signifying site equal in status to the characters.[9]

While Holly may present herself chicly to the outside world, her apartment is not nearly so polished (see Fig. 10.2). In fact, it is virtually the complete opposite of the groomed Holly. Its kitchen, living room and bedroom are almost entirely undecorated or unadorned. There is little on the walls except for one exceedingly large full-length mirror, and the living room has empty bookshelves, crates and suitcases indicative of an unsettled person. In the novella, Holly's 'business' card reads 'Holiday Golightly, Traveling' and her apartment is described as 'fly by night' with crates and suitcases on the floor. The gerund *travelling* implies a person in transit, a person between places, a person with no essential identity but rather one that is to be constituted on the move. Holly, therefore, is more defined by what she does outside than inside, by the places she is travelling through or to—even if only in her imagination—rather than by the place she lives in. This is embedded in her name, 'Go-lightly,' and is physically spelled out in the movie by the travel magazines on the crate serving as a coffee table in the living room, and further by the zebra rug, which references far-off and exotic places. The fashion magazines piled there also speak to mobility: in this case, Holly's own class mobility from Southern urchin to chic city playgirl. When Paul sees Holly's apartment for the first time, he asks her whether she has lived there long, expecting the answer to be no; on the contrary, the answer is yes.

Fig. 10.2. Holly's apartment. *Breakfast at Tiffany's* (1961).

The refrigerator, a notable site and sign of habitation or life, is devoid of anything but ballet slippers and milk—primarily for the stray cat Holly has adopted but, importantly, not named. Holly's refrigerator signifies that she does not feed herself, but waits to be fed—as a child might—depending on the largesse of others, as she does with her gentlemen backers. Given that the apartment has so few things in it, the disarray of Holly's personality is performed or enacted through a disorientation of objects. Sometimes, even a pair of shoes cannot be kept together. On the one hand, this disarray might be attributed to the narrative, to the wild parties she has in her living space or perhaps equally wild sexual encounters; on the other hand, it materializes an internal disorganization and feminine fragility.

The living room couch takes this construct or metaphor further. It is a claw-foot bathtub cut in half, sporting magenta pillows and a purple cushioned seat. One might ascribe to the bathtub-cum-couch the kinds of meanings that Victoria Rosner brings to her analysis of the Bloomsbury group and their avant-garde proposals for living untraditionally in traditional spaces.[10] In keeping with this, the kookiness or zaniness of the bathtub couch in Holly's apartment spatializes both Holly's unconventional life and its lack of fixity. The tub is made improper not just because of its placement in the living room, but also because of its alterity. Cut in half, it is severed from its original function. The bathtub can no longer contain water. Transposed to another setting, given a new function, redecorated, in a sense, the bathtub-cum-couch can stand for Holly herself—a transposed performance

but an inherently clean and pure one. As Joanne Entwhistle interprets Goffman, space is both external to individuals, imposing particular rules and norms upon them, and internal to them—in that it is experienced and transformed by them.[11] In Holly's case, the external space has not been transformed. Instead, it exemplifies a lack of self-imposition, a lack of inscribed identity, its bare lines recalling an empty stage waiting for performance.

The bathtub couch also bears relating to contemporary pop art such as Robert Rauschenberg's *Bed* (1955), a work which subverts the status quo by offering up the everyday as a new reality and questions 'entire systems of aesthetics', to use Andrea Branzi's reading.[12] The same kind of subversion animates Holly's use of her foyer mailbox as an exterior vanity; it holds her perfume and mirror. She redefines the foyer space as an extension of her own, part of her process or movement into the outside world. It collapses boundaries between herself and public space, translating public to private and vice versa. It also suggests a feminization of the public sphere—in this case, making the foyer into a kind of workplace or performance space since, for Holly, the application of lipstick and perfume are the tools of her trade.

Holly's bedroom is likewise spare. It has a bed with a red wool blanket on it, a vanity with an assortment of perfume bottles and a hairdryer. The bed, vanity and dryer earmark the room as a space in which to sleep and dress—with allusions to sexual activity, given that the blanket reads 'Harvard', a men's school at the time.[13] The vanity singularizes

the importance of dressing, grooming and seeing oneself prior to stepping out into the world, a series of practices that again articulate a space between private and public. Indeed, *Breakfast at Tiffany's,* as mentioned earlier, is notable for this kind of repeatedly visible and visual preparation or construction of appearance.[14] In various scenes, Paul watches Holly as she dresses herself, genders herself or 'performs' her identity— acts ordinarily deemed personal or private in mid-century America. Variously attired—or not attired, whether in her apartment during a party or in a taxicab—Holly/Hepburn effortlessly transforms herself into a model of contemporary/youthful beauty, shifting what should be done inside to outside and highlighting gender and femininity as modes of transformation and potential empowerment. Clothes and makeup serve Holly as a kind of protection, a suit of armour containing within it a tenuous interiority. (She needs to put on lipstick before she can face the letter in which her lover ends their relationship.)

Holly admits that she is fearful of being caught, held and owned. And love for Holly is a form of ownership. Describing the purposely unnamed cat in the novella, she says: 'He's an independent, and so am I. I don't want to own anything until I've found the place where me and things belong together.'[15] Interestingly, Holly's connections to men are based on a self-commodification, or consumption, of her company, rather than on emotional investment. Her inability to impress herself into her apartment, by her own statements, conflate identity with ownership and place: 'If I could find a place that made me feel like Tiffany's, well, I'd buy some furniture

and give the cat a name.' Holly's apartment has been purposely designed as unstructured and undefined; its playful disorder exposes Holly's lack of a comfortable interior identity or interiority.[16] The real Holly resides somewhere else, somewhere outside her apartment—in that space where she sings 'Moon River.' The cat prowling the practically empty space likewise marks the apartment as a minimally inhabited cage.

Paul Varjak's apartment has to be read in relation to Holly's—existing as it does within the same row house (see Fig. 10.3). As written into Capote's story by the screenwriter, Paul is a writer who had early success with his first book, *Nine Lives* (note the title in relation to the topic of identity), but has been suffering with writer's block ever since. Unable to produce anything new, he has returned from a trip to Rome as the lover of Mrs. Faylenson, nicknamed '2E' in the movie. More than just renting the apartment for Paul, however, Mrs. Faylenson has decorated it. Paul Varjak's apartment is so over-decorated that it seems to exist in a different time and place than Holly's despite being in the same building. As uninhabited as Holly's apartment is, every inch of Paul's space has been colonized. An eighteenth-century-style aristocratic male portrait, a late Louis XV–style desk, a bronze bust and swords, are surrounded and covered over in suffocating and precious materials— flocked wallpapers, sheer silk shades, ormolu and a whole host of decorative elements incompatible with the writer's youth as well as his easy, casual style. Instead, the apartment décor materially dramatizes Mrs. Faylenson's taste, her notion of what a 'male' interior, or her male's interior, should be, making it a

peculiarly feminized version of the masculine. This surfeit of decoration feminizes Paul in a manner consistent with the 'Romantic Hero' as read by film theorist Christine Gledhill, reducing him to a kind of nakedness within the domestic.[17] Paul's personal sense of self, style or identity is barely discernible here.

All the agency of consumption, all cultural capital—to use Pierre Bourdieu's terms—belongs to Mrs. Faylenson, who, when introduced to Holly as Paul's decorator, alerts the viewer to the significance and power of design in the movie.[18] Not only does Mrs. Faylenson provide Paul with a living space, but she also buys his clothing. When Paul finally ends his relationship with her, he sarcastically suggests that her next writer be about his size so that she will not need to shorten the sleeves. Even the closet is not Paul's own. Mrs. Faylenson consumes space the way she consumes men. At one point in the film, the viewer sees Mrs. Faylenson speaking to Paul by phone from her own apartment, comfortably lounging on a white couch in a richly elegant room with an immaculately groomed white poodle on her lap (see Fig. 10.4). The spectator sees an equally immaculately groomed married woman whose economic class is what allows her to keep a man as she would a pet. The camera view purposefully includes an obviously aged male hand to the right, suggesting that Mrs. Faylenson herself is owned by her appreciably older husband. Class here is clearly attached to ownership and décor of another's person. Even the decorative goods chosen for Paul's apartment, its swords and busts, speak to the spoils of empire and desire. Mrs. Faylenson's historicizing style in both interior and fashion is diametrically opposed to the youthful Holly's undomesticated or subversive one that rejects ownership.

Mrs. Faylenson can own Paul because he is unable to write. Though he may be able to perform sexually for Mrs. Faylenson, he cannot perform for himself as a writer.[19] Paul's sexual prowess is separate from his identity as a writer. Suggestive of a kind of writer's castration, his typewriter does not even have a ribbon in it until Holly gives him one as a gift. The two instruments of communication seen on the desk in Paul's apartment are contradictions. The telephone is encrusted with an ornamental façade so fake and foreign to the actual object that it becomes laughable when used by him.

Fig. 10.3. Paul's apartment. *Breakfast at Tiffany's* (1961).

Fig. 10.4. Mrs. Faylenson's apartment. *Breakfast at Tiffany's* (1961).

Paul's typewriter, in contrast, stands out for its modernity against the rest of the densely old-fashioned and claustrophobic décor. The one possession that is clearly his, the Smith-Corona typewriter, speaks to functionality as identity and modern taste. The typewriter 'types' Paul as a writer in contrast to the superfluous decoration that hides function and obfuscates purpose throughout the rest of the room. The 1960 Smith Corona was notably modern and known especially for the power cartridge return, only recently introduced.[20] The typewriter is also obviously a portable one. So, like Holly, Paul and his typewriter can be read as travelling or in transit. Neither Paul's living space nor Holly's is a home in the sense that it comports with any normalized domestic arrangement; neither space embodies identity; one implodes while the other explodes; one is claustrophobic, the other vacant. Each serves as a space for unfixed identity.

Instead, it is outside in the city where Holly and Paul appear freest to be themselves, whether on the fire escape of the brownstone (see Fig. 10.1) or in a taxicab. They are happiest when they spend a day together dedicated to doing things they have never done before or finding themselves within the urban milieu. For Holly, this is going to the New York Public Library, and for Paul, it is going to Tiffany's—gendered spaces within which each connects symbolically to the other. Arguably, the most exuberant moment is when they are together in a Five and Dime store preparing to shoplift two children's masks, one in the form of a dog, the other a cat. Donning and stealing the masks is a transgression that trumpets masquerade.

As Angela Partington has written, however, masquerade is not necessarily about concealment or deception but about license to behave in otherwise prohibited ways.[21] For Paul and Holly, the shoplifting allows them to re-enact and parody the performative aspects of the lives they lead. The masks ironically reveal their gendered and shifting roles as dog and cat in relation to each other and to others in their lives.[22]

License to behave in otherwise prohibited ways can be characteristic of the city in general. Both Elizabeth Wilson and Joan Entwhistle describe the city as a place in which dress can serve to identify and conceal.[23] The city offers the possibility of multiple identities. The fact that New York in 1960 was itself being architecturally transformed via the International Style reifies personal and public renewal. Significantly, Paul and Holly are shown sitting outside the recently constructed Seagram Building (1958; see Fig. 10.5).[24] *Breakfast at Tiffany's* privileges the city as an arena for the pursuit of identity by allowing Paul and Holly to convert the city into a private playground, making it more personally meaningful than either of their apartments. Indeed, Tiffany's is where Holly goes when she has the 'mean reds' or is afraid—perhaps because its wooden interiors and organized displays of such longstanding reputation reach back to the kind of solid and secure past she never had as a child.

At Tiffany's later in the film, Paul, having sold a story, wants to buy Holly a gift. However, all he can afford is the engraving on a ring found earlier in a box of crackerjack. The engraved crackerjack ring is the counterpart

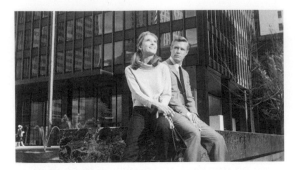

Fig. 10.5. Seagram Building. *Breakfast at Tiffany's* (1961).

to the gift that Holly had given Paul, the typewriter ribbon that enabled him to write and publish—and/or to reaffirm his identity as a writer. The exchanged gifts solidify their emotional reality.[25] Paul's writing via the typewriter ribbon and the Tiffany engraving on the crackerjack ring can be equated as parallel acts in which identity is not performed but is literally inscribed. This inscription of identity in physical or material objects is more real than any interior living space.

Apartments are not homes in *Breakfast at Tiffany's*. They are confining, not defining— and sometimes even threatening. The private interiors in the film mark identities as compromised and unstable. Instead, identity is to be claimed in the public arena. The binary opposition of public and private spaces, as Penny Sparke has written, is not so fixed and is easily eroded in modern life.[26] Paul's identity is better located in the New York Public Library where his book is catalogued and kept than where he is 'kept' in his Mrs. Faylenson–decorated apartment. The assorted collection of off-beat and international guests that attend a party in Holly's apartment convert that space into a foreign mélange of strangers while the public

space of Tiffany's is warm, intimate, and reassuring.

Breakfast at Tiffany's was rewritten for the film in ways that added a story almost totally absent from Capote's original one. Capote's story complicated sexuality in a way that may be related to his own. Certainly, for Capote, the city served as a freeing atmosphere within which to perform both as a writer and as a rather flamboyant gay man, and a case can be made, and has been, that Holly is, in part, Capote.[27] What the filmmakers did instead was to foreground a story of romantic heterosexual love set against a very modern New York. This romantic love is played out not in private interior spaces but in public ones, perhaps because the ideology of romantic love in American film at the time demanded to be spelled out in an ever larger context as women claimed new freedoms outside the home.[28] Private spaces can be too transitory and too suffocating. Romantic love as filmed in *Breakfast at Tiffany's* is set against the most contemporary monuments of urban capitalism and then juxtaposed to its back alleys to give it the breadth of naturalism. It is outside in the city that Holly and Paul come together and enter each other's internal space, where Paul as the romantic hero makes Holly confront and affirm her true emotional self, as a loved object. It is outside in an alley in the rain where they embrace each other and 'cat' to form a family—where Holly's raincoat finally functions as intended—that is, as a coat to be worn in the rain—and where her overly large and dark concealing sunglasses are no longer needed. It is in the additions to Capote's story, in its design and décor, that the cultural meanings of *Breakfast at Tiffany's*

as a movie, myth or representation are to be located. And the myth here appears to be that identity ceases to be about performance when re-contextualized as heterosexual love—or when heterosexual love enters the picture.

Notes

1. T. Capote, *Breakfast at Tiffany's and Three Stories* [1958] (Vintage International, Vintage Books: A Division of Random House, Inc., 1993); E. Goffman, *The Presentation of Self in Everyday Life* (Doubleday, 1959).

2. Capote claimed to want to fictionalize one of these young women. Many of his socialite friends, including Gloria Vanderbilt, claimed to be Holly. However, in one interview, Capote said he based Holly on a German woman he met in his early years in New York City. In Capote's narrative, Holly proclaims that she may have had 11 lovers by the age of 19. Her quest in the novella is to find a rich husband. P. Kramer, 'The Many Faces of Holly Golightly: Truman Capote, *Breakfast at Tiffany's,* and Hollywood', *Film Studies* 5 (Winter 2004), pp. 60–1, 63. See also S. Wasson, *Fifth Avenue, 5 A.M.: Audrey Hepburn, Breakfast at Tiffany's, and the Dawn of the Modern Woman* (HarperStudio, 2010), pp. 65–9.

3. James Sanders writes that the New York row house is easily romanticized. Once the home for a discrete family, but now broken down into separately rented units, it is a domestically haunted space in which the lives of independent but spatially contingent beings can meet and unite. J. Sanders, *Celluloid Skyline: New York and the Movies* (Alfred A. Knopf, 2002), pp. 210–2.

4. A Paramount Pictures memo entitled 'Production Notes and Synopsis "Breakfast at Tiffany's" [*sic*] (A Jurow-Shepherd Production for Paramount)' singles out Hepburn's wardrobe as 'created for her by the high-style designer, Hubert de Givenchy [*sic*], of Paris' and indicates the importance of Hepburn's wardrobe to the film. See *Breakfast at Tiffany's* clippings file, New York Public Library, Performing Arts Division.

5. R. Moseley, *Growing Up with Audrey Hepburn: Text, Audience, Resonance* (Manchester University Press, 2002).

6. Sam Wasson also discusses the play with duplicitous identity and 'facades' or 'looking' in the movie. S. Wasson, *A Splurch in the Kisser: The Movies of Blake Edwards* (Wesleyan University Press, 2009), pp. 57–8.

7. Wasson also notes the presentation of Holly in closed and open spaces as correlative to her desire for freedom. See Wasson, *A Splurch in the Kisser,* pp. 57–8.

8. Moseley examines class relationships in relation to the films of Audrey Hepburn utilizing the work of Beverley Skeggs. For Skeggs, a 'respectable body is white, desexualised, hetero-feminine and usually middle-class'. See Moseley, *Growing Up with Audrey Hepburn: Text, Audience, Resonance,* p. 19.

9. Introduction, P. Kirkham and J. Thumin, eds, *Me Jane: Masculinity, Movies and Women* (Lawrence & Wishart, 1995), p. 28.

10. V. Rosner, *Modernism and the Architecture of Private Life* (Columbia University Press, 2005), pp. 81 and 127–8. See also chapter 1, 'Kitchen Table Modernism'.

11. J. Entwhistle, *The Fashioned Body: Fashion, Dress and Modern Social Theory* (Polity Press, 2000), p. 33.

12. A. Branzi, *The Hot House: Italian New Wave Design* (Thames and Hudson, 1984), p. 51. The bathtub couch might also be read in relation to pop furniture such as the *Joe Chair* (1968), a supersized baseball glove by Design Studio, Depas, D'Urbine, Lomazzi or Claes Oldenburg's later *Lipstick Monument* (1969).

13. The bed in the novella is described as blond wood with tufted satin. See T. Capote, *Breakfast at Tiffany's,* p. 52.

14. For Judith Butler, 'Gender is always a doing . . . There is no gender identity behind the expressions of gender; that identity is performatively constituted by the very "expressions" that are said to be its results.' J. Butler, *Gender Trouble: Feminism and the Subversion of Identity* (Routledge, 1990), pp. 24–5. See also note 23.

15. Capote, *Breakfast at Tiffany's,* p. 39.

16. I am drawing, in particular, on the work of Diana Fuss. For Fuss, the interior, 'defined in the early modern period as a public space, becomes in the nineteenth century a locus of privacy, a home theater for the production of a new inward-looking subject'. Fuss suggests that changes in domestic architecture 'account for this evolving notion of human interiority, of life lived outside the public eye'. See D. Fuss, *The Sense of an Interior: Four Writers and the Rooms that Shaped Them* (Routledge, 2004), pp. 9–10. Capote's first novel, even in its title, relates narrative to space. T. Capote, *Other Voices, Other Rooms* [1948] (Vintage International, Vintage Books, A Division of Random House, Inc., 1994).

17. C. Gledhill, 'Women Reading Men', in Kirkham and Thumin, *Me Jane,* pp. 81–2. Paul's career as a writer might also feminize him in that, as Diana Fuss suggests, a writer's career was attached to the domestic or home. See Fuss, *The Sense of an Interior,* p. 10. The Paramount Pictures memo cited in note 4 indicates that Paul's apartment as

decorated by Mrs. Faylenson was designed specifically as an apartment of 'brilliant bad taste'.

18. Pierre Bourdieu asserts 'the aesthetic sense as the sense of distinction'. P. Bourdieu, *Distinction: A Social Critique of the Judgement of Taste,* tr. R. Nice (Harvard University Press, 1984), pp. 55–6.

19. A comparison can be made to the film *Sunset Boulevard,* with its ultimately deadly relationship between the aging silent-film star and the struggling 'kept' writer. *Sunset Boulevard,* directed by Billy Wilder (Paramount Pictures, 1950). See S. Street, ' "Mad about the Boy": Masculinity and Career in *Sunset Boulevard*', in Kirkham and Thumin, *Me Jane,* pp. 223–33.

20. In 1960, the Smith Corona company invented the typewriter power carriage return. Contemporary advertisements for the Galaxie model, similar to the one on Paul's desk, assert its modernity in 'style, speed, and spirit'.

21. 'Identity is multiple' and 'gender is an identity tenuously constituted in time, instituted in an exterior space through a stylised repetition of acts'. See A. Partington, 'Perfume: Pleasure, Packaging and Postmodernity' in P. Kirkham, ed., *The Gendered Object* (Manchester University Press, 1996), p. 213. Partington bases her thinking here on Judith Butler's *Gender Trouble* (Routledge and Kegan Paul, 1990).

22. In yet another scene, Mrs. Faylenson dons one of the stolen masks. In the party scene, a man removes the patch over his eye to reveal a good eye, similarly parodying masquerade and performance.

23. See J. Entwhistle's chapter 'Fashion and Identity' in J. Entwhistle, *The Fashioned Body,* pp. 112–39; and E. Wilson, *Adorned in Dreams: Fashion and Modernity* [1985] (New Rutgers University Press, 2003).

24. William Pereira (the brother of Hal Pereira, one of the movie's art directors) was himself an architect. One can reasonably assume that Hal Pereira would have been more than familiar with the most modern architecture in the country.

25. As Arjun Appadurai writes, 'Gifts link things to persons and embed the flow of things in the flow of social relations.' They represent a 'spirit of reciprocity, sociability, and spontaneity' and are starkly opposed to the circulation of commodities in capitalist culture. A. Appadurai, ed., *The Social Life of Things: Commodities in Cultural Perspective* (Cambridge University Press, 2006), p. 11.

26. Penny Sparke asserts that the distinction between public and private interiors is eroding and that 'the distinction between "home" and "non-home" ' is increasingly difficult to make. There is a "comfortable domesticity" that co-exists with an "anti-domesticity" '. See P. Sparke, 'Introduction', in S. McKellar and P. Sparke, eds, *Interior Design and Identity* (Manchester University Press, 2004), p. 6–7. Holly's apartment is a representation of 'anti-domesticity'.

27. Capote wrote *Breakfast at Tiffany's* just after his mother died in 1954. There are many parallels between the character of Holly and Capote's mother, including the fact that Capote's mother had changed her name from Lily Mae to Nina. Nina Capote apparently struggled with Capote's flaunted homosexuality. See Kramer, 'The Many Faces of Holly Golightly', p. 61.

28. Sam Wasson's *Fifth Avenue, 5 A.M.: Audrey Hepburn, Breakfast at Tiffany's, and the Dawn of the Modern Woman* explores the movie in relation to the modern woman of the early 1960s. R.A.M. Stern's *New York, 1960: Architecture and Urbanism between the Second World War and the Bicentennial* (Monacelli Press, 1995) uses 1960 as a watershed year for the city's architecture.

Chapter Eleven

Front and back of house: staging queer domesticity in New Canaan

Alice T. Friedman

As the art historian Jill Casid suggests in *Sowing Empire* (2005), her trenchant analysis of the politics and practices of picturesque landscape design, 'queer versions of Georgic' could be found behind the protective gates of many an eighteenth-century estate.[1] From William Shenstone's Leasowes, his garden retreat near Birmingham, to Plas Newydd in Wales, home to the 'Ladies of Langollen', the pleasures of the pastoral realm extended well beyond the conventions of literature and planning through which they had been expressed and experienced since the Renaissance: according to Casid and others, these villas and their surroundings—and the list can be extended to Walpole's Strawberry Hill and William Beckford's Fonthill—offered gay and lesbian landowners the opportunity to build, to dream and to socialize in ways that differed significantly from those of their heterosexual neighbours.[2] Like the distant forests of Shakespeare's plays, queer country estates, standing apart from polite society in 'another part of the wood', became sites of experimentation and discovery where irony, performance and sophisticated staging,

together with a host of other carefully orchestrated devices, highlighted difference.[3] Whether real or only imagined by the outside world—and Casid very usefully proposes this distinction in her discussion of Marie Antoinette's 'hameau' at Versailles—this 'queering' of the tropes of virtuous and salubrious rural life became pivotal themes in the planning of a number of eighteenth-century sites. Thus the verses by Shenstone that greeted visitors to Leasowes could be read in a variety of ways, establishing the dominant tone of sophistication and *double entendre* throughout the estate:

> Here, in cool grot or mossy cell,
> We rural fays and faeries dwell;
> Tho' rarely seen by mortal eye,
> When the pale moon, ascending high,
> Darts thro' yon limes her quivering beams,
> We frisk it near these crystal streams.[4]

For Philip Johnson (1906–2005), a gay American architect, curator, collector, socialite and lover of the arts, the extensive property at New Canaan, Connecticut, that he acquired

just after World War II offered seclusion, personal autonomy, a multifunctional domestic retreat and a significant canvas on which to sketch out a twentieth-century version of queer pastoral. Indeed, by designing his estate as a picturesque landscape dotted with modern monuments—including the Glass House (see Fig. 11.1), the Guest House (see Fig. 11.2) and the little classical Pavilion in the Lake (1962)—set into a meticulously maintained tableau of rolling lawns, water features, stone walls and mature trees, Johnson actively fostered a revival of eighteenth-century architecture and planning that had significance both for the evolution of modern architecture in the United States and for Johnson's own contributions to the history of queer design and patronage.[5]

Like the queer landowners and designers who preceded him, Johnson used his country estate as a place in which both to withdraw from society and to fashion his own distinctive identity on his own terms, in his own time and in the ways in which he chose. Like them, Johnson was subject to the scrutiny and ridicule of contemporaries who wondered

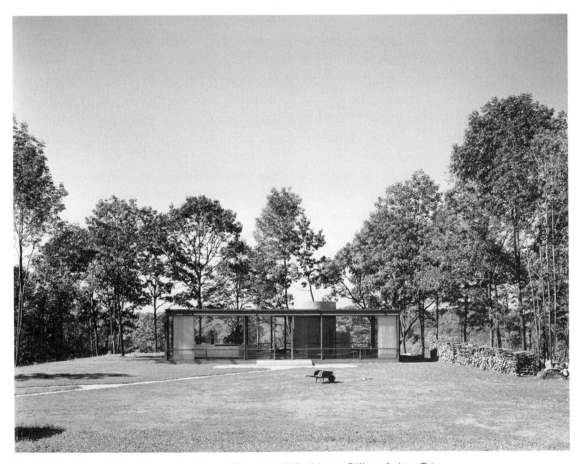

Fig. 11.1. Residence of Philip Johnson, New Canaan, CT. Architect: Philip Johnson. © Wayne Andrews/Esto.

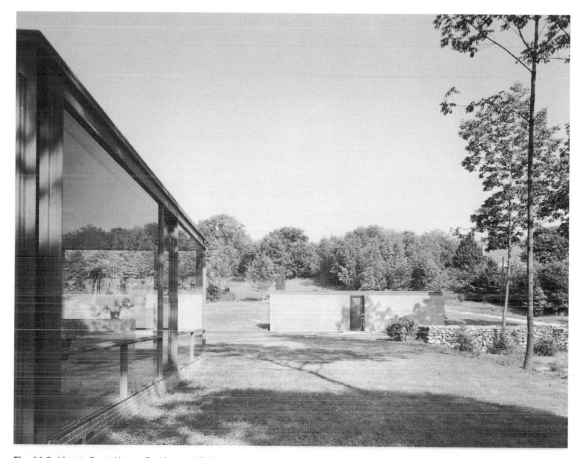

Fig. 11.2. View to Guest House. Residence of Philip Johnson, New Canaan, CT. Architect: Philip Johnson. Ezra Stoller © Esto.

aloud about just what sorts of debauchery and deviance went on behind the closed gates of his estate, but he used his evident erudition, his charm and his knowledge of social mores—and one can easily make the comparison to a figure like Horace Walpole in this context—not only to advance himself professionally but also to conceal, to mock and ultimately to take pleasure in his status as a gay man who moved quite freely in 'polite' society.[6]

He was a force to be reckoned with in the field of architecture for almost a century—as a critic, historian, collector, power-broker, mentor, friend, teacher, and of course, as an architect his influence is unparalleled in the history of American modernism.[7] From his earliest accomplishments as a young, inexperienced curator in his twenties—contributions such as organizing the first exhibition of modern architecture at the Museum of Modern Art in 1931 with Henry-Russell Hitchcock and then codifying the modernist canon with the publication of *The International Style* catalogue in 1932—right through to his last forays into the realms of postmodernism (such as the AT&T Building of 1984) or deconstructivism while in his

eighties, Johnson remained at the centre of the architectural profession, acting as a kingmaker, a gatekeeper and, not un-importantly, a style setter in the areas of architecture and interior design.[8] Nevertheless, he remains a figure of enormous complexity, someone who is difficult to pin down or fully comprehend on any of the many fronts in which he made a significant contribution— whether architectural or personal, social or, indeed, political—as his many friends, and those of us who have tried to write about his life and work, freely acknowledge. Thus, he remains fascinating, elusive and vexing in equal measure, even years after his death in 2005.

As is well known, Philip Johnson began his career not as an architect but as a critic, patron and curator, and as such he championed the architecture of Mies van der Rohe, commissioning the furniture and interior design for his New York apartment in 1931 and making Mies one of the principal figures both of his *International Style* exhibition at the Museum of Modern Art (MoMA) and its related publication the following year. Mies's architecture of 'clarity, simplicity, logic and honesty,' as Johnson would later describe it, served as the basis for the sort of moralizing modernism that MoMA promoted during the period when Johnson served as chairman of its Department of Architecture.[9] Indeed, Johnson's loyalty to Mies seemed on the surface to remain unshakeable for the better part of his career: after an extended absence from the field of architecture in the second half of the 1930s, and a period of study at Harvard's Graduate School of Design, during which he designed and built his own highly Miesian Ash Street house as his Harvard

masters thesis, Johnson returned to the Museum of Modern Art as the curator of a major retrospective of Mies's work in 1947 and, once again, head of the Department of Architecture (a position he held until his resignation in 1954). However, despite what many observers took to be Johnson's subordinate role and his seemingly slavish devotion to his mentor, what emerges both from a careful examination of the New Canaan estate and from a close reading of Johnson's own lectures and published writings is a far more complex and interesting picture of his evolving approach to history, theory and architectural expression.

There are two reasons why Johnson's work is significant for the history of modern architecture and for the modern interior in particular: first, Johnson was a leading practitioner and theorist within the context of American responses to and adaptations of European design, especially during the postwar period; and second, as I have argued previously in *Women and the Making of the Modern House* (1998), Johnson's work represents a significant cultural commentary, from the perspective of a gay architect and encoded in the subtle language of architecture and interior design, on the supposedly neutral stance of modern architecture in regard to questions not only of structure and materials but also to issues of domesticity, gender, sexuality, privacy and other cultural values. Johnson interrogated these positions throughout his career, and much of the work that he produced in the 1950s and 1960s reflects these concerns.[10]

To grasp the complexity of Johnson's status in this modernist architectural

discourse, particularly as his work relates to the International Style, it is useful to compare Johnson's Glass House with Mies van der Rohe's well-known Farnsworth House in Plano, Illinois, of 1951, with which it is often paired.[11] The story of the Farnsworth House, built for a single female doctor, is one that I recount at length in *Women and the Making of the Modern House*; only the bare outlines bear repeating here. Dr. Farnsworth had commissioned the weekend house from Mies in 1945, initiating a long period of design development and friendship with the architect which would result in the completion of the building—over budget and over deadline—at the end of 1950. The house was on the boards in Mies's office for years before it was completed, and a model of it was prominently featured in the exhibition of Mies's work that Johnson mounted at the Museum of Modern Art in 1947. Johnson explicitly credited Mies's Farnsworth House with providing the inspiration for his own Glass House, both in interviews and in an article that he published in the *Architectural Review* in 1950, and many commentators have concentrated on the similarities between them.[12] Yet beyond the obvious fact that both houses are boxy in shape and clad in glass curtain walls, they are clearly very different: whether one focuses on the way in which each building meets the ground, or the designs of their steel frames and 'window' mullions or, indeed, on the organization of the plan and the placement of solid objects such as enclosed 'rooms' and partition walls within the space of the house, it is evident not only that there are significant disparities in the ways in which materials and forms are deployed, but that they were produced by two fundamentally different design sensibilities.

These differences highlight Johnson's singular contributions to modern architecture and interior design. For Mies, architecture was about formal, timeless design values and their expression in highly aestheticized materials—the minimal and perfectly proportioned steel frame, the smooth planar extension of the travertine marble platform, the thinness of the roof slab and the sea of green meadow that served as a foil to a perfect architectural composition. For Johnson, on the other hand, architecture was animated by narratives set in motion by processional movement through landscapes and spaces in ways that engaged both inhabitants and visitors and enabled them to make up stories of their own. Thus the theatrical presentation of the New Canaan estate opens with a carefully choreographed journey from the outside world of the street to the private realm of the Glass House, a series of picturesque revelations that Johnson described in an article entitled 'Whence and Whither: The Processional Element in Architecture'; he noted that the visitor to his estate began by moving down a meandering driveway; walking around a high stone wall that screened the house; proceeding along a diagonal path to the house on its promontory; moving through the foyer-like area created by the space between the front doorway, the 'kitchen' (see Fig. 11.3) and the brick cylinder; and finally arriving at the formal seating area, a 'raft of white rug' which, Johnson noted, 'floats in a separate sea of dark brick' (see Fig. 11.4).[13] This poetic journey, framed as a series of vignettes and emotional experiences,

is clearly conceived in the eighteenth-century tradition of the picturesque landscape.

As a narrative exposition, Johnson's architecture often focused on the contradictions inherent in contemporary American domesticity and garden design (as, most notably, at the Glass House/Guest House complex) or on the meaning and value of history, nature and everyday life for modern architecture. Moreover, for Johnson, as for his eighteenth-century forebears, architecture was clearly a device for telling stories and exploring deep-seated memories. If one looks closely at the first half of his career, in particular,

it is clear that his professional identity was only secondarily as form maker, in which role he would always focus on design not for its own sake but in the service of ideas. These differences with Mies represent two very different—one might suggest diametrically opposed—approaches to the practice of architecture, and two different strands of American modernism, both of which, rather confusingly, Johnson championed over the course of his own long career.

At the Glass House, with its potted plant, its figural sculpture of two large women by Elie Nadelman and its herringbone brick

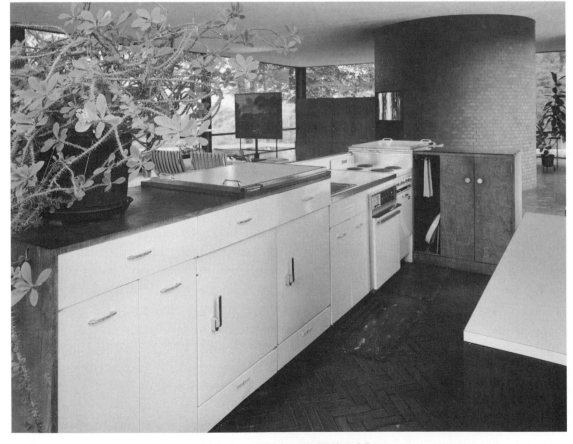

Fig. 11.3. Kitchen. Glass House, New Canaan, CT. Architect: Philip Johnson. Bill Maris © Esto.

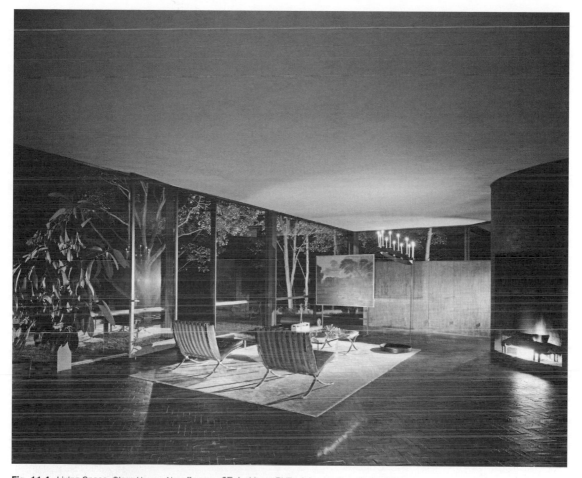

Fig. 11.4. Living Space. Glass House, New Canaan, CT. Architect: Philip Johnson. Ezra Stoller © Esto.

floor, Johnson placed modern architecture in a context of historical (and vernacular) associations, emphasizing a sense of time and place. Here it is notable that he uses a number of Mies's own furniture designs in this work: this deceptive gesture, I would argue, points not to slavish conformity but to a pointed interrogation. At the Glass House, the interior furnishings function not as formally perfect objects in a neutral environment but as islands floating in animated, narrativized space—stops along the way in a circuitous route around an interior landscape which was inhabited by both people and things with stories to tell. Thus, the differences between Johnson's Glass House and Mies's Farnsworth House are not simply a matter of architectural 'composition', but of architectural intent in virtually every aspect of form and experience.

Johnson's incorporation of everyday objects into the Glass House, albeit minimal compared with the interior decorating norms and extensive use of colour prevalent throughout suburbia in the 1950s, was a far cry from Mies's language of abstract

forms and simple, elegant surfaces. At the Farnsworth, the beauty of the void, and of open space enclosed by glass, is celebrated by the placement of the solid wooden block containing the bathrooms and the fireplace, a formal mass which further served to divide the interior into zones for various activities. Indeed, looking at Mies's design, which is a tour de force of architectural composition in its handling of proportions and materials, it is easy to see why many modern architects, including Johnson, admired it so much. It is also possible to see, however, how very little the Farnsworth House had to do with the temporal and quotidian experiences of its female occupant, or with her socially and culturally based notions about her identity as a woman, her experience of her home or her life in Plano, Illinois in the 1950s. Mies's house is purely about architecture and strives to be timeless; Johnson's house, on the other hand, is about lived experience located in history, in the specific site of New Canaan, Connecticut, and within the culture of the postwar period.

Finally, when we study the plans in detail, it becomes clear that the service core at the Farnsworth has the effect of constricting and routinizing the life of the occupant; the fireplace, kitchen and bathrooms, clustered together at the centre of the block, become merely signs for the most basic bodily functions within the home; there are no 'sign posts' for relational experience or social spaces, beyond the rigid furniture groupings and the 'area' rug, which might create a sense of place or identity. Movement through the space is meant to proceed in straight lines along a rectangular grid: service areas

such as the galley kitchen and bathrooms are intended to perform highly focused activities rather than serve as sites for the pleasures and rituals of domestic life. Johnson's approach is not nearly so abstract: on the contrary, it is metaphoric, discursive and picturesque. Here, as one moves through the various architectural zones, objects mark 'events' in the domestic landscape—the cylindrical chimney enclosing a bathroom (see Fig. 11.5), the bedroom area screened by a storage partition (see Fig. 11.6), the kitchen, the living furniture group in the centre of the space. The views and the experience of interior space at the Glass House demand movement along a curving, serpentine path, and they are constantly changing.

Fig. 11.5. Bathroom. Glass House, New Canaan, CT. Architect: Philip Johnson. Bill Maris © Esto.

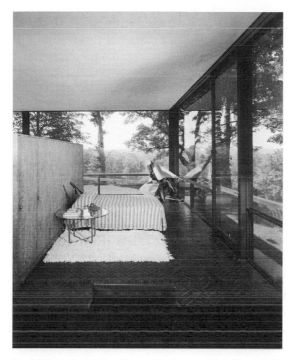

Fig. 11.6. Bedroom. Glass House, New Canaan, CT. Architect: Philip Johnson. Bill Maris © Esto.

All these features tell a carefully narrated story, but ultimately the most obvious difference between Mies's building and Johnson's is the presence of the Guest House in the latter and its absence—and, indeed, the absence of any private space at all—at the Farnsworth House. This fact provides the key to the two projects; the pairing of the Glass House and the Guest House at New Canaan seems rooted in the battles being fought by Johnson and his gay contemporaries in both urban New York and suburban Connecticut—the struggle for privacy in the face of increasing pressure for conformity and, perhaps most important for Johnson's project, the fear of people who chose to live their lives differently from those in the 'normative' mainstream.[14]

Johnson was, in a sense, taunting the defenders of conventional American values by including the brick Guest House in the programme for his estate, and this idea was more fully elaborated when he renovated the interior of this building to give it its present form in 1953. We cannot really understand this project fully without taking note of the ironic, gay, cultural discourse of 'camp' in which these taunts were expressed—this was a language in which Johnson became not only fluent but an undisputed master. In this discourse, exaggeration, satire and sophisticated artistry were all brought to bear on an extended parody of heterosexual norms and social respectability. Within the norms of modernist architectural culture, the Guest House was camp, too: with its pink fabric-covered walls (always thought to have been Fortuny silk but now, thanks to a recent renovation, known to be printed cotton), its soft platform bed, slender pilasters and suspended domical vaults, it was a pleasure palace for seduction, a 'Moorish' room, as Johnson called it, shaped by atmospheric scenography.[15] As such, it came as close to the setting of a Las Vegas–style floorshow as any work of modern architecture of the period had come. And we can well understand why Mies, and his International Style disciples, would have hated it.

Claiming the eighteenth-century breakfast room in Sir John Soane's house in London as his source—a source that becomes more plausible when the wall panels are moved aside to reveal hidden walls of bookshelves (see Fig. 11.7)—Johnson stated that the interior represented an experiment in anti-functionalism: it did 'five or six things besides

providing for sleeping', he said, including providing a sense of wonder and mystery: 'it does something to cradle the spirit to be in a curved surface,' Johnson noted in a lecture entitled 'Whither Away: Non-Miesian Directions', presented at the School of Architecture at Yale in 1959, and he added: 'The room is small up to the columns, and then the great outdoors takes over with light on the pink walls.'[16] In this historicizing, sexualized space, with its soft, romantic lighting, controlled by a dimmer box at the head of the bed, the guest or the gay architect—perhaps taking a vacation from the rigours of life in the Glass House—could play whatever role he chose, 'performing' masculinity or femininity, in the language of cultural critic Judith Butler, without fear of being under surveillance.[17] Although Johnson would later describe how he discovered the sources for such 'emotional space' in the work of both Mies and that of his hero, the neoclassical architect Karl Friedrich Schinkel, there can be no doubt that full credit for the glamour and theatricality of the Guest House interior—as well as the particular effects of staging and lighting that characterize the New Canaan estate as a whole—belongs to Johnson alone.[18]

As his essay in the *Architectural Review* (1950) made clear, Johnson was particularly interested in the siting of villas and outbuildings on the grand estates of Europe, and he referred to the work of Schinkel at the Casino at Potsdam on the same page as he cited Ledoux and Mies. Thus, the traditions of classicism—both the geometric/ rational strand followed by Mies and the romantic classicism of the picturesque and

Fig. 11.7. Shelving. Glass House, New Canaan, CT. Architect: Philip Johnson. Bill Maris © Esto.

the rococo—were of interest to Johnson as design prototypes and as history. Further, as Phyllis Lambert showed in a recent article, Johnson was drawn not only to the traditions of exterior treatment illustrated here but also to the fashionable interiors of the eighteenth century.[19] His thoughtful use of lighting for both day and night effects, conceived in collaboration with the talented lighting designer Richard Kelly, essentially turned the New Canaan estate into a stage set in which a wide range of activities—from glamorous parties, to theatre and dance, to the quiet contemplation of nature and reflections on the glass windows by the solitary weekend visitor—were possible.

For Johnson, the evolution of modern architecture was a natural process of

change, just as his own transition from ultra-orthodox Miesian to postmodernist and finally deconstructivist could be explained and justified by history. Indeed, he used similar arguments in response to questions about his political past and his ultimate rejection of the fascist ideas he had so vigorously championed during the 1930s.[20] Though this lack of allegiance to a single set of convictions was repugnant to many observers, he insisted on his right to change, just as he insisted on his right to express emotion freely (and, like a true eighteenth-century romantic, he was often moved to tears) or to dress for the theatre, or—as he said of his Pavilion in the Lake at New Canaan—to design a building that was beautiful to look at rather than simply useful. In an article entitled 'Full Scale Fall Scale' published in 1963, Johnson compared this pavilion—which was fun to look at and even more fun to play in because of its false-scale, five-foot-high arches—to a pair of 'high-style, high heel evening slippers, preferably satin, a pleasure-giving object, designed for beauty and the enhancement of human, preferably blonde, beauty'.[21] 'Usefulness as a criterion condemns our art to a mere technological scheme to cover ourselves from the weather,' he wrote, 'much as to say that shoes should be practical, not hurtful or handsome. Actually, there exist shoes designed just for comfort and we all know them for the hideously ugly monstrosities that they are. But somehow the idea has come about that mere functional (cheap) buildings are good enough for Americans . . . I say, just as in footwear, we need beautiful, in addition to mildly useful, buildings.'[22] Johnson was always saying things like this, it seems—outrageous, campy quips designed to amuse his listeners and focus their attention away from their prejudices. Yet alongside the campy image that Johnson sometimes projected was another role that he often assumed: that of the leader and teacher, who could turn almost any conversation into an important learning opportunity.

Johnson's brand of modern architecture ultimately evolved into a flexible system that could accommodate a far wider range of social and cultural circumstances than the International Style had been able to respond to. Yet he remained committed to MoMA and to his mentor: he worked alongside Mies until his death, dedicated to the process of glamorizing Miesian modernism for American clients. Witness the Seagram Building, with its elegant steel frame and perfect proportions, and the ways in which the baroque pearl of Johnson's glamorous Four Seasons restaurant and bar serves as a luxurious container for the human drama, ornamented with shimmering surfaces and sparkling lights in the trees. Nowhere else in the history of modern architecture and interiors do we find design brought into such harmony with the aspirations and rituals of the private consumer or of the corporate world—and no one was better than Johnson at using modern architecture's forms, lighting (again by Richard Kelly) and rich materials to create a theatrical effect that equalled the aristocratic mise-en-scènes of the Old World.

Johnson had the sort of agile mind and, as a gay man, the kind of outsider status that enabled him to look ahead rather than to remain stuck in theories or systems: for

example, his free-ranging curiosity motivated him, as early as the mid-1980s, to promote the groundbreaking new work of architects like Frank Gehry, Daniel Liebeskind, Rem Koolhaas and Zaha Hadid, designers who are now the most prominent and sought-after members of their profession. His influence is thus still very much alive today. Try as his critics might, they were unable to dislodge him from his secure position as a kingmaker and power broker, and he continued to offer his perverse, ironic wisdom from the safety of his hard-won perch in the profession right up to the time of his death. Though he remains a controversial figure, Johnson is surely one of the most influential architects of the twentieth century, a man who should be recognized both for his pioneering critique of modern architecture's narrow social programmes and for his efforts to broaden the range of artistic expression and symbolic meaning in modern design.

Notes

1. See J. H. Casid, 'Some Queer Versions of Georgic', in J. H. Casid, *Sowing Empire: Landscape and Colonization* (University of Minnesota Press, 2005); and 'Queer(y)ing Georgic: Utility, Pleasure, and Marie-Antoinette's Ornamented Farm', *Eighteenth-Century Studies* 30/3 (1997), pp. 304–18.

2. Questions about Horace Walpole's sexuality and its relevance for the history and design of Strawberry Hill, his villa at Twickenham, are taken up by George Haggerty in the chapter 'Strawberry Hill: Friendship and Taste', in M. Snodin, ed., *Horace Walpole's Strawberry Hill* (Yale University Press, 2009). For an overview of villa typology and literature see J. S. Ackerman, *The Villa: Form and Ideology of Country Houses* (Princeton University Press, 1990).

3. The phrase introduces Act II, Scene 2, of Shakespeare's *A Midsummer Night's Dream,* in which lovers cavort in a pastoral Eden and Oberon places a magic spell on Titania that causes her to fall in love with Bottom, a man whose head is transformed into that of a donkey.

4. Quoted by Casid, *Sowing Empire,* p. 134.

5. For an overview of Johnson's career and architectural contribution, see S. Fox, *The Architecture of Philip Johnson* (Bulfinch Press, 2002). For the New Canaan estate, see S. Jenkins and D. Mohney, *The Houses of Philip Johnson* (Abbeville Press, 2001), pp. 60–93; N. Levine, 'Afterword: Philip Johnson's Glass House: When Modernism Becomes History' in the same volume, pp. 268–84; and A. T. Friedman, *American Glamour and the Evolution of Modern Architecture* (Yale University Press, 2010), chap. 1. For the Glass House see D. Whitney and J. Kipnis, eds, *Philip Johnson: The Glass House* (Pantheon Books, 1993); A. T. Friedman, *Women and the Making of the Modern House: A Social and Architectural History* (Harry N. Abrams, 1998), chap. 4; and J. Ockman, 'Glass House', in R. Ingersoll, ed., *World Architecture 1900–2000: A Critical Mosaic,* vol. 1 (China Architecture and Building Press, 2000), pp. 104–7.

6. See F. Schulze, *Philip Johnson: Life and Work* (Alfred A. Knopf, 1994).

7. Johnson's career has been extensively documented and studied (see note 5). For his well-known involvement with the Nazi party, see K. Varnelis, 'We Cannot Know History: Philip Johnson's Politics and Cynical Survival', *Journal of Architectural Education* (November 1994), pp. 92–104. The issue of Johnson's history of anti-Semitism and his work for Jewish clients is brilliantly analysed by Joan Ockman in 'The Figurehead: On Monumentality and Nihilism in Philip Johnson's Life and Work', in E. Petit, ed., *Philip Johnson: The Constancy of Change* (Yale University Press, 2009), pp. 82–109.

8. See A. H. Barr Jr, *Modern Architecture: International Exhibition* (Museum of Modern Art, 1932) and *The International Style: Architecture Since 1922* (Norton and Company, 1932). For Johnson's role at MoMA, see T. Riley, 'Portrait of the Curator as a Young Man', *Studies in Modern Art* 6 (1998), pp. 34–69.

9. The quote comes from a talk entitled 'Whither Away-Non-Miesian Directions', delivered at Yale University on 5 February 1959, reprinted in Philip Johnson, *Writings,* foreword by V. Scully, introduction by P. Eisenman, commentary by R. A. M. Stern (Oxford University Press, 1979), pp. 226–40, quotation pp. 229–30.

10. Friedman, *Women and the Making of the Modern House,* chap. 4.

11. Numerous images of the Farnsworth House, including plans and detailed sections, are available both in print media and online.

12. 'House at New Canaan, Connecticut', *Architectural Review* CVIII (September 1950), pp. 152–9.

13. See 'Whence and Whither: The Processional Element in Architecture', *Perspecta* 9/10 (1965), pp. 167–78, reprinted in Johnson, *Writings,* pp. 50–5. The most perceptive treatment of Johnson's theatrical design techniques, at New Canaan and elsewhere, is P. Lambert, '*Stimmung* at Seagram: Philip Johnson Counters Mies van der Rohe', *Grey Room* 20 (Summer 2005), pp. 38–59.

14. See A. M. Black, ed., *Modern American Queer History* (Temple University Press, 2001); and B. Harvey, *The Fifties: A Woman's Oral History* (Harper/Perennial, 1994).

15. For the 2010 renovation to the Brick Guest House, see http://philipjohnsonglasshouse.org/preservationatwork/brickhouse.

16. Johnson, *Writings,* p. 237.

17. See, among other texts, her *Gender Trouble: Feminism and the Subversion of Identity* (Routledge, 1990).

18. The most detailed discussion of these sources is Johnson's 'Schinkel and Mies' (1961), reprinted in Johnson, *Writings,* pp. 164–81, 177.

19. See note 13.

20. H. Lewis and J. O'Connor, *Philip Johnson: The Architect in His Own Words* (Rizzoli, 1994); and K. Varnelis, eds, *The Philip Johnson Tapes: Interviews with Robert A. M. Stern* (Monacelli Press, 2008).

21. 'Full Scale False Scale', originally published in *Show* III (June 1963), pp. 72–5, reprinted in Johnson, *Writings,* pp. 250–2, quotation p. 251.

22. Ibid., p. 251.

Chapter Twelve

Dressing the part(y): 1950s domestic advice books and the studied performance of informal domesticity in the UK and the US

Grace Lees-Maffei

Behaviour is subject to fashion as much as clothing, furniture and other designed goods. As a discourse of ideals, domestic advice literature—and by that I mean advice literature pertaining to the social and material composition of the home, namely etiquette, homemaking and home decoration books—can be read retrospectively to trace fashionable changes in both design *and* manners and is therefore a useful resource in uncovering the history of intersections between fashion, performance and the modern interior. This chapter examines three domestic advice books from the UK and the US—American industrial designers Russel and Mary Wright's *Guide to Easier Living,* revised edition 1954 (1950), British journalist Julia Cairns's *Home Making,* also 1954, and British author Daphne Barraclough's *How to Run a Good Party* of 1956—to examine a historical moment in which a shift in fashionable behaviour produced new advice about domestic interactions, or performances, within the home. With reference to Erving Goffman's dramaturgical metaphor developed in *The Presentation of Self in Everyday Life,* here advice books are presented as scripts for domestic performances within the home as a stage.

It is usual for authors of domestic advice to identify the contemporary moment as one of unprecedented change, and a retrospective reading of domestic advice literature suggests that in the UK and the US, in the twentieth century, informality was increasingly upheld as a social ideal, in response to the accretion of formality of the previous century.[1] The extent to which twentieth-century social interaction is more informal than that of earlier periods has been the subject of debates among historical sociologists. In *Über den Prozeß der Zivilisation* (*The Civilizing Process*), a German sociologist who worked mainly in Britain, Norbert Elias, analysed etiquette books from the thirteenth to the nineteenth centuries, primarily from Germany and France. He argued that the long view shows that society has become increasingly civilized,

as interdependence between states and individuals has increased and as state force has been centralized.[2] Elias maintained that where a point of etiquette is dropped from the literature it is because it has been adopted by the readership and no longer needs stating in an instructional context; thus, etiquette books are used to exemplify his thesis that behaviour has become more civilized over time. Dutch sociologist Cas Wouters has argued that the period since 1890 is characterized by informalization based on increased social integration, a widening middle class and lack of external controls, which has necessitated greater internalized self-restraint.[3] Wouters's recognition that informalization characterizes the pattern of social behaviour since 1890 supports the views expressed by authors of the larger category of domestic advice books that social life has become increasingly informal.

Ironically, far from dispensing with a need for published advice, informalization necessitated what US industrial designers Mary and Russel Wright termed, in 1950, 'the New Hospitality'. The Wrights recognized that 'we live in a transition period in which there are few established rules'.[4] The introduction to their *Guide to Easier Living* railed against the 'Old Dream' of gracious living inherited from 'the stilted ritual of the English manor house':

Subtly preached by that able evangelist Emily Post, the Dear Old Dream dominates writing and merchandising concerned with the home, haunts domestic architecture across the country, and tyrannically rules American family life.[5]

The *Guide* was as important as their tableware designs in prompting curators Donald Albrecht and Robert Schonfeld to assert in 2001 that 'more than their fellow modernists Charles and Ray Eames or George Nelson, the Wrights influenced the postwar home in an all-encompassing way'.[6] Russel Wright began his career designing for the theatre, like Norman Bel Geddes, for whom he worked as an apprentice, and this training may have influenced his contextualized approach to design. A retrospective at the Cooper-Hewitt National Design Museum in 2001 sought to communicate 'both the formal and social dimensions of Russel and Mary's work, from individual objects to scripts for entertaining', and included an interpretation of his interior design, landscaping and architectural output as 'Stage Sets for American Living'.[7] But while they were explicitly engaged in scripting 'the new hospitality', Mary and Russel Wright tried to sidestep this paradox:

Once you've shaken free of traditionalism, don't, for heaven's sake, go looking for a new type of Dream House, or for a new Emily Post to put yourself in bondage to. Don't swallow anyone's ideas whole, not even the ones in this volume.[8]

Aspirations to informality are particularly highlighted in the act of home entertaining, which not only requires a considerable effort on the part of the hostess and/or host, but also demands that such effort be concealed or denied, for the avoidance of embarrassment. Wouters's argument that informal interactions require more internalized labour for the individual has a parallel in the extent to which informal patterns

of home entertaining have not diminished the work of the hostess and/or host, but rather forced it into hiding, under the pretence of nonchalant ease. As Mary and Russel Wright state, without intended irony: 'We can plan for that informal, relaxed kind of entertaining.'[9] Although the authors would probably deny it, their book shows that, because it is undertaken without hired help, entertaining informally is no less demanding of the hostess and/or host than earlier formal models. Their emphasis is on planning and simplification ('perhaps the most important consideration of all in the new etiquette') of both menu and service:

> We believe that your degree of non-conformance to useless convention determines the extent of your meal's smooth service, plus meaning less work for you. Any of these simplifications, if executed thoughtfully, can be in good taste, can even have 'style'.[10]

The Wrights offer a range of options for entertaining informally, including 'the Kitchen Buffet', 'quite the most unconventional and informal variation, if your kitchen is large enough to permit it', and a T-shaped setting termed 'the Cafeteria Table' — 'a work-saver for family meals; it is easily adapted to company meals', in which guests move along the short side of a table collecting flatware, plates, bread, butter and a drink and then sit down at the long sides of the table to help themselves to food set in the middle (see Fig. 12.1).[11] This recommendation is followed by a chart in which the 82 items carried to and from the table for a conventional setting are compared, item by item, with the 36 pieces needed for the 'Cafeteria' setting. It is fitting,

if not a little ironic, that the designers of 'by far the best known [tableware] in the country' (as claimed on the flyleaf for *Guide to Easier Living*) should also have been influential in the art of doing without unnecessary table items.

The market for new advice on how to entertain informally, and without staff, burgeoned in the US and the UK alike. In her *How to Run a Good Party,* published in London in 1956, Daphne Barraclough devotes a chapter to the period between making the preparations for a party and the arrival of the guests, which she titles 'Zero hour!'

> That short rest before zero hour is invaluable to any hostess, and if you rest awhile before putting on your party dress you will feel refreshed and ready to enjoy the fruits of your own labour. Planning and catering called for 'behind the scenes' skill as a hostess. The arrival of the first guest calls for on-stage skill in the same capacity . . . You've worked and planned for a happy smooth-running party, but your aim should now be to give the impression that it is all too easy — just a little something to be taken in your stride any day of the week. Your guests are assembled, you are wearing your prettiest dress, and the room is full of happy laughter. So just relax — and enjoy yourself.[12]

The period between preparations and party is here presented as having the potential for a therapeutic ritual in which the hostess ceases work and becomes, instead, distanced from her earlier self and capable of enjoying the fruits of her own labour just like a guest. Barraclough is explicit in her encouragement that hostesses cultivate a

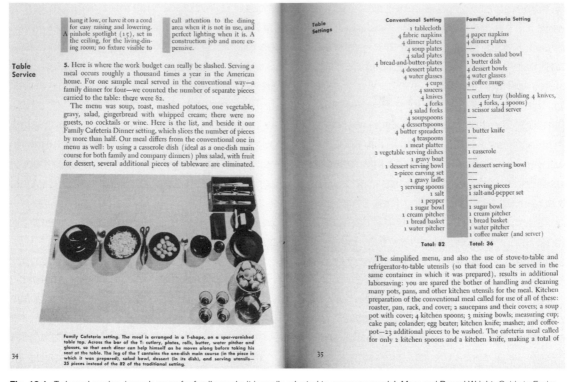

Fig. 12.1. T-shaped service, 'a work-saver for family meals; it is easily adapted to company meals'. Mary and Russel Wright, *Guide to Easier Living,* New York: Simon and Schuster, 1954 (1950). Image © Russel Wright Studios.

deceptive impression of ease. Explicit, too, is the injunction to relaxation and enjoyment which, again, places the hostess with her guests. The opposite of a relaxed hostess is one consumed by 'party flurry' as a response to the demands of home entertaining without assistance.[13] The necessity of avoiding party flurry and of appearing to be relaxed is not just about enhancing the hostess's/host's experience of the party but also, crucially, about minimizing the embarrassment that guests might feel about being waited on by a peer and friend. If the hostess and/or host appear to be as relaxed as their guests (even while they perform the duties of a cook and

waiter, as well as that of hosts), then they achieve an equal footing with their guests.

Barraclough's metaphorical references to the theatre ('behind the scenes', 'on-stage') are echoed in the extended dramaturgical conceit of American sociologist Erving Goffman's analysis *The Presentation of Self in Everyday Life,* first published as a report by Edinburgh University Press in the same year as Barraclough's *How to Run a Good Party* and then by Doubleday, New York, three years later in 1959.[14] While Goffman did not feature advice books in his analysis, he recognized that 'one of the richest sources of data on the presentation of idealised performances is

the literature of social mobility', and his work helps us see how domestic advice is a tool of social conditioning which articulates the unspoken in textual codes for interaction.[15] If people's behaviour at home can be seen as performance, as Goffman shows, then domestic advice writers can be seen as scripting ideal, fashionable performances. Domestic life and home entertaining occur within a setting controlled by the hostess and/or host, in which everything from the décor to the food communicates something about them upon which guests may base their judgements. The social front comprises 'the "setting", involving furniture, decor, physical layout, and other background items which supply the scenery and stage props for the spate of human action played out before, within, or upon it' and the 'personal front', composed of appearance, gesture, clothing, insignia and manner.[16] Spaces, and the behaviours they require, are divided into front and backstage, depending on the nature of the performance. In this way, we remove aspects of our lives from the scrutiny of others, thereby avoiding embarrassment and maintaining conspicuous consumption appropriate to status and context. The backstage is where illusions are devised and stored, and 'costumes and other types of personal front are adjusted and maintained'.[17] While Goffman argued that 'the backstage character of certain places is built into them in a material way' and acknowledged the role of the built environment as a focal point for social interaction, his interest in material culture extends only as far as it assists the performer in staging a good show: 'A status, a position, a social place is not a material

thing to be possessed and then displayed, it is a pattern of appropriate conduct, coherent, embellished, and well-articulated.'[18] For Goffman, 'decorous behaviour' is defined by 'showing respect for the region and setting' and audience.[19]

Goffman's 1959 account of front and backstage is complicated by the fashion for open-plan interiors and zoned living that preoccupied postwar architects, interior designers and domestic advice writers. There is little scope for the cover (and refuge) provided by a backstage environment in a kitchen-diner, a bedsitter or a home without internal walls. For the Wrights, these environments necessitated new forms of entertaining:

> Who would think about wearing an evening gown on the golf course? Isn't it just about as ridiculous to set a traditional table, complete with starched white damask and all the trimmings in the dinette, or in a combination living-dining room?[20]

They recommend enlisting help from guests, so that whether in conventional homes with clearly demarcated front and backstage spaces, or in homes where front and backstage are collapsed, guests will find their way into the kitchen, thereby necessitating new etiquette (see Fig. 12.2). As an example of 'present-day good manners', the Wrights cite the importance of hostesses/hosts cleaning up after meal preparation and before guests arrive, so that if a guest offers to help with the post-meal cleaning, you 'don't inflict your unwashed before dinner pots and pans on them' (see Fig. 12.3).[21]

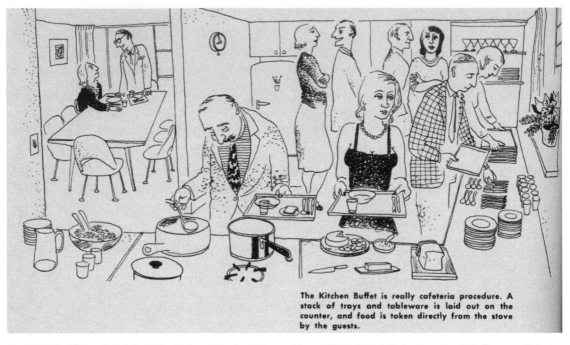

The Kitchen Buffet is really cafeteria procedure. A stack of trays and tableware is laid out on the counter, and food is taken directly from the stove by the guests.

Fig. 12.2. 'The Kitchen Buffet', illustration by James Kingsland. Mary and Russel Wright, *Guide to Easier Living*, New York: Simon and Schuster, 1954 (1950). Image © Russel Wright Studios.

Whatever the material makeup of the home in which hostesses or hosts were to entertain, they were encouraged to set the scene with care, considering everything in the home as evidence of their personalities, and therefore as being of potential value in supporting their hospitality. French sociologist Pierre Bourdieu worked briefly with Goffman at the University of Pennsylvania and, within a brilliant and wide-ranging career, he is perhaps best known for his development of Elias's concept of habitus to denote an inherited world view conditioned by social environment and by various types of unevenly distributed power, termed social, cultural and physical capital.[22] Bourdieu's classic 1979 book, *Distinction,* used field research from 1963 and 1967–1968 to explore the ways in which class was determined by taste and consumption as well as production.[23] In following Max Weber's work on 'styles of life', Bourdieu showed that communication through commodities is subtle and unspoken.[24] Bourdieu's work collapses Goffman's 1959 notion of front and backstage to reveal that every aspect of our lives, including what might have been traditionally backstage spaces such as kitchens, have become sites of status display. Bourdieu asserted that trends in modernist utility, for example, are not merely the product of economic or practical necessity, but are also a choice of class distinction. It is precisely an appreciation of the beauty of utility, which he associated with a refined and privileged taste, which has enabled home entertaining to take place in regions

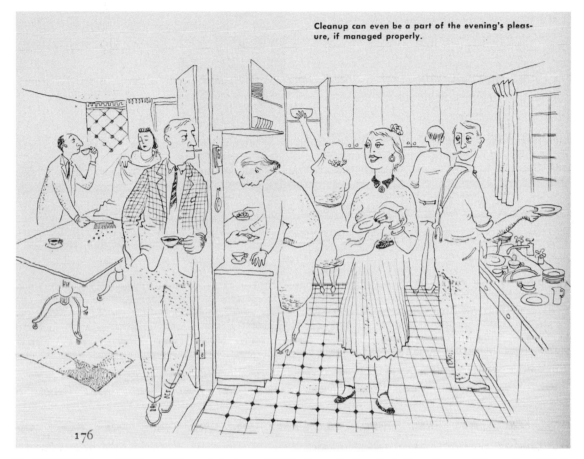

Fig. 12.3. 'Cleanup can even be part of the evening's pleasure, if managed properly', illustration by James Kingsland. Mary and Russel Wright, *Guide to Easier Living*, New York: Simon and Schuster, 1954 (1950). Image © Russel Wright Studios.

previously designated as backstage, such as the kitchen. This model echoes the advice presented in domestic discourses for flexible modifications of spaces such as dining rooms, living rooms and latterly kitchens for social interaction, and a reordering of parts of the home as public (suitable for extrafamilial entertaining) and private, front and backstage.

Women, particularly, have been the subject of a continuing association with the home in domestic advice literature and across the popular media. In her book *The Personality of a House* (1930–1948), based on articles from the *Ladies' Home Journal,* pre-eminent US etiquette author Emily Post discusses the importance of decorating to flatter one's own colouring:

In choosing her own most becoming background, the woman of taste is merely a stage director who skilfully presents—herself . . . Why not look your best at home, where you are seen every day by those who love you most, rather

than think of your appearance solely when you choose a street or party dress?[25]

In 1950, journalist Julia Cairns noted a connection between a woman's dress and her interior décor in her book, *Home Making: The Mid-Twentieth Century Guide to the Practical Yet Subtle Art of Making a House a Home:*

> *Quite often, too, I have quietly noted how the woman who has a natural flair for dress is frequently just as talented and competent in arranging rooms, choosing background colours and scheming decorative accessories. How, you are wondering, does this work out? Like this. The well-dressed woman has decided taste. She is intelligently interested in fashion. But, here's the point—she adapts fashion to her taste, to type, instead of slavishly following fashion. Spurning the sensational, she thereby achieves consistent success and retains her own individuality. Even so, homemaking goes deeper still. Besides all else, it calls for qualities of heart and spirit.*[26]

Figure 12.4 shows the author's portrait from her book. Cairns's own dress and her setting display the flair she describes. Figure 12.5 provides an example of the kinds of 'decorative accessories' mentioned. Her merging of chic woman and fashionable home recalls Cairns's 1938 publication, *Re-Dress Your Rooms: Some Practical Needlework Notions in Keeping with 1938 Furnishing Fashions,* for the Singer Sewing Machine Company. As the aforementioned quotation implies, the amalgamation of woman and home (itself the title of a long-running British women's magazine, established in 1926

Fig. 12.4. Author portrait, frontispiece, Julia Cairns, *Home Making*, London: Waverley, 1950. © IPC+ Syndication.

and still in press) displays, on the one hand, positive associations of home being where the heart is:

> *The markers of home, however, are not simply inanimate objects (a place with stuff), but the presence, habits, and effects of spouses, children, parents, and companions. One can be at home simply in the presence of a significant other.*[27]

On the other hand, however, this tendency perpetuates constraining Victorian ideologies of separate spheres and the angel at the hearth. In the former, men were seen to occupy the public, professional, extra-domestic sphere while women stayed at home in the

HOME MAKING

Two focal points which can contribute decorative charm to the dining-room are the mantelpiece and the table. For the one, a graceful Dresden shepherdess looks down upon a simple mixture of dried flowers, and seed-heads, in a glass bowl. Although this is essentially an end-of-summer study, the same idea can be varied with the seasons and range from a springtime bowl of early Roman hyacinths to a summer bunch of fresh garden flowers. Well-chosen china, shapely glass, well-polished silver and simple mats, self-fringed, lend distinction to the table itself.

126

Fig. 12.5. 'A graceful Dresden shepherdess looks down upon a simple mixture of dried flowers and seed-heads, in a glass bowl.' Julia Cairns, *Home Making*, London: Waverley, 1950. © IPC+ Syndication.

nonprofessional, familial, domestic realm. The latter was an idealized representation of women which gained currency following the publication of Coventry Patmore's poem 'The Angel in the House' (1854–1862).[28]

The merging of woman and home is complicated by women's professional engagement with the home, for example as design journalists. Cairns's book *How I Became a Journalist* (1960) explains the genesis of her successful career in her practical approach to decorating:

I never wrote about what I hadn't actually done. I remember on one occasion doing an article on laying linoleum in a kitchen, and the same kindly editor saying: 'This is good, very good. It's practical. Tells you what to do and what not to do. Reads as if you've done it.' 'I did, last week,' I told her truthfully.[29]

Cairns's practicality is exemplified in her directions for using a dual-purpose living/dining room, shown in Figure 12.6. The caption notes that the dining table 'can be extended or reduced as required', implying its suitability for entertaining and family meals alike, while the settee and easy chairs which are shown opened out towards the dining area 'can readily be focussed around the well-planned hearth'. Cairns also draws attention to a range of lighting options and the beneficial spatial effects of the over-mantle mirror. Cairns's pragmatism was combined with her enthusiasm for literary aesthetics. In the same book she noted:

With the current inclination towards the casual in many things, from clothes to punctuation, with the consequent exclusion of many of the niceties of life, I already detect a welcome come-back to delicate detail . . . So, as writers destined to live in a practical age and remaining contemporary-minded, let us endeavour not to lose entirely the poetic, the elegant and the gracious. With the philosopher and poet Ralph Waldo Emerson let us agree, 'The way to speak and write what shall not go out of fashion, is to speak and write sincerely.'[30]

Cairns's emphasis is on direct experience harnessed to achieve the desirable qualities

of clarity and directness in her instructional writing, and sincerity. It is apt that she quotes from Emerson, who, as the late American cultural historian Warren Susman noted, provided a much-repeated definition of character: 'Moral order through the medium of individual nature'.[31] Sociologists and historians have posited a shift in the twentieth century from inward, moral 'character' to an other-directed 'personality'.[32] Susman has described the way in which self-help literature can be used to trace such a shift and notes the contradictions implicit in being true to oneself while at the same time seeking the approval of others:

> *The new personality literature stressed items that could be best developed in leisure time and that represented themselves in an emphasis on consumption. The social role demanded of all in the new culture of personality was that of a performer. Every American was to become a performing self . . . At the same time, clothing, personal appearance, and 'good manners' were important, but there was little interest in morals . . . The new stress on the enjoyment of life implied that true pleasure could be attained by making oneself pleasing to others.*[33]

Within these terms, the act of entertaining others through the provision of food and the consumption of other forms of entertainment, within one's own home, represents an apogee of personality and its expression.

Daphne Barraclough's advice in *How to Run a Good Party* extends beyond the arrangement of existing furnishings and into the fabrication of artificial props which are designed to help create a party environment

THE DINING-ROOM

These photographs show two views of the same dual-purpose interior. Typical of many semi-detached houses of today, it combines a living-room and dining-room, with its small kitchen opening directly off without any intervening passage. The room is light and spacious in effect, due partly to the generously proportioned windows, and partly to the fact that adequate furniture, with nothing superfluous, has been chosen. A well-made dining-room table, which can be extended or reduced as required, with four modern ladder-back chairs, are grouped at one end with a pleasant window view. Elsewhere a settee and easy chairs can readily be focussed around the well-planned hearth which, surmounted by a large mirror, appears to make the room look even larger than it is. A centre ceiling light ensures good overall light, but additional points for a reading or standard lamp safeguard current economy and provide local light when only required for sewing or reading. Charmingly curtained in a simple modern print, note the trim, neat effect of painted plywood pelmets.

119

Fig. 12.6. 'Two views of the same dual-purpose interior . . . it combines a living-room and a dining-room.' Julia Cairns, *Home Making*, London: Waverley, 1950. © IPC+ Syndication.

and atmosphere. Barraclough's temporary fabrications complexify the association of a hostess/host with her/his domestic environment and exemplify other-directed personality rather than character:

> *A few bottles of wine and an odd shelf can become a fascinating bar if you follow these instructions. Make an awning framework from lathes to extend the length of any suitably placed shelf. Fix the frame to the wall above the shelf and cover it with gaily striped wallpaper, finishing with a scalloped edge. Tie bright*

7. A few bottles of wine and an odd shelf can become a fascinating bar if you follow these instructions. Make an awning framework from laths to extend the length of any suitably placed shelf. Fix the frame to the wall above the shelf and cover it with gaily striped wallpaper, finishing with a scalloped edge. Tie bright ribbons round the wine bottle necks and stand them in coloured pie frills on the shelf. Place a table lamp at each end of the shelf to throw a good light on the "bar". (Fig. 7.)

Fig. 7

8. Use harlequin table mats or harlequin cups and plates The more variety in shape and colour of china the gayer the the effect. Mats can be quickly made from odd pieces of linen cut to size and fringed out all round.

9. For an impressive focal point on a large wall area fix up a diamond pattern trellis painted dazzling white. Place shrub tubs or a deep trough on the floor in front of the

116

Fig. 12.7. 'A few bottles of wine and an odd shelf can become a fascinating bar if you follow these instructions.' Daphne Barraclough, *How to Run a Good Party,* London: Foulsham, 1956, p. 116. Text and image © W. Foulsham & Co Ltd, http://www.foulsham.com.

ribbons round the wine bottle necks and stand them in coloured pie frills on the shelf. Place a table lamp at each end to throw a good light on the 'bar'.[34]

This (see Fig. 12.7) is one of several similar suggestions in Barraclough's book, where a setting is staged for a party and afterwards discarded. If the home can be fashionable and if it can be dressed, then Barraclough's party decorations represent the home in its party clothes, which, however informal, are certainly the product of a hostess's or host's labour.

We have seen, within the pages of domestic advice books, a contradiction between the labour expended on entertaining friends in the home and the appearance of fashionable ease. In invoking Emerson, Cairns emphasizes individual integrity, distinct from the idea of social interaction as performance seen in Barraclough's and Goffman's writings. As Goffman noted in a 1951 article:

Symbolic value is given to the perceptible difference between an act performed unthinkingly under the invisible guide of familiarity and habit, and the same act, or an imitation of it, performed with conscious attention to detail and self-conscious attention to effect.[35]

Here, Goffman anticipates Bourdieu's theorization of the importance of the 'manner of acquisition' of knowledge. The individual manages his or her internalization of the habitus differently according to the mode by which it was acquired. Established members of the middle class have no need for advice literature, instead gathering social knowledge through experiential, familial channels. Bourdieu observed that those who 'lack practical mastery of a highly-valued competence'

have to provide themselves with an explicit and at least semi-formalised substitute for it in the form of a repertoire of rules, or of what sociologists consider, at best, as a 'rôle',

i.e. a predetermined set of discourses and actions appropriate to a particular 'stage part' . . . Consider, for example, in very different fields, the petty bourgeoisie with its avid consumption of manuals of etiquette, and all academicisms with their treatises on style.[36]

The irony is that those seeking self-improvement within the pages of advice books can never succeed because their book learning will produce only studied performances and pedantry rather than the true ease upon which social confidence relies:

The language of rules and models, which seems tolerable when applied to 'alien' practices, ceases to convince as soon as one considers the practical mastery of the symbolism of social interaction—tact, dexterity, or savoir-faire—presupposed by the most everyday games of sociability and accompanied by the application of a spontaneous semiology, i.e. a mass of precepts, formulae and codified cues. This practical knowledge, based on the continuous decoding of the perceived—but not consciously noticed—indices of the welcome given to actions already accomplished, continuously carries out the checks and corrections intended to ensure the adjustment of practices and expressions to the reactions and expectations of the other agents.[37]

Bourdieu voices the view of the dominant class responding to attempts by nonmembers to emulate their behaviour. We can extrapolate that the problem Bourdieu identifies is particularly acute when the fashionable ideal of social interaction is one of informality.

Domestic advice literature has as its stock-in-trade the promise of solving pressing, real-world problems. What could be more practical than a book which purports to tell its readers how to manage the endless round of domestic tasks from cleaning to parties, cooking to decorating, laundry to buying anything from a chair to a mackerel? Yet, according to Bourdieu, published advice is doomed to ineffectuality. This is especially the case during a period in which informality is the fashionable mode of social interaction: informality and social ease cannot be attained through reading the published advice of others, however assiduously. How, then, do we explain the continued popularity of published advice?

Domestic advice writers have depended less on direct strategies such as testimonials from successful householders than they have on abstracted accounts of suggested behaviours designed simply to *inspire* readers' own domestic practices and performances. Such books have typically been illustrated with photographs and diagrams of depopulated staged interiors—showrooms drawn from advertising and magazine sources rather than real homes—into which readers can imaginatively project themselves, their families and their friends. The domestic advice genre offers an experience of reading *detached* from everyday life even while it is ostensibly *about* everyday life. Domestic advice offers an Archimedean point from which homemakers can enjoy fashionable modes of behaviour and design as a form of entertainment while, perhaps, reflecting on their own domestic practices and

imaginatively inserting themselves into the scene.[38] While the small but growing number of academic studies of advice seek to emphasize its social significance, it is also crucial to recognize domestic advice books, like theatre, as a form of entertainment, as fiction, as escapism.[39] The domestic advice genre has been consistently popular since the seventeenth century, whether in the form of books, magazines or its more recent televisual incarnations as property and entertaining series where vicarious enjoyment apparently subsumes practical instruction.[40] Recognizing the fictive status of text and images contained within the literary genre of domestic advice books enables consideration of the kinds of social practices recommended within as another layer of cultural construct: domestic performance.

This chapter has examined examples of UK and US postwar domestic advice which encouraged readers to pursue fashionable informal ideals of domesticity, contextualized using contemporaneous sociological theory to examine two core clusters of disjunctions. Firstly, increasingly informal social interactions rely on self-discipline for effective social performances, thereby engaging an ironic relationship between the ease needed to entertain successfully and the concealed labour equally as necessary to the smooth running of home entertaining, which relies in turn on a dissociation between the front regions where domestic performances take place and the backstage where preparations are made. Secondly, the oxymoron that the ease achieved via experiential, familial learning can never be replicated through book learning has prompted consideration

of the escapist entertainment function of advice literature. Associated contradictions exist between the real world problems of householders seeking advice and the problem-free ideal domesticity depicted through word and image in domestic advice books; between the practical, material realm of the home and the abstract, imaginative realm of the ideals of domestic discourse; between the home as a place of familial or extrafamilial sociability and the home as a locus of escapist fantasy and individual reverie. The abstracted, depopulated, staged interiors and domestic practices presented in postwar domestic advice books were ostensibly designed to inspire readers to attempt to recreate such scenes in their own homes, but they were also consumed in their own right as fantastic fictions, satisfying and delighting readers as an untouched and ultimately untouchable ideal of domesticity.

Notes

1. G. Lees-Maffei, 'From Service to Self-Service: Etiquette Writing as Design Discourse 1920–1970', *Journal of Design History* 14/3 (2001), pp. 187–206.

2. N. Elias, *The Civilizing Process* [1939], tr. E. Jephcott (Blackwell, 1994).

3. C. Wouters, *Informalization: Manners and Emotions since 1890* (Sage, 2007).

4. M. Wright and R. Wright, *Guide to Easier Living: 1,000 Ways to Make Housework Faster, Easier and More Rewarding*, rev. ed. (Simon and Schuster, 1954), p. 187.

5. Ibid., p. 2.

6. D. Albrecht and R. Schonfeld, 'Introduction', in D. Albrecht, R. Schonfeld and L. Stamm Shapiro, eds, *Russel Wright: Creating American Lifestyle* (Cooper-Hewitt, National Design Museum, Smithsonian Institution, Harry N. Abrams, Inc., 2001), p. 19.

7. Albrecht and Schonfeld, 'Introduction', p. 21.

8. Wright and Wright, *Guide to Easier Living*, p. 9.

9. Ibid., p. 166.

10. Ibid., pp. 167 and 169.

11. Ibid., pp. 173 and 174.

12. D. Barraclough, *How to Run a Good Party* (Foulsham & Co., 1956), pp. 30–1.

13. G. Lees-Maffei, 'Accommodating "Mrs Three in One": Homemaking, Home Entertaining and Domestic Advice Literature in Post-War Britain', *Women's History Review* 16/5 (2007), pp. 723–54.

14. E. Goffman, *The Presentation of Self in Everyday Life* (Doubleday, 1959), was first published as a report by the University of Edinburgh, Social Sciences Research Centre, Monograph no. 2 (1956). The first British mass market edition was by Allen Lane, Penguin Press, in 1969 (1990).

15. Ibid., p. 45.

16. Ibid., p. 32.

17. Ibid., p. 125.

18. Ibid., p. 81.

19. Ibid., p. 111.

20. Wright and Wright, *Guide to Easier Living,* p. 189.

21. Ibid., p. 175.

22. P. Bourdieu, *Distinction: A Social Critique of the Judgment of Taste* [1979], tr. R. Nice (Routledge, 1984).

23. Bourdieu, *Distinction,* p. 483.

24. M. Weber, 'Class, Status and Party' [1948], in M. Weber, *From Max Weber: Essays in Sociology,* tr. C. Wright Mills and H. H. Gerth (Routledge, 1990), pp. 180–95.

25. E. Post (Mrs. Price Post), *The Personality of a House: The Blue Book of Home Charm,* rev. ed. [1930] (Funk and Wagnalls Company, 1948), p. 186.

26. J. Cairns, *Home Making: The Mid-Twentieth Century Guide to the Practical Yet Subtle Art of Making a House a Home* (Waverley, 1950), p. 6. The book was produced by the Amalgamated Press (later Fleetway Publications), for whom Cairns worked as a magazine editor.

27. J. MacGregor Wise, 'Home: Territory and Identity', *Cultural Studies* 14/2 (2000), pp. 295–310, quotation p. 299.

28. See L. K. Kerber, 'Separate Spheres, Female Worlds, Woman's Place: The Rhetoric of Women's History', *Journal of American History* 75/1 (June 1988), pp. 9–39; L. K. Kerber, N. F. Cott, R. Gross, L. Hunt, C. Smith-Rosenberg and C. M. Stansell, 'Beyond Roles, Beyond Spheres: Thinking about Gender in the Early Republic', *William and Mary Quarterly,* 3rd ser., 46/3 (July 1989), pp. 565–85; J. A. McGaw, 'No Passive Victims, No Separate Spheres: A Feminist Perspective on Technology's History', in S. H. Cutcliffe and R. C. Post, eds, *In Context: History and the History of Technology* (Lehigh University Press, 1989); A. Vickery, 'From Golden Age to Separate Spheres? A Review of the Categories and Chronology of English Women's History', *Historical Journal* 36/2 (June 1993), pp. 383–414; and C. Turbin, 'Refashioning the Concept of Public/Private: Lessons from Dress Studies', *Journal of Women's History* 15/1 (Spring 2003), pp. 43–51. Coventry Patmore's poem 'The Angel in the House' (1854–1862) is anthologized in C. Ricks, ed., *The New Oxford Book of Victorian Verse* (Oxford University Press, 1987).

29. J. Cairns, *How I Became a Journalist,* Enterprise Library (Thomas Nelson and Sons, 1960), pp. 12–13.

30. Cairns, *Journalist,* p. 83.

31. W. I. Susman, 'Personality and the Making of Twentieth-Century Culture', in J. Higham and P. K. Conkin, eds, *New Directions in Intellectual History* (Johns Hopkins University Press, 1979), reproduced in W. I. Susman, *Culture as History: The Transformation of American Society in the Twentieth Century* (Pantheon Books, 1984), p. 274.

32. D. Riesman with N. Glazer and R. Denney, *The Lonely Crowd* (Yale University Press, 1950).

33. Susman, 'Personality', pp. 280–1.

34. D. Barraclough, *Good Party,* p. 116.

35. E. Goffman, 'Symbols of Class Status', *British Journal of Sociology* 2/4 (1951), pp. 294–304, quotation p. 300.

36. P. Bourdieu, *Outline of a Theory of Practice,* Cambridge Studies in Social Anthropology, no. 16, tr. R. Nice (Cambridge University Press, 1977 (1972)), pp. 2 and 198, note 3.

37. Bourdieu, *Outline,* p. 10. See also Bourdieu, *Distinction,* pp. 65–8; and Lees-Maffei, 'From Service to Self-Service', p. 190.

38. M. Jehlen, 'Archimedes and the Paradox of Feminist Criticism', *Signs* 6/4 (1981), pp. 575–601, reproduced in R. R. Warhol and D. P. Herndl, eds, *Feminisms: An Anthology of Literary Theory and Criticism* (Rutgers University Press, 1991), pp. 75–96.

39. G. Lees-Maffei, 'Studying Advice: Historiography, Methodology, Commentary, Bibliography', in G. Lees-Maffei, ed., *Domestic Design Advice,* a special issue of the *Journal of Design History* 16/1 (2003), pp. 1–14.

40. Lifestyle television is presented as a subcategory of 'factual entertainment' by C. Brunsdon, C. Johnson, R. Moseley and H. Wheatley, 'Factual Entertainment on British Television: The Midlands TV Research Group's 8–9 Project', *European Journal of Cultural Studies* 4/1 (2001), pp. 29–62.

Part Four

1970–Present

Introduction

1970–Present
Patricia Lara-Betancourt

The period since 1970 has witnessed the emergence of a new cultural landscape, partly the result of the social, political and economic conditions created by the Cold War. With the demise of communism as a viable economic and political system, the last decades of the twentieth and the first of the twenty-first centuries have witnessed the strengthening and development of late capitalism throughout the world. In this period, in spite of a cycle of economic recessions and booms, capitalism and consumerism have brought international commerce to new heights, producing and distributing an enormous range and quantity of goods all around the globe, thus creating a truly worldwide consumer society and economy. What characterizes post-1970 globalization is the intensification of this process mainly due to the advent of mass-media technologies, including the Internet, which have both collapsed the globe spatially and reached every corner of the earth with images encouraging consumption.

Although the consumer society has had many critics and detractors, the last forty years have been extraordinarily productive in terms of design and interior design, which can, on one level, be seen as capitalism's message. Particularly since the 1970s, public sphere interior design flourished and expanded in different avenues: design collectives have multiplied, with work ranging from airports, new concept hotels, large leisure complexes and commercial and retail spaces to the redevelopment of existing buildings and sites and the renovation of museums and galleries. Interiors have also been at the core of an increasing number of television programmes addressing the design and furnishing of domestic spaces, of large businesses dedicated to the provision of domestic furnishing (such as IKEA) and of countless magazines on the topic (*Homes & Gardens, Wallpaper, World of Interiors,* etc). Additionally, online publicity and retailing have enhanced access to interior design products and services. Computer software and CAD/CAM technologies have revolutionized the profession by transforming the design process in architecture, interior and product design and manufacture. And in the face of ecological disaster, designers have embraced the credo of sustainability, changing their products and the way they work. However, the role of the mass media has been the most prominent influence on interior design.

Postmodernity and the modern interior

For the period from 1970 to the present, the overarching influence in terms of design has been postmodernism, understood as a rejection of modernism and its sets of rules. Seeking liberation from strict functionalism and rationality, interiors have reflected a taste for the ephemeral and the expressive possibilities of space, giving birth to new stylistic trends in design, including high tech and minimalism. Postmodernism allowed designers to create and develop a new language embracing popular culture together with high culture, actively seeking references to the past and welcoming decoration and patterns based on popular values. It imposed no universal definition of good design, but offered instead flexible parameters which included a range of styles. Even minimalism, which is seen as an expression of neo-modernism in its adherence to function, geometric minimal forms and a rejection of the past, does not pretend to be universally valid and has abandoned any ideological connotation. In postmodernism, there is no attempt to question capitalism, but rather the embrace of market-led design.[1]

This period has seen the emergence of the 'celebrity designer' (Ralph Lauren, Giorgio Armani, Philippe Starck) linked to the phenomenon of 'designer culture' and the proliferation of design collectives such as Archigram and Superstudio in the 1960s, Studio Alchimia and Memphis in the 1980s and Droog Design in the 1990s. The collectives, also known for being part of the radical, anti-design debate, aimed to challenge accepted notions of 'good taste' and convention and develop a new way of understanding their practice. These groups liberated design from the rules and constraints of modernist ideals, making design practice more socially and culturally aware. Although born in the Netherlands in 1993, Droog Design is nowadays an international network of designers concerned with the manufacturing process who are exploring the relationship between design, production and consumption. Through the creation of experimental and thought-provoking furniture, interiors and decorative art products, the collective encourages an understanding of design as part of a wider economic and cultural process. The work of all these groups has had a deep influence on mainstream designs for domestic and other interiors.

Among contemporary designers, nobody is more emblematic of the confluence of celebration and critique in a capitalist society than the internationally famous French designer Philippe Starck. He is well known for product designs such as the 'Juicy Salif' lemon juicer for Alessi (1990), but also for his interior designs of restaurants, bars, night clubs and hotels, ranging from the Cafe Costes in Paris (1984), the redesign of the Royalton Hotel in New York in 1988 commissioned by Ian Schrager—which introduced the concept of the boutique hotel—to many commissions all around the world, including several other hotels in New York, Los Angeles, London and China, all of which share a sense of theatricality and the spectacular. His Felix restaurant-bar (on the 28th floor) at the Peninsula, Hong Kong (1994), had urinals facing glass and

a magnificent view in the men's washroom. Much of Starck's design engages with spatial effects and the use of a technology-oriented experience. As Trevor Keeble has pointed out, Starck's work constitutes 'the ultimate postmodern understanding of the interior as image' and, it could be added, of the interior as a stage.[2]

There has been a close relationship between dress, fashionability and the interior since 1970, but, in general, the academic discourse about the modern interior has been concerned with earlier periods and therefore less with the contemporary era. There has been little thought about the relationship between interiors and notions of staging, fashionability and performance. In trying to understand the contemporary interior, it is thus valuable and pertinent to consider the ways in which interior design and fashionable dress have influenced and determined each other, thinking of them as part of the same creative process, with the concept of 'fashion', in its widest sense, informing and defining both.

On several levels, the worlds of fashion and interiors relate closely to each other. In recent decades, big and successful names in the fashion industry—such as Ralph Lauren, Giorgio Armani, Jasper Conran and Calvin Klein—have transferred their design skills and business acumen to branch out into domestic furnishings and product design. Their efforts in creating an aestheticized lifestyle have been so relentless that it is hard to think of an object of everyday life outside of the potential remit of their design influence. Business interests aside, the extension of the principles and aesthetic language of fashion

to the area of home furnishings seems natural and unsurprising in view of the concept of the interior as an extension of the body.[3] This partnership is a historical one, exemplified by the hundreds of department stores since the nineteenth century which have brought dresses and home furnishings under one roof, informed by the implicit belief that they are closely related not only in terms of style but also in what they signify. Although the term *lifestyle* was not used a century ago, middle-class consumers have long expected their material culture to reflect their taste and status and to reinforce their sense of social and cultural belonging. Tying together dress and interiors continues to be an essential way for individuals and social groups to define and perform their identities.

Lifestyle, mediation and inhabitation

As in the previous sections of this volume, the terms *stage, fashion, performance* and *modern* are considered in different contexts. The chapters explore a variety of interior environments, all created by artists, designers or architects: domestic and hotel interiors, fashion runways, shops, hotel lobbies, television stage sets, disused and derelict historical buildings and heritage interiors. They are viewed as sites of public and private encounter, social and ritual performance, corporeal and sensual experience and public and private consumption. The chapters explore these themes and environments from a range of disciplinary and critical perspectives including art and

design history, interior design, production design, cultural and critical studies and visual and material culture.

John Potvin's chapter addresses the work of the Italian fashion designer Giorgio Armani, which he defines as 'modernity without futurism'. In '"Stay with Armani": Giorgio Armani and the Pursuit of Continuity, Stability and Legacy', Potvin focuses on the close relationship the designer has built over the years between his homes and his business—studio, fashion shows, stores and hotels. Potvin shows how fashion and home designs have come to be inextricably connected in reflecting Armani's lifestyle, which is also the lifestyle proposed for his customers. Unlike other fashion designers who have also extended their design lines to include home furnishings, Armani is unique in reinforcing systematically the connection between his enterprises and his homes. Other fashion designers, such as Gianni Versace and Salvatore Ferragamo, have also ventured into the hospitality business, but only Armani treats the hotel as an extension of his home and lifestyle. As Potvin demonstrates, the designer and the luxury label he represents are almost indistinguishable, and Armani's ambition to create a 'total environment' can be seen as the equivalent of the *Gesamtkunstwerk* embraced by the modernists of the 1930s. The idea of total control over the environment is a powerful one in that it points at a complete identification and symbiosis between the individual, his/her clothes and the space he/she inhabits. For this end, Armani has exploited cleverly the potency of clothes and interiors in defining and promoting identities and Armani's lifestyle. As Potvin puts it, the designer works on 'setting the stage through the signifying power of the domestic space' and on creating 'sites of spectacle and intimacy'.

In the 1980s and 1990s, the notions of 'lifestyle' and 'designer culture' proliferated in design discourses and literature. In its sociological sense, the term lifestyle refers to the way of life of particular social groups. In the context of a consumer culture, the term alludes to those items that can act as indicators of personal taste—for example clothes and accessories, the home and its furnishings, means of transport, holiday places, pastimes and leisure, food, etc. Thus, for example the interiors one creates, inhabits and chooses to spend time in have the capacity to connote and represent one's modern lifestyle. They reflect who we are and our awareness of what they represent.[4] Although the notion of a lifestyle encompasses various aspects of everyday life, more and more the domestic space has become a defining part of it. The importance of the home remains connected to the notion that there is nothing more personal than our own abodes. It is the accumulation, groupings, associations and relationships between objects and spaces that give the domestic space its meaning. As stylized interiors and extensions of the home, hotels nowadays have also become products of consumption and are even marketed as branded products.[5]

In the last three decades, and with a marked increase in cultural tourism, the hotel sector has seen the emergence of a customized approach to targeting the new elites, in contrast to the uniformity and standardization

of the box hotels of global chains. As Penny Sparke explains, 'The more standardized mass-produced interiors become, the greater is the desire to create "difference" at a higher level of the market through an open alliance with designer-culture.'[6] The so-called 'boutique' or 'designed' hotel not only exploited a niche market, but also transformed its interiors into spaces that incorporate aspects of the home, workplace and spa.[7] As with the self-proclaimed 'art hotels', this new concept harnessed art and design to achieve and create social 'distinction'.[8]

In her chapter, '"Lobby Living": The Performance of Lifestyle', Nicky Ryan tells that in the 1980s, the collaboration between Ian Schrager and Philippe Starck produced the boutique hotel concept and, in so doing, reinvented the lobby as a space promoting a new way of socializing. Ryan places the modern hotel in the same category as department stores, arcades and offices, all expressions of a new building type developed in the nineteenth century in response to the challenges of industrialization and modernization that also affect transport and communication. The chapter addresses the contemporary hotel lobby as a space that is suited to the performance and 'enactment of social relations and hierarchy' and illustrates its role as a site in which identities are constructed and staged. Focusing on the lobbies of Schrager's hotels from the last two decades, particularly on his 2006 Gramercy Park project, Ryan analyses how the interior design and work of studio artist Julian Schnabel was central to the creation of theatrical settings, spatial effects and the construction of the lobby as an exclusive

and fashionable public site of spectacle, sociability and entertainment. Ryan argues that lobbies became important sites for a new cultural elite, while at the same time communicating a strongly aestheticized corporate identity. Like John Potvin's, this chapter is also about the performance of a lifestyle understood as aestheticized living: 'Lifestyle choices provided an opportunity to achieve distinction and alignment with a particular cultural group.' For both Schrager and Armani, the idea of the *Gesamtkunstwerk* as an expression of lifestyle is all important.

Addressing the theme of mass-media technologies, Teresa Lawler's chapter, 'Designing for the Screen: The Creation of an Everyday Illusion', considers the role of the interior in specific television productions. It is also an invitation to reflect on the tools and language used by production designers to create and recreate interiors. Lawler explains that television interiors are not meant to be inhabited, but, through careful design and decoration, their images must convey signs of inhabitation and be credible for the audience. In this sense, they represent real interiors through a careful manipulation of the visual language of those elements that characterize them as, for example domestic environments, offices, shops, etc. 'These sets are a peculiar hybrid not only of interior and theatre design but also of office and domestic design.' In contrast, Lawler informs us, those interiors that represent themselves, such as those in news and entertainment programmes and quiz shows, follow stage conventions and particular briefs. The environments created by television production designers are meant to be transitory and respond to

the particular needs of specific productions. Art and design, through the background training and work of production designers, also inform these interiors, although in a more pragmatic way they are determined by function and budgets. Finally, Lawler also discusses the role of digital technology in drama productions and explains how, rather than decline in the face of virtual and digital tools, television productions are working hand in hand with them, with physical sets being as important as virtual ones.

Real interiors, such as those seen on television, are sets which viewers inhabit for a given time every day, effectively acting as extensions of our living spaces. Although they are realized interiors, they are inhabited only visually, via an electronic image. As the relationship with the mass media has been highly influential in shaping the modern interior, Lawler's chapter is pertinent in considering the role of media consumption in defining modern interiors and identities, particularly since 1970. In television, it is perhaps settings representing domestic interiors that are the most widely used. A telling trend is that of numerous programmes focusing on the design, furnishing and decoration of the home, from BBC's *Changing Rooms* in the 1990s to Channel 4's *Grand Designs* nowadays. But in an effort to provide a sense of realism, all sorts of everyday life interiors appear in this medium, reinforcing the dominance of the visual media in representing interiors. Furthermore, these representations strengthen the role of design in promoting lifestyles and branding and, thus, its crucial link to identity formation.

As part of the retro movement and the nostalgia experienced in the 1970s, it was not only period styles that were revived in home furnishing and decoration; international and local organizations also seriously invested in the restoration of heritage buildings and interiors. The legacy of the postindustrial city and its disused and derelict spaces provoked a cultural movement for urban regeneration which continues today in a constant reassessment and reassignment of places and interiors. As Helen Potkin demonstrates in her essay, 'In-Habiting Site: Contemporary Art Practices within the Historic(al) Interior', these efforts have proved fertile ground for artists who, in recent decades, have been working outside traditional gallery spaces and exploring instead historical buildings, sites and museums. Potkin examines a selection of contemporary art practices—commissions and residencies—where interiors have been 'reclaimed, re-designated or re-imagined'. With an emphasis on the domestic environment, examples include installations in house museums, renovated hotels and disused public housing apartments. Potkin's essay considers the artistic responses suggested by the experience of these unique interior spaces with their links to history and memories. In this context, 'space' can be defined as 'performative', with the interior acting as a stage in which histories of place are performed, and with art animating that space. Considering Geraldine Pilgrim's installation at Belsay Hall, Potkin highlights its disruptive potential in upsetting traditional meanings of domestic interiors. She also discusses the work that the group Luna

Nera carried out at the Midland Grand Hotel St Pancras, involving light, heat, smell and sound, all elements pertaining to atmosphere and inhabitation. Furthermore, the chapter highlights the role of works of art in increasing the cultural capital of commercial/cultural spaces, such as hotels and museums, and the artists' input into regeneration efforts and the rebranding of places. It is a reflection on those interiors—historic, refurbished, derelict or abandoned—whose meanings are challenged, altered and disrupted in their re-engagement with contemporary art and life. Potkin's case studies explore a cultural and social critique, using art to question society's values and the way we live nowadays. Art is used to invite reflection on the ways we have inhabited and continue to inhabit interiors.

In the last chapter in this section, 'The Spectacular Form of Interior Architecture under the New Conditions of Urban Space', Pierluigi Salvadeo examines architecture as a new form of space, one with a scenographic and self-referential quality. Drawing on the work of contemporary thinkers such as Guy Debord, Robert Venturi, Marc Augé and Arjun Appadurai, he reflects on the condition of postmodern culture and urban space within the frame of hyper-capitalism. The chapter describes how architecture's role has become not so much to provide a fixed physical space but rather to offer an experience of space, something to gaze at. In response to contemporary life being more mobile, and inhabitation more temporary, a sense of identity is forged less in connection with fixed inhabitation and more in relation to travelling and wandering. Salvadeo also refers to the way in which a network of immaterial space is formed and linked to the use of digital technology, arguing that the predominant trend in architecture and the city is the transformation of space into an image, a spectacle. In his view, architecture has become a stage set, the result of theatrical effects and living spaces with blurred boundaries between reality and its representation: 'architecture has been theatricalized, becoming not only the ideal site of spectacle, but in fact the spectacle itself.' In this final chapter, the metaphor of the interior as a stage gradually disappears as representation blends into reality.

Notes

1. For a thorough contextual discussion of interior design from 1970 to today, see P. Sparke, 'The Designed Interior', in P. Sparke, *The Modern Interior* (Reaktion Books, 2008), pp. 185–212; and Trevor Keeble's section introduction to the companion to this volume, which includes a discussion of academic literature: T. Keeble, 'Introduction: The Late-Twentieth-Century Interior, 1970–Present', in P. Sparke, A. Massey, T. Keeble and B. Martin, *Designing the Modern Interior: From the Victorians to Today* (Berg, 2009), pp. 219–31. See also P. Sparke, *The Genius of Design* (Quadrille, 2009), pp. 201–45.
2. Keeble, 'Introduction', p. 223.
3. P. Sparke, 'General Introduction', in Sparke et al., *Designing the Modern Interior*, p. 3.
4. M. Featherstone, 'Lifestyle and Consumer Culture', *Theory Culture & Society* 4/1 (February 1987), pp. 55–70; Sparke, *The Modern Interior*, p. 208.
5. Sparke, *The Modern Interior*, p. 208.
6. Ibid. p. 208.
7. J. Mitchell, 'Domestic Bliss', *FX* (November 2010).
8. P. Bourdieu, *Distinction: A Social Critique of the Judgment of Taste*, tr. Richard Nice (Routledge, 1984).

Chapter Thirteen

In-habiting site: contemporary art practices within the historic(al) interior

Helen Potkin

In recent years, contemporary art has been increasingly situated outside of traditional art spaces such as the gallery and, in particular, located in historic sites, museum collections, public places and abandoned buildings.[1] The move outside of the gallery can be traced to the 1960s and 1970s, as artists searched for alternative sites in an attempt to circumvent the gallery system and challenge the commodity status of art and the nature of art itself. This chapter considers a range of case studies in which art has been located 'beyond' the gallery, focusing on artistic practices and work within the interior.[2] The first two examples explore contemporary art within historic houses, followed by an examination of artistic practices and work in grand hotels built in the nineteenth century. The chapter concludes with an analysis of an artists' project in a 1960s tower block. In each case, I have selected one work in order to examine more closely the nature of the exchange between art and site. In each of the examples, artists have responded to the site, inspired by the historical associations of place, its formal characteristics, its inhabitants or the experience of working in the place itself. In these ways, they can be understood as site-specific or situated practices, where the context is intrinsic to the work.

In general terms, we might understand the concern with context, site specificity and the move beyond the gallery in relation to what Deborah Cherry and Fintan Cullen refer to as the 'spatialisation' of social life and contemporary culture. They point to the ways in which many discipline areas, including art history, have become increasingly concerned with places and spaces: 'from the micro-histories of art in the domestic interior, palace, or exhibition gallery to the macro-histories of art and the city'.[3] This chapter discusses examples of spatial practice which illuminate our understanding of place as performative. The interior acts as a stage on which histories of place are performed but the work also activates and animates the space. It is suggested that the juxtaposition creates a dynamic in which the performative nature of the visitors' encounter with the work is foregrounded. In particular, this chapter engages with the nature of that juxtaposition,

exploring the productive nature of the encounter between old and new, historic and contemporary.

The opening case studies contrast work in two different kinds of historic sites in relation to current debates about heritage interpretation. In 2005, British sculptor Richard Wentworth was commissioned to create site-specific temporary work inspired by the character, heritage and environment of Felbrigg Hall in Norfolk. The commission was part of the Contemporary Art in Historic Places project, a collaboration between the National Trust, English Heritage, and Commissions East, which also included work by Louise K. Wilson and Imogen Stidworthy.

Felbrigg Hall is a seventeenth-century house composed of two wings of differing styles, one from the 1620s (Jacobean) and the other from 1680 (Charles II). Its interiors were remodelled in the eighteenth century to represent the taste of its then owner returned from the grand tour.[4] Richard Wentworth's work, entitled *14 Rooms Upended,* consisted of a series of mirrors arranged at different heights and angles, and with different reflective surfaces and edges interpolated in fourteen rooms in the house, including the gothic library.[5] Wentworth was joined on the project by his son, who is an engineer. Working in the house required sensitivity about how the work was inserted into the historic space, with the solution being the careful placing of freestanding mirrors. Wentworth also involved and collaborated with the house volunteers, bringing a social dimension and participatory aspect to the installation.

Wentworth is particularly interested in 'things with a previous owner, with a history

of particular circumstances'.[6] At Felbrigg, he began with the notion of the historic house as a stage set:

We were a theatrical intervention. There is a modernity in the house—books from the 1960s as well as artefacts from 300 years ago. There is a debate to be had about what the British think of our past—we are a culture that is in love with its fictions about history.[7]

Wentworth's installation counters the rational order of heritage display and interpretation with which we are familiar and the visitor's expectations are confronted. The mirrors are subtle interventions in the space, and, as temporary interjections, contingent and provisional. As in much of Wentworth's practice, the ordinary, everyday object is subverted from its original function, and the process of juxtaposition creates new and unexpected relationships and dialogues. In this exploration of the interior through reflection and distortion, the mirror also operates as a device; reframing and repositioning objects and spaces and our encounter with them. Wentworth reorganizes or shuffles how we see or interact with the interior at Felbrigg Hall and at the same time makes the viewer more observant.[8] The space is 'enlivened', and the act of looking itself might be understood as performing a critical revision or reordering through the collision of past and present.

In recent years, the country house has been at the centre of debates about the heritage industry. Both the National Trust and English Heritage have been keen to counter criticisms concerning accusations of 'identifying with elitist interests' and

having a 'bland standardised look in every house'.[9] The more recent interpretative philosophy of the National Trust is concerned that the experience of visiting heritage sites resonates with people's lives and is bespoke to the property.[10] Contemporary art in this context can be seen as part of the strategy to create distinctiveness and contemporary relevance. English Heritage's approach is less concerned with bringing the past to life than with bringing real life into buildings from the past, 'engaging interest, stimulating the imagination and instilling a sense of self-discovery'.[11]

In his speech to the Museums Association conference in 2008, the chairman of the Arts Council England, Sir Christopher Frayling, commented on the role of contemporary art in 'unlocking the creative potential of collections'.[12] In it, he discussed the productive collision and blurring of distinctions between notions of the historic/heritage and the contemporary and cited examples of contemporary art practices or interventions in the museum and historic site, the benefits of which would allow a new

prism through which to view the historic collections; a sense of the dynamism of then and now—not standing outside history but feeling part of it; a frame of reference for contemporary work; a reason to take a second look at the objects and the space, in new and unexpected ways.[13]

For Frayling, alongside many commentators, the role of art in the heritage context is part of a wider concern with creating more immediate and relevant experiences as well as presenting a temporary event that encourages repeat visits. These developments also relate to the Arts Council's ten-year strategy, Turning Point (2006), aiming to strengthen the visual arts, one aspect of which is partnerships with organizations such as the National Trust and English Heritage.

As suggested earlier, these developments also relate to recent concerns within the heritage sector about the display and interpretation of the historic house (museum) and its contemporary relevance. The practice of artists working with and interpreting collections is intended to attract new and returning audiences as well as to create a more immediate visitor experience. As Frayling remarked, 'Art can help them live again and give them a renewed relevance to today's visitors.'[14] Frayling notes the practice at Felbrigg Hall alongside several other innovative projects, including those at Belsay Hall in Northumberland.

Belsay Hall is a Greek Revival mansion completed in 1817. It was designed by Sir Charles Monk, the then owner, and was inspired by his honeymoon grand tour to Greece. The villa has stood empty since the family left during World War II, and it was given to English Heritage in the 1980s on condition that the house remained unfurnished. Belsay's empty rooms have provided the opportunity to use it as an exhibition space, and since 1996, there has been a series of shows in the building and grounds.[15]

The exhibition *Picture House: Film, Art and Design at Belsay* (2007) was part of English Heritage's contemporary art and design programme in the North-east and was curated by Judith King. Artists and musicians

were invited to respond to the place and produce work in a variety of media and forms: projected film, interactive animation, fashion, installations and performance. For this exhibition, set designer Geraldine Pilgrim began with the idea of an empty Belsay, with layers of history inscribed or embedded in the very fabric of the building. The artist describes the process of creating her work as 'like peeling away different layers of wall paper to release the ghost of the building's past'.[16] Pilgrim responded to stories about the Middleton family who had lived there and became particularly intrigued by Kitty Middleton (born in 1907) and with recounted memories of her growing up in the house from people who had worked there. In *Dreams of a Winter Night,* located in the upper bedrooms (see Fig. 13.1), Pilgrim created a spectacular installation in which she imagined Kitty's feelings the night before her debut party: 'The dreams of a young girl the night before her coming out party inhabit these empty bedrooms at Belsay Hall. Longing for love and romance, her childhood world dissolves into social connections, potential husbands and family obligations.'[17]

Against the austerity and refinement of the neoclassical building, the installation created a dramatic juxtaposition. The theatrical tableaux conveyed an uncanny sense of anxiety and anticipation, suggesting, too, the instability of the concepts of home and homeliness.[18] In inhabiting and narrating the space, the work brings stories of the people who once lived there to life and into the present. Responding to stories and oral histories about place, the work is not an attempt to recreate history but to reimagine the past through experience and emotions.

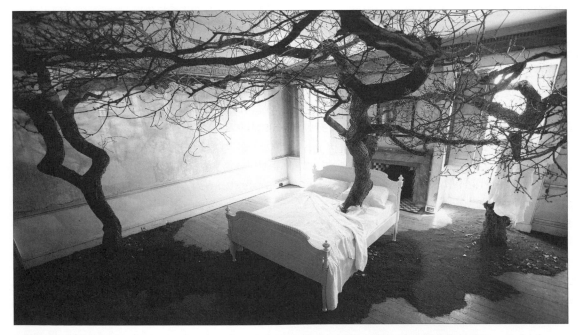

Fig. 13.1. Geraldine Pilgrim, *Dreams of a Winter Night* (2007), Belsay Hall, Northumberland. Photograph: Sheila Burnett.

It represents an understanding of heritage as a place which is not only 'conceived as representational of past human experiences, but also as creating an affect on current experiences and perceptions of the world'.[19]

Gaynor Bagnall's work on performance and performativity at heritage sites is instructive here. Based on visitor research at two sites, she counters the assumption of the passive viewer and regards the 'interpretative agency' of the visitor as instrumental. She argues that the relationship between visitors and the sites is based as much on 'emotion and imagination as it is on cognition', and moreover, this emotion and imaginary relationship is engendered by 'the physicality of the process of consumption'.[20] Specifically, the emotional engagement of visitors plays a major role in their ability to 'imagine' at the sites. This personal response, which allows the visitor to map the sites, represents the 'need to break the spell of national memory'.[21]

Contemporary art such as the work at Belsay might be seen as encouraging the viewer to engage emotionally with the place and its histories, and to imagine what life might have been like in the very space they are standing, intensifying both the sense of personal involvement and identification with place; Isabel Vasseur has remarked that in this way the exhibition at Belsay 'allowed the public to feel part of the narrative of others as well as their own'.[22]

Museum theorist Hilde Hein has also suggested that the imaginative quality of the arts can create more intense and emotive experiences than the everyday.[23] She elucidates: 'Art has the power to displace time and space, to prise us loose from our ordinary lives and to implant us spiritually in another place.'[24]

It has been suggested that museums and heritage contribute to processes of distancing immanent in contemporary culture and that they present largely uncritical histories.[25] For many commentators, what contemporary art does in historic sites is introduce an element of criticality which may raise questions about the contemporary significance and role of the historic and cultural institution.[26] For Jane Rendell, 'art as a form of critical spatial practice holds a special potential for transforming places into spaces of social critique'.[27]

What the work does here is make the experience of visiting a historic house more historically and aesthetically meaningful. At the same time, contemporary art is used in the historic site to resist the notion of nationalistic nostalgia with the site 'embalmed' as a relic of history. Rather, the historic site engages in dialogue with contemporary life and creates a sense of present-ness in the experience.[28] A recent issue of *Museum Practice* contained a section offering advice to the museum sector on working with artists. It commented on the potential of contemporary art to create a sense of freshness, among other elements:

> *These ways of working with artists result partly from the growth in interest in the contemporary art scene over the past decade, but partly as museums, galleries and many artists have become interested in open, accessible participative and process driven practices.*[29]

The next two examples consist of projects within grand railway hotels. The first one,

the Great Eastern Hotel (now Andaz), on Liverpool Street, London, has been recently refurbished; the other, the Midland Grand Hotel St Pancras, also in London, was in a derelict state prior to its renovation. Both hotels were built at the height of the Victorian enthusiasm for railways. Both fell out of fashion in the late twentieth century with the depletion of the railway system and as new forms and styles of accommodation emerged in relation to shifting patterns of travel, work and leisure; both have now been refurbished. The exhibitions that took place in these two locations offered an opportunity to contrast the role of contemporary art in relation to issues of urban regeneration.

In 2005, eleven emerging artists were invited to create new site-specific work for the Great Eastern Hotel and reflect upon the architectural spaces, history and secret life of the guest in an exhibition entitled *Stay.* The exhibition was curated by Cherry Smyth and funded by Arts Council England, through Escalator Visual Arts and Commissions East. Designed by Charles Barry, the architect of the Houses of Parliament, and his son, the hotel originally opened in 1884. After decades of decline, it reopened in 2000 with a £65 million refurbishment by Conran & Partners and the Manser Practice, transforming the Great Eastern into a contemporary British design statement. For *Stay,* invited artists engaged with the notion of the durational and temporary habitation inferred by the title as well as addressed the role of contemporary art in a contemporary designer hotel context.

Australian-born artist Lyndall Phelp's work *Drift* (2005) responded to the renovated spaces and architecture of the hotel, which she saw as cold and corporate with many of the original ornate Victorian features removed. Phelps combined aspects of research into earlier decorative schema in the hotel with the desire to introduce the decorative and 'natural and feminine'.[30] *Drift* consisted of the insertion of flocked wallpaper into the new dramatic central light-well, which rises through the full height of the building (see Fig. 13.2). Phelps worked with wallpaper manufacturer Cole and Son to produce white flocked wallpaper in twelve background colours, which were installed on the first-floor balcony. The colours graduated from cool pastels through to deep blues and purples then onto hot reds and oranges. This colour scheme was echoed in painted rings on the upper balconies. The floral design paid homage to the garden designs of Gertrude Jekyll, quotes from whose writing were reproduced on postcards accompanying the installation. The work attempts to reanimate the space through inferring past use and style and through the title conveys notions of horticultural design recommended by Jekyll as well as the movement through the space by the hotel guests.[31]

Phelps's work refers to the way art is used conventionally in hotel and commercial environments to try to make them feel a bit more like home. It quietly and subtly disrupts the space, implies an aspect of restoration of the past and hovers between decoration and art. Phelp's work, like other pieces within the show, negotiates art's role as a commodity as well as having the ability to 'create discomfort and expose contradictions'.[32]

The second hotel project to be discussed is *The Derelict Sensation,* a site-specific

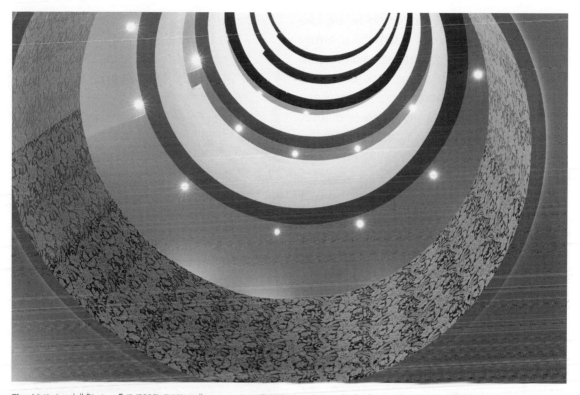

Fig. 13.2. Lyndall Phelps, *Drift* (2005), Flock wallpaper and acrylic paint installation, Andaz (former Great Eastern Hotel, London), commissioned by Commissions East. Photograph: Richard Davies.

exhibition organized by the artist group Luna Nera in the Gothic splendour of the former Midland Grand Hotel at King's Cross in 2003. The exhibition was held in the last month before the hotel began its reconversion from derelict site to grand hotel. The Midland Grand Hotel was built between 1868 and 1876, closed in 1935, and was renamed St Pancras Chambers and used as British rail offices until 1988. The hotel became an example of spectacular dereliction that has held a place in the public imagination.

Luna Nera was founded by Sandrine Albert, Valentina Floris and Gillian McIver, who have worked together on various projects since 1997. Luna Nera's aim is to stimulate interest in the environmental and architectural heritage of localities. In their manifesto, they say, 'our mission is to reclaim disused or abandoned "forgotten" spaces through art'.[33] They work with spaces that have had a specific former use and are particularly interested in buildings that had some form of public function.

Working in St Pancras Chambers presented an opportunity to engage with the impressive and romantic building not just as backdrop but emphasizing 'the critical relationship and interaction between the event and site—opening up the monumental to an alternative programme or reading by the transgression of formal and cultural expectations'.[34] In this transient state, the building also offered

a moment in between in which to explore its potentiality before its return to a luxury hotel. Geographer Tim Edensor comments: 'As things decay they lose their status as separate objects, fragmenting and dissolving as discrete entities.' At the same time, they lose their value as commodities, 'and this loss allows us to reinterpret and use them otherwise'.[35]

Gillian McIver, who curated *The Derelict Sensation,* invited artists who had had experience of working site responsively and in nontraditional environments. The title was chosen as a specific and focused theme to direct the artists to think about the assignation of the building as well as our physical and perceptual engagement with it. Hilary Powell's work for the show, *Smog Nocturne,* was inspired by the factual, literary and visual notions of 'fog's eternal and spectral presence in the city and its status as the most infamous Victorian meteorological phenomena' (see Fig. 13.3).[36] The work used a smoke machine to create the atmospheric conditions in an interior context. Realignment of space, light and sound were also used to create an intense and suggestive environment. Coal and the sound of trains invoked the historical meanings of the place during its early history and, in particular, the effects of industrial revolution on everyday lives.

The Derelict Sensation was concerned with sensory experience, and much of the work, for example that of Sandrine Albert, used light, sound and even smell. Edensor writes that decaying buildings or ruins have 'alternative aesthetic properties', impose their materiality upon the sensory experience of visitors and can conjure up forgotten ghosts.[37]

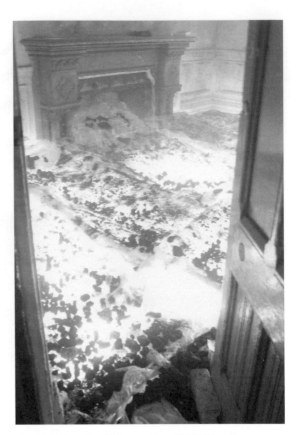

Fig. 13.3. Hilary Powell, *Smog Nocturne* (2003), St Pancras Chambers (former Midland Grand Hotel at King's Cross, London). Photograph: Gillian McIver.

The work in the exhibition seemed to evoke the idea of the decaying building itself as well as the physical engagement of the viewer: 'This differently performing body, acting contingently in these unfamiliar surroundings is not merely reactive to the effusion of sensory affordances but also actively engages with the things it beholds.'[38]

Luna Nera's practice can be situated in relation to wider interests in abandoned and neglected buildings, in ruins of the past in the post-industrial landscape. For many artists, such places provide much-needed space outside institutional sanction, but they also represent a fascination with obsolescence.

The final example is a project that took place in a partially occupied tower block in Liverpool. *Up in the Air* (2000–2001) followed by *Further Up in the Air* (2001–2004) consisted of artist residencies based in Kenley Close in Sheil Park. Built in the late 1960s, there were originally 67 blocks in Sheil Park, but by the 1990s, mainly because of poor maintenance and falling occupancy, a process of demolition had begun. The intention of the projects was to invite a range of artists to live and work in the partly empty tower blocks due for demolition as part of a regeneration scheme led by Liverpool Housing Action Trust (LHAT). 'The projects were seen as an opportunity to bring a group of creative people together in an environment traditionally marginalized by the arts and for the artists to spend time and engage with residents.'[39]

There was a high degree of participation from the residents, including involvement in the selection process for contributing artists. The ten invited artists lived in the block alongside the residents (many of whom had been there since the blocks were built), with the intention that 'interesting questions and frictions would arise from everyday confrontation'.[40] The project was not perceived as offering an alternative exhibition space, but it was a process of engagement and also a way of residents reflecting 'on their own situation and presenting it—as something worthy of attention—to the outside world'.[41]

Neville Gabie, also one of the curators, contributed to the first project with *Void,* a photographic work based on the discarded items left behind in empty flats (see Fig. 13.4). He selected one object from each vacated flat, and these were then photographed and

recontextualized in wallets on the wall of one flat. Like Richard Wentworth, Gabie draws out meaning from the everyday. In the work, Gabie has imposed a new form of order and meaning on his found objects, endowing them with a dignity and status. In representing symbolic traces of ownership and belonging, the work can be understood as acting as 'testimonials to the flats' occupancy'.[42] For the period of the project, the work also reinhabited the space with its presence.

The project 'invites us to reflect on the idealism of 1960s civic architecture and the impact it has on peoples' lives'.[43] It also asks us to think about the potential for art to revitalize. In 'What Is Art up to In Disused Buildings?' Elske Rosenfeld remarks: 'Beyond any immediately recognisable, quantifiable or "sustainable" results, these projects can contribute to gradual change of the social and cultural patterns and strategies that they choose to position themselves in.'[44]

Visitors to Kenley Close found themselves reflecting on the differences in our relationship to buildings as visitors or as inhabitants.[45] Moving around the tower in search of art, the viewer entered into the tenant's world, piecing together another's reality from the remnants and re-performing the daily existence of their lives. The project conceives of place as embodied experience. The interior is not an empty shell or void but redolent with meanings. In the context of demolition, it speaks to issues of social housing, and the twentieth- and twenty-first-century experience of tower block living. It calls into question ideas of community and home as well as issues of displacement and urban regeneration.

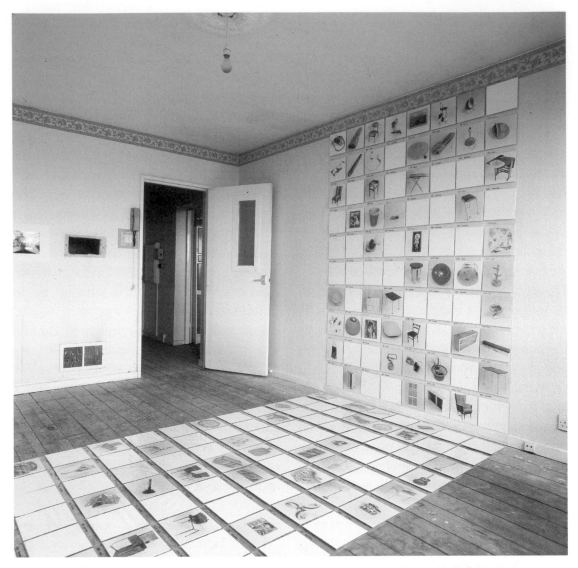

Fig. 13.4. Neville Gabie, *Void,* project *Up in the Air* (2000), Sheil Park, Liverpool. © Neville Gabie. Photograph: Neville Gabie.

All the projects discussed in this chapter have been sited within the historic interior, but there are some very clear distinctions between them. From the country house, once the seat of aristocratic families now in public ownership; to grand railway hotels undergoing processes of decline and regeneration; to modernist housing, once an idealist solution to overcrowding but about to be pulled down: the different (re)incarnations and usage of buildings discussed in this chapter chart shifts in forms of habitation and occupancy.

Artistic projects differed in terms of the nature of the commission and curatorial ambition, approach and authority. The projects

at Felbrigg and Belsay were concerned with increasing new and repeat visitors but also aimed to create a meaningful encounter for the visitor through the creation of different forms of experience. More broadly, we can relate these practices to developments in museum interpretation away from the educational or didactic, to what we could view as the emotional or experiential turn, in which the space is understood as a creative space—'a space of vital engagement, as audience space, as an experience and not as a static object'.[46] Such a view is based on an understanding of the museum/heritage space as a programmable or changeable space, and as a creative performance space.[47]

At the heart of the discussion has been the notion of place as unfixed, contested and multiple, as 'an unstable stage for performance'.[48] Artists' interventions in the city can be seen to challenge and reshape our understanding of space and the ways in which we inhabit or occupy them. Geographer Alex Loftus remarks that urban interventions 'seek to draw attention to powerful interests and specific relationships that make cities the places they are. They invite us to explore alternative ways of organising relationships and different ways of producing space'.[49]

The locating of contemporary art in derelict or abandoned buildings permits new ways to think about the complex forms and manner in which history is made manifest in the present and the productive, sometimes unsettling, nature of that collision. In her discussion of the 'what-has-been and the new', Jane Rendell has explored how 'new elements inserted into given contexts aim to critique the construction of the past in the present,

drawing attention to repressed aspects of history'.[50] The case studies presented in this chapter can be understood as offering the potential for alternative modes of thinking about the contemporary significance of the historical, and also to 'reconfigure the temporality of sites repositioning the relationship between past and present'.[51]

The specific focus of this study on the historic interior presents an opportunity to engage with ideas of interior practices and, in particular, with the notion of inhabitation. In the course of this chapter, the ways in which the space and artistic practices have engaged, accommodated and negotiated with each other can be seen as forms of adjustment and modification in which new forms of thinking about how we occupy places may come into being. In this way, contemporary art might somehow make the space more accessible or inhabitable in the sense that it allows for the process of the contemporary viewer's identification.

Notes

1. P. Curtis, 'Old Places for New Art', *AN Magazine* (February 2003), p. 22.

2. There is an expanding literature on art beyond the gallery. See for example J. Rendell, *Art and Architecture: A Place Between* (I B Tauris, 2006, reprinted 2010); N. Kaye, *Site Specific Art: Performance, Place and Documentation* (Routledge, 2000); M. Kwon, *One Place after Another: Site-Specific and Locational Identity* (MIT Press, 2004).

3. D. Cherry and F. Cullen, *On Location* (Blackwell, 2007), p. 2.

4. See R. Wilson and A. Madeley, *Creating Paradise: The Building of the English Country House, 1666–1880* (Hambledon & London, 2000), pp. 72–7.

5. See images at Commissions East, 'Richard Wentworth', http://www.commissioneast.org.uk/html/casestudies/comtemporaryartinhistoricplaces/richardwentworth.htm, accessed 13 May 2010.

6. R. Malbert, 'The Ungothroughsomeness of Stuff', in S. Grooms, ed., *Richard Wentworth* (Tate Publishing, 2005), p. 22.

7. Richard Wentworth, Commissions East, *Contemporary Art in Historic Places. Discussion Summary*, 2005, http://www.commissionseast.org.uk/pdf/FINALC~1.PDF, accessed 13 May 2010.

8. Karen Chancellor, Commissions East, *Contemporary Art in Historic Places. Discussion Summary*, 2005, http://www.commissionseast.org.uk/pdf/FINALC~1.PDF, accessed 13 May 2010.

9. E. Barker, 'Heritage and the Country House', in E. Barker, ed., *Contemporary Cultures of Display* (Yale University Press and Open University, 1999), p. 200.

10. R. Taylor, 'The National Trust', in A. Hems and M. Blockley, eds, *Heritage Interpretation* (Routledge, 2006), p. 102.

11. A. Hems, 'Thinking about Interpretation: Changing Perspectives at English Heritage', in Hems and Blockley, eds, *Heritage Interpretation*, p. 191.

12. C. Frayling, *Unlocking the Creative Potential of Collections*, Museums Association Conference, 7 October 2008, http://www.museumsassociation.org/download?id=17459, accessed 24 May 2010.

13. Ibid.

14. Ibid.

15. See I. Vasseur, 'Five Exhibitions at Belsay Hall', *Art and Architecture Journal* 66–7 (2008).

16. J. King, *Corridor*, excerpt from Picture House catalogue, http://www.corridorperformance.org/belsay.htm, accessed 8 June 2010.

17. Geraldine Pilgrim quoted in King, *Corridor*.

18. Recent work on the concept of the uncanny and the interior includes: H. Steiner, 'On the Unhomely Home: Porous and Permeable Interiors from Kierkegaard to Adorno', *Interiors: Design Architecture Culture* 1/1–2 (2010), pp. 133–47; and K. Deckers, 'The Disquieting Workings of the "Uncanny": A Creative Device for Architectural Representation', *Interiors: Design Architecture Culture* 1/1–2 (2010), pp. 119–32.

19. L. Smith, *Uses of Heritage* (Routledge, 2006), p. 77.

20. G. Bagnall, 'Performance and Performativity at Heritage Sites', *museum & society* 1/2 (2003), p. 87.

21. Ibid., p. 96.

22. Vasseur, 'Five Exhibitions at Belsay Hall', p. 52.

23. H. Hein, *The Museum in Transition: A Philosophical Perspective* (Smithsonian Institute Press, 2000), p. 78.

24. Ibid.

25. K. Walsh, *The Representation of the Past: Museum and Heritage in the Post-Modern World* (Routledge, 1992).

26. P. Usherwood, 'Private View', *Third Text* 10/35, p. 97.

27. Rendell, *Art and Architecture: A Place Between*, p. 2.

28. C. Wood, 'Property Values', *Artforum* 47/7 (2009), p. 87.

29. *Museum Practice* (Autumn 2005), p. 44.

30. C. Smyth, 'Drift', in *Stay,* exhibition catalogue, http://www.lyndallphelps.com/Lyndall_phelps/pdf/Drift.pdf, accessed 8 June 2010.

31. Ibid.

32. P. Lafuente, ' "Who, Me" Review of "Us and Them at the Great Eastern Hotel" ', *Art Review* 53 (July/Aug. 2002), p. 94.

33. See Wasted Spaces, 'Luna Nera', http://www.wastedspaces.org/luna-nera, accessed 15 June 2010.

34. H. Powell, 'The Derelict Sensation: Way Station', http://www.luna-nera.com/thederelictsensation/waystation.htm, accessed 15 June 2010.

35. T. Edensor, 'Waste Matter: The Debris of Industrial Ruins and the Disordering of the Material World', *Journal of Material Culture* 10/311 (2005), p. 320.

36. H. Powell, 'Smog Nocturne', http://www.luna-nera.com/thederelictsensation/hilarystp.htm.

37. Edensor, 'Waste Matter', p. 311.

38. Ibid., p. 326.

39. F. Lord, 'Up in the Air', Public Art Online, http://www.publicartonline.org.uk/casestudies/housing/up_in_air/description.php, accessed 20 June 2010.

40. E. Rosenfeld, 'What Is Art up to in Disused Buildings?' in P. Oswalt, ed., *Shrinking Cities: Interventions*, vol. 2, Ostfildern-Ruit (Hatje Cantz, 2006), p. 359.

41. Ibid.

42. Lord, 'Up in the Air'.

43. R. Roberts, 'On Being a Tourist', in *Up in the Air*, exhibition catalogue (uita, 2001), p. 8.

44. Rosenfeld, 'What Is Art up to?' p. 359.

45. See J. Winter, 'Up in the Air', *AN Magazine* (February 2001), pp. 26–7; and Roberts, 'On Being a Tourist'.

46. S. Greenberg, 'The Vital Museum', in S. MacLeod, ed., *Reshaping Museum Space: Architecture, Design, Exhibition* (Routledge, 2005), p. 236.

47. Ibid.

48. T. Cresswell, *Place: A Short Introduction* (Blackwell, 2004).

49. A. Loftus, 'Democratic Interventions into the Urbanisation of Nature', 2006, http://www.socialpolis.eu/index.php/web-links/index.php?option=com_docman&task=doc_details&gid=96&Itemid=167, accessed 14 September 2010.

50. Rendell, *Art and Architecture*, p. 121.

51. Ibid.

Chapter Fourteen

'Lobby living': the performance of lifestyle

Nicky Ryan

A great hotel is not just a building, it is an individual with personality, spirit and authenticity. It's original, romantic, surprising, poetic and whimsical. It evokes an emotional response like a work of art.[1]

Gramercy Park Hotel opened in New York in 2006 and was the creation of entrepreneur and hotelier Ian Schrager. The claims made on the hotel's website about its unique and innovative qualities were echoed by magazines such as *Vogue* and *Time,* which congratulated Schrager on 'raising the bar' and initiating 'another lifestyle revolution'.[2] Intense media interest was aroused due to the reputation of its owner as a formative influence on trends in hotel development, the historical and bohemian associations of the hotel and the fact that its interiors were designed by artist Julian Schnabel (see Fig. 14.1).

This chapter considers the role of the hotel and in particular the lobby as a site of identity construction—a stage for the performance of lifestyle. Anthony Giddens defined a lifestyle as 'a more or less integrated set of practices which an individual embraces, not only because such practices fulfil utilitarian needs, but because they give material form to a particular narrative of self-identity'.[3] The public spaces of the modern hotel, and in particular the lobby, have, since the inception of this building type in the nineteenth century, provided a place for the enactment of social relations and hierarchy. Following the rise of chain hotels after World War II and the increasing standardization and consolidation of their interiors, the dramatic potential of the lobby appears to have diminished. However, in the 1980s, the introduction of the boutique hotel concept, credited to Ian Schrager, involved the reinvention of the lobby as a new kind of gathering place embodied in the notion of what the hotelier characterized as 'lobby socialising'.[4]

The design of Schrager's boutique hotels and the discourses surrounding that design are discussed as a means of exploring the social practices that are produced by and embedded in the production of these spaces.[5] The hotel lobby is interpreted as a cultural artefact with multiple meanings where codes in style are used to signal and stage social

difference. This chapter begins with a brief historical overview of the development of boutique hotels followed by a consideration of the growing importance of the hotel lobby as site of spectacle and entertainment. The final section focuses on the 'artistic' narratives communicated by Gramercy Park and its significance as a key signifier in the communication of an aestheticized corporate identity.

Hotels have an important relationship with the city and serve a variety of purposes in addition to their more obvious function as sites of hospitality. Throughout their history, the role of the hotel has included that of urban landmark, symbol of civic pride in central business districts and flagship in regeneration strategies designed to attract tourists and support the convention industry.[6] Since the early nineteenth century and the rise of the mercantile bourgeoisie, hotels have been associated with the idea of luxury. Luxury is a relative concept with a sign value that is produced in specific narratives and is used in processes of stratification and distinction.[7] The meaning of luxury is not immutable but changes within the context of specific temporal, geographical, social and cultural conditions.[8] Along with department stores, arcades and offices, the modern hotel was a new building type that responded to the changes wrought by capitalist industrialization and its innovative modes of transportation and communication.

Hotels such as the Tremont House in Boston (1829) 'established the aristocratic palace as the model for hotel architecture' and were forerunners of the contemporary urban hotel in terms of size, service, style

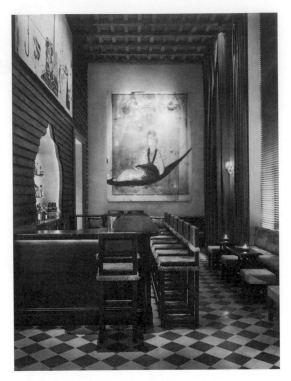

Fig. 14.1. Jade Bar, Gramercy Park Hotel, with paintings by Julian Schnabel, *Blue Japanese Painting no. 2* (2005) and Jean-Michel Basquiat, *Revised Undiscovered Genius of the Mississippi Delta* (1983). Photograph courtesy of Ian Schrager Company.

and technology.[9] Designed by a professional architect, Isaiah Rogers, and incorporating a stained-glass rotunda, it was the first hotel to become renowned for the opulence of its design as well as the quality of its service. The aristocratic model of luxury established by grand hotels such as the Ritz in Paris (1898), London's Savoy (1889) and the Waldorf-Astoria Hotel in New York (1893/1931), provided a key site for the staging of what Thorstein Veblen described as 'conspicuous consumption' and 'conspicuous leisure'.[10] The bourgeoisie, which had previously entertained mainly at home, could enjoy socializing and fine dining in magnificent interiors that

provided a glamorous environment in which to see and be seen.[11]

By the 1950s, the idea of what constituted luxury was rapidly changing as critics and designers rejected the pretensions of palatial décor in favour of the austerity of the International Style. Modernist architecture and Scandinavian furniture began to be promoted as the choice of preference for the discerning consumer. This is illustrated by the commercial success, but critical failure, of the hotels at Miami Beach created by Morris Lapidus during this decade. The Fontainbleau (1954) and Eden Roc (1955) drew on the glamour and fantasy of Hollywood movies but were castigated by critics for their architectural excess and vulgarity.[12] In the context of a prosperous postwar America where an increasing number of people could afford to consume expensive goods, the old elite were forced to create alternative symbols of luxury to underline their social status. A dislike of flamboyant design and an appreciation of simplicity became the new signifiers of luxury and marked out the clientele of Lapidus's ostentatious hotels as lacking the prerequisite 'cultural capital'.[13]

The period following World War II witnessed a growth in air travel and mass mobility that created the ideal conditions for hoteliers to locate their properties abroad as well as to open additional sites in the domestic market. Global chains were able to offer customers a consistent experience with reliable service in a range of international locations. Standardization and uniformity were emphasized and profits maximized through economies of scale. This was the birth of the 'box' hotel, or the 'McDonaldisation' of the hotel concept, with its standardized operational procedures, strong branding and architectural uniformity. 'McDonaldisation', a term coined by sociologist George Ritzer, was characterized by 'efficiency, predictability, calculability and control', but it was a process that could result in sameness and cultural homogeneity.[14] To avoid the latter condition, global chains such as Hilton International designed their hotels to communicate a strong brand identity inflected with local or regional characteristics.[15] This customization to local conditions was intended to guarantee guests a consistent level of service in a range of different architectural environments.

In the 1980s and 1990s, major chains such as Marriott, Hilton and Starwood consolidated their positions and came to dominate the international hotel industry. During this period, the boutique, designer or lifestyle hotel emerged as a reaction to the standardization and anonymity of many corporate global chains. In 1984, Ian Schrager and business partner Steve Rubell opened Morgans in New York. Designed by Andrée Putman, the concept was based on a private gentlemen's club featuring leather chairs, panelled walls and chequered marble flooring. It was, however, Schrager's collaboration with Philippe Starck, whom he hired in 1988 to design the Paramount Hotel in New York, that produced the boutique's signature style, which combined a sense of theatre with a minimalist aesthetic. The hotelier's claim that 'you are where you sleep' highlighted the connection between individual choice and lifestyle, the latter being, as Giddens has argued, at 'the very core of self-identity, its making and remaking'.[16] Lifestyle

choices provided an opportunity to achieve distinction and alignment with a particular cultural group.

The boutique hotel has been characterized as a thematic and architecturally notable environment offering warmth and intimacy to affluent visitors in the 25- to 55-year-old age range. Consumers looking for something different from standard hotel provision were attracted by factors such as location, quality, uniqueness, amenities and personal levels of service.[17] Small-scale—usually with fifty to one hundred rooms decorated in different styles—and non-chain operated, boutique hotels with their cutting edge design proved to be attractions in their own right. As urban flagships, they reinvigorated the idea of the hotel as a design palace with the lobby providing an important gathering place for both tourists and style-conscious local residents.

The lobby marks the border between the public realm of the street and the private realm of the hotel bedroom. It is a threshold, a liminal space between inside and outside where people meet, wait and observe others. A space of possibility and indeterminacy, it has provided rich subject matter for artists, novelists and cultural commentators. The lobby was a new spatial form to emerge from the nineteenth-century revolution in travel and transportation that transformed the modern city. For Siegfried Kracauer writing in Weimar Germany, it was an emblematic space of modernity, characterized by boredom, alienation and displacement, where individuals sat isolated in silence, reading to avoid eye contact.[18] He argued that this space of 'un-relatedness' lacked identity and purpose and

was a site of 'heightened exchange value, subject to nomadic, deterritorialising flows of information and desire'.[19]

The theme of disconnection is further elaborated by Fredric Jameson in his analysis of John Portman's Bonaventure Hotel in Los Angeles.[20] The hotel is an architectural metaphor for a larger totality and is used to illustrate the changes in aesthetic production that Jameson argued were characteristic of postmodernism. The Bonaventure aspired to be 'a total space, a complete world, a kind of miniature city' that eschewed the utopian language of modernism and drew on the vernacular of the American city. For Jameson, the hotel lobby immersed guests in its vast 'milling confusion'; it was a 'postmodern hyperspace' which transcended the 'capacities of the individual human body to locate itself . . . to map its position in a mappable external world'. The disorientation of visitors within the lobby necessitated the introduction of signifiers including colour coding and directional signage to re-establish spatial coordinates and maintain the flow of business.

Whether formed of multistorey atria surrounded by restaurants and shops, or adorned with chandeliers, rich draperies and monumental staircases, the lobby played a major role in communicating the identity of a hotel through its design. This was particularly the case in the boutique hotels of Ian Schrager, where the small bedrooms encouraged guests to spend more time in the lounges, bars and lobbies. The slogan 'lobby living' was invented to promote the hotel lobby as a fashionable site of entertainment and spectacle. With his background in nightclubs,

including Studio 54, which opened in 1976, Schrager claimed he would make hotels the nightclubs of the 1990s. Studio 54 had achieved notoriety for its lavish interiors, drug and alcohol consumption and famous clientele such as Andy Warhol. Entry was restricted to individuals who were deemed suitable to form part of an interesting mix of different groups. This 'social engineering', a practice continued in Schrager's hotels, set up alternative hierarchies that highlighted the status of his properties as fashionable places in which to be seen.[21]

Schrager refashioned the hotel lobby into a location for exclusive social gatherings framed against a backdrop of spectacular lighting and theatrical visual effects. At Morgans, the Paramount, Delano, Sanderson's, Clift, Mondrian and Hudson's, guests were encouraged not only to sleep and dine in the premises but also to 'perform' as part of a group experience which reinforced their membership of a stylish elite. The lobby was ostensibly a public space but it was not a democratic one and had from the outset excluded certain groups. Inclusion was limited through the mechanism of rituals and barriers such as class distinctions in the aristocratic palace model or the door policy of the boutique hotel. On special occasions at Schrager hotels, the lobby was roped off and surrounded by a crowd of spectators and paparazzi watching and photographing celebrities as they arrived. This was part of the 'society of the spectacle' — 'capital become an image' — a site of illusion and ideology that embodied society's basic values.[22] The boutique hotel lobby was a paradigmatic space of consumption that highlighted

the relationship between celebrity, mass spectacle, tourism and metropolitan life.

Through the refurbishment of existing and unusual buildings, thematic design and a reliance on celebrity guests and public relations rather than mass advertising, Schrager's hotels were able to generate media interest and attract an affluent niche market. External factors, including a sustained period of economic growth and rising disposable income, increased access to Internet travel sites and the demand for experiences and more personalized services, supported this development. The lobby was no longer the generic and impersonal place with anodyne furnishings and dull tones once described by Kracauer, but rather a 'scripted space' where participation in staged events was part of the service offered.[23] Hotel staff, often part-time models or actors, played a part in this experience and were often hired on the basis of looks and style. As Postrel has argued, the appearance of employees is an integral feature in an 'aesthetic economy' where style is an important part of company strategy.[24]

By the 1990s, the glossy and stylized interiors favoured by Schrager had been emulated by competitors within the hotel industry, and a range of boutique hotels emerged targeting different customer groups. This reflected a broader 'democratisation of luxury' where products and services which had formerly been the preserve of the wealthy and upper classes became accessible to a mass market.[25] For example, traditional 'box' companies such as Starwood Hotels and Resorts, the largest hotel company in the United States, moved into the lifestyle sector with its W hotels, promoting the

business hotel as boutique. As the trend for sleek minimalist hotels gathered global momentum and boutique hotels proliferated at a range of price levels, Schrager claimed that his concept had been 'co-opted by the mainstream'.[26] In 2005, he sold the Morgans Hotel Group and set up the Ian Schrager Company, which owns, develops and brands hotels and residential and mixed-used projects. In 2006, with characteristic hyperbole, Schrager announced that the boutique hotel was dead and that his latest enterprise, Gramercy Park Hotel, heralded the invention of a new genre.[27]

The significance of Gramercy Park within the evolution of hotel design was due primarily to the identity of its designer and the source of his inspiration, the artist's studio. The hotel was designed by neoexpressionist artist, sculptor and film director Julian Schnabel and was modelled on the artist's own home and place of work. With its rich renaissance colours, contrasting textures and curvilinear forms, the refurbishment appeared to represent a departure in terms of style from the minimalist boutique hotels that preceded it. The original hotel, an eighteen-storey Renaissance Revival building (1925–1930), had been frequented by artists, filmmakers, fashion editors, architects and actors, and this bohemian heritage was renewed and accentuated by Schnabel's redecoration. Huge canvasses worth millions of dollars painted by the artist and his former friends Jean-Michel Basquiat, Cy Twombly and Andy Warhol adorned the public spaces of the hotel, while the guest rooms were hung with contemporary and vintage photographs (see Fig. 14.2).

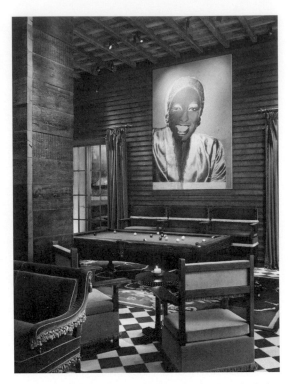

Fig. 14.2. Pool Table, Gramercy Park Hotel, with painting by Andy Warhol, *Ladies and Gentlemen* (1983). Photograph courtesy of Ian Schrager Company.

Displaying art in hotels was not a new idea, but the reputation of hotel art had significantly declined with the rise of the chains and the proliferation of low-quality prints as a form of inexpensive wall decoration. In the 1980s and 1990s, there was a growing interest in displaying 'authentic' pieces of art such as Robert Mapplethorpe's work in the guest rooms of Morgans and the incorporation of art into the interior design of hotels. 'Art hotels' such as Hotel Max in Seattle, Hotel Fox in Copenhagen and Hotel des Arts in San Francisco began to proliferate. The common feature of these self-proclaimed 'art hotels' was that they promoted art and design as a means of distinction. Their claims were

based on a relationship with art that included showing art on walls or in gardens, featuring rooms designed by artists and designers, hosting temporary exhibitions within the hotel or associated galleries and being located in or near a cultural district.

The benefit for hotels in a close association with the arts was that it created a point of difference from the competition and could attract media attention. For artists, the hotel offered an alternative site to the museum in which to display their work, often loaned free of charge in return for publicity. Locating their work within this context does not appear to have constituted a form of 'institutional critique' or artistic strategy for questioning normative exhibition conventions in order to reveal their underlying ideological functions.[28] What was significant about the majority of art hotels was an absence of curatorial vision or any critical engagement with the site; instead, art performed a decorative and marketing function. The rise of the art hotel reflected the increasing fashionability of art as 'a metropolitan mass pursuit' and the associated growth in cultural tourism that had occurred since the 1980s.[29] The utility of art for the hotel industry further underlined the importance of aesthetic values to economic life and, in this case, the construction of corporate identity.

The classification of Gramercy Park as a type of art hotel was vigorously refuted by Schrager, who claimed that its distinctiveness lay in the 'artistic' lifestyle evoked. The Gramercy Park website maintained that the hotel had a 'unique atmosphere imbued with the same spontaneous, hauto bohemian, eclectic, eccentric and edgy sophistication

one would find in an artist's studio or home'.[30] Historically viewed as the centre of the artistic universe and imagination, the studio was the context for the creation of 'masterpieces' and 'the unique place of art's production'. In his essay *The Function of the Studio,* conceptual artist Daniel Buren announced the demise of the studio, arguing that art produced in this context failed to engage with the site where it was eventually to be shown.[31] The studio has nevertheless continued to be the location where many artists produce their work and remains the locus and emblematic site of creativity. In the case of Gramercy Park, there is no literal recreation of the artist's studio within the hotel, but instead the references to its symbolic value were encoded within Schnabel's design.

The Gramercy Park lobby (see Fig. 14.3), with its deep red and ochre palette, richly textured furnishings, chandelier, dark wooden ceiling and black and white floor tiles, bore a striking resemblance to the interior featured in Johannes Vermeer's *The Art of Painting* (1666). This work depicted an artist in his studio sitting in front of an easel observing an elaborately dressed female model. From the seventeenth century onwards, the studio was a familiar subject in paintings through which artists could explore ideas about art and the nature of their vocation. The model in Vermeer's painting was dressed as Clio, the muse of history, wearing a crown of laurel that signified glory. In one hand she held a trumpet representing fame and in the other a book symbolizing history. The artist was dressed in fine clothing to indicate his status and provided the conduit through which the muse found expression.[32] What appeared

to be an everyday scene was in fact an allegory about art and inspiration. Although this specific work of art was not alluded to by Schnabel or Schrager in interviews, the hotelier confirmed that the rooms were designed to evoke paintings.[33]

Institutional rhetoric also played a key role in communicating the artistic narratives of Gramercy Park. Descriptions of the hotel on its website used terms from art historical discourse referencing Romanticism, the bohemian, individuality, uniqueness, authenticity and creativity. Promoted as 'the new high Bohemia' and 'Bohemia re-invented for the 21st century', Gramercy Park's 'authentic' bohemian credentials were set up in opposition to what was claimed to be the falseness and commercialization of mass culture exemplified by 'copycat' boutique hotels. The idea of the artistic bohemian and the construction of a bohemian identity originally arose out of the transformation of cultural production and consumption in the nineteenth century, when market relations replaced traditional forms of patronage.[34] The Romantic movement elevated the artist to the status of creative genius and established him as a heroic rebel rejecting bourgeois convention through the creation of radical experimental art.[35]

In the twenty-foot-high lobby and adjacent Rose and Jade bars at Gramercy Park, bohemian identity was signified through what appeared to be an informal-looking ensemble of furniture and fittings that included objects renovated from flea markets, made to order by craftsmen or designed by Schnabel (see Fig. 14.4). This was not a casual juxtaposition of artefacts but a highly ordered space which

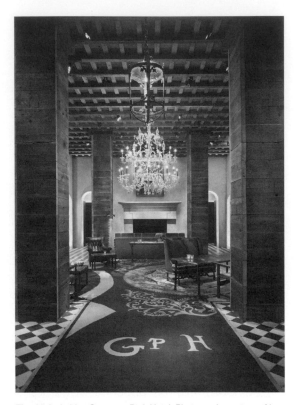

Fig. 14.3. Lobby, Gramercy Park Hotel. Photograph courtesy of Ian Schrager Company.

deliberately excluded mass-produced and generic products. The bronze tables, lanterns, rug, door handles, curtain rods, finials and hand-carved fireplaces were designed by the artist and formed part of a design scheme in which all elements bore the mark of his creative genius. What was celebrated here was the myth of the artist-genius, an artistic concept in which individualism was valued and the artist viewed as a 'feeling being whose works express both a personal sensibility and a universal condition'.[36] At Gramercy Park, the significance of Schnabel's design lay not so much in any technical skills demonstrated but in the transformation of ordinary commodities

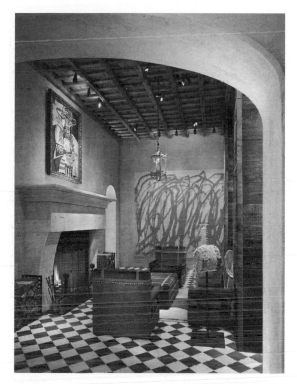

Fig. 14.4. Lobby, Gramercy Park Hotel, with paintings by Julian Schnabel, *Suddenly Last Summer* (2005) and Cy Twombly, *Bacchus* (2005). Photograph courtesy of Ian Schrager Company.

into works of art through the 'magical powers' of the artist.[37]

In the nineteenth century, the bohemians had continually pushed the boundaries of bourgeois taste, but their stylistic innovations were rapidly absorbed by consumer culture. By the turn of the twentieth century, the lifestyle of the bohemian—with its emphasis on excess, rebellion and rejection of middle-class safety—became as important to the identity of this avant-garde as the art it produced.[38] It is this relationship between bohemianism and lifestyle that was exploited at Gramercy Park. Here, the individuality and uniqueness of the hotel were reliant on the reputation and celebrity of Schnabel rather

than the innovative qualities of his design. If, as has been argued, art is useful in terms of its 'provision of moments, places and tools for self-reflection, critical thinking and radical practice', there was little evidence of this at Gramercy Park.[39] Schnabel did not use the opportunity to interpret or critique the notion of hospitality, accommodation, mobility or travel, the key characteristics of the hotel, nor did he engage with the site in terms of decoding or recoding institutional conventions in order to reveal their underlying operations.[40]

In a magazine interview, Schrager revealed that the look of the hotel was not based on a poverty-stricken artist's garret but rather drew inspiration from the residence of a 'bohemian with money'.[41] At Gramercy Park, there appeared to be little to distinguish the bourgeois world of capitalism from any bohemian counterculture. The hotel catered for 'a new information age elite', labelled by sociologist David Brooks as 'bourgeois bohemians' or 'Bobos', who adopted a bohemian lifestyle but were affluent and middle class.[42] This symbiotic relationship between contemporary bohemia and the new economy was also explored by Richard Lloyd in his discussion of the value of the 'neo-bohemian' lifestyle to post-industrial society.[43] Gramercy Park appeared to represent a further stage in the commodification of artistic lifestyles already evident in the gentrification of many urban districts such as Soho, New York, formerly occupied by artists.[44]

The hotel lobby is not a neutral space, but it is an important site for the performance of lifestyle and the promotion of corporate identity. Designed with the consumer at its

centre, it is a place of cosmopolitan urbanity where subtle forms of distinction are encoded within its design and associated marketing communications. Originally a place where social rituals reinforcing class and status were performed, more recently demarcations of class have been replaced by a different set of hierarchies associated with celebrity, glamour and lifestyle. Luxury is a social construct that is subject to continual reinvention, and recent market research claims that luxury is less about a product or service but more about providing 'authentic', 'unique, memorable experiences that are differentiated'.[45] Within

the context of a leisure sector dominated by minimalism and affordable boutique hotels, the idea of luxury communicated by Gramercy Park lay in the bohemian lifestyle it evoked (see Fig. 14.5).

Schrager's strategy with regard to his hotels was consistent with contemporary trends in marketing, distinction and branding where collaborations with artists and architects reinforced a corporate association with the arts and satisfied consumer enthusiasm for the cult of personality.[46] At Gramercy Park Hotel, customers were promised an 'idiosyncratic, eclectic vision that offers a perfect modern alternative to the institutional approach one now finds in even the most high-end boutique design hotels'.[47] In the spaces of the hotel, the myth of the artist as an eccentric and individualistic figure was used as a metaphor for creativity and high culture, thereby associating the narratives of imagination, passion and vision with the image of the Schrager brand. The symbolic reproduction of an 'artistic' theme was designed to communicate a superior taste and lifestyle choice to a mobile, affluent and culturally cognisant group of individuals attracted by the idea of aestheticized living.

Fig. 14.5. Rose Bar, Gramercy Park Hotel, with paintings by Julian Schnabel, *Suddenly Last Summer* (2005) and *Teddy Bears Picnic* (1988), and Andy Warhol, *Rorschach* (1984). Photograph courtesy of Ian Schrager Company.

Notes

1. Gramercy Park Hotel website, http://www. gramercyparkhotel.com/gramercy_park_hotel.html, accessed 10 July 2010.

2. E. McSweeney, 'Up at the Old Hotel', *Vogue* (September 2006), pp. 532–3; K. Betts, 'A Hotel Guru Changes Rooms', *Time* 168/7 (August 2006), http://www.time.com/ time/magazine/article/0,9171,1223352,00.html, accessed 10 July 2010.

3. A. Giddens, *Modernity and Self-identity: Self and Society in the Late Modern Age* (Stanford University Press, 1991), p. 81.

4. See Ian Schrager Company's website, http://www.ianschragercompany.com/ian_schrager.html.

5. G. Rose, *Visual Methodologies: An Introduction to the Interpretation of Visual Materials* (Sage, 2001), p. 142.

6. D. McNeill, 'The Hotel and the City', *Progress in Human Geography* 32/3 (2008), pp. 383–98.

7. D. Mortelmans, 'Sign Values in Processes of Distinction: The Concept of Luxury', *Semiotica* 10 (2005), pp. 497–520.

8. F. Braudel, *Capitalism and Material Life, 1400–1800* (Harper Torchbooks, 1967), p. 122.

9. D. Albrecht, *New Hotels for Global Nomads* (Merrell, 2002), p. 11.

10. T. Veblen, *The Theory of the Leisure Class* (Dover Publications, 1994 [1899]).

11. E. Denby, *Grand Hotels, Reality and Illusion. An Architectural and Social History* (Reaktion, 1998), p. 224.

12. A. T. Friedman, 'The Luxury of Lapidus: Glamour, Class, and Architecture in Miami Beach', *Harvard Design Magazine* 11 (Summer 2000), pp. 39–47.

13. P. Bourdieu, *Distinction: A Social Critique of the Judgement of Taste* (Routledge, 1984).

14. G. Ritzer, *The McDonaldisation Thesis: Explorations and Extensions* (Sage, 1998).

15. F. Kaçel, 'Rethinking Public vs. Private: The Istanbul Hilton and Its Beyond', in *Contribution and Confusion: Architecture and the Influence of Other Fields of Inquiry. Proceedings of the 2003 Association of Collegiate Schools of Architecture (ACSA) International Conference* (ACSA Press, 2004), pp. 487–92.

16. Ian Schrager quoted in O. Riewoldt, *New Hotel Design* (Laurence King Publishing, 2006), p. 44; Giddens, *Modernity and Self-identity,* p. 81.

17. M. Aggett, 'What has Influenced Growth in the UK's Boutique Hotel Sector?' *International Journal of Contemporary Hotel Management* 19/2 (2007), pp. 169–77.

18. S. Kracauer, *The Mass Ornament: Weimar Essays* (Harvard University Press, 1995).

19. M. Katz, 'The Hotel Kracauer', *Differences: A Journal of Feminist Cultural Studies* 11/2 (1999), pp. 134–52, quotation p. 148.

20. F. Jameson, *Postmodernism, or the Cultural Logic of Late Capitalism* (Verso, 1991).

21. B. Ryder, *Bar and Club Design* (Abbeville Press, 2002).

22. G. Debord, *The Society of the Spectacle* (Zone Books, 1994 [1967]). Writing in 1967, Guy Debord's critique of consumer society and commodity fetishism argued that authentic life had been replaced by its representation. Individuals were no longer in control of their lives but were passive consumers of the capitalist spectacle, which could only be resisted by taking to the streets and reappropriating the urban environment.

23. D. Trigg, 'Furniture Music, Hotel Lobbies, and Banality: Can We Speak of a Disinterested Space?' *Space and Culture* 9/4 (2006), pp. 418–28, quotation p. 422.

24. V. Postrel, *The Substance of Style: How the Rise of Aesthetic Value Is Remaking Commerce, Culture, and Consciousness* (Harper Collins, 2003), p. 127.

25. J. Twitchell, *Living It Up: Our Love Affair with Luxury* (Columbia University Press, 2002), p. 29.

26. Betts, 'A Hotel Guru Changes Rooms'.

27. Gramercy Park Hotel website (see note 1).

28. B. Buchloch, 'Conceptual Art 1962–1969: From the Aesthetic of Administration to the Critique of Institutions', *October* (Winter 1990), p. 528.

29. E. Wilson, 'The Bohemianisation of Mass Culture', *International Journal of Cultural Studies* 2/1 (1999), pp. 11–32.

30. Gramercy Park Hotels website ('Bars'), http://www.gramercyparkhotel.com/bars.html, accessed 10 July 2010.

31. D. Buren, 'The Function of the Studio', *October* 10 (1979), pp. 51–8.

32. A. Wheelock, *Vermeer and the Art of Painting* (Yale University Press, 1995), pp. 129–40.

33. Schrager quoted by C. Gandee, 'Bohemian Rhapsody', *Travel + Leisure* (October 2006), p. 247.

34. J. Rykwert, 'The Constitution of Bohemia', *Res* 31 (1997), pp. 109–27.

35. E. Barker et al, eds, *The Changing Status of the Artist* (Yale University Press, 1999), pp. 9–11.

36. G. Pollock, 'Art, Art School, Culture', in J. Bird et al., eds, *The Block Reader in Visual Culture* (Routledge, 1996), pp. 50–67.

37. P. Bourdieu, *Sociology in Question* (Sage, 1995), p. 147.

38. Wilson, 'The Bohemianisation of Mass Culture', pp. 11–32; and A. Sturgis et al., *Rebels and Martyrs: The Image of the Artist in the Nineteenth Century* (National Gallery Company Ltd, 2006), pp. 18–23.

39. For example J. Rendell, 'Public Art: Between Public and Private', in S. Bennet and J. Butler, eds, *Locality, Regeneration & Divers[c]ities* (Intellect, 2006), pp. 19–26, quotation p. 26.

40. M. Kwon, *One Place after Another: Site-specific Art and Locational Identity* (MIT Press, 2002), p. 14.

41. A. Blum, 'Welcome to the Art Hotel', *Business Week* (25 May 2006), http://www.businessweek.com/innovate/content/may2006/id20060525_807517.html, accessed 10 July 2010.

42. D. Brooks, *Bobos in Paradise: The New Upper Class and How They Got There* (Touchstone, 2000), p. 11.

43. R. Lloyd, *Neo-Bohemia: Art and Commerce in the Postindustrial City* (Routledge, 2006), pp. 47–72.

44. S. Zukin, *Loft Living: Culture and Capital in Urban Change* (John Hopkins Press, 1982), pp.173–92.

45. S. Coupe, 'The Changing Face of Luxury Travel', *Locum Destination Review* 19 (2007), http://www.locumconsulting.com/pdf/LDR19TheChangingFaceOfLuxury.pdf, accessed 10 July 2010.

46. N. Ryan, 'Prada and the Art of Patronage', *Fashion Theory* 11/1 (2007), pp. 7–23.

47. Gramercy Park Hotel website (see note 1).

Chapter Fifteen

'Stay with Armani': Giorgio Armani and the pursuit of continuity, stability and legacy

John Potvin

I have no idea whether my homes are the way they are because I am a fashion designer, or whether I am a fashion designer because I have the gift of taste which is expressed in my homes.[1]

Today, more than ever before, fashion has expanded to encompass our way of life—not just how we dress, but where we live, which restaurants we eat at, which car we drive, where we go on holiday and which hotels we stay at.[2]

—Giorgio Armani

Giorgio Armani's sale of his blue Volkswagen in 1975 to help toward the paltry $10,000 start-up funds he and his then partner Sergio Galeotti used to establish Giorgio Armani SpA in Milan is now the stuff of fashion legend. One year later, they moved to Via Durini 24—a seventeenth-century Milanese palazzo designed by architect Francesco Maria Ricini. The rooms of the palazzo are filled with mythological and allegorical frescoes, antithetical to the rigorous, minimalist Armani aesthetic. Despite this, the company remained there until 1982. In this same year, when Armani appeared on the cover of *Time* magazine, not without controversy, he took up a nineteen-year lease for a larger and equally grand seventeenth-century palazzo at Via Borgonuovo 21, where he also set up house and home on the second and third floors. The palazzo was aptly and originally owned by Franco Marinotti of SNIA Viscosa, the manufacturer of Riva cotton. Not unlike in Via Durini, the environment was one in which classical frescoes loomed large, hovering omnipresent above Armani's work and life. This time, however, screens and a drop ceiling were built to cover them, avoiding any and every visual distraction. According to the minimalist designer: 'It's necessary to create an ambience for working so nothing disturbs you. The outside world is too complicated and demanding, but geometric forms in clean, open spaces are relaxing and make work easier.'[3] The interior was designed by architect Giancarlo Ortelli, who went on to design the inaugural prototype for Giorgio Armani boutiques around the world; the

palazzo also features both an all-weather garden and a Zen garden. Three main influences informed Ortelli's designs: Roman classical architecture, Japanese design and the International Style of the 1920s. The 'resulting effect is pure form' and early on was often referred to as a Zen monk's cell.[4]

Three short years later, in 1985, Armani commissioned American architect and designer Peter Marino, known for his work for some of the fashion industry's most celebrated and influential designers, to redesign the interiors of Via Borgonuovo. In what became a more richly tactile and sumptuously coloured design, Armani was and remains inspired by, and an avid collector of, furniture by surrealist and modernist designer Jean-Michel Frank (1895–1941). The reference for Marino from which to work, therefore, was that of the 1930s, in particular the work of Frank. 'I suggested a period in the past as a point of reference, since the structure of the house was suitable for the kind of atmosphere,' Armani states. For the designer, it was 'the simplicity of the lines and the richness of the fabrics of that era' that he liked and that are qualities reflected in his clothing collections season after season.[5] These new digs, in tandem with his fashion, represent for him 'simplicity of line, the love of natural materials, modernity without futurism'.[6] The walls of each room are lined with sycamore (bedroom), oak (library and salon), parchment (dining room) and goatskin (library). Doors and their casements are fashioned from French polished ebony or in sand and ivory coloured woods reminiscent of Frank's often pale furniture. Furnishings included wood folding screens, black lacquered tables, desks and

a secretaire for his private home office and raw silk beige and sand sofas. Beyond the interplay between browns and black, the space is one of neutral and rigorous restraint. The subtlety of detail and surface treatments refer to a play of texture and light that Armani is known for. As Marino puts it: 'It's not about colour, pattern, or decoration. It's a game of textures and finishes.'[7] Perhaps the most revealing feature of the apartment is how a simple, unobtrusive pocket door leading into his private residence minimally suffices to demarcate and separate the porous spheres of public and private.

In the basement are to be found a small private gym, a lap pool wide enough for one man with arms fully outstretched and, more significantly, the runway where Armani presents his twice yearly men's and women's collections.[8] First used in July 1983 for the men's S/S 1984 collection, the stage, or runway, is in industrial glass, lit from below with a rear projection system, while the orange honeycombed structure in the ceiling allows for an intricate lighting system which can be lowered or raised. Seating is provided on three sides; the far end is reserved exclusively for press photographers and has a perfect view of the facing sliding panels from where models exit, an arrangement heavily lauded by buyers and press writers who are often challenged for an unobstructed vantage point. Armani was the first Milanese designer to show his runway collections away from the centralized, sanctioned venue of the Fiera and to welcome people into what was ultimately his home. No other designer in the last quarter of the twentieth century has extended such an intimate invitation.

Like so many traditional Italian craftsmen and merchants, Armani's move to Via Borgonuovo forever sealed the fate of the *bottega-casa* (store-home) relationship (or, in his case, the studio-casa) for the designer. The symbolic (yet slight) separation between home and work at Via Borgonuovo materially and spatially substantiates Armani's repeated claim that his work *is* his life. It is here that Armani the man and Armani the label are fused together in the coeval spaces of life and work. When Armani moved his design studio and home to Via Borgonuovo, he also made another symbolic and materially significant move. Up until that point, the label in each Giorgio Armani *couture* garment was rather simple—a white background with black lettering. When he made the move, so too did his label, of sorts. Now, the label was black with white lettering with a uniform typeface and read: 'GIORGIO ARMANI A Milano—Borgonuovo 21.' The new so-called 'black label' seemed to express so much more vital information about the identity of this growing Milanese-based company. As a signifier of a lifestyle already in the making, the label now designated the designer's name, the city with which he identified so passionately and in which he was building his empire and finally the address of both his design studio and home. The relationship between fashion and lifestyle was forever symbolically crafted.

In this essay, I posit that through Armani's more recent foray into home furnishings with his Armani/Casa collection (begun in 2000), the designer has sought to create a design ethos and lifestyle ideal premised on continuity, stability and legacy.

The inauguration of the collection also coincided with a number of other significant accomplishments and initiatives for Armani. Notable among these were the opening of Armani/Via Manzoni, a department-store-scale multilabel store which featured the first full-range Armani/Casa outlet as well as other expanding lifestyle products under one roof, and the Giorgio Armani Retrospective at the Guggenheim Museum in New York, which honoured the designer's contribution to the world of fashion and aesthetics. In no way exhaustive, this essay also seeks to explore, through various snapshots, how the space of and designs for the home and fashion have always been so inextricably interwoven for the designer in his creation and elucidation of a complete lifestyle for both himself and the ideal Armani customer. With the creation of Armani/Casa, which takes its inspiration from his black label couture collection, Armani has set the stage on which to enact what is likely the last performance in establishing his position in the history of design: the inauguration of a network of hotels.

Armani has always been known for being at once a modernist and a classicist, and his foray in 2000 into furnishings and designs for the spaces of the home was and remains no different. Inspired by the moralist 'less is more' design ethos, the idiomatic expression remains the same in both the aesthetic enterprises of fashion and furniture, frequently inspired by the perceived purity of the interwar period and an inchoate Asia. As Armani himself asserts: 'I hate excess in houses, and I hate excess in dress. When I design clothes, I pursue an exact mathematical philosophy . . . The way I create and marry fabrics is peculiar to me,

unique. I conduct a detailed and personal research for each of my fabrics.'[9] Unlike any other designer of his time, Armani's Milanese palazzo, throughout the 1980s and 1990s, at least, consistently figured as the conceptual thread weaving together the various facets of his design enterprises. Early on in his career, Armani designed furniture to suit his house and boutiques. The most notable examples were the sloping lamps he created for both venues and which would eventually serve as the minimalist, silhouetted logo for his Armani/Casa line.

Armani hints at the importance living bodies play within the confines of his home:

> If the walls and interiors of my houses are sleek, it's because I want my presence to create the mood, not the presence of furniture or the paintings or the objects. It's the same principle that guides my clothing design. Women shouldn't be admired for what they are wearing; they should be adored for the intelligence and character they possess behind the veneer.[10]

And again he makes an important appeal for the sensorial dynamic of textiles in the creation of an ideal aesthetic experience for both fashion and the home:

> My designer's eye refuses unrealistic shapes, vulgarity in a fabric or colour. I have chosen to make both my home and my fashions restful and natural. The similarity between them lies in the seductive choice of materials ordered by what I like to call a lyrical geometry. This is the true luxury of simplicity—I love the 'invisible' element of true elegance.[11]

While he purports never to design at home, the separation between home and work in real terms is tenuous at best.[12] Additionally, the designer has also claimed that Armani/Casa does not function as an extension of his own home, given that the collection possesses more 'feminine touches', as purchases for the home are generally the purview of women. Yet despite this, he has also stated that he has used his homes as a sort of laboratory 'to test a concept before putting [it] into production'.[13] On a recent trip to New York and while poring over the myriad photo shoots in the Fairchild Publication Archive, usually as pre-collection editorial material, I noted the numerous images of Armani's elegant home interiors deployed as idealized backdrops to his men's and women's fashions, seamlessly reinforcing the complete lifestyle he inspired throughout the 1980s, even in those early years of the company.

Beyond the realm of magazine editorials for the industry's most influential trade publications such as *DNR* (*Daily News Record*) and *WWD* (*Women's Wear Daily*), Armani's various homes, particularly his Milan residence, have featured prominently in advertising campaigns for his various clothing lines, setting the stage through the signifying power of the domestic space in the elucidation of meaning for the fashioned garment. As campaigns for the black label, for example, the F/W 1986–1987 and S/S 1988 feature his Milanese home; F/W 1988–1989 shows his country home in Forte dei Marmi; S/S 1991 is set everywhere important to his world: his favourite restaurant, his home, his Milan boutique, the streets of Milan; and F/W

2002–2003 is set in the then new Armani/ Teatro designed by Japanese architect Tadao Ando. These campaigns are in addition to other Armani Collezioni and Emporio Armani campaigns shot at the designer's Milan home and summer resort on the little volcanic island of Pantelleria, and more recently set against rich yet ambiguous backgrounds of Armani/Casa-designed interior spaces. The aforementioned advertising campaigns, often taken by Italian photographer Aldo Fallai, conjure a narratological, even filmic quality to the spaces of embodied, lived clothing; even if only within a fantastic, though plausible, context. Storytelling through objects is well understood by the designer himself when he asserts that the power of objects within the home helps to 'recall a particular moment, a brief moment from a beautiful story'.[14] More than simply showcasing clothing, so too can a total environment help stage a *Gesamstkunstwerk*—in contemporary terms, a complete lifestyle. The message, then, is a rather simple one: that clothes with such a strong and unique vision beg an ideal aesthetically akin and equally strong environment to best showcase them.

For the S/S 2007 men's and women's collections, Armani featured his models walking down his runway silhouetted by large projected images of his residences in Milan, New York and Pantelleria. The idea was to evoke the synergy between his fashion and furniture lines and remind his audience of the importance of the home within the creative design process. The visual analogy was taken into the window displays of his Giorgio Armani boutiques around the world, with photographs of his homes serving, once again, as backdrops to his fashions; colours and shapes paralleled three-dimensional mannequins as if stepping out from two-dimensional surfaces (see Figs. 15.1 and 15.2). In this instance, the mannequins are set in front of his summer home. Designed by architect Gabriella Giuntoli, the pictures display the entrance to one of his four *dammusi*—a Sicilian word for the rocky habitations found on Pantelleria—which is located between the Sicilian and Tunisian coasts. In Figure 15.2, North African outdoor lights are affixed to the picture to create an emerging three-dimensionality. Here, two-dimensional fabric and visual surfaces are given life and fullness through the spaces of the shop window, which echo the spaces of the designer's home. In the past, Armani has also deployed the notional home as an ideal when creating retail space, as when he claimed that his then new and controversial four-storey Marino-designed Madison Avenue boutique (1996), for example, should represent 'a familiar atmosphere to that of a friend's home'.[15] Returning to the London boutique windows, the silent, beguiling performance of the mannequins reinforces the symbiosis between fashion and space(s) as well as engenders a sense of desire to be part of the Armani (man and company) lifestyle. Rarely does Armani deploy his own image or parts of his purportedly private life as marketing or advertising tools. Like the pocket door which separates work from life in his Milan palazzo, here private lifestyle and public consumption become nearly indistinguishable.

Like the physical spaces of work and play, the fashion and furniture collections embody

Fig. 15.1. Giorgio Armani, London boutique, window display S/S 2007. Photograph: John Potvin.

Fig. 15.2. Giorgio Armani, London boutique, window display S/S 2007. Photograph: John Potvin.

the same ideological underpinnings, that of a 'combination of comfort, and sophistication, functionality and elegance. The Armani/Casa atmosphere mirrors the Armani fashion philosophy: rigorous shapes—which make people feel comfortable—enriched with precious materials, creating a unique, luxurious atmosphere'.[16] The cross-dressing from fashion to furniture is one adhered to via a very clear mandate: 'The strongest link between Armani/Casa and my fashion collections is the need to be functional and comfortable without sacrificing luxurious materials and a strong sense of style.'[17] As his former right hand and vice-president Gabriella Forte once claimed: 'Since Sergio's death [in 1985], it has become impossible to separate the living human being from the businesses.'[18] Life and work collapsed into each other even more and called for a greater sense of security and continuity between all facets of the designer's life. With Sergio Galeotti's death, Forte, who

has since left the company, moved back to Milan to be closer to Armani. During her tenure at Armani SpA as a sort of emissary, Forte was usually dispatched before Armani's arrival at any given destination, especially if it was somewhere he had never travelled to before. Given that travel, even during the 1990s, made the controlled designer nervous, her role was to ensure 'with absolute certainty who and what he will find when he gets there'.[19] The result is sameness in design, environment and experience, though always with a touch of local flavour; Armani's aesthetic is imposed on whatever space or moment, away from his compound. According to the designer, 'If people feel relaxed, they also feel secure,

and the best living environments make us feel safe and protected.'[20] The sense of comfort and security might refer us back to the ideals of modernist architecture and interior design, especially the work of Adolf Loos, for example. As Beatriz Colomina has asserted, Loos's inclinations away from a Victorian ethos and towards a modernist notion of the domestic interior were predicated on a material comfort and visual control of that space which assured the movement of the actors within the often gendered spaces of the home, but also ensured security against external, seemingly and potentially predatory actors and forces.[21] For Armani, security, comfort and control coincide at the moment of the aesthetic experience.[22] Always the aesthete, Armani has even gone so far as to claim that should he find himself in a hotel in which the décor is offensive, sleeping becomes a problem. It seems, therefore, a logical step to create your own brand of hotels in key destinations around the world.

The Armani/Casa line has been labelled by one critic as a sort of 'proto-modernism as nostalgia . . . a world of space, luxury, sensuality, discretion, subdued light' — in other words, an atmosphere premised on an otherness, a difference from the present condition and location.[23] Art deco motifs and functional luxury evoke Paris of the 1930s and, as in his Milan residence, are fused with an ambiguous pan-Asian décor to create a collection at once 'sober and elegant', 'composed and geometric' and yet providing 'warm and comfortable sensuality'. Referring to his obsession with the art deco style, Armani claims 'that during that historical and cultural period functional discipline was allied with the search for fabrics, textures and decoration'; fabric and texture serving as hallmarks of his own success story.[24] His love for the style of the 1930s has led him to claim that beyond his desire for 'severe interiors' (clearly referring to his own), he would 'be ready to give up a lot for that Art Deco glamour'.[25] Numerous have been the Armani/Casa collections which pay homage and owe much to art deco stylings. In his 2005–2006 collection aptly entitled *Maison de Charme,* for example, *luxe, calm et volupté* of Paris in the 1920s and 1930s is clearly evoked, however, with an attention to contemporary fabrics and functional needs. Often Parisian, his use of art deco is set in relief to the exotic overtures of Shanghai deco of the same period, a reference fuelled by his expansion into that city in 2004.[26] Out of step with his contemporaries, both in terms of fashion and furniture, the year of his birth (1934) is more suggestive of the significance he attributes to the interwar period. 'The years from 1930 to 1940 were years of great invention and creativity,' he concludes. 'I have always referred to them, both in my fashion and my furniture.'[27] The deco styling provides for the designer a strong sense of continuity within his own collections and aesthetic vision season after season, and he asserts that after five years he can 'enjoy the interplay between the fashion and the furniture collections' where he 'can bring inspiration for colours, fabrics and materials from one to the other and vice versa'.[28] To this end, one can see how fabric used for a throw for the private space of the domestic realm in the 2005–2006 Armani/Casa collection is taken up again in the F/W 2005–2006 women's collection for a pair

of shorts and wrap to be sported in public. Armani states that 'people's homes tend to be reflections of themselves', and in this way Armani/Casa is 'a natural extension of [his] fashion collections. Each year the Armani/Casa collection is enhanced with new colours, new finishes, accessories or simple details that in many ways reflect [his] most recent fashion collection'.[29]

For the 2008–2009 collection presented at the annual Salone del Mobile in Milan, and later at the London Design festival, Armani elected to showcase vintage black label garments taken from the Armani Archive. These select few garments also featured in the itinerant retrospective which began at the Guggenheim Museum. The collection was, once again, heavily indebted to the art deco of the 1930s, with allusions to the iconic work of Eileen Gray. Taken from various collections, the vintage garments too were reminiscent of the interwar period whose new historicist identity served the designer in two imbricated ways: first, as nod to a significant period in the history of design to which the designer often refers, and second, to the legacy and contribution Armani's past styles have for his own work more specifically and for design history generally. The press release for the collection stated that 'this combination of furniture and furnishings, and fashion, clearly emphasizes how Armani/Casa represents a harmonious extension [of a] common philosophy and unity in style'.[30] Here, past and present conjure timelessness, an ahistorical style legacy. Style, understood to reside beyond the vagaries of the fashion system, is here historicized, a product of the archive, while at the same time brought forward

anew to bear upon the present at a time when vintage is at its most popular. As Nadia Seremetakis beautifully evokes, nostalgia 'speaks to the sensory reception of history. In Greek there is a semantic circuit that weds reception to agency, memory, finitude, and therefore history—all of which are contained within the etymological strata of the senses'.[31] Armani's move is not simply a nod to popular taste, however, but rather a means to begin to create a lifestyle and legacy sustainable after his departure as he furthers to reinstitute the mutuality of these two design practices.

However, the use of the archive is but a small circuit within his expansive lifestyle network. Armani/Casa, it must be stated, is not merely and only a collection of designed objects and furnishings for the home, but importantly also provides a much sought-after interior design service in Milan, Paris, London and New York. Numerous high-profile projects have been initiated through the creation of the Armani/Casa Interior Design Studio. These include, for example, the Chelsea Football Club Armani/Lounge, the luxury residential development of the Collection at 20 Pine Street around the corner from Wall Street in New York, and the Cavour 220 complex in the heart of Antique Rome, where, according to the exquisite hardcover publicity book, 'history turns to contemporary'. However, nothing can now compare to the latest and final design enterprise of the Armani/Hotel global expansion Armani has inaugurated with his first luxury hotel in Burj Khalifa, Dubai, in 2010. The message for these projects and one used explicitly for the Armani/Hotel enterprise website is one of intimacy in the face of globalization: 'Stay with Armani.'

The designer does not see the move into the hotel business as a dilution of his name or brand. Quite the contrary, Armani claims that 'it's totally natural for me to do a hotel. I design casa. That's not just furniture—it's structure and interiors as a whole. Yes, a hotel is on a bigger physical scale but it is the same application of style'.[32] Recognizing the shifting and ephemeral nature of fashion, Armani has said that he envisions the multi-hotel project to be 'something that will be remembered'.[33] The 160-room hotel opened in April 2010 and significantly features as an important part of the world's new tallest building. While Armani is not the first fashion designer to create and run his own hotel — with Krizia, Bulgaria, Ferragamo and Versace as a few compatriots already in the game— the designer's global clout and resources will surely make him one of the most successful among these new haute hoteliers. Real estate developer and construction giant Emaar (30 percent of which is owned by the Dubai government) is collaborating with Armani to develop this and another ten more hotels; the next is slated to open in Milan in 2011 atop his Via Manzoni shopping complex, the site of the first full-range Armani/Casa boutique.

The five-star hotel in Dubai boasts numerous unique features and services. Chief among these are a 600-member staff (about four to every room) which includes 'lifestyle managers' and specialist concierges; six restaurants including Indian, Japanese and Italian eateries; and finally the Burj Fountain, the world's largest, shooting water 450 feet into the air at a cost of $280 million. Upon walking into the $1.5 billion tower, one is immediately taken by the multistorey golden schematic silhouette arches of a mosque in the towering entrance. This minimalist schematic motif is used extensively throughout the hotel and can be seen on stainless steel door handles or on the chocolate boxes left in each bedroom. The motif-cum-logo is specially designed for this location, while each hotel will have a unique design feature logo. This is a small aspect of the overarching consideration to the details of design to which Armani has paid close attention. Every space and product has been customized: sugar cubes have a capital A inscribed on them, for example. In addition to Armani/Casa being showcased so prominently throughout the hotel (every item in the rooms will, incidentally, be for sale), speciality sections of the hotel will also feature retail areas devoted to Armani cosmetics, fragrances, flowers, chocolates, clothing and accessories. In addition, there are 144 Armani apartments for sale, all of which are tailor-made to each client's specifications and residential needs.[34] The grand opening was conspicuously absent of the usual international celebrities, a feature which has become a staple of an Armani opening or special event. Instead, Armani claimed the hotel as the star of the day. He did, however, mark the event by taking the opportunity to stage a runway showing of his haute couture collection for 500 special guests, reaffirming the synergies of design in the network that is the Armani world as well as the exclusive and couture nature of his latest venture.

With an itinerant retrospective exhibition which toured for seven years, the creation of segmented brands within a single brand and his move into hotels and residences, Armani is set to once and for all establish and pen

(designed by himself, of course) the final chapter of his legacy. Interior space, whether a museum, hotel or private residence, is at times an odd, yet deeply powerful thing. Often it is the site of tension, overlap, negotiation and ambivalence due in large measure to the fashioned bodies which utilize and pass through such spaces. Like Borgonuovo 21, the Burj Armani Hotel is at once both private and public, removed while inviting sites of spectacle and intimacy. Indeed, as per the designer's own desire to be remembered as someone who created both something stylish and lasting, these interior spaces, these edifices of glamour and temples of fashion, are surely the foundations of a future legacy whose history has yet to be written. And so, the last words must go to him: 'Hotels close the circle on our unique multi-brand approach and on the Armani world . . . I have invented an entire story. Now the story is complete.'[35]

Notes

1. Armani in L. Loratt-Smith, *The Fashion House: Inside the Homes of Leading Designers* (Conran Octopus Limited, 1997), p. 26.

2. Armani in an interview with *Metropolitan Home* (May 2009), p. 58.

3. R. Buckley, 'Giorgio's Geometry', *DNR: The Magazine* (September 1983), p. 28.

4. Ibid.

5. J. Arlidge, 'The Armani Collection' [Final 1 Edition], *Sunday Times* (10 September 2006), p. 32, UK Newsstand, ProQuest.

6. C. Grandee, 'The House of Armani', *House and Garden* (UK) (April 1990), p. 151.

7. Ibid., p. 152.

8. Armani presented his mainline Giorgio Armani (men's and women's) and secondary Emporio Armani (men's and women's) collections in Via Borgonuovo until 2001, when he inaugurated Armani/Teatro. The new headquarters, designed by Japanese architect Tadao Ando, was once a Nestlé factory.

9. Armani in F. Tournier, 'Armani Plays Prospero' (interview with Giorgio Armani), *Elle Decor* (March 1990), p. 90.

10. Ibid., p. 84.

11. Armani in Loratt-Smith, *The Fashion House,* p. 24.

12. Armani in Ibid., p. 22.

13. 'Armani Creates Style for the Home', *New Zealand Herald* (23 March 2006), n.p.

14. Tournier, 'Armani Plays Prospero', p. 93.

15. My translation. Armani in 'Boutique de Luxe et de Mode', *Architecture Interieure Crée* 275 (1997), p. 107. For more of a discussion on this flagship boutique and other boutiques from around the world see J. Potvin, 'Armani/Architecture: Giorgio Armani and the Textures of Space', in J. Potvin, ed., *The Places and Spaces of Fashion, 1800–2007* (Routledge, 2009), pp. 247–63.

16. Armani in C. Long, 'From Catwalk to Cushions', *Times* (22 September 2006), p. 18.

17. Armani in K. Bryant, 'Armani's Latest Adventure: He's Branching into Home Furnishings with a New WEHO Store', *LA Times* (14 November 2001), p. E1.

18. P. Howarth, 'Elements of Style', *GQ* (UK) (March 1994), p. 22.

19. P. Reed, 'Casa Vogue', *Sunday Times Magazine* (9 January 1994), p. 39.

20. Armani in an interview with *Metropolitan Home* (May 2009), p. 60.

21. See B. Colomina, 'The Split Wall: Domestic Voyeurism', in *Sexuality and Space* (Princeton University Press, 1992), pp. 73–128.

22. S. Giacomoni, *The Italian Look Reflected* (Mazzotta, 1984), p. 70.

23. Armani in P. Popham, 'Buy Giorgio Armani's New Homeware Collection', *Independent* (12 April 2008), n.p.

24. '1/50', Armani press release (May 2005).

25. Tournier, 'Armani Plays Prospero', p. 84.

26. For more on the art deco influence in the designer's Armani/Casa collections and the gendered implications see 'Cross-Dressing Fashion and Furniture: Giorgio Armani, Orientalism and Nostalgia', in J. Potvin and A. Myzelev, eds, *Fashion, Interior Design and the Contours of Modern Identity* (Ashgate, 2010), pp. 225–44.

27. Popham, 'Buy Giorgio Armani's New Homeware Collection', n.p.

28. 'Armani Creates Style for the Home', n.p.

29. Armani in Long, 'From Catwalk to Cushions', p. 18.

30. Armani press release (17–23 September 2008).

31. N. Seremetakis, *The Senses Still: Perception and Memory as Material Culture in Modernity* (Westview Press, 2001), p. 4.

32. J. Arlidge, 'Dubai's Battle of the Bling Hotels', *Sunday Times* (2 May 2010), p. 1, UK Newsstand, ProQuest.

33. G. Deeny, 'Armani Opens Debut Hotel in Dubai', *FashionWireDaily* (28 April 2010), n.p.

34. To date, approximately 50 percent of the units have sold, with prices ranging from £1 to £5 million.

35. Arlidge, 'Dubai's Battle of the Bling Hotels'.

Chapter Sixteen

Designing for the screen: the creation of an everyday illusion

Teresa Lawler

While design is an essential part of both television and film production, the screen referred to in the chapter title is that of the television set and not of the cinema. Writing on this subject has tended to focus on process—Terry Byrne's *Production Design for Television* (1993) is a well-established text in this area—while explorations of production design as a creative entity have mainly considered film rather than television.[1] Jane Barnwell does examine television design in her 2004 book *Production Design: Architects of the Screen,* but her analysis also covers film; where television is dealt with, the book tends to concentrate, although not solely, on drama productions.[2]

Television design shares many elements with film and theatre design but differs significantly in that many if not most people watch television daily, while film and theatre are viewed on a more occasional basis. This repeated exposure means some screen environments have become almost virtual extensions of our living space—rooms that we visit with almost as much frequency as some in our homes. It has also resulted in a familiarity that strongly influences our ideas of the setting a specific character would inhabit or the background a particular situation would demand. Barnwell describes this open ended quality as 'a particular strength of television', which is unrestricted by the time frame imposed by a feature length film.[3]

Television delivers the world we expect the characters on screen to occupy but strangely, through this daily exposure, also seems to form these expectations. This essay is an exploration not only of the part that the television production designer plays in forming and delivering this vision but also of how the viewer becomes engaged in this process in a way that is quite different from the audience experience of film. Research was conducted mainly through interviews with designers who are specialists in their chosen fields, informed by knowledge gained in my previous practice as a designer for television.

While most images we see on screen are the result of a series of complex interactions between various key personnel involved in a production, it is the production designer

who is mainly responsible for the physical environment. Most viewers are familiar with the roles of director, producer or editor, yet the job of the production designer or art director is largely unknown.[4] Their work can be linked to many disciplines—architecture and interior design, for example—but the environments that they create are transitory, built to respond to the particular needs of a production. Television design can also be related to art forms such as theatre, painting and sculpture—period drama for example may depend greatly on paintings for references to interiors, particularly in the pre-photography era, while large-scale entertainment programmes are often presented before an audience in a theatrical format. The latter also often use abstract sculptural forms in their design, usually combined with state-of-the-art technology. In fact, an exact definition of production design is difficult due to the fact that the input of the designer will depend on the size and nature of the production and that designers themselves are drawn from many different disciplines, including those mentioned earlier.

A useful distinction to make when looking at television design in its entirety is that employed by the British Royal Television Society, which for its craft awards divides productions into two categories: *drama* and *entertainment and non drama*. The latter deals with design for the type of production which is clearly within a studio environment and which is quite abstract in nature. This can range from an afternoon children's programme using a minimal set and a few handmade props to a large-scale music show involving a set using multiple LED screens and a complex lighting rig. The UK television programme *The X Factor* is the quintessential example of this type of production, with a set that is capable of instant and complex changes mainly due to its incorporation of multiple large-scale LED screens, video projectors and numerous lighting strips in its design.[5]

By contrast, production design for drama—whether contemporary or period—requires a completely different approach. Here, the aim is generally to create an entirely believable world which the actors inhabit, whether this is the suburban world of the British sitcom, the realism required of a police procedural or the manipulated gentility of a period drama. This believable world, however, may not necessarily be a true reflection of the world we inhabit. Authenticity may not always serve the designer well.

Whatever the subject matter, what all drama has in common is the building of the history of a cast of characters, not only through the design of the interiors but also through set decoration and the choice of small props. Colour, texture and light are used in drama in a more recognizable way, and all design is oriented towards the successful telling of a story. This is also the area of design which has increasingly moved out of the studio and onto location—sometimes with the aid of computer-generated imagery, which allows inconvenient anachronisms to be removed through post-production techniques.

In defining the various parts of the production design spectrum in this way, the scope of the work involved becomes apparent. Whether the setting is the totally artificial world of the newsroom or the recreation of some form of reality in drama,

the setting on screen will always be in some way the work of the art department.

The environment created for the presentation of news programmes illustrates clearly the nature of design for productions described as 'non drama'. A production designer on 'news and current affairs', which falls into this category, deals with design in a way that blends theatre and interior design. A combination of technology and soft furnishings is used both to relay imagery or information and provide decorative lighting states that define the interior which the newsreader inhabits. These sets epitomize the familiar spaces previously mentioned, with the living space of the viewer providing the fourth wall that is missing to allow camera access. Financial constraints mean that these sets are often used for other productions with only simple changes. The sense of familiarity is in this way reinforced.

Simon Jago's set for *BBC Breakfast News* (see Fig 16.1), which was also used throughout the day for the *Politics Show, Working Lunch* and *Newsnight,* among other BBC productions, offers an illustration of this type of multiple use.[6] This is an example of what is described in the industry as a 'fixed and flexible' set, which enables rapid transformations throughout the day and can establish the identity of each of the productions through minimal change.[7] This is achieved through movement of the air-lifted rostra (the low platform on which the desk is placed) and by altering the images on the projection screens which form the background and the lighting, which tends to gradually dim throughout the day.

The design format has emerged slowly over many years but is now entirely accepted as the environment from which news is issued on a daily basis. The television audience accepts this strange extension to their living space even though it bears no resemblance to any interior we inhabit. On examination, these sets are a peculiar hybrid not only of interior and theatre design but also of office and domestic design. Asked what was required of him for this particular set, Jago's response was that practical requirements were outlined together with the need for a 'branding statement'[8]. This needed to be 'clear and authoritative' and reflect a polished professionalism, yet be accessible to a range of viewers.[9] Most important, there was a need to demonstrate how technologically aware the programme is—technological awareness being synonymous with instant news delivery. This difficult balance is achieved by the use of a combination of materials ranging from backlit perspex in the 'business' end of the set, where hard news is delivered, to what is described as 'the soft end', usually defined by sofa and chairs. The harder the focus of the programme, the less comfortable the seating arrangements seem to be. The logical conclusion of this strand of design is the office-based newsroom as exemplified in *Channel 4 News.* Also designed by Jago, the entire set is light based and hard edged, the only seating is executive office chairs and the main news is read by a standing news reader.[10] This is intended to inject movement and energy into a situation where it is difficult to show any.

While the news set locates itself midway between the home environment and the

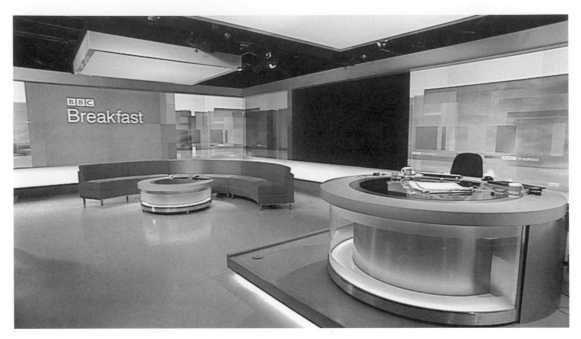

Fig. 16.1. *BBC Breakfast*—morning news programme (BBC TV, 2006). Acknowledgements to BBC News, Simon Jago (designer).

office, the chat show is a different kind of hybrid. Here, the set is half living room, half theatre, with the space generally divided into a seating area that reflects the persona of the interviewer and one that can accommodate some form of performance. *Parkinson,* for example, used a range of blues, which has traditionally been seen to most complement the broadest range of skin tones.[11] *Parkinson* was very much a representation of a comfortable living space—almost an extension of the host's home—and seemingly had the aim of putting guests at ease. In the same way, this set-up can be used to introduce an element of slight discomfort which contributes to the edginess and perceived alternative nature of a programme. Jonathan Ross, for example, exercised clear control of his eponymous chat show from

behind a desk while his guests were seated on a somewhat uncomfortable, low sofa.[12]

While both these programmes are clearly within the traditions of light entertainment in terms of design, what has emerged in recent years is the type of production that, while using another long-established light entertainment format—the game show—has introduced a much more drama-based approach to the set. One of the first British productions to do this was *The Weakest Link,* a quiz show where the set is in the round, forming a kind of arena with presenter Anne Robinson in the centre controlling the game.[13] This format also has the effect of excluding the viewer, as the presenter has her back to camera much of the time, with the set curved around her in contrast to the open design of most chat shows. The gladiatorial

feel of this production is emphasized by the almost exclusive use of hard-edged materials and the added employment of beams of light to form columns around the set. This dramatic approach to lighting was unusual for a programme scheduled at this time— late afternoon—when most programmes are predictably well lit in an approximation of a domestic setting. The usual rule of thumb prior to this seemed to be the earlier the programme, the brighter the lighting. This was one of the productions that arguably changed this approach.

Another example of the use of dramatic elements in this type of 'non drama' production is the 2008 design for *Crimewatch,* a BBC programme that deals with the reconstruction of unsolved crimes and asks the public to phone in with information.[14] Jonathan Taylor, the production designer of *Waking the Dead,* a drama series dealing with similar fictional subject matter, was approached by the production team of *Crimewatch* to design a new set.[15] Up until this point, the set had been a brightly lit version of other current affairs programmes, with a very recognizable style that owed much to light entertainment. In the brief, Taylor was asked to retain the flavour of the police drama and aim for a much moodier set with echoes of film. This resulted in an unusual and effective fusion of elements (see Fig.16.2) which could almost be described as *Bladerunner* meets *The Office.*[16]

Unlike these designs for non drama, sets designed for drama generally need to reflect the characters inhabiting them—the design is script-driven rather than brief-driven. The designer effectively builds the history of the characters through the choice of

props as well as the design of the interior architecture.

Waking the Dead, which was the inspiration for the *Crimewatch* design, has evolved over a number of series and in many ways exemplifies this type of TV drama. Designers working in this genre, which could broadly be described as contemporary drama, will often heighten reality in order to create a convincing vision of the world the characters occupy.

In *Waking the Dead,* Taylor adopted a very restrained palette. As with most productions of this type, initial research was conducted into actual environments inhabited by professionals in the field—in this case, forensic science labs. (Interestingly, access to forensic labs would not be possible now because of the risk of DNA contamination.) To fit the needs of the script, the sets have been manipulated in various ways to produce a more isolated feel. Over several series, the linking of exteriors to interiors has all but disappeared, increasing the idea of this unit acting independently. This is also accentuated by the lack of any outside vistas, reinforcing the idea of a self-contained world.[17] Any depth is created within the sets themselves by using internal windows and dividing partitions made from translucent material together with artificial light sources in the background (see Fig. 16.3). This latter device is one used frequently in film and television drama, and it is rare to see a production on screen that does not have some form of lighting at the back of the set. While the designer can define the physical space, it is brought to life through lighting, by a combination of on-set lights—desk lights, hanging lights, etc.— known as 'practicals' together with other

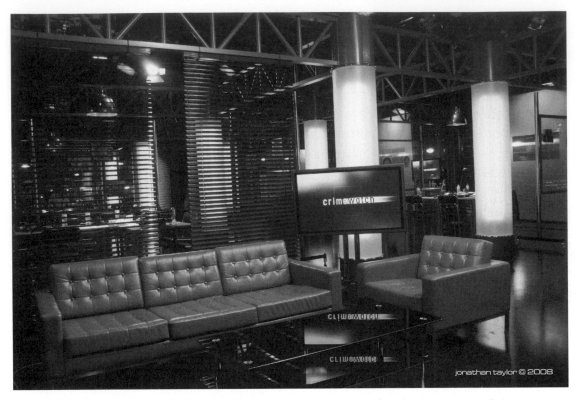

Fig. 16.2. *Crimewatch* (BBC TV, 2008). Acknowledgements to BBC TV, Jonathan Taylor (designer). Photograph: Jonathan Taylor.

forms of illumination provided by the director of photography. Examples of this are daylight outside a window or the precise lighting of an actor for each shot to complement the action. However, in positioning a window or door in a specific location, the designer is to some extent also contributing to the lighting state in a set.

The sets in *Waking the Dead* are four walled and are built solidly in the same way most film sets are constructed, while those for soaps and sitcoms are generally three sided. The series is shot completely on film—as most TV drama is now—providing a seamless viewing experience. This is in contrast to TV dramas of twenty years ago, when the practice of shooting exteriors on film and interiors with multiple cameras in the studio could result in an uncomfortable merging of the two in editing. Current high production values added to the effectiveness of the actual design result in a convincing depiction of a particular setting. This can go on to form the viewer's concept of what a particular environment looks like even though it may differ significantly from the actual workplace.

While the sets of *Waking the Dead* do not represent environments with which the average viewer would be familiar, they frame ideas of what this type of space should look like. In contrast, soaps and sitcoms provide us with variations on domestic interiors. In the

Fig. 10.3. *Waking the Dead* (BBC TV—first set 2002). Acknowledgements to BBC TV, Jonathan Taylor (designer). Photograph: Jonathan Taylor.

case of *EastEnders,* one of the most popular British soaps, interiors are matched directly to exterior shots.[18] However, exteriors are also sets, part of an extensive 'lot' built at the start of transmission in 1984 in Borehamwood, north of London, and regularly adapted ever since.

Most soaps' sets are shot with multiple cameras and, for this reason, are built with walls that can be struck for ease of access. Some of the *EastEnders* studio sets have been around as long as the characters and have developed almost in real time over a period of years. As close scrutiny would reveal the extent to which they have been assembled and reassembled on a weekly basis, the advent of high definition television has meant that both interior and exterior sets need to undergo major refurbishment. While such

advances in technology have meant creative changes in the look of news programmes and light entertainment productions, sets on long-running serials rely on the viewer *not* registering change in order to maintain the suspension of disbelief. An article in the *Times* online as early as 2008, entitled 'Sets Too Shabby for Latest TVs Force *EastEnders* out of Town', covered a proposed move to Pinewood, where 'a brick and concrete set was to be built'.[19] However, since then it has been decided that the production should remain at the Elstree (Borehamwood) site and that any updating should be done there. One of the ways in which this work has been facilitated was by the burning down of one of the longest standing sets, the Queen Vic pub, in an episode in September 2010. This featured the departure of one of the

best-known characters, Peggy Mitchell, while also enabling a complete revamp of the interior. It will be interesting to see what other storylines develop which affect the design of the production or explain necessary changes to the sets.

Wherever they are based and whatever they are built of, these sets are known intimately by viewers who have aged with the programme, and if a change is called for, it needs to be explained in the script. This is the reason the characters are occasionally seen decorating their homes—stripping wallpaper or painting a wall—on screen. A particular difficulty is posed if the scenes are shot out of order—i.e. the newly decorated set is shot before the decorating scene in the old one. It is the designer's job to make this possible, sometimes with the build of two identical sections of the set—one with the old décor, one with the new. This type of problem is posed by scheduling, often dictated by actors' availability, and is one of many that production designers are faced with regularly on drama sets of all kinds.

While it is fairly unusual for drama designers to cross over into the design of light entertainment, the designers of situation comedies may be drawn from either world. The reason for this could be their hybrid nature. While sitcoms are often recorded in front of a live audience and therefore have some of the qualities of theatre about them, they also require the skills needed to build the characters' histories within the set. To allow free access to the multiple cameras that are used to shoot this type of production quickly and to provide a viewing point for the audience, the fourth wall is entirely lost,

presenting the set in much the same way as in a theatre. Classic examples of this type of production have included *Absolutely Fabulous* and *Only Fools and Horses.*[20]

Situation comedies can, however, be less guarded about changes to familiar sets as key props may be added to support a line in the script or reinforce a visual gag. A reference to the 'awful design' of a fruit bowl for example could cause the sudden unexplained appearance of one on set without creating quite the same continuity problems as an unexplained addition to an established soap character's home. Most designers who have worked on this latter type of production are likely to confirm that caution needs to be exercised even with small changes as it is probable that they will be noted and commented on by someone in a viewing public of millions.

A genre that incorporates some aspects of both contemporary drama and sitcoms is that known as comedy drama. Shot on film with equal production values to other drama productions, comedy dramas such as *Jonathan Creek* and *Love Soup* are as painstakingly designed as productions with more serious subject matter.[21] While the design of soap sets develops over the lifetime of the production (they may go on for many years), most drama sets are carefully constructed to appear to have evolved slowly while usually being set in a day whether in the studio or in an adapted location. This use of locations is now very common, with the designer's work assumed to be (even by the crew, on occasion) part of an existing site. Jonathan Creek's home is a case in point. Situated in an unconverted

windmill, the location is cleverly dressed with carefully selected props to disguise large pieces of machinery that cannot be moved. In addition, 'walls were clad and painted to give a plainer background for all the dressing'.[22] Designer John Asbridge notes: 'My drawing of Creek's workroom was done to help the director understand how I intended to dress the space' (see Figs. 16.4, 16.5 and 16.6).[23]

Scenery is not the only element of design to be introduced to this type of setting. One of the locations in *Love Soup,* also designed by Asbridge, was the fragrance hall in a department store where the central character worked. As Asbridge has said about the process:

While the original expectation was to have to build this as a 'standing set' (a set built for the duration of a series) this could also have required extensive use of approved products as well as designing our own range of products for the main counter. However the production was fortunate in being able to use an actual department store in the city that is closed at weekends and redress part of the perfume area.[24]

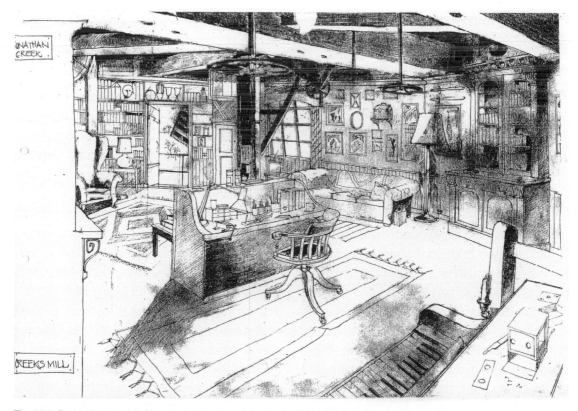

Fig. 16.4. Drawing by John Asbridge showing the planned dressing for Shipley Windmill, West Sussex, UK, as the home of Jonathan Creek. Acknowledgements to BBC TV, John Asbridge (designer).

Fig. 16.5. The interior of Shipley Windmill prior to it being dressed as the home of Jonathan Creek. Acknowledgements to Shipley Windmill, West Sussex, UK. Photograph: Jim Woodward-Nutt.

In order to do this, a complete range of products was designed for the fictitious company the central character worked for. This included not only devising all the packaging for the scents (nine in all) but designing all the promotional background material which would be used to dress the store. A process that would normally take a specialist company months needed to be designed and finalized by an art director on the production in weeks. This type of 'hidden' design is commonplace in TV productions. Every photographic image used, whether it is of a range of products, a family photograph made into a prop that is picked up for seconds by an actor on screen or an image in a magazine that is fleetingly featured on camera but is crucial to the plot, all need to be organized by an art director, photographed and made into the prop that has been outlined in the script.

This process becomes even more involved in period drama as every element needs to evoke the era in question. The crucial difference between designing contemporary drama and period drama is arguably the fact that no direct comparison with an existing reality is possible. This provides the designer with a much greater degree of freedom in the creation of an on-screen world. Yet as discussed earlier, while authenticity is not always the intention, any element that would draw the viewers' attention in a way that

Fig. 16.6. Interior of Shipley Windmill dressed as the home of Jonathan Creek. Acknowledgements to BBC TV, Shipley Windmill, West Sussex, UK, John Asbridge (designer). Photograph: Antony Cartlidge.

would make them question the credibility of a scene would need to be removed or altered in some way.

For Malcolm Thornton, award-winning designer of both period productions (*Our Mutual Friend, The Young Visitors, Othello*) and contemporary drama (most recently *Law and Order: UK,* the British version of the American production), the design of drama can be more about the atmosphere of the piece rather than a recreation of either the past or the present.[25] For Thornton, the design process often begins with an emotive response to the script that may result in his

focusing on a single image—daylight falling on a face or a figure standing alone in a room. In-depth research will then be carried out for the specific demands of the script both in relation to the architecture and dressing. As budgets tighten, locations are used increasingly, even though a set offers more control in terms of lighting and direction, and the selection of key props becomes even more important in the creation of a setting without the construction of scenery. However, rather than automatically responding to the need for a specific prop in the script—a storage rack for apples in the nineteenth century for one production, for example—Thornton finds himself questioning if this single piece could be used as shorthand for a particular place or period and whether it could also be used, among other things, as a means of creating an interesting lighting effect, a key component in the creation of an onscreen illusion. In this way, the choice of a single object can define concisely period, place and atmosphere in a set.[26]

Finally, the ongoing effect of digital technology on production design should be mentioned. CGI (computer generated imagery) has become very useful in drama productions mainly as a post-production tool, not only to create architectural features but also to remove unwanted elements or anachronisms. The use of computers and a work force fluent in their use have also resulted in the design and often the production of prop graphics by the in-house art department rather than outsourcing to a specialist company. Designers also 'use 3D programmes to "view" sets and work out CGI elements' in addition to employing computers to produce some of the drawings needed for

construction (although hand drafting is still widely used both in television and film).[27]

In terms of non drama, while virtual sets seemed once to be forecast as the future of this type of design in television—the BBC had a dedicated unit examining this in the 1980s—currently that does not seem to be the case, with virtual elements often integrated with physical sets. Several BBC studios are now 'virtually capable', and this facility can be offered to any production that needs to incorporate digital elements into the design.[28]

While the decline of television productions has been predicted with the rise of the Internet, this idea seems to be changing with the two mediums often seen as complementary. Integration once more seems to be the key. In Giles Hattersley's article for the *Sunday Times*[29] examining the phenomenon of *The X Factor*, David Brennan, head of research and strategy at Thinkbox, is quoted as saying that 'the internet is fuelling television. You might not be watching a show, but you hear something at work then you watch a clip on YouTube, then suddenly you're hooked'.[30] This fusion, coupled with the increasingly prohibitive cost of large-scale feature films, would seem to indicate that television production, in some form, is set to continue. However this material is distributed, it still needs to be written, produced and designed, and it would seem that the skills of the television production designer are currently still very much in demand.

Notes

1. T. Byrne, *Production Design for Television* (Focal Press, 1993).

2. J. Barnwell, *Production Design: Architects of the Screen* (Wallflower Film Studies, 2004).

3. Ibid., p. 38.

4. Peter Ettedgui discusses the difficulty in defining the role of the production designer in relation to film design in the introduction to his book *Production Design and Art Direction* (Screencraft series, RotoVision, 1999).

5. *The X Factor* (Talkback Thames / SYCO tv, 2004–).

6. *BBC Breakfast News* (BBC TV); *Politics Show* (BBC TV, 2003–); *Working Lunch* (BBC TV, 1994– 2010); *Newsnight* (BBC TV, 1980–). The *BBC Breakfast News* set, designed by Simon Jago, was launched in 2006. Information relating to this set and the other sets mentioned was gained from telephone conversations with Jago between 2008 and 2010.

7. Telephone conversation with Simon Jago, 2008.

8. Ibid.

9. Ibid.

10. *Channel 4 News* (Channel 4—produced by ITN, 1982–). The current set, designed by Simon Jago, was launched in 2005.

11. *Parkinson* (BBC TV, 1971–1982 and 1998–2004; ITV, 2004–2007).

12. *Friday Night with Jonathan Ross* (BBC TV, 2001–2010).

13. Barnwell, *Production Design*, p. 99. Versions of this format are now shown internationally: *The Weakest Link* (BBC TV, 2000–).

14. *Crimewatch* (BBC TV, 1984–). The set, designed by Jonathan Taylor, was launched in 2008.

15. *Waking the Dead* (BBC TV, 2000–). The set was launched in 2002.

16. *Bladerunner* (directed by Ridley Scott, 1982); *The Office* (BBC TV, 2001). Versions of *The Office* are shown internationally.

17. Information relating to *Crimewatch* and *Waking the Dead* in this section was gained from conversations with the designer Jonathan Taylor between 2008 and 2010.

18. *EastEnders* (BBC TV, 1985–).

19. A. Sherwin, 'Sets too Shabby for Latest TVs Force *EastEnders* out of Town' [Final 1 Edition], *The Times* (18 February 2008), p. 11, UK Newsstand, ProQuest.

20. *Absolutely Fabulous* (BBC TV, 1992–1996 and 2001–2004); *Only Fools and Horses* (BBC TV, 1981–1991; additional Christmas specials until 2003).

21. *Jonathan Creek* (BBC TV, 1997–); *Love Soup* (BBC TV, 2005–2008).

22. John Asbridge, in a note to author, 2009. Information relating to *Jonathan Creek* and *Love Soup* was gained from conversations with, and notes sent to, the author by the designer John Asbridge between 2008 and 2010.

23. Ibid.

24. Ibid.

25. *Our Mutual Friend* (BBC TV, 1998); *The Young Visitors* (BBC TV, 2003); *Othello* (LWT, WGBH Boston, Canadian Broadcasting Corporation, 2001); *Law and Order: UK* (Kudos Film and Television, Wolf Films, NBC Universal, 2009–).

26. Information in this section was gained from conversations with the designer Malcolm Thornton between 2009 and 2010.

27. Notes sent to the author by John Asbridge, 2009.

28. BBC, 'BBC Studios and Post Production', http://www.bbcstudiosandpostproduction.com.

29. G. Hattersley, 'The X Factor: All Together Now', *Sunday Times*, 13 December 2009.

30. Thinkbox is the marketing body for commercial TV in the UK. Its structure includes a Marketing Department and a Research and Strategy Department.

Chapter Seventeen

The spectacular form of interior architecture under the new conditions of urban space

Pierluigi Salvadeo

Architecture nowadays aims to be gazed upon rather than to function as a tool with which to address the real world. It focuses all attention on its own superficial appearance, offering a novel idea of spectacle as the reflection of the different way people live now. What we are faced with is something whose ongoing reality is less concrete, more visual, which makes room for a theatrical aspect in which architecture tends to identify itself with backdrops and facades. This evolution in architecture, which makes the human agent subordinate to the backdrop and the construction to the image, gives a considerably enhanced value to the quest for self-referential display as spectacle.

'Consumption' and 'image' seem to be the concepts that best summarize the present state of contemporary society, whose living space is constantly becoming less a matter of reality and more one of imagery or imagination: less and less stable, more and more transitory. What is unreal but representational—the illuminated or image-decorated surface, the sketched design, the model—is replacing the traditional concept of 'building', and architecture seems to be becoming a matter of installations and stage sets. We are presented with a particular spatial aesthetics, the aesthetics of the provisional, of the media, advertising and spectacle—more generally, the aesthetics of communication. The city, with its architectural features and its indoor and outdoor spaces, is no longer calibrated in terms of its three-dimensional voids and solids: its very identity is more and more often a matter of the two-dimensional presentation of messages and images. This suggests a new concept of space.[1]

The quality of this new form of space is not immediately evident: its real complexity is inward and virtual. It is something more mental than volumetric, more temporal than spatial, something that challenges us to consider a new system of relationships in its entirety, involving issues of time, energy, land use, networking and so on. This gives rise to an unprecedented kind of mapping, the description of a composite structure which dispenses with any special or fixed viewpoint. The terms of urban representation have been altered: instead of being

shown the city's inhabited spaces, we are increasingly often obliged to try to imagine them, or at least to grasp them, by means of motley and sometimes contradictory scraps of information that require constantly updated viewpoints. This kind of space— less functional, more scenographic—can be accessed from more than one direction: it is multiethnic, multidisciplinary, occasional, casual, episodic, unsystematic, reversible and lacking in ballast; it follows a new, broader system of links and references. It is a self-referential space made up of scenographic architectures (or architectural set designs) which have overtaken and replaced the reassuring but now outmoded idea of a building's functionality.

When Guy Debord wrote *La Société du spectacle* in the late 1960s, the world had not yet reached that spectacular phantasmagoria of forms and images which we find quite ordinary nowadays.[2] Debord's new aesthetics were those of the capitalist society then taking shape, the society of consumption and mechanization, which was discovering a new conception of reality in the media, advertising and spectacular entertainment and was finding its point of maximum expression in that conception's corollary, the *image*. Things' value in use (i.e. their physical consumption) became less important than their value in exchange (or potency in circulation), and it is this that now represents their true value. What matters most of all in an object, accordingly, is its potential as a commodity—the symbolic outweighs the material; the abstraction represented trumps the physical reality. Spectacle takes its place within this new reality in which that

which is produced is stripped of its original value and reduced to its exchange value alone. The true essence of things is now their abstraction as spectacle; they are no longer bought just to be consumed, but primarily for what they symbolize or represent.

La Société du spectacle was written in 1967. When we reread it today it speaks to us of our own times, for the idea of 'spectacle' seems a near-perfect representation of the real load-bearing skeletal core of today's society of consumption and image. With remarkable intuition, Guy Debord foresaw the overwhelming dematerialization of modern society, in which spectacle transforms the world into a parallel—but equally authentic— reality. The Indian anthropologist Arjun Appadurai, one of the most expert contemporary commentators on globalization and its cultural aspects, takes the view that advertising nowadays creates what could be described as a sort of 'imagined nostalgia': a 'nostalgia for things that never were'.[3] 'Imagined nostalgia' is an inversion of our fantasy's temporal order: usually we fantasize forwards, imagining what might happen in the future; but this is a nostalgia for the present, induced by a proliferation of advertising messages in their manifold forms of expression, as if the present were already on the point of vanishing. We consumers seem to live in a back-to-the-future atmosphere, where the present is already periodized. Such notions lead Appadurai to argue that the new techniques of mass marketing actually construct time, even though it is thought of as lost, absent or remote. Accordingly, whereas Guy Debord discovered the idea of a spectacular reality in

advertising and the media, Arjun Appadurai now finds the same idea of spectacle in much the same terms, but amplified by an implosive and retrospective construction of time. This concept of the space-time of real life is entirely consistent with the space-time of the spectacle.

The conditions of urban space have changed, and so has the idea of habitation: its traditional static connotation of being housed somewhere, of having a home, has been lost. The very idea of place is becoming a changeable concept, its identity no longer established once and for all. In these circumstances of mutability, then, 'where we live' is no longer just in a place called 'home', but in way stations and excursions, for we are always in movement; generic travellers, as it were, who can live in no single place, but in many.[4] This new way of thinking takes hybridization as a given, and the individual merges with the space he or she inhabits simply by appearing there. There is a different perspective on what it means to live somewhere: the pattern that is clearly discernible is that of a wandering life lived by a theoretical inhabitant of no fixed abode.

The Dadaists in their day created the first urban 'ready-mades' by going on walks around the dullest and most utterly ordinary places in their cities, a direct and dynamic action in the city's real space that trumped the futurists' static representations of motion and made the transition to an authentic adoption of movement itself as 'home'. After the Dadaists came the surrealists, who also used the city for dynamic performances, but in their case the aim was, by walking around, to reach a state of unknowing, to

lose their bearings, as it were, and so lose control, leading apparently to a hypnotic and 'surreal' condition. Their saunterings put them in touch with the more unconscious aspects of their urban geography, and the space through which they wandered was not the city landscape so much as the human mind. As in their artistic productions, they were looking not to the visible world of the actual city, but rather to the landscapes of the unconscious.

In the early 1950s, the International Situationists also used to roam the city's least-known districts: they called it 'urban drifting' (dérive), and it was a means whereby individuals could experiment with new forms of behaviour in their lives: 'A living moment, concretely and deliberately engineered through the collective organization of a shared ambiance and the random play of events.'[5]

The practice of urban drifting consisted of getting lost in a city, giving rise to 'situations' of unmediated consumption, living the present moment. The Situationists' 'psychogeographic maps' were accordingly an invitation to lose oneself in the city, and such wanderings opened up new territories for investigation, new itineraries, and above all new spaces in which to live. The theory behind this 'drifting' was the development of what would be a scientific method in its own right: a method of investigation and at the same time a source of design ideas. Psychogeography, as studied by the Situationists, recognized and investigated the psychic effects of urban surroundings on individuals and their resulting behaviour. This inevitably led to experimentation with new forms of behaviour in the individual's real life.

The Situationists regarded this procedure, at once investigatory, critical and generative of ideas, as a new collective art form, an artistic endeavour by a group and, indeed, the only one that was acceptable in that it alone could annihilate the individual element in the traditional work of art, which they saw as pointless or even downright harmful to society and civilization. Drifting, according to Guy Debord, made it possible to acknowledge and celebrate 'constructive play' that went beyond the conventional notions of travelling or strolling to reveal an aspect of awareness of reality that matched the idea of a wandering abode. Starting as a method of investigation and a way of interpreting space, drifting becomes a criterion for its construction, and moving around becomes a form of architectonic composition in its own right, an architecture of experiential space.

The idea of a wandering that can trace out new ways of living in cities subsequently led Constant Nieuwenhuys to conceive of his New Babylon as the ideal site for wandering abodes: a city of nomads, whose inhabitants would not be constrained by any sedentary ties but free to wander at will over the terrain, as space would be organized under a new dispensation to be available to everyone.[6] New Babylon spreads throughout the world, rolling out like a horizontal Tower of Babel to follow the nomadic wanderings of its inhabitants, whose movements would thus turn into architecture and whose travels would create their space. Constant's ideas are resurfacing today, as Jeremy Rifkin records modern society's abolition of 'jobs' constrained within the limited space characteristic of industrial society as traditionally conceived.[7] It is the

accelerating pace of automation that is bringing about the worker-less factory and forcing a rethink that can picture a new social economy capable of providing occupation for the considerable numbers of people driven out of work; but this is not the only space being colonized by the intelligent machine: higher up the corporate hierarchy, the managers, too, together with their various complicated tasks, are being replaced along with the assembly-line workers.

Under these new conditions, time tends to take over the function of space, and the actual ownership of an asset is destined to be steadily replaced by access to it—or to the service or cultural experience associated with it. This is the so-called 'experience economy', in which asset use is determined by the intangible network, making the symbolic or spectacular aspect an important feature even of the asset itself. The old concept of a market based on ownership is disappearing, as ideas, concepts, images and experiences become the fundamental elements of value. The result is a new way of using space and a different mode of inhabiting the surface of the Earth. Ownership no longer ties our lives down; our dwelling space is ordered in creative ways that are untrammelled by the usual ordinary constraints: a new society inhabits space in a freer, more open manner, as a society of wanderers who can insert themselves at any point alike in the network's immaterial spaces, as in the constructed spaces of the city. Our mode of habitation changes from sedentary to itinerant and is no longer place dependent; we follow a new and more extensive system of landmarks. This is how Jeremy Rifkin puts it:

Global travel and tourism, theme cities and parks, destination entertainment centres, wellness, fashion and cuisine, professional sports and games, gambling, music, film, television, the virtual worlds of cyberspace and electronically mediated entertainment of every kind are fast becoming the centre of a new hyper-capitalism that trades to access cultural experiences.[8]

Our framework of orientation is increasingly a mobile one, even if it still coincides in a curious way with the fixed installations of our cities. Space fragments and swells in all directions alike, and our capacity to recognize it depends more and more on receiving messages via communications. 'Where I live' no longer has just one meaning: I can live in many places at once, and the space I inhabit is not only physical space, but also the immaterial, virtual space of the network, my access to which is merely provisional. Space is giving way to time as an almost material factor, the primary factor for measuring all we do.

Every day we find ourselves faced with a sort of spatial multitasking in which the simultaneity of our actions and the places we live in modify the time available to us. The *Visual Networking Index* is the result of research recently conducted by Cisco Systems into how many things we can now do simultaneously each day.[9] It defines a 'digital day' as the day lived by people whose time is spent doing many things at once: they surf the Internet while listening to music, sending an e-mail, answering the telephone and so on. Cisco Systems' research found that our 24-hour days have now swelled to

36 hours' worth and by 2013 will actually have doubled to 48 hours.

The fact that time and space no longer coincide, that time runs at a different pace from that used in the perception of space, has an undeniable aspect of spectacle. It is, in fact, the space-time of spectacle which is floating free from that of real life. Life as spectacle has accordingly become one of the modern modes of habitation; the wandering abode comprises time just as much as space. Furthermore, it comprises every activity, from the nearest at hand to the most remote, from work to leisure. It is our postindustrial society's creative mode of habitation, capable of forever finding new ways of occupying space—ways that may sometimes be improper, but are always innovative.

This new mode of habitation matches the evolving aspect of the modern city, as Richard Florida argues: his 'Creative City' is one that is not only more open, multiethnic and multicultural, but also can sustain interaction among its diversities at a profound level and make changeableness a generative force.[10] The classical sense of habitation is lost, and accordingly a creative class arises to match this creative city, a class capable of inventing new ways in which to use the city and its various spaces, and new modes of inhabiting them.

Contemporary society is made up of new inhabitants who make use of the city and its architecture in a creative way that defies fixed categories, often altering such uses and adapting buildings to whatever kind of purpose the occupier wishes. The global city's buildings and spaces set up a form of

physical network, and this physical network now combines with the virtual one to allow free circulation of ideas and things, of tangible and intangible goods. This globalized all-purpose network shows even more glaringly the difference between what is in the network and what is excluded from it, between what facilitates the free circulation of goods and ideas and what still belongs to a more partial way of thinking.

According to Marc Augé, the global network is that which is controllable, while the local represents that which remains outside the network and is accordingly less readily monitored or controlled.[11] That which is local—and consequently partial, small-scale and private—is now on the outside: outside the network, outside the system. It has become external and is therefore free and could potentially rebuild a new urban system, a new and broader planning system. The network, on the other hand, is on the inside once more: it is the 'indoors', and within it we find the same firms, the same trademarks, the same things we still use to recognize who and where we are. The new 'outdoors', then, is the complex system of the small scale, sprawling spatially. This is a complete inversion of values, a revolution in the concept of 'indoors': a widely dispersed interior, which comprises other locations in space while remaining similar to itself in form. In this view, the notion of the inhabited interior spreads far beyond its ordinary boundaries.

Some of the historical and social factors which help explain how the concept of living in a place came to be broadened in this way may be found in the widespread dereliction of industrial districts that began during the 1970s. During those years, as robot technology spread through the factories, many industrial spaces gradually came to be abandoned. Conditions favoured the rise of a new, small-scale, geographically dispersed form of enterprise which, as Andrea Branzi has argued, has begun to invent new creative occupations for itself and new ways of using the city's spaces.[12] This is the effect of what has been called 'the third industrial revolution', in which a restless and sometimes irrational mass of people use the architectures of the city in a creative way that defies fixed categories: they work at home, in the car or in the train; they live in warehouses, make universities out of disused factories, banks out of churches and so on. The postindustrial city generates itself in a process of continuous reassignment of its indoor spaces, and for this purpose requires an atomized system of artefacts suited to the new needs of a society whose main characteristic is its lack of precise contours, which is always ready for something different, new or provisional. The dynamic, flexible condition of this new fluid society takes material form in spaces which often have little functional identity but can be adapted to whatever kind of function people choose to give them.[13] Lacking any real means of marking such spaces' identities, people find refuge in a new system of products, the all-permeating system of movable objects and furnishings. The postindustrial city arises out of a process of continuous reuse of its interior spaces, and this takes place through the use of subsystems and what we might call a kind of kit of parts for a living space, which can

exert an influence beyond its own borders. In this way, interior design moves beyond the boundaries of furnishing as a discipline and turns into a system capable of controlling the overall functioning of the city: a sort of new urban planning—and an unprecedented responsibility for interior architecture. The design of occupied space is increasingly unconstrained, and the boundary between reality and its representation is becoming blurred. Instead of constructing a space, we can more and more often try imagining, describing or performing it, as in a story or a stage set.[14] The boundaries between the virtual and the real are less and less solid; even their essential natures are less distinguishable, increasingly uncertain and more open to negotiation. As Guy Debord had already glimpsed as early as the 1950s, spectacle has now become the contemporary city's predominant aspect and the real guiding principle of city life. With the idea of 'spectacle' comes changes in the concepts of place and identity: we are losing our sense of 'the built environment'; the notion of 'the local context' is being powerfully eroded, for we are becoming more and more used to being context independent. Space itself has been eroded; city places are less and less local—just the physical meeting places of cultural diversities, sites whose identity seems to consist of no more than their very lack of identity.

We may now speak of new kinds of space, spaces characterized by a powerful scenographic element, places of dramaturgy conceived as sets in their own right, idealized spectacle venues, urban stages not set in any particular place but representative only of themselves, all attention focused on the wholly abstract place they are designed as. Unlike traditional stage sets with their close relationship to a theatrical narrative, these places set a scene as a given space supplied with particular characteristics by the drama performed in it. Their narrative function discarded, these independent sets define a new kind of metropolitan realism; they embody a theatrical mix of media, spectacle and reality where installation, scenery and illusion are mingled, actor and onlooker change places and fiction is superimposed on reality and vice versa. Architecture seems to be giving way to set design, which plays a greater and greater part in expressing the relationship between space and function. Lived-in space, set design and urban planning are being brought into a new relationship under a new system of logical connection.

In 2003–2004, an installation at Tate Modern in London reproduced natural time in a thoroughgoing atmospheric experience. The Weather Project by the Danish artist Olafur Eliasson used a sun of single-wavelength lamps positioned high up at the back of the gallery's vast Turbine Hall, together with a mirror to duplicate its effect and disco fog generators to transform it into a surreal place that superseded the idea of imitating nature and enlisted a new conception of nature itself. The entire space was wrapped in a steadily replenished mist that recreated the idea of a watery vapour: the effect was a surreal feeling of suspension. It is as though we were seeing a sensational sunset for the first time; visitors lay down flat, on the ground or on the ramps of the Tate, as if they were at the beach; they looked upward and noticed

their own reflections in the mirrored ceiling. In this way, the spectators became part of the museum, part of the spectacle, and bathed in this surrogate sunlight, this scrap of artificial nature. It was a true stage set, independent of any functional requirement; the space it represented was not an analogue of any other. It was not meant to represent other spaces, nor indeed anything other than itself. It was a self-fulfilling theatrical space.

It is Olafur Eliasson's belief that nature does not exist in and of itself, but is wholly bound up with the way in which we observe it (see Fig. 17.1). The same kind of subjectivity allows the Dutch sound artist Edwin van der Heide to create artificial scenes that accurately match the sounds that come out of deafening loudspeakers. In his *Laser Sound Project,* lasers are hooked up to the sound emissions, and wall-like sheets of light materialize, demarcating environments that feel like actual rooms. In this way, the sound makes its presence felt within acoustic space and leads the visitor to interact with it in a total-immersion experience. *Laser Sound Project* involves affect rather than technology; the space it generates puts the beholder in touch with his or her feelings and subjective perceptions. We are in the presence of an abstract space that is as autonomous and self-referential as the music that generates it (see Fig. 17.2).

It should be pointed out, however, that this identification between music and space is not a twenty-first-century invention. There were those, almost a hundred years earlier, who looked to musical rhythm as an avenue into some thorough investigations of the relationships between architectural space and the space of the stage set. One of these was Adolphe Appia, an early craftsman of the new staging that emerged in reaction to the naturalistic theatre of the nineteenth century.[15] His fundamental principles were that the stage set had its own artistic autonomy, that sets should not be required to be objectively lifelike and that the purpose of set design as an art could not be mere imitation, but on the contrary the expression of an ideal. Appia maintained that sets should not be based on the idea of imitating nature, but on their own inherent artistic qualities as something purely sui generis and abstract.

Adolphe Appia believed that through rhythmical movement we are united with our surrounding space by means of music: such movement allows us to rediscover the

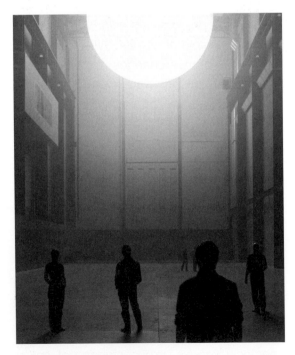

Fig. 17.1. Olafur Eliasson, *Weather Project,* Tate Modern, London, 2003. Photograph: Olafur Eliasson.

Fig. 17.2. Edwin van der Heide, *Laser Sound Project*, 2005. Photograph: Edwin Van Der Heide

essential point where body and spirit come together. He found his stimulus in eurhythmics for the creation of the drawings we know as his *Rhythmic Spaces*. The *Rhythmic Spaces* are ideal settings for spectacle and consist of three-dimensional, workable sets. The scenes are not set in any particular place: they portray only themselves; and the attention is wholly focused on the quest to create spectacle following its own logic and values. They are architectural spaces which do not follow plot cues or stage directions and do not belong to given situations but instead refer to the abstraction of music, evoking other spaces

and other situations. Unlike traditional set designs which are always at the service of theatrical narration, Appia's *Rhythmic Spaces* present the setting as a given, something that exists prior to the action and accordingly has its own autonomous spatial and cultural connotations, its own dramaturgy quite apart from any narrative form (see Fig. 17.3). Like a veil hung between the virtual world of subjective perceptions and the objective world of real space, the scene merges with the real world to make a new space in which people live and move. The traditional relationship of dependence between form and function has

been taken off its hinges, and more complex and heterogeneous relations are the order of the day.

The case of Las Vegas is particularly revealing, as Robert Venturi describes it in his celebrated work *Learning from Las Vegas*: a great billboard, its 'anti-spatial' architecture a matter of advertising.[16] One famous example is the design of the interiors of the buildings on Freemont Street, where the fruit machines are installed to look like the buildings' pillars. Nowadays, however, Las Vegas has undergone a further transformation, even better than virtual reality. In Las Vegas,

there is no need to try to believe one is somewhere else; for, in fact, anyone who is in Las Vegas is indeed in another place, or rather in many other places. We may speak of a theatricalization of architecture in which it becomes not only an ideal site for spectacle, but also the actual spectacle itself. As well as the simple 1960s two-dimensional neon signs on the casino facades, we now have new luminous inserts and mega-screens, while the buildings' interiors have been transformed into remote, exotic places such as savannahs, deserts, glaciers and so on. Venturi recognizes that today's Las Vegas is

Fig. 17.3. Adolphe Appia, *Spazi Ritmici, Scherzo*, 1909/1910. Photograph: Pierluigi Salvadeo.

different from what it was when he wrote his famous book. The city has been Disneyfied and is changing from a strip designed to be driven along in a car into a Disneyland, a series of stage sets for strolling through, in which the public participate interactively and feel themselves actors on a constantly changing stage (see Fig. 17.4). Such interactive narratives are not linear ones like a film plot; they are hyper-narratives, stories in which it becomes possible to make leaps—logical or illogical—from one system of plot segments to another.

That is the case with Studio Azzurro's 'luci d'inganni' (deceptive lights), in which the domestic space is reinterpreted virtually using light as the main material.[17] Studio Azzurro itself calls this kind of experience a 'Video-environment' (or 'Video-room'), indicating that its research explores the borders of the real, the virtual and the theatrical. The 'Video-cabinet', with its content of objects shown life-size, seeks to move beyond the realm of represented objects to engage in a dialogue with the real object, which is in front of the image or beside it. Studio Azzurro

Fig. 17.4. Las Vegas, Venetian resort. Photograph: Pierluigi Salvadeo.

contends that video does much more than report a thing: it allows whatever is left unclear or in suspense to be filled in by the spectator's imagination and in this way lets that imagination help complete the space (see Fig. 17.5).

To conclude, one might sum up by saying that architecture has taken on the job of representation which has traditionally belonged to the stage set; that architecture has been theatricalized, becoming not only the ideal site of spectacle, but in fact the spectacle itself. The hyper-structured (mutually referential) internal complexity of these two disciplines (architecture and set design) is crumbling in the face of powerful

and aggressive pressures from other aspects of today's world. In their mutual exchanges, set design and architecture can nowadays be seen to be following a common trajectory. A sort of polyglot multivalency is to be found in the areas occupied by each, which is clearly an effect of modernity: living space is becoming space for display or representation, and display space is turning into living space.

Notes

1. See for example P. Virilio, 'From the Media Building to the Global City: New Scope for Contemporary Architecture and Urban Planning', *Crossing* 1/1 (December 2000), pp. 5–7.

2. G. Debord, *La Società Dello Spettacolo* (Baldini & Castoldi, 2001 [1967]).

3. A. Appadurai, *Modernità in Polvere* [Modernity at Large: Cultural Dimensions of Globalization] (Meltemi, 2007).

4. On the subject of itinerant living as an art form and as a primary terrain-transforming act see F. Careri, *Walkscapes, Camminare come Pratica Estetica* (Giulio Einaudi, 2006).

5. G. Debord and G. Sanguinetti, *Situazionisti e la Loro Storia* (Manifestolibri, 1999), p. 24. My translation.

6. See F. Careri, *Constant: New Babylon, una Città Nomade* (Testo & Immagine, 2001).

7. J. Rifkin, *La Fine del Lavoro* [The End of Work] (Mondadori, 2006).

8. J. Rifkin, *L'Era dell'Accesso* [The Age of Access] (Mondadori, 2001), p. 10.

9. Cisco, founded in San Jose (California) in 1984, is one of the leading manufacturers of networking devices.

10. R. Florida, *L'Ascesa della Nuova Classe Creativa* [The Rise of the Creative Class] (Mondadori, 2003).

11. M. Augé, *Tra the Confini: Città, Luoghi, Integrazioni* (Mondadori, 2007).

12. A. Branzi, 'La Progettazione degli Interni nella Città Contemporanea', in A. Cornoldi, ed., *Architettura degli Interni* (Il Poligrafo, 2005).

13. Z. Bauman, *Modernità Liquida* [Liquid Modernity (2000)] (Bari, 2004).

Fig. 17.5. Studio Azzurro, *Luci di Inganni,* 1982. Photograph: Studio Azzurro.

14. See for example G. Amendola, *La Città Postmoderna: Magie e Paure della Metropoli Contemporanea* (Laterza, 2005).

15. P. Salvadeo, *Adolphe Appia, 1906—Spazi Ritmici* (Alinea, 2006).

16. R. Venturi, D. Scott Brown and S. Izenour, *Learning from Las Vegas* (Massachusetts Institute of Technology, 1996).

17. B. Di Marino, ed., *Studio Azzurro, Videoambienti, Ambienti Sensibili e altre Esperienze tra Arte, Cinema, Teatro e Musica* (Feltrinelli, 2007) [DVD and book].

Contributors

Eric Anderson is assistant professor of art history at Kendall College of Art and Design, Ferris State University, Michigan. He completed his PhD dissertation, *Beyond Historicism: Jakob von Falke and the Reform of the Viennese Interior,* at Columbia University in 2009. Current topics of research include the reception of folk crafts at the world's fairs, German immigrant designers in the nineteenth-century United States and the intersection between architecture and the social sciences. He curated the exhibition Garden Communities in Queens at the Queens Museum of Art and recently received a Baird Society Resident Fellowship from the Smithsonian Institution.

Mary Anne Beecher heads the Department of Interior Design at the University of Manitoba in Winnipeg, Manitoba. She is an associate professor and teaches interior design studio and courses on design research methods and the history of interior spaces and furniture. Beecher holds a doctoral degree in American studies with an emphasis in material culture studies from the University of Iowa and interior design degrees from Iowa State University. Her research explores the evolution of interior space in the twentieth century by investigating the reciprocal influence of design and culture, especially as it is evidenced in the design of storage space and storage objects. She is also interested in the evolution of the interior design profession as it emerged in the period following World War II. She is a member of IDEC, ACEID/ ACEDI and the Vernacular Architecture Forum, and she serves on the Council of the Professional Interior Designers Institute of Manitoba.

Christopher Breward is principal of Edinburgh College of Art and former head of the Research Department at the Victoria & Albert Museum, London. His research interests lie in the field of fashion history, and he has published widely on fashion's relation to masculinity, metropolitan cultures and concepts of modernity. His publications include: co-edited with D. Gilbert, *Fashion's World Cities* (Berg, 2006); co-edited with C. Evans, *Fashion and Modernity* (Berg, 2005); *Fashion* (Oxford University Press, 2004); *Fashioning London* (Berg, 2004); co-edited with B. Conekin and C. Cox, *The Englishness of English Dress* (Berg, 2002); and *The Hidden Consumer* (Manchester University Press, 1999). Christopher is a fellow of the Royal Society of Arts and sits on the editorial boards of the journals *Fashion Theory* and the *Journal of Design History*.

Marilyn Cohen has a PhD in art history from the Institute of Fine Arts, New York University, and a masters degree in decorative arts, design history and material culture from the Bard Graduate Center in New Yor City. She currently teaches in the masters programme in the History of Decorative Arts and Design at Parsons the New School for Design/Cooper-Hewitt National Design Museum. She has given papers and published on the subject of popular/material culture in relation to

film and television, including: 'A Design for Greed: Set Decoration in Oliver Stone's *Wall Street*', 'Furnishing *I Love Lucy*', 'The Material Culture of *Toy Story*', 'Mass Market Chinoiserie', and '*The Best Years of Our Lives*: Design, Disability & Displacement in Postwar America'. She is author and curator of Reginald Marsh's New York (1983), an exhibition at the Philip Morris Branch of the Whitney Museum of American Art.

Fiona Fisher is a postdoctoral researcher in the Modern Interiors Research Centre at Kingston University. She worked in consumer magazine publishing for over ten years before returning to education in 2001. She completed a BA in the history of art, architecture and design in 2004, and her PhD, *In Public, in Private: Design and Modernisation in the London Public House, 1872–1902,* was awarded by Kingston University in 2008. Her publications include: with P. Sparke and J. Black, 'Changing Places: Public Leisure Interiors in the Work of the Camden Town Group', for the Camden Town Group Online Research Project (Tate Britain/Getty, forthcoming); and 'Privacy and Supervision in the Modernised Public House, 1872–1902', in *Designing the Modern Interior: From the Victorians to Today* (Berg, 2009).

Alice T. Friedman is Grace Slack McNeil Professor of the History of American Art at Wellesley College, Massachusetts, where she has taught since 1979. Her research specialisms are architecture, gender and social history. She has written widely on these subjects and is the author of *Women and the Making of the Modern House: A Social and Architectural History* (Harry Abrams, 1998). Her current research focuses on mid-century modern architecture and includes a book-length study entitled *American Glamour and the Evolution of Modern Architecture* (Yale University Press, 2010).

Tag Gronberg is postgraduate tutor, in charge of research, in the Department of History of Art and Screen Media at Birkbeck, University of London. Between 2006 and 2009, she was a principal investigator on the AHRC-funded project 'The Viennese Café and fin-de-siècle Culture', carried out jointly at Birkbeck and the Royal College of Art. Her publications include *Designs on Modernity: Exhibiting the City in 1920s Paris* (Manchester University Press, 1998/2003); and *Vienna: City of Modernity 1890–1914* (Peter Lang, 2007). She was on the organizing committee for the V&A exhibition Modernism 1914–1939: Designing a New World (2006), for which she wrote the catalogue essay on 'Performing Modernism'.

Meltem Ö. Gürel is head of the Department of Interior Architecture and Environmental Design at Bilkent University, Ankara, where she has been teaching since 1994. Previous to her full-time academic engagement, Gürel practiced architecture and interior design in Illinois and New York. She taught as an adjunct professor at the University of Illinois, Urbana-Champaign, from which she received her PhD in architecture, Master of architecture, BSc in architectural studies and BSc in interior design. She has published in the *Journal of Architectural Education,* the *Journal of Architecture, Gender, Place and Culture,* the *Journal of Design History,* the *International Journal of Art & Design Education* and elsewhere. Her research interests include cross-cultural histories of modernism with an emphasis on society, gender and culture as they have influenced the built environment—especially in Turkey in the mid-twentieth century—as well as the domestic

domain, interior space and interior design/ architecture education.

Trevor Keeble is associate dean in the Faculty of Art, Design and Architecture at Kingston University, London. His PhD, *The Domestic Moment: Design Taste and Identity in the Late Victorian Interior,* was awarded in 2005 by the Royal College of Art. He has contributed essays on the history of domestic interiors to a number of publications, including most recently to *Designing the Modern Interior: From the Victorians to Today* (Berg, 2009); *Design and Culture* (vol. 1, no. 3, Berg, 2009); and *The Walls Are Talking: Wallpaper, Art and Culture* (KWS/Chicago University Press, 2010).

Patricia Lara-Betancourt works as a postdoctoral researcher for the Modern Interiors Research Centre at Kingston University and was until recently, editorial assistant to *Interiors: Design Architecture Culture* (Berg). Her PhD, *Conflicting Modernities? Arts and Crafts and Commercial Influences in the Furnishing and Decoration of the Middle-Class Home, 1890–1914,* was awarded by Kingston University in 2009. Patricia completed her BA in history at the Pontificia Universidad Javeriana in Bogota, Colombia, where she lectured from 1990 to 1996 in Colombian and Latin American History. In 1997, she was awarded her MA by the Universidad Nacional de Colombia, where she carried out extensive research on the design and material culture of the nineteenth-century drawing room in Santa Fe de Bogota. Based on this research, she has published several articles in Colombian history journals.

Teresa Lawler is course director of MA Production Design for Film and Television and MA Film Design and 3D Visual FX at Kingston University. She joined BBC TV in 1981, where she worked as a designer

and art director on a wide variety of projects from current affairs to light entertainment and drama until leaving in 1993. Since then, TV credits as a freelancer include *EastEnders* (BBC TV 1997, designer), *Jonathan Creek — The Black Canary* (BBC TV 1998, art director) *Jonathan Creek — Satan's Chimney* (BBC TV 1998, art director) and *The Cazalets* (BBC TV, WBGH Boston — in association with Cinema Verity 2001, art director). She also has extensive experience as a theatre designer and artist and has exhibited work widely in the UK and internationally, most recently in the National Open Art Competition in Chichester and London (2007 highly commended, and 2008).

Grace Lees-Maffei MA RCA FHEA is reader in design history at the University of Hertfordshire, where she coordinates the tVAD Research Group in its work on 'Relationships between Text, Narrative and Image'. She is co-editor, with Rebecca Houze, of *The Design History Reader* (Berg, 2010), and her monograph on postwar domestic advice literature (produced with support from the AHRC and the Design History Society) is forthcoming. Grace's publications examine design discourse and the mediation of design through channels including domestic advice, corporate literature, advertising and magazines. She is currently editing an anthology entitled *Writing Design,* developed from the 2009 Design History Society conference on that theme, which she co-convened with Jessica Kelly (Middlesex). Grace is a member of the advisory board for the *Poster* and has served as an editor of the *Journal of Design History* (2002–2008) and as a trustee of the Design History Society (1998–2002).

Brenda Martin is curator of the Dorich House Museum at Kingston University. Her publications

include: 'A House of Her Own; Dora Gordine and Dorich House', in *Women's Places: Architecture and Design, 1860–1960* (Routledge, 2003); 'Photographs of a Legacy', in *The Modern Period Room, 1870–1950* (Routledge, 2006); and 'An Artist at Home: Studio Residences and Dora Gordine', in *Embracing the Exotic: Jacob Epstein and Dora Gordine* (Papadakis, 2006). Her research contributed to the first monographic study of Dora Gordine, *Dora Gordine: Sculptor, Artist, Designer* (Philip Wilson, 2007), and she was the curator of the first major retrospective exhibition of Dora Gordine's work at the Kingston Museum and Dorich House Museum in 2009. In 2012, she will curate a solo show of Gordine's work at the Adamson Eric Museum in Tallinn, Estonia.

Bridget A. May is professor of interior design in the School of Arts and Sciences, Marymount University, Virginia. Her research interest is in historic interiors and interior decorators. She is co-author with Buie Harwood and Curt Sherman of *Architecture and Interior Design through the 18th Century: An Integrated History* and *Architecture and Interior Design from the 19th Century: An Integrated History,* which were awarded the ASID Education Foundation/Joel Polsky Award in 2002 and 2009. A combined volume entitled *Architecture and Interior Design: An Integrated History to the Present* was published in March 2011. She has held office and committee responsibilities in the Interior Design Educators Council (IDEC) and has been active in the American Society of Interior Designers (ASID). She is on the editorial review boards for the *Journal of Interior Design* and *Interiors: Architecture, Design, Culture* and serves as the latter's exhibition review editor.

Helen Potkin is principal lecturer in art history in the Faculty of Art, Design and Architecture at Kingston University. She is course director for three undergraduate courses in the School of Art & Design History. Her research and teaching interests are concerned with artistic practices 'beyond' the gallery including public sculpture, performance art and installation. Publications include 'Performance', in *Feminist Visual Culture* (Edinburgh University Press, 2000); and with Fran Lloyd and Davina Thackara, *Public Sculpture of Outer West London and Surrey* (Liverpool University Press, 2011).

John Potvin is associate professor at the University of Guelph, Ontario. In addition to several book chapters and articles, he is the author of *Material and Visual Cultures beyond Male Bonding: Bodies, Boundaries and Intimacy, 1870–1914* (Ashgate, 2007), editor of *The Places and Spaces of Fashion, 1800–2007* (Routledge, 2009) and co-editor of *Material Cultures, 1740–1920: The Meanings and Pleasures of Collecting* (Ashgate, 2009) and *Fashion, Interior Design and the Contours of Modern Identity* (Ashgate, 2010). He is currently preparing two manuscripts, *Bachelors of a Different Sort: Modernism and the Queer Aesthetic Interior* (Melbourne University Publishing); and *Giorgio Armani: Empire of the Senses* (Ashgate), which explores the Italian's influence on design, aesthetics and industry.

Nicky Ryan is principal lecturer in visual culture and theory in the Faculty of Design at the London College of Communication. Research interests include the relationship between art and business, museums and the role of culture in regeneration. She has delivered a range of conference papers

and authored publications on these topics and is a regular reviewer for the *Museums Journal.* Recent publications include: 'Wynn Las Vegas: A Flagship Destination Resort', in *Flagship Marketing: Concepts and Places* (Routledge, 2009); 'Patronising Prada', in *Limited Language: Rewriting Design* (Birkhäuser, 2009); 'Crystal Palace and the Politics of Place', in *Tourism and Leisure: Local Communities and Local Cultures in the UK* (LSA, 2009); 'The Network Museum', in *Networks of Design* (Universal-Publishers, 2009); and 'Millstone or Milestone? The Perceived Value of Cultural Studies for Art and Design Students and Teachers', in *Art, Design & Communication in Higher Education* 8/1 (2009).

Samantha Erin Safer is Brand Communications Manager for the commercial arm of the Victoria & Albert Museum, London, and has published widely on twentieth-century fashion history. She was a contributing author to *Lucile Ltd: London, Paris, Chicago and New York. 1890s–1930s* (V&A Publishing, 2009) and *Grace Kelly Style* (V&A Publishing, 2010) and co-authored *My Favourite Dress* (ACC Editions, 2009). Samantha holds two masters degrees, one in the history of design from the Royal College of Art, London, as well as a degree in design management from London College of Fashion. Her most recent book, *Zandra Rhodes: Textile Revolution: Medals, Wiggles and Pop 1961–1971,* was published by Antique Collectors Club in 2010.

Pierluigi Salvadeo is an assistant professor in the Architecture & Society Faculty of the Architecture and Planning Department, Politecnico di Milano, Italy. He has a PhD in interior architecture and exhibition design from Politecnico di Milano and serves on the doctorate's board. He was awarded first prize in the 1995 *Opera Prima* competition (Milan) and first prize in the 1998 Domus/InArch awards for his design of a twelve-apartment building at Lodivecchio in Milan. He also won the competition for the design of three social housing apartment buildings at Monteluce in Perugia (2007). His publications include: *Architettura A Teatro* (Clup, 2004); *Adolphe Appia, 1906, Spazi Ritmici* (Alinea, 2006); and *Architetture Sonore* (Clup, 2006). His most recent book is *Abitare lo spettacolo* (Maggioli, 2009).

Andrew Stephenson is the subject director of visual theories at the University of East London. He has published extensively on British art and design of the late nineteenth and twentieth centuries. His publications include: '"Wonderful Pieces of Stage-Management": Masculine Fashioning, Race and Imperialism in J. S. Sargent's British Portraits, c.1897–1907', in *The Art of Transculturation: Cross-Cultural Exchanges in British Art, 1770–1930* (Ashgate, 2011); 'Strategies of Display and Modes of Consumption in London Art Galleries in the Inter-War Years, c.1919–40', in *The Rise of the Modern Art Market in Europe 1850–1939* (Manchester University Press, 2010); 'Questions of Artistic Identity, Self-Fashioning and Social Referencing in the Work of the Camden Town Group, c.1905–1914', the Camden Town Group Online Research Project (Tate Britain/Getty, forthcoming); and 'Edwardian Cosmopolitanism c.1901–1912', in *The Edwardian Sense: Art and Experience in Britain 1901–10* (Paul Mellon Centre for Studies in British Art/Yale University Press, 2010).

Mark Taylor is associate professor of interior design, Queensland University of Technology,

Brisbane. His research is widely published in journals and books, and his design work has been exhibited at Melbourne Museum (2007) and at la Biennale di Venezia (2008). He is editor of *Surface Consciousness* (John Wiley, 2003), co-editor with Julieanna Preston of *Intimus: Interior Design Theory Reader* (John Wiley, 2006), and is currently editing *Interior Design & Architecture: Critical and Primary Sources,* 4 vols (Berg, 2012). Recently, Mark Taylor and Gini Lee co-convened the international symposium entitled *Interior Spaces in Other Places* (2010). He is currently completing his PhD at Queensland University of Technology on the life and work of nineteenth-century English art critic Mary Haweis.

Sabine Wieber is a design historian and lecturer in art history at Glasgow University. Her research concentrates on German and Austrian modernism with particular attention to the domestic interior as an important cultural site of modern identity. She recently co-curated Madness & Modernity: Kunst und Wahn in Wien um 1900 at the Wien Museum, Vienna, and is currently preparing a monograph on Central European salon culture from 1870 to 1930. Her publications include: 'The Allure of Nerves: Class, Gender and Neurasthenia in Klimt's Society Portraits', in *Madness and Modernity* (Lund Humphries, 2008); and 'Munich Historicist Interiors and German National identity, 1871–1888', in *International History Review* (2007).

Illustrations

Fig. 1.1 'Männliche und Weibliche Tracht, 1520–1530', from A. Eye and J. Falke, *Kunst und Leben der Vorzeit,* 2nd ed., Nuremberg: Bauer und Raspe, 1868, plate 47.

Fig. 1.2 Hans Makart's decoration of the study of Nikolaus Dumba, Parkring 4, Vienna. Watercolour by Rudolf Alt, 1877. Collection of the Historisches Museum der Stadt Wien, inventory number 58.124.

Fig. 1.3 Hans Makart, study for the imperial wedding anniversary parade, confectioners group (detail). Oil on canvas. Collection of the Historisches Museum der Stadt Wien, inventory number 17.738/1.

Fig. 1.4 Hans Makart, portrait of a woman with a feathered hat, seen from behind. Oil on canvas. Collection of the Germanisches Nationalmuseum, Nuremberg, inventory number GM 1658.

Fig. 1.5 Interior of Hans Makart's studio. Photograph taken ca. 1875. Collection of the Historisches Museum der Stadt Wien, inventory number 97.283.

Fig. 2.1 Mary Eliza Haweis (1848–1898). From H. R. Haweis, ed., *Words to Women: Addresses and Essays by the Late Mrs. H. R. Haweis,* London: Burnet and Isbister, 1900.

Fig. 2.2 Title page with woodblock initial letter. From Mary Haweis, *Beautiful Houses,* London: Low, Marston, Searle and Rivington, 1882.

Fig. 2.3 The Narcissus Hall, Leighton House. © English Heritage, NMR.

Fig. 2.4 The Staircase Hall viewed from Narcissus Hall, Leighton House. © English Heritage, NMR.

Fig. 3.1 Warner House. From *Harper's New Monthly Magazine,* October 1874.

Fig. 3.2 Stair hall of Warner House. From *Harper's New Monthly Magazine*, October 1874.

Fig. 3.3 An old-time New England farmhouse. From *Harper's Weekly,* 15 July 1876.

Fig. 3.4 Making Thanksgiving pies. From A. E. Morse, *Home Life in Colonial Days,* 1898.

Fig. 3.5 Washington: The Centennial Tea Party in the Rotunda. From the *New York Times,* 17 December 1874.

Fig. 3.6 Henry Loveloy, 'A Puritan Hearthstone', c. 1906. Library of Congress, LC-USZ62–90823.

Fig. 4.1 Reinhold Voelkel, *Café Griensteidl,* 1896. Wien Museum.

Fig. 4.2 Batt (Oswald Barrett), 'Beethoven Nears the End', Percy A. Scholes, *The Oxford Companion to Music,* Oxford University Press, 3rd ed., 1941, plate 18. Courtesy of Michael Abbott.

Fig. 4.3 Batt (Oswald Barrett), 'Brahms Begins the Day', Percy A. Scholes, *The Oxford Companion to Music,* Oxford University Press, 3rd ed., 1941, plate 23. Courtesy of Michael Abbott.

Fig. 4.4 Batt (Oswald Barrett), 'Schubert Leaving the Coffee House', Percy A. Scholes, *The Oxford Companion to Music,* Oxford University Press, 3rd ed., 1941, plate 149. Courtesy of Michael Abbott.

Fig. 4.5 Jiro Osuga, *Café Jiro,* 2009. Installation at the Flowers gallery. By permission of the artist.

Fig. 5.1 'Miss Marion Terry as Lady Claude Derenham in Mollentrave on Women', from *Sketch* supplement, 15 March 1905, p. 8. Courtesy of the Yale University Library.

Fig. 5.2 The Louis XIV Restaurant, Piccadilly Hotel, Regent Street, London, plate 1 from souvenir programme, *Special Morning Performance in Aid of the Re-building Fund of the Royal National Orthopaedic Hospital* (3 December 1908). V&A Theatre Collections.

Fig. 5.3 The St James's Theatre, London, from *Sketch,* 25 March 1896. V&A Theatre Collections.

Fig. 5.4 'Mrs. George Alexander with "Pan," a Favourite', from *Play Pictorial* 17, no. 101 (1911), p. 48. Courtesy of the Yale University Library.

Fig. 5.5 Mme Simone le Bargy in *The Man of the Moment*, from *Sketch* supplement, 12 July 1905, p. 4. Courtesy of the Yale University Library.

Fig. 6.1 Lady Duff Gordon styling a mannequin, undated, Lucile Archive © V&A Images/Victoria and Albert Museum, London.

Fig. 6.2 Private mannequin parade with tea at Lucile Ltd, Paris, c. 1911–1913. Lucile Archive © V&A Images/Victoria and Albert Museum, London.

Fig. 6.3 The Rose Room at Lucile Ltd, 1400 Lake Shore Drive, Chicago. Lucile Archives 1915–1925. Courtesy of Special Collections, Gladys Marcus Library, Fashion Institute of Technology, New York.

Fig. 6.4 The Parlour Room, Lucile Ltd, 37–39 West 57th Street, New York. Lucile Archive © V&A Images/Victoria and Albert Museum, London.

Fig. 6.5 The Rose Room at Lucile Ltd, 37–39 West 57th Street, New York. Lucile Archives 1915–1925. Courtesy of Special Collections, Gladys Marcus Library, Fashion Institute of Technology, New York.

Fig. 7.1 The Séeberger brothers. Photograph of Harry Pilcer and Gaby Deslys, 1919, Deauville, France. Estampes et Photographie © Bibliothèque nationale de France.

Fig.7.2 The Séeberger brothers. Photograph of Mlle Lily Damita, Biarritz, France, September 1933. Estampes et Photographie © Bibliothèque nationale de France.

Fig. 7.3 The Séeberger brothers. Photograph of dance hall 'Au petit balcon', rue de Lappe, Paris, 1930. Médiathèque de l'Architecture et du Patrimoine, Paris © Ministère de la Culture — Médiathèque du Patrimoine, Dist. RMN / Frères Séeberger (FSK35–03).

Fig. 7.4 Cover of *Détective,* April 1931 © Bibliothèque nationale de France.

Fig. 8.1 Unpublished appendix to *Annual Report New York State Extension Service in Home Economics,* vol. 16, pt. 2, 1933, n.p. Courtesy of the Division of Rare and Manuscript Collections, Cornell University Libraries.

Fig. 8.2 Florence E. Wright, *Reconditioning Furniture* (Cornell Bulletin for Homemakers No. 256), Ithaca, New York: New York State College of Home Economics, April 1933, p. 12. Courtesy of the Division of Rare and Manuscript Collections, Cornell University Libraries.

Fig. 8.3 Florence E. Wright, *Reconditioning Furniture* (Cornell Bulletin for Homemakers No. 256), Ithaca, New York: New York State College of Home Economics, April 1933, p. 18. Courtesy of the Division of Rare and Manuscript Collections, Cornell University Libraries.

Fig. 8.4 Cornell University Rare and Manuscript Collection, Collection 23/18/919 Wayne County photographs: photo #7–76-Wa-62-M (no date), Ithaca, New York. Courtesy of the Division of Rare and Manuscript Collections, Cornell University Libraries.

Fig. 8.5 Cornell University Rare and Manuscript Collection, Collection 23/18/919 Rochester County photographs: photo #7–50–12 (no date), Ithaca, New York. Courtesy of the Division of Rare and Manuscript Collections, Cornell University Libraries.

Fig. 9.1 Dichotomous images: The pair, comparing a veiled woman to women in summer dresses, encapsulates the symbolic role of fashion in depicting the modern and its other in the streets of Istanbul. *Resimli Hayat,* January 1954.

Fig. 9.2 Advertisements for women's cosmetic products depict the imported postwar expression of femininity, characterized by an enthusiasm for frivolity and hygienic confidence and symbolizing modernity. *Hayat,* 15 June 1956.

Fig. 9.3 Advertisements for building materials and finishes exemplify how women's gendered identities intertwined with notions of fashion, femininity, the modern home and consumerism. *Arkitekt,* 193–4 (1948).

Fig. 9.4 A typical page layout of *Yedigün* pairing 'Our Home' and 'Fashion' sections. The former features new home plans that frame contemporary living and the latter features Western fashions that frame modern women. *Yedigün,* 25 September 1948.

Fig. 9.5 A typical page layout of *Hayat* pairing women's fashion with the 'Beautiful Home' section. The composition reinforces and codifies the strong connection between women's clothing and domestic designs while framing contemporary looks. *Hayat,* 13 March 1959.

Fig. 10.1 Fire escape at East 71st Street. *Breakfast at Tiffany's* (1961).

Fig. 10.2 Holly's apartment. *Breakfast at Tiffany's* (1961).

Fig. 10.3 Paul's apartment. *Breakfast at Tiffany's* (1961).

Fig. 10.4 Mrs. Faylenson's apartment. *Breakfast at Tiffany's* (1961).

Fig. 10.5 Seagram Building. *Breakfast at Tiffany's* (1961).

Fig. 11.1 Residence of Philip Johnson, New Canaan, CT. Architect: Philip Johnson. © Wayne Andrews/Esto.

Fig. 11.2 View to Guest House. Residence of Philip Johnson, New Canaan, CT. Architect: Philip Johnson. Ezra Stoller © Esto.

Fig. 11.3 Kitchen. Glass House, New Canaan, CT. Architect: Philip Johnson. Bill Maris © Esto.

Fig. 11.4 Living Space. Glass House, New Canaan, CT. Architect: Philip Johnson. Ezra Stoller © Esto.

Fig. 11.5 Bathroom. Glass House, New Canaan, CT. Architect: Philip Johnson. Bill Maris © Esto.

Fig. 11.6 Bedroom. Glass House, New Canaan, CT. Architect: Philip Johnson. Bill Maris © Esto.

Fig. 11.7 Shelving. Glass House, New Canaan, CT. Architect: Philip Johnson. Bill Maris © Esto.

Fig. 12.1 T-shaped service, 'a work-saver for family meals; it is easily adapted to company meals'. Mary and Russel Wright, *Guide to Easier Living,* New York: Simon and Schuster, 1954 (1950). Image © Russel Wright Studios.

Fig. 12.2 'The Kitchen Buffet', illustration by James Kingsland. Mary and Russel Wright, *Guide to Easier Living,* New York: Simon and Schuster, 1954 (1950). Image © Russel Wright Studios.

Fig. 12.3 'Cleanup can even be part of the evening's pleasure, if managed properly', illustration by James Kingsland. Mary and Russel Wright, *Guide to Easier Living,* New York: Simon and Schuster, 1954 (1950). Image © Russel Wright Studios.

Fig. 12.4 Author portrait, frontispiece, Julia Cairns, *Home Making,* London: Waverley, 1950. © IPC+ Syndication.

Fig. 12.5 'A graceful Dresden shepherdess looks down upon a simple mixture of dried flowers and seed-heads, in a glass bowl.' Julia Cairns, *Home Making,* London: Waverley, 1950. © IPC+ Syndication.

Fig. 12.6 'Two views of the same dual-purpose interior … it combines a living-room and a dining-room.' Julia Cairns, *Home Making,* London: Waverley, 1950. © IPC+ Syndication.

Fig. 12.7 'A few bottles of wine and an odd shelf can become a fascinating bar if you follow these instructions.' Daphne Barraclough, *How to Run a Good Party,* London: Foulsham, 1956, p. 116. Text and image © W. Foulsham & Co Ltd, http://www.foulsham.com.

Fig. 13.1 Geraldine Pilgrim, *Dreams of a Winter Night* (2007), Belsay Hall, Northumberland. Photograph: Sheila Burnett.

Fig. 13.2 Lyndall Phelps, *Drift* (2005), Flock wallpaper and acrylic paint installation, Andaz (former Great Eastern Hotel, London), commissioned by Commissions East. Photograph: Richard Davies.

Fig. 13.3 Hilary Powell, *Smog Nocturne* (2003), St Pancras Chambers (former Midland Grand Hotel at King's Cross, London). Photograph: Gillian McIver.

Fig. 13.4 Neville Gabie, *Void,* project *Up in the Air* (2000), Sheil Park, Liverpool. © Neville Gabie. Photograph: Neville Gabie.

Fig. 14.1 Jade Bar, Gramercy Park Hotel, with paintings by Julian Schnabel *Blue Japanese Painting no. 2* (2005) and Jean-Michel Basquiat, *Revised Undiscovered Genius of the Mississippi Delta* (1983). Photograph courtesy of Ian Schrager Company.

Fig. 14.2 Pool Table, Gramercy Park Hotel, with painting by Andy Warhol, *Ladies and Gentlemen* (1983). Photograph courtesy of Ian Schrager Company.

Fig. 14.3 Lobby, Gramercy Park Hotel. Photograph courtesy of Ian Schrager Company.

Fig. 14.4 Lobby, Gramercy Park Hotel, with paintings by Julian Schnabel, *Suddenly Last Summer (*2005) and Cy Twombly, *Bacchus* (2005). Photograph courtesy of Ian Schrager Company.

Fig. 14.5 Rose Bar, Gramercy Park Hotel, with paintings by Julian Schnabel, *Suddenly Last Summer* (2005) and *Teddy Bears Picnic* (1988), and Andy Warhol, *Rorschach* (1984). Photograph courtesy of Ian Schrager Company.

Fig. 15.1 Giorgio Armani, London boutique, window display S/S 2007. Photograph: John Potvin.

Fig. 15.2 Giorgio Armani, London boutique, window display S/S 2007. Photograph: John Potvin.

Fig. 16.1 *BBC Breakfast*—morning news programme (BBC TV, 2006). Acknowledgements to BBC News, Simon Jago (designer).

Fig. 16.2 *Crimewatch* (BBC TV, 2008). Acknowledgements to BBC TV, Jonathan Taylor (designer) Photograph: Jonathan Taylor.

Fig. 16.3 *Waking the Dead* (BBC TV—first set 2002). Acknowledgements to BBC TV, Jonathan Taylor (designer). Photograph: Jonathan Taylor.

Fig. 16.4 Drawing by John Asbridge showing the planned dressing for Shipley Windmill, West Sussex, UK, as the home of Jonathan Creek. Acknowledgements to BBC TV, John Asbridge (designer).

Fig. 16.5 The interior of Shipley Windmill prior to it being dressed as the home of Jonathan Creek. Acknowledgements to Shipley Windmill, West Sussex, UK. Photograph: Jim Woodward-Nutt.

Fig. 16.6 Interior of Shipley Windmill dressed as the home of Jonathan Creek. Acknowledgements

to BBC TV, Shipley Windmill, West Sussex, UK, John Asbridge (designer). Photograph: Antony Cartlidge.

Fig. 17.1 Olafur Eliasson, *Weather Project,* Tate Modern, London, 2003. Photograph: Olafur Eliasson.

Fig. 17.2 Edwin van der Heide, *Laser Sound Project,* 2005. Photograph: Edwin Van Der Heide.

Fig. 17.3 Adolphe Appia, *Spazi Ritmici, Scherzo,* 1909/1910. Photograph: Pierluigi Salvadeo.

Fig. 17.4 Las Vegas, Venetian resort. Photograph: Pierluigi Salvadeo.

Fig. 17.5 Studio Azzurro, *Luci di Inganni,* 1982. Photograph: Studio Azzurro.

Select Bibliography

Ackerman, J.S., *The Villa: Form and Ideology of Country Houses,* Princeton, New Jersey: Princeton University Press, 1990.

Adamson, G., *The Craft Reader,* Oxford: Berg, 2009.

Albrecht, D., *New Hotels for Global Nomads,* London: Merrell, 2002.

Albrecht, D., Schonfeld, R., and Stamm Shapiro, L., *Russel Wright: Creating American Lifestyle,* New York: Cooper-Hewitt, National Design Museum, Smithsonian Institution, Harry N. Abrams, Inc., 2001.

Amendola, G., *La città postmoderna Magie e paure della metropoli contemporanea,* Roma-Bari: Laterza, 2005.

Appadurai, A., ed., *The Social Life of Things: Commodities in Cultural Perspective,* Cambridge: Cambridge University Press, 2006.

Aubenas, S., and Demange, X., with Chardin, V., *Elegance: The Séeberger Brothers and the Birth of Fashion Photography, 1909–1939,* San Francisco: Chronicle Books, 2007.

Augé, M., *Non-places: Introduction to an Anthropology of Supermodernity,* London: Verso, 1995.

Axelrod, A., ed., *The Colonial Revival in America,* Winterthur, Delaware: The Henry Francis du Pont Winterthur Museum, 1985.

Bagnall, G., 'Performance and Performativity at Heritage Sites', *museum & society,* 1/2 (2003), pp. 87–103.

Bailey, P., *Popular Culture and Performance in the Victorian City,* Cambridge: Cambridge University Press, 1998.

Bailey, S., and Conran, T., *Design: Intelligence Made Visible,* London: Conran Octopus, 2007.

Baricco, A., *I Barbari, saggio sulla mutazione,* Milan: Feltrinelli, 2006.

Barnwell, J., *Production Design: Architects of the Screen,* London: Wallflower Press, 2004.

Barr Jr, A.H., *Modern Architecture: International Exhibition,* New York: Museum of Modern Art, 1932.

Barr Jr, A.H., *The International Style: Architecture since 1922,* New York: Norton and Company, 1932.

Barraclough, D., *How to Run a Good Party,* London: Foulsham & Co. Ltd, 1956.

Barringer, T., and Prettejohn, E., eds, *Frederic Leighton: Antiquity, Renaissance, Modernity,* New Haven: Yale University Press, 1999.

Bell, D., and Hollows, J., eds, *Historicizing Lifestyle. Mediating Taste, Consumption and Identity from the 1900s to 1970s,* Aldershot: Ashgate, 2006.

Benjamin, W., *The Arcades Project,* ed., R. Tiedemann, tr. H. Eiland and K. McLaughlin, Cambridge, Massachusetts: Harvard University Press, 1999.

Benton, C., Benton, T., and Wood, G., eds, *Art Deco, 1910–1939,* London: V&A Publications, 2003.

Betsky, A., *Building Sex: Men, Women, Architecture, and the Construction of Sexuality,* New York: William Morrow, 1995.

Betsky, A., *Queer Space: Architecture and Same-Sex Desire,* New York: William Morrow, 1997.

Black, A.M., ed., *Modern American Queer History,* Philadelphia: Temple University Press, 2001.

Booth, M.R., and Kaplan, J.H., eds, *The Edwardian Theatre: Essays on Performance and the Stage,* Cambridge: Cambridge University Press, 1996.

Bourdieu, P., *Distinction: A Social Critique of the Judgment of Taste,* tr. R. Nice, London: Routledge, 1984.

Bourdieu, P., *Outline of a Theory of Practice,* tr. R. Nice, Cambridge and New York: Cambridge University Press, 1977.

Bozdoğan, S., and Kasaba R., eds, *Rethinking Modernity and National Identity in Turkey,* Seattle and London: University of Washington Press, 1997.

Bozdoğan, S., *Modernism and Nation Building: Turkish Architectural Culture in the Early Republic,* Seattle and London: University of Washington Press, 2001.

Breward, C., *Fashioning London: Clothing and the Modern Metropolis,* Oxford: Berg, 2004.

Breward, C., and Evans, C., eds, *Fashion and Modernity,* Oxford: Berg, 2005.

Breward, C., Gilbert, D., and Lister, J., *Swinging Sixties: Fashion in London and Beyond, 1955–1970,* London: V&A Publications, 2006.

Branzi, A., *Modernità debole e diffusa,* Milan: Skira, 2006.

Branzi, A., *The Hot House: Italian New Wave Design,* London: Thames and Hudson, 1984.

Brooks, D., *Bobos in Paradise: The New Upper Class and How They Got There,* New York: Touchstone, 2000.

Brooker, G., and Stone, S., *Re-Readings: Interior Architecture and the Design Principles of Remodelling Existing Buildings,* London: RIBA, 2004.

Butler, J., *Gender Trouble: Feminism and the Subversion of Identity,* New York and London: Routledge, 1990.

Buxbaum, G., *Mode aus Wien, 1815–1938,* Salzburg: Residenz Verlag, 1986.

Byrne, T., *Production Design for Television,* Boston: Focal Press, 1993.

Cairns, J., *Home Making: The Mid-twentieth Century Guide to the Practical Yet Subtle Art of Making a House a Home,* London: Waverley, 1950.

Cairns, J., *How I Became a Journalist,* London: Thomas Nelson and Sons, 1960.

Capote, T. [1948], *Other Voices, Other Rooms,* New York: Vintage International, Vintage Books, 1994.

Capote, T. [1958], *Breakfast at Tiffany's and Three Stories,* New York: Vintage International, Vintage Books: A Division of Random House, Inc., 1993.

Casid, J.H., 'Some Queer Versions of Georgic', in J.H. Casid, *Sowing Empire: Landscape and Colonization,* Minneapolis and London: University of Minnesota Press, 2005.

Casid, J.H., 'Queer(y)ing Georgic: Utility, Pleasure, and Marie-Antoinette's Ornamented Farm', *Eighteenth-Century Studies,* 30/3 (1997), pp. 304–18.

Castillo, G., *Cold War on the Home Front: The Soft Power of Midcentury Design,* Minneapolis: University of Minnesota Press, 2010.

Clark, H., and Brody, D., *Design Studies: A Reader,* Oxford: Berg, 2009.

Colomina, B., *Privacy and Publicity: Modern Architecture as Mass Media,* Cambridge: Cambridge University Press, 1996.

Colomina, B., *Sexuality and Space,* New York: Princeton Architectural Press, 1992.

Cooper, J., *Victorian and Edwardian Furniture and Interiors: From Gothic Revival to Art Nouveau,* London: Thames and Hudson, 1987.

Crary, J., 'Spectacle, Attention, Counter-Memory', *October* 50 (Fall 1989), pp. 97–107.

Crook, J.M., *William Burges and the High Victorian Dream,* London: John Murray, 1981.

Cunningham, P.A., and Voso Lab, S., eds, *Dress in American Culture,* Bowling Green, Ohio: Bowling Green University Popular Press, 1993.

Curtis, P., 'Old Places for New Art', *AN Magazine* (February 2003), p. 22.

Cytowic, R., *The Man Who Tasted Shapes,* Cambridge, Massachusetts: MIT Press, 2003.

Darling, E., *Re-Forming Britain: Narratives of Modernity before Reconstruction,* London: Routledge, 2007.

Davidoff, L., and Hall, C., *Family Fortunes: Men and Women of the English Middle Class 1780–1850,* London: Routledge, 1987.

Debord, G. [1967], *The Society of the Spectacle,* New York: Zone Books, 1994.

Doherty, C., *Contemporary Art: From Studio to Situation,* London: Black Dog, 2004.

Duff Gordon, Lady, *Discretions and Indiscretions,* London and Norwich: Jarrods Ltd, 1932.

Edwards, J., *Alfred Gilbert's Aestheticism: Gilbert amongst Whistler, Wilde, Leighton,* Aldershot: Ashgate, 2006.

Edwards, J., and Hart, I., eds, *Rethinking the Interior: Aestheticism and the Arts and Crafts Movement, 1867–1896,* Aldershot and Burlington, Vermont: Ashgate, 2010.

Elliott, B., and Helland, J., *Women Artists and the Decorative Arts, 1880–1935: The Gender of Ornament,* Aldershot and Burlington, Vermont: Ashgate, 2002.

Entwhistle, J., *The Fashioned Body: Fashion, Dress and Modern Social Theory,* Cambridge, UK: Polity Press, 2000.

Etherington-Smith, M., and Pilcher, J., *The 'It' Girls: Lucy, Lady Duff Gordon, the Couturiere, 'Lucile' and Elinor Glyn, Romantic Novelist,* London: Hamish Hamilton Ltd, 1986.

Ettedgui, P., *Production Design and Art Direction,* Hove, UK: RotoVision, 1999.

Falke, J. [1871], *Art in the House: Historical, Critical and Aesthetical Studies on the Decoration and Furnishing of the Dwelling,* tr. C.C. Perkins, Boston: L. Prang and Company, 1879.

Falke, J., *Die deutsche Trachten- und Modenwelt: Ein Beitrag zur deutschen Culturgeschichte,* 2 vols, Leipzig: Gustav Mayer, 1858.

Featherstone, M., 'Lifestyle and Consumer Culture', *Theory, Culture & Society,* 4/1 (February 1987), pp. 55–70.

Fletcher, I., 'Some Aspects of Aestheticism', in O.M. Brack Jr, ed., *Twilight of Dawn: Studies in English Literature in Translation,* Tucson: University of Arizona Press, 1987.

Fletcher, P.M., *Narrating Modernity: The British Problem Picture, 1895–1914,* Aldershot: Ashgate, 2003.

Fogg, M., *Boutique: A 60s Cultural Phenomenon,* London: Mitchell Beazley, 2003.

Forty, A., *Objects of Desire: Design and Society since 1750,* London: Thames & Hudson, 1986.

Foster, H., *Postmodern Culture,* London: Pluto Press, 1990.

Foucault, M., *The Archaeology of Knowledge,* New York: Pantheon Books, 1972.

Fox, S., *The Architecture of Philip Johnson,* Boston: Bulfinch Press, 2002.

Friedman, A.T., *American Glamour and the Evolution of Modern Architecture,* New Haven, Connecticut: Yale University Press, 2010.

Friedman, A.T., *Women and the Making of the Modern House: A Social and Architectural History,* London: Harry N. Abrams, 1998.

Frizot, M., and De Veigy, C., *Vu: The Story of a Magazine that Made an Era,* London: Thames & Hudson, 2009.

Fuss, D., *The Sense of an Interior: Four Writers and the Rooms that Shaped Them,* New York and London: Routledge, 2004.

Galton, F., *Inquiries into Human Faculty and its Development,* London: Macmillan, 1883.

Gere, C., *Nineteenth-century Decoration: The Art of the Interior,* New York: Harry N. Abrams, 1989.

Giddens, A., *Modernity and Self-identity: Self and Society in the Late Modern Age,* Stanford, California: Stanford University Press, 1991.

Gilman, N., *Mandarins of the Future: Modernization Theory in Cold War America,* Baltimore and London: Johns Hopkins University Press, 2007.

Goffman, E., *The Presentation of Self in Everyday Life,* Garden City, New York: Doubleday, 1959.

Goldhagen, S., and Réjean Legault, R., eds, *Anxious Modernisms: Experimentation in Postwar Architectural Culture,* Cambridge, Massachusetts, and London: MIT Press, 2000.

Gordon, B., 'Costumed Representations of Early America: A Gendered Portrayal, 1850–1940', *Dress,* 30 (2003), pp. 3–33.

Gordon, B., *The Saturated World: Aesthetic Meaning, Intimate Objects, Women's Lives, 1890–1940,* Knoxville: University of Tennessee Press, 2006.

Gronberg, T., *Designs on Modernity: Exhibiting the City in 1920s Paris,* Manchester, UK: Manchester University Press, 1998.

Gronberg, T., *Vienna: City of Modernity, 1890–1914,* Oxford: Peter Lang, 2007.

Gürel, M.Ö., 'Consumption of Modern Furniture as a Strategy of Distinction in Turkey', *Journal of Design History,* 22/1 (2009), pp. 47–67.

Gürel, M.Ö., 'Defining and Living Out the Interior: The "Modern" Apartment and the "Urban" Housewife in Turkey during the 1950s and 1960s', *Gender, Place & Culture,* 16/6 (2009), pp. 703–22.

Hansen, M., 'Benjamin, Cinema and Experience: "The Blue Flower in the Land of Technology"', *New German Critique,* 40 (Winter 1987), pp. 179–224.

Harrison, J.E., and Baron-Cohen, S., 'Synaesthesia: An Introduction', in J.E. Harrison and S. Baron-Cohen, eds, *Synaesthesia, Classic and Contemporary Readings,* Oxford: Blackwell, 1997.

Harvey, B., *The Fifties: A Woman's Oral History,* New York: Harper/Perennial, 1994.

Haweis, M., *Beautiful Houses,* London: Low, Marston, Searle and Rivington, 1882.

Haweis, M.E., 'Women as Writers', in H.R. Haweis, ed., *Words to Women: Addresses and Essays by the Late Mrs. H.R. Haweis,* London: Burnet and Isbister, 1900.

Hems, A., and Blockley, M., eds, *Heritage Interpretation,* London: Routledge, 2006.

Heynen, H. and Baydar, G., eds, *Negotiating Domesticity: Spatial Productions of Gender in Modern Architecture*, New York: Routledge, 2005.

Hine, T. *Populuxe,* London: Bloomsbury, 1990.

Holls, E., et al., eds, *Thinking Inside the Box: A Reader in Design for the Twenty-First Century,* Enfield, UK: Middlesex University Press, 2007.

Inglis, S., *Archibald Leitch—Football Ground Designer,* London: English Heritage, 2005.

Jameson, F., *Postmodernism, or, the Cultural Logic of Late Capitalism,* London: Verso, 1991.

Jenkins, S., and Mohney, D., *The Houses of Philip Johnson,* New York: Abbeville Press, 2001.

Johnson, P., *Writings,* foreword by V. Scully, introduction by P. Eisenman, commentary by R.A.M. Stern, New York: Oxford University Press, 1979.

Jones, A., and Stephenson, A., *Performing the Body/Performing the Text,* London: Routledge, 1999.

Kaplan, J.H., and Stowell, S., *Theatre & Fashion: Oscar Wilde to the Suffragettes,* Cambridge: Cambridge University Press, 1994.

Kassal-Mikula, R., ed., *Hans Makart, Malerfürst (1840–1884),* Vienna: Historisches Museum der Stadt Wien, 2000.

Kinney, L., 'Fashion and Fabrication in Modern Architecture', *Journal of the Society of Architectural Historians,* 58 (1999/2000), pp. 472–81.

Kirkham, P., and Thumin, J., eds, *Me Jane: Masculinity, Movies and Women,* London: Lawrence & Wishart, 1995.

Kirkham, P., ed., *The Gendered Object,* Manchester, UK, and New York: Manchester University Press, 1996.

Koolhaas, R., *Delirius New York,* Rotterdam, the Netherlands: 010 Publishers, 1994.

Koolhaas, R., *Junkspace,* Macerata, Italy: Quodlibet, 2006.

Kracauer, S., *The Mass Ornament: Weimar Essays,* Cambridge: Harvard University Press, 1995.

Lambert, P., '*Stimmung* at Seagram: Philip Johnson Counters Mies van der Rohe', *Grey Room,* 20 (Summer 2005), pp. 38–59.

Lawrence, D., *Bright Underground Spaces: The Railway Stations of Charles Holden,* London: Capital Transport Publishing, 2008.

Lees-Maffei, G., and Houze, R., *The Design History Reader,* Oxford: Berg, 2010.

Lewis, H., and O'Connor, J., *Philip Johnson: The Architect in His Own Words,* New York: Rizzoli, 1994.

Lillethun, A., and Welters, L., *The Fashion Reader,* Oxford: Berg, 2007.

Lupton, E., and Abbott Miller, J., *The Bathroom, the Kitchen and the Aesthetics of Waste: A Process of Elimination,* Cambridge, Massachusetts: MIT List Visual Arts Center, 1992.

Marling, K.A., *George Washington Slept Here: Colonial Revivals and American Culture, 1877–1986,* Cambridge, Massachusetts: Harvard University Press, 1988.

May, B., 'Progressivism and the Colonial Revival', *Winterthur Portfolio,* 26/2–3 (Summer/Autumn 1991), pp. 107–22.

Maynard, W.B., ' "Best, Lowliest Style!" The Early-Nineteenth-Century Rediscovery of American Colonial Architecture', *Journal of the Society of Architectural Historians,* 59/3 (2000), pp. 338–57.

McKellar, S., and Sparke, P., eds, *Interior Design and Identity,* Manchester, UK, and New York: Manchester University Press, 2004.

McLeod, M., 'Undressing Architecture: Fashion, Gender, and Modernity', in D. Fausch, ed., *Architecture: In Fashion,* New York: Princeton Architectural Press, 1994.

McNeill, D., 'The Hotel and the City', *Progress in Human Geography,* 32/3 (2008), pp. 383–98.

Mendes V., and de la Haye, A., *Lucile Ltd London, Paris, New York and Chicago: 1890s-1930s,* London: V&A Publishing, 2009.

Moseley, R., *Growing Up with Audrey Hepburn: Text, Audience, Resonance,* New York: Manchester University Press, 2002.

Nava, M., and O'Shea, A., eds, *Modern Times: Reflections on a Century of English Modernity,* London: Routledge, 1996.

Narotzky, V., 'Dream Homes and DIY: Television, New Media and the Domestic Makeover', in J. Aynsley and C. Grant, eds, *The Imagined Interior: Representing the Domestic Interior since the Renaissance,* London: V&A Publications, 2006.

Oboussier, C., 'Synaesthesia in Cixous and Barthes', in D. Knight and J. Still, eds, *Women and Representation: Proceedings of the Women Teaching French Conference May 1994,* Nottingham, University of Nottingham Occasional Papers No 3, 1995.

Ockman, J., 'Glass House', in R. Ingersoll, ed., *World Architecture 1900–2000: A Critical Mosaic,* i, New York: China Architecture and Building Press, 2000.

Oswalt, P., ed., *Shrinking Cities: Interventions,* ii, Ostfildern-Ruit, Maidstone: Hatje Cantz, 2006.

Petit, E., ed., *Philip Johnson. The Constancy of Change,* New Haven, Connecticut: Yale University Press, 2009.

Post, Emily (Mrs Price Post) [1930], *The Personality of a House: The Blue Book of Home Charm,* new rev. ed., New York and London: Funk and Wagnalls Company, 1948.

Potvin, J., and Myzelev, A., eds, *Fashion, Interior Design and the Contours of Modern Identity,* Aldershot, UK, and Burlington, Vermont: Ashgate, 2010.

Potvin, J., ed., *The Places and Spaces of Fashion, 1800–2007,* New York and London: Routledge, 2009.

Preston, J., 'Introduction: In the Mi(d)st of', *AD (Architectural Design) Interior Atmospheres,* 78/3 (May–June 2008), pp. 6–11.

Rappaport, E.D., *Shopping for Pleasure: Women in the Making of London's West End,* Princeton, New Jersey: Princeton University Press, 2000.

Reed, C., 'Design for [Queer] Living: Sexual Identity, Performance, and Décor in British Vogue, 1922–1926', *GLQ,* 12/3 (2006), pp. 377–403.

Reed, C., *Not at Home: The Suppression of Domesticity in Modern Art and Architecture,* London: Thames and Hudson, 1996.

Rendell, J., *Art and Architecture: A Place Between,* London: I B Tauris, 2006.

Rhoads, W.B., *The Colonial Revival,* New York: Garland Publishing, 1977.

Rice, C., *The Emergence of the Interior: Architecture, Modernity, Domesticity,* Oxford: Routledge, 2007.

Rifkin, A., *Street Noises: Parisian Pleasure 1900–40,* Manchester, UK: Manchester University Press, 1993.

Rifkin, J., *The Age of Access,* London: Penguin, 2000.

Rosner, V., *Modernism and the Architecture of Private Life,* New York: Columbia University Press, 2005.

Ross, K., *Fast Cars, Clean Bodies: Decolonization and the Reordering of French Culture,* Cambridge, Massachusetts: MIT Press, 1995.

Rossano, G.L., ed., *Creating a Dignified Past: Museums and the Colonial Revival,* Savage, Maryland: Rowman & Littlefield Publishers, 1991.

Ryan, N., 'Prada and the Art of Patronage', *Fashion Theory,* 11/1 (2007), pp. 7–23.

Salachas, G., *Le Paris d'Hollywood,* Paris: Caisse nationale des monuments historiques et des sites, 1994.

Salvadeo, P., *Abitare lo spettacolo,* Milan: Maggioli, 2009.

Sanders, J., *Celluloid Skyline: New York and the Movies,* New York: Alfred A. Knopf, 2002.

Schlansker Kolosek, L., *The Invention of Chic: Thérèse Bonney and Paris Moderne,* London: Thames & Hudson, 2002.

Schorske, C.E., *Fin-de-siècle Vienna: Politics and Culture,* New York: Vintage Books, 1981.

Schulze, F., *Philip Johnson: Life and Work,* New York: Alfred A. Knopf, 1994.

Segel, H.B., *The Vienna Coffeehouse Wits, 1890–1938,* West Lafayette, Indiana: Purdue University Press, 1993.

Smith, B., *Highbury: The Story of Arsenal Stadium,* Edinburgh: Mainstream Publishing, 2005.

Smith, L., *Uses of Heritage,* London: Routledge, 2006.

Sparke, P., *Elsie de Wolfe: The Birth of Modern Interior Decoration,* New York: Acanthus Press, 2005.

Sparke, P., Massey, A., Keeble, T., and Martin, B., eds, *Designing the Modern Interior: From the Victorians to Today,* Oxford: Berg, 2009.

Sparke, P., *The Genius of Design,* London: Quadrille, 2009.

Sparke, P., Martin, B., and Keeble, T., eds, *The Modern Period Room: The Construction of the Exhibited Interior, 1870–1950,* London: Routledge, 2006.

Sparke, P., *The Modern Interior,* London: Reaktion Books, 2008.

Spigel, L., and Mann, D., eds, *Private Screenings: Television and the Female Consumer,* Minneapolis: University of Minnesota Press, 2003.

Spigel, L., *Welcome to the Dreamhouse: Popular Media and Postwar Suburbs,* Durham, North Carolina: Duke University Press, 2001.

Stephenson, A., ' "Pariscope": Mapping Metropolitan Mythologies and Mass Media Circuitry', *Oxford Art Journal,* 18/1 (1995), pp. 160–5.

Stern, R., *New York, 1960: Architecture and Urbanism between the Second World War and the Bicentennial,* New York: Monacelli Press, 1995.

Stillinger, E., *The Antiquers,* New York: Alfred A. Knopf, 1980.

Sturgis, A., et al., *Rebels and Martyrs: The Image of the Artist in the Nineteenth Century,* London: National Gallery Company Ltd, 2006.

Susman, W. I., 'Personality and the Making of Twentieth-Century Culture', in J. Higham and P. K. Conkin, eds, *New Directions in Intellectual History,* Baltimore: Johns Hopkins University Press, 1979.

Sudjic D., *The Language of Things,* London: Allen Lane, 2008.

Sweet, F., *Philippe Starck: Subverchic Design,* London: Thames and Hudson, 1999.

Taylor, M., and Preston, J., *INTIMUS: Interior Design Reader,* Chichester, UK: John Wiley and Sons, 2006.

Tickner, L., *Modern Life & Modern Subjects: British Art in the Early Twentieth Century,* New Haven, Connecticut, and London: Yale University Press, 2000.

Torberg, F., *Tante Jolesch or the Decline of the West in Anecdotes,* Riverside, California: Ariadne Press, 2008.

Troy, N., *Couture Culture: A Story of Modern Art and Fashion,* Cambridge, Massachusetts, and London: MIT Press, 2002.

Varnelis, K., ed., *The Philip Johnson Tapes: Interviews with Robert A. M. Stern,* New York: Monacelli Press, 2008.

Veblen, T. [1899], *Theory of the Leisure Class: An Economic Study in the Evolution of Institutions,* London: Penguin Books, 1994.

Venturi, R., Scott Brown, D., and Izenour, S., *Learning from Las Vegas,* Cambridge, Massachusetts, and London: MIT Press, 1972.

Vischer, F. T. [1859], 'Vernünftige Gedanken über die jetztige Mode', in *Kritische Gänge,* Stuttgart: Cotta, 1861.

Wagner, R., 'The Art-Work of the Future', in *Richard Wagner's Prose Works,* tr., W. A. Ellis, London: K. Paul, Trench, Trübner, 1895.

Wasson, S., *A Splurch in the Kisser: The Movies of Blake Edwards,* Middletown, Connecticut: Wesleyan University Press, 2009.

Wasson, S., *Fifth Avenue, 5 A.M.: Audrey Hepburn, Breakfast at Tiffany's, and the Dawn of the Modern Woman,* New York: HarperStudio, 2010.

Whiteley, N., *Pop Design: Modernism to Mod,* London: Design Council, 1987.

Whitney, D., and Kipnis, J., eds, *Philip Johnson: The Glass House,* New York: Pantheon Books, 1993.

Wigley, M., *White Walls, Designer Dresses: The Fashioning of Modern Architecture,* Cambridge: MIT Press, 1995.

Wilson, E., 'The Bohemianisation of Mass Culture', *International Journal of Cultural Studies,* 2/1 (1999), pp. 11–32.

Wilson, E., *Adorned in Dreams: Fashion and Modernity,* New Brunswick, New Jersey: Rutgers University Press, 2003.

Wouters, C., *Informalization: Manners and Emotions since 1890,* London: Sage, 2007.

Wright, M. and R. Wright [1950], *Guide to Easier Living: 1,000 Ways to Make Housework Faster, Easier and More Rewarding,* rev. ed., New York: Simon and Schuster, 1954.

Index